ON HIGHWAY 61

DENNIS MCNALLY

ON

HIGHWAY

Music, Race, and
the Evolution of
Cultural Freedom

COUNTERPOINT
CALIFORNIA

Library of Congress Cataloging-in-Publication Data

McNally, Dennis.
On Highway 61 / Dennis McNally.
pages cm
ISBN 978-1-61902-449-6 (hardback)
1. African Americans--Music--History and criticism. 2. Popular music--United States--History and criticism. I. Title.
ML3479.M36 2014
781.640973--dc23
2014014417

ISBN 978-1-61902-581-3

Cover design by Charles Brock, Faceout Studios
Interior design by Megan Jones Design

COUNTERPOINT
Los Angeles and San Francisco, CA
www.counterpointpress.com

Printed in the United States of America

To Henry David Thoreau,
who started it all

Contents

Introduction

THIS IS AN idiosyncratic history of the American alternate voice, the countervoice to the materialist mainstream of American thought, which sees instead the essence of the American idea as centering on the pursuit of freedom.

The alternate view has many strands, especially in the socioeconomic realm of labor politics and history, but the thread I felt was most important to trace is specifically connected with cultural and spiritual freedom. This quest for cultural freedom has often been associated with Bohemianism, but that's merely a label, and a frequently distracting one at that.

This work follows the concept of freedom as it moves through a sequence of connections beginning with Henry David Thoreau, who developed the grammar of freedom in *Walden* and embedded it in the concept of the pastoral while simultaneously creating a sociopolitical philosophy that fundamentally responded to the fact of slavery. Mark Twain brought the pastoral to a triumphant fictional existence in *Huckleberry Finn* and in so doing linked it forever to the struggles of African Americans. His own life documents the evolving relationship of white America to the emerging African American culture, first through minstrelsy and then through the spirituals of the Fisk Jubilee Singers.

That culture, largely in its musical manifestations, carried forward the message of freedom. As minstrelsy and spirituals were succeeded by the new musical forms of the turn of the century, increasing numbers of white people began to join Twain and respond to African American life by seeing the intellectual shackles in their own lives and learning

the lessons that those at the bottom of the social pyramid had to offer. The effect of black music on white people did not always lead to overt changes, but to a widening of vision, a softening of the heart, and an increase in tolerance. Eventually, that growth would lead to an understanding that included action.

Ragtime would have an almost immediate influence on white lives through the medium of dance. Jazz would bring considerable white participation in the music's performance. Blues would influence white lives at first largely through its component presence in jazz, and then reach white youth in the '50s and after. Utimately, Bob Dylan would become the greatest artist of that tradition and the apotheosis of the white-black progression, deeply connected to the ongoing civil rights movement of his time.

Put in simplest terms, each of these artists preached a moral critique of American society and culture in light of the concept of freedom, and each was heavily influenced by the African American experience.

It is no accident that a significant part of this story takes place along the Mississippi River and the parallel Highway 61. This is a very specific place, even if ordinarily it is not so understood.

The result of this evolution was an era that challenged inherited assumptions about American culture on any number of levels, including skepticism about acquisitiveness and materialism, a rejection of institutional Christianity, opposition to racism, suspicions of power, a resistance to limits on sensual behavior, and a tendency to side with the individual against the corporation and/or nation/state. These challenges in the 1960s were the manifestation of a long, rich progression.

It is a progression that I began to study many years ago, although I began near the end, with a study of Jack Kerouac and the Beats (*Desolate Angel*) and then of the quintessential avatars of their decade, the Grateful Dead (*A Long Strange Trip*). Then I began to muse on a question: What caused the cultural shifts of the '60s? I accepted the consensus that the civil rights movement, the folk music renaissance,

sexual freedom, and the psychedelic world had been the immediate stimuli, but I wanted to dig into older and deeper roots for that most intriguing era. I ended up finding a fundamental origin in the ongoing relationship between white, often young Americans and African American culture, primarily music.

I

RACE AND THE FREEDOM PRINCIPLE IN NINETEENTH-CENTURY AMERICA

America and Henry Thoreau

As YOU LAND at Boston's Logan Airport, it's possible—with a window seat, a forgiving angle, and some imagination—to visualize nothing but virgin forest rolling away west from the Atlantic, to picture it as it was when the first settlers arrived in 1620. It really was a new world to them—*the* New World, Nova Terra. Due in considerable part to the massive die-off of Native Americans thanks to European diseases like smallpox, the land seemed endlessly open and the essence of freedom, the pastoral root of what came to be called the American Dream. "The pastoral ideal," wrote Leo Marx, "has been used to define the meaning of America ever since the age of discovery."

But the Puritans saw the land not as an Edenic vision of gardens but as a howling wilderness that needed taming. The notion that nature was something made for man to dominate was the first of four major elements of the American creed that the nation's first great social critic, Henry David Thoreau, would challenge. (The other three shibboleths were that America was the noble exception to all nations in its moral perfection, that Christianity was the only possible American religion, and that the Protestant work ethic and its implied worship of materialism were desirable and essential elements of any life.)

The worldview the Puritans brought to the new land was dramatically different from the Native American nature worship that preceded their arrival. The Hebraic shift to monotheism placed God outside and superior to nature. Their further belief that mankind was made in God's image divided people from all the other animals, from life itself, and marked a starting point for history and the origins of modern consciousness. By the time of Christianity, which grafted Greek rationality and the notion of the soul onto the Yahwist tradition, the process was complete. Civilization was understood to be a purely human-oriented construct in a dualistic world where God was sacred and humans profane. Nature was to be used.

Initially, the Puritans opposed luxury, materialism, and individualism with a religion the scholar David Shi suggested most closely resembled "late medieval Catholicism," which located one's ethical life above commerce. This would not last. The equation at the root of the Protestant ethic, wherein hard work and frugality lead to prosperity, would soon flower into Cotton Mather's notion that God's favor could be shown in riches. By the eighteenth century, New England was ruled by a merchant aristocracy that was far more influenced by the individualism of John Locke than by Christianity.

Along with individualist capitalism, the settlers brought with them a second social institution that would ensure that America was not Eden: slavery. It's critical to understand that slavery wasn't a tangential aberration to the democratic core of American development. It was essential to European expansion into the Western Hemisphere via the sugar trade, and it involved all the maritime nations of Europe and all the societies of West Africa.

U.S. slavery was surely among the most absolute in human history, wherein the enslaved had almost no past, and little visible future. As well, their value to their masters grew with every baby. By the 1790s, the other industry in the American South was that of breeding slaves.

The contemporary justification for slavery was that the Africans were heathens. In fact, the ancient Western justification for slavery went back to original sin, punishment, and the need to live "by the sweat of your brow"—which meant that any subgroup that you could dominate should do the heavy lifting. The language of the Enlightenment and of liberty undermined these rationalizations. By 1776, one in five inhabitants of the new United States was a slave, and by the time the English surrendered at Yorktown, a quarter of the Continental Army was black. The roots of the coming civil war lay in the American Revolution, with the northern states committing to freedom. Vermont banned slavery in 1777 by constitutional mandate, Massachusetts by judicial decision in the early 1780s, New Hampshire soon after. Contrarily, the people of South Carolina preferred to risk losing the war rather than empower slaves by using them as troops against the British.

As the nineteenth century progressed, the romantic impulse to ennoble labor and see how slavery degraded it began to generate a complicated response that weakened pro-slavery thinking but, out of fear of competition, stimulated working-class racism. At the same time, sociotechnological creations like the Erie Canal, the steam engine, and railroads jumpstarted economic development, and the eighteenth-century culture of "land, family, and community" was succeeded, wrote one historian, by one based on "reckless speculation, crass opportunism, and shameless social climbing."

Economic opportunity and the accretion of wealth became the baseline national creed, and this attitude found its keynote in the enshrinement of Ben Franklin as the great exemplar. This was not entirely fair. Though he embodied the bourgeois values of practicality, creativity, and good sense, he was cosmopolitan and never a moneygrubber. Still, the thrifty materialism and sociable networking he so brilliantly practiced as a young man were useful models for the upwardly mobile of the nineteenth century.

Ben *was*, as the historian Gordon Woods put it, the first American. In the nineteenth century, America had become a place to make money, and Ben's advice could help with that. And Thoreau? Thoreau would become one of the very first Other Americans, who saw America for what it had become, and would remain—and said no, beginning a long tradition of dissent.

BORN IN 1817 in Concord, Massachusetts, the iconic cradle of the American Revolution, Thoreau grew up watching the nineteenth-century development of the great American money machine, most directly in 1839 when he and his brother traveled by canoe on the Concord and Merrimack rivers. Their voyage brought them to the fulcrum of American economic development, the erstwhile utopia of Lowell, Massachusetts, which by 1839 had already come to more closely resemble William Blake's vision of dark satanic mills.

Thoreau had graduated from Harvard two years before, where he had become part of an intellectual revolution that can simplistically be described as the romantic revolt against the cold, empirical rationality of John Locke and Adam Smith, the intellectual framework that had helped generate the industrial era. In New England, Locke's thinking also created cerebral Unitarianism, sweeping away traditional Calvinist Christianity.

The rational nature of Unitarianism struck some as insufficiently fulfilling. In an old and pointed joke, a Unitarian comes to a fork in the road. One way goes to heaven, and one goes to a discussion about heaven; he takes the discussion. Just a few years after the development of Unitarianism, a significant portion of its intellectual leadership would withdraw and espouse beliefs more reflective of German idealism and Goethean romanticism, something focused on the individual, something a little more dramatically spiritual.

Led by Ralph Waldo Emerson, the Unitarian brain trust generated the creed of transcendentalism and located the divine in Nature. They

believed, wrote Emerson, "in miracle, in the perpetual openness of the human mind to new influx of light and power . . . in inspiration, and in ecstasy." Conveniently enough, Emerson moved to Concord in this time, and Thoreau had a master with whom to study.

On July 4, 1845, Thoreau declared his own personal independence and went to live in a cabin he'd built on Emerson's land at Walden Pond, about two miles south of Concord. During the two years he lived there and the seven years afterward it took him to write and publish *Walden*, he would develop an analysis of American society and of nineteenth-century materialism that would constitute the fundamental grammar of an alternative worldview, a practical philosophy of living that focused on voluntary poverty and an intimate connection to nature.

Walden was, as the critic Stanley Cavell has written, a scripture, a call for heroic spiritual regeneration and a return to the original American ideals. It was so radical that much of its central message would not be truly recognized until the 1960s, when the ideas of the simple life and the environmentalist vision of humans as part of, not owners of, the natural world became a great deal more appreciated.

Long before that, though, his resistance to the American norm connected him with a parallel dissenting tradition, one that, over the next one hundred years, would engage many more Americans than the philosophy of antimaterialism and the natural world. The most glaringly visible flaw in the American culture was slavery and the moral debt owed the kidnapped African American slaves. Henry located the grammar of dissent not only in antimaterialism and in the environmental ethos, which in *Walden* he placed in an intellectual wrapper called the pastoral, but also in an overt resistance to slavery.

In the fall of 1837, just as Thoreau returned from college, Angelina and Sarah Grimke, the abolitionist daughters of a slave-owning family from South Carolina, came to Concord to speak. Six weeks later, on October 18, sixty-one local women gathered to form the Concord Female Anti-Slavery Society. Henry's mother, Cynthia Thoreau, and

her daughters, Sophia and Helen, her boarders, Mrs. Joseph Ward and daughter Prudence, and Lidian (Mrs. Ralph) Emerson were among them. Concord would soon be the single most active such society in Massachusetts, which was by far the most active abolitionist state in the Union. The center of the Concord society's activities was the Thoreau dinner table.

Thoreau's fundamental orientations in life were individual and not social, philosophical and not political. Each of the occasions he actively devoted himself to opposing slavery came as an interruption to his normal routine, which in itself constituted a form of social criticism. But the night in late July 1846 that he spent in the Concord town lockup due to his refusal to pay a poll tax to a government engaged in slavery and an imperialist (and slavery-spreading) war against Mexico is an essential moment in American history, not least because it didn't end when town constable Sam Staples got around to letting him out in the morning. That night's effects will never end.

When asked about the incident, Thoreau drafted a lecture, and the lecture became an essay that is one of the fundamental moral documents of American history. His "Resistance to Civil Government" was published in 1849 and posthumously became "Civil Disobedience," and it would be the inspiration to freedom-seekers from India to Alabama. So long as the powerless strive for freedom, Thoreau's incarceration will speak to them.

It would have been even more virtuous for Thoreau to seek to free those slaves out of simple opposition to injustice rather than be first concerned with his own guilt or innocence in the support of slavery. His journal entry of 1845, that "The degredation [sic] & suffering of the black man will not have been in vain if they contribute thus indirectly to give a loftier tone to the religion and politics of this country," is patronizing and insensitive to human suffering.

He would grow, and the result of his moral evolution was that slavery, the fate of the African American population of America,

would be the primary source of his entire theory of the sociopolitical relations among citizens. That imprisoned population, even after emancipation, would be a major source of knowledge and inspiration to Americans resisting the mainstream of American thought for the next century and more.

An individual to the end, Thoreau never joined an abolitionist organization, so his greatest contribution to the effort was the writing of "Civil Disobedience." In the essay he locates morality not in society but in a higher law: "There will never be a really free and enlightened State until the State comes to recognize the individual as a higher and independent power, from which all its own power and authority are derived, and treats him accordingly." Many have interpreted this as a philosophical anarchism—certainly Emma Goldman later thought so. But what Thoreau really wanted was a country so moral that he could willingly conform to it. "I have never declined paying the highway tax, because I am as desirous of being a good neighbor as I am of being a bad subject."

It is his skepticism about voting—"a sort of gaming"—and dismissal of majority rule as mere expedience that disturbs so many. Yet his alternative is ethical, if radical: "Action from principle, the perception and the performance of right, changes things and relations; it is essentially revolutionary . . . Let your life be a counter-friction to stop the machine." The individual dissolves his relationship to the Union, to the State, by refusing to pay tax. As the ethical issues grew ever more pressing and closer to violence, Thoreau would follow suit.

In 1850 Henry Clay and Daniel Webster brokered a final compromise in a series, which in return for a free California included a Fugitive Slave Act that required all citizens to assist slave catchers. Antislavery Northerners were apoplectic. On May 24, 1854, a fugitive slave named Anthony Burns was arrested in Boston. Three platoons of marines and an artillery regiment, some fifteen thousand soldiers, ensured that despite Thomas Wentworth Higginson and the

abolitionist Vigilance Committee's best efforts, he would be returned
to the South. Higginson, the Unitarian minister in Worcester, spoke
for all abolitionists when he growled, "In spite of your free Soil votes,
your *Uncle Tom's Cabin*, and your *New York Tribunes*, here is the
simple fact: *the South beats us more and more easily every time.*" The
alliance of Northern manufacturers and slaveholders, the fact that
most of the nation's presidents had been from the South, and that
slavery was part of the Constitution combined to suggest that slavery
was impregnable.

Thoreau grew ever more radical. In Framingham on July 4, 1854,
he gave his speech "Slavery in Massachusetts." The leading abolition-
ist and editor of *The Liberator*, William Lloyd Garrison, was there and
set fire to copies of the decision returning Burns to slavery, the Fugitive
Slave Law, and the Constitution. Sojourner Truth and Wendell Phillips
also spoke. Thoreau not only called for Massachusetts to leave the
union of the states but also remarked, "My thoughts are murder to the
state." The Fugitive Slave Law's "natural habitat is in the dirt," and
must be trampled there, along with "Webster, its maker." "The law
will never make men free; it is men who have got to make the law free."

He went further still. The abolitionist activist John Brown visited
Concord to raise funds for his efforts in Kansas in March 1857, and
Franklin Sanborn, a Concord man then boarding with the Thoreaus,
brought him by. Thoreau and Brown would spend an evening in deep
discussion. On October 16, 1859, Brown and eighteen followers, five
of them black, all of them young, captured the U.S. arsenal at Harpers
Ferry, Virginia (now West Virginia), killing one marine and four local
residents, including a black freeman.

Having done so, wrote the distinguished historian C. Vann
Woodward, Brown "proceeded to violate every military principle in
the book. He cut himself off from his base of supplies, failed to keep
open his only avenues of retreat, dispersed his small force, and bottled
the bulk of them up in a trap where defeat was inevitable." At his trial,

he gave a speech that claimed, "I never did intend murder, or treason, or the destruction of property, or to excite or incite slaves to rebellion, or to make an insurrection." A few years later Emerson would compare Brown's trial speech with the Gettysburg Address.

Thoreau, who had waited for a sign on how to confront slavery, cared nothing for the dubiousness of the tactics nor for Brown's claims of innocence. For Thoreau it was time for a higher law, one that justified even violence if slavery was ever to end, if the cause of freedom was to be honored. Though Thoreau had not been one of the so-called Secret Six (Sanborn, Higginson, and Theodore Parker, among others) who had raised money for Brown, including $5 from Cynthia and Sophia Thoreau just five days before Harpers Ferry, he would become one of Brown's greatest public defenders in the aftermath of the raid.

He began writing on October 19 and was consumed, keeping pencil and paper under his pillow to catch stray ideas. Once finished, he announced that he would speak. Emerson advised against it, and Henry replied, "I did not send to you for advice, but to announce that I am to speak." It was not a time for compromise.

On October 30, he gave "A Plea for John Brown," most likely at the First Church in Concord, and then again in Boston on November 1, substituting for Frederick Douglass, who had avoided arrest by departing the premises, and on November 3 in Worcester. Infuriated by the press coverage and by his own "craven hearted" neighbors who said that Brown had thrown his life away—"Which way have they thrown *their* lives, pray?"—he lauded Brown as "by descent and birth a New England farmer . . . He was like the best of those who stood at Concord Bridge once."

Acknowledging that he did not have all the facts about the raid itself, Thoreau spoke mostly of Brown's principles and depicted him as "a transcendentalist above all, a man of ideas and principles,—that was what distinguished him . . . For once we are lifted out of the trivialness and dust of politics into the region of truth and manhood."

In the end, Thoreau defended not so much the act or even Brown as a person, but the principle under which he acted. Brown's "peculiar doctrine" was that "a man has a perfect right to interfere by force with the slaveholder, in order to rescue the slave. I agree with him." Even more to the point, Brown had *acted*—and Thoreau was shamed by that action. Thoreau celebrated the man who "had the courage to face his country herself, when she was in the wrong." In his unconditional defense, Thoreau shared space primarily with African Americans.

THE COURSE WAS set. The direction embodied in Thoreau's abolitionist writings would be a primary direction for the alternative voice in America for the next century. But if *Walden* would have to wait a century for its true power to be appreciated, its medium, the celebration of liberty that was the pastoral, would resurface much more quickly. The next great American literary document of independence would also use the pastoral mode, filling it with the story of a black man and a young white boy, a fugitive slave and a runaway, on their way to redemption and freedom.

2

A Child of the River
and the South

JUST AS THOREAU was establishing the alternative American
voice at Walden Pond, a boy named Sam Clemens was growing up
in Hannibal, Missouri, along the river that would so impress Thoreau,
who visited it shortly before he died. That boy would eventually con-
vey in fiction a great deal of what Henry had first expressed in *Walden*
in a tale that brilliantly brought to life the pastoral and linked for all
time the fate of enslaved African Americans with the spiritual aspects
of everyone's need for freedom. It is perhaps only coincidence that one
of Thoreau's last acts was to visit the river, but it was and is a potent
place, the locus for a significant slice of the American culture from
Clemens onward.

If the continent of North America is alive, the Mississippi is the
artery that pumps the blood of the being, the circulating fluid that
keeps the land vital. The river is power, the accumulated power of its
vast drainage basin, gathering water from 40 percent of the continent,
1.2 million square miles, from just south of Buffalo, New York, to
Wyoming, from thirty-one states and two Canadian provinces. As it
goes south, the flow narrows, deepens, and accelerates, finally putting

six hundred thousand to seven hundred thousand cubic feet of water into the Gulf of Mexico every *second.*

Hannibal is part of a very long and narrow place, one single place all the way from the source at Lake Itasca, Minnesota, to the Gulf of Mexico. It's all connected, from river to tree to human society. As Thoreau put it, "The whole tree itself is but one leaf, and rivers are still vaster leaves whose pulp is intervening earth, and towns and cities are the ova of insects in their axils."

Formed two million years ago, the river was named Mezz-sippi, "Big River," by the Ojibwe. The first Europeans to see it were in the party led by the Spaniard Hernando de Soto, fresh from the conquest of Peru, slogging overland from Florida to reach the river near present-day Tunica County, Mississippi, in 1541. In 1682, René-Robert Cavelier, the Sieur de La Salle, and his party descended the length of the river from Quebec and on April 9, near where the river meets the Gulf, claimed the entire river basin for France and King Louis XIV, naming the region Louisiana. Napoleon would sell the land to America, and soon after, the river's steamboats, though vulnerable to fire, exploding boilers, and the treacherous river itself, would become a great symbol of American independence and the glory of the American West.

Missouri entered the Union in 1817, a slave state balanced by Maine in the Missouri Compromise, which promised that no other territory north of the southern border of Nebraska would permit the institution. This made Missouri a wedge of slavery surrounded by free states to the east, north, and west. Until 1837, when John Deere invented the steel plow, the plains farther west were thought to be desert, which made Missouri the frontier and the settling place of choice for emigrants from the slave states.

Among them were John Marshall Clemens of Virginia and his wife, Jane Lampton of Kentucky. They settled in Florida, Missouri, where Jane gave birth to her sixth of seven children (only four would survive childhood), the premature and fragile Samuel, on November 30, 1835.

Moving thirty miles east to Hannibal on the river, John Clemens began a law practice that earned him local prominence but little income.

Sam's earliest memories were of sounds, especially voices, and black voices in particular. He spent many summers on his Uncle John Quarles's farm near Florida, where he passed time with black people like "Aunt" Hannah, he wrote, a "bedridden white-headed slave woman whom we visited daily and looked upon with awe, for we believed she was upward of a thousand years old and had talked with Moses." Above all there was "Uncle" Dan'l, "a faithful and affectionate good friend, ally and adviser . . . a middle-aged slave whose head was the best one in the negro quarter, whose sympathies were wide and warm and whose heart was honest and simple and knew no guile." Uncle Dan'l was a superb storyteller, a master of "impressive pauses and eloquent silences," and his stock of African American fables like the ghost story "The Golden Arm" would touch Clemens for the rest of his life.

Clemens would put these voices on the page and, eventually, enter the highest reaches of American literature with the result, but the journey from a boy listening to stories to a mature storyteller, from a Southerner of conventional opinions to a profound and liberating social satirist, would be a long and torturous one. Born into a slave-holding family and culture, he would have a great deal to unlearn. In later years, Clemens would soft-pedal the slave culture in which he was reared, suggesting that the "mild domestic slavery" of Hannibal was nothing like the "brutal plantation article." Perhaps. But one of Hannibal's first laws after its incorporation in 1838, just one year before the Clemens family arrived, was an ordinance "Respecting Slaves, Free Negroes, and Mulattoes." No more than five Negroes could assemble except for work purposes. Any Negro who would "wantonly canter or gallop any horse" through the streets would receive ten to twenty lashes. Teaching reading to slaves was banned. And so forth.

What dramatically complicated slavery in Hannibal was that freedom for any slave was just a half mile away across the river. When Sam

was six, three idealistic abolitionist students from the nearby mission-
ary school in Quincy, Illinois, decided to come to Hannibal and free
slaves. Naïvely approaching a crew working in the fields, they were
soon turned in to the authorities, since the slaves most likely assumed
the students were trying to steal them and sell them south. One of the
members of their jury was John Marshall Clemens, and not long after
they were sentenced to twelve years in prison, Clemens was elected
justice of the peace. Two years later, Judge Clemens sentenced a slave
named Henry to twenty lashes for the crimes of possessing a large knife
and uttering threatening speech. The whipping was public, and Sam
could well have seen it.

Slave culture was rooted in the churches of Hannibal, where the
local pulpit, Sam recalled, "taught us that God approved it." Even his
own mother understood that "the wise and the good and the holy were
unanimous in the conviction that slavery was right, righteous, sacred,
the peculiar pet of the Deity and a condition which the slave himself
ought to be daily and nightly thankful for." When Sam's minister dur-
ing his teen years, Joseph L. Bennett, left town and became an aboli-
tionist, the town was rocked.

Sam could ignore church politics, but he would not forget what he
witnessed daily on the streets of Hannibal. He watched his father lash
a slave boy whom the family had leased. He saw an overseer kill a slave
by throwing a lump of iron ore at him because he'd been awkward.
In his memoirs Sam would recall the community's indifference to the
death, although there was much sympathy for the slave's owner, who
had been deprived of a valuable property. As property, the slave was
sacred, and helping a slave escape was "a much baser crime" than
stealing a horse, for instance, "and carried with it a stain, a moral
smirch." Melpontian Hall, the slave-trading center of Hannibal, was
just four blocks from the Clemens home.

As a Whig, John Marshall Clemens felt that slavery had a bad
effect on white people and favored sending slaves back to Africa. He

expressed a desire to free his slaves, and expressed regret that his family was in "straitened means" and could not afford to do so. Instead, he sold their slave Jenny, and then their last slave, Charley. Charley went for $40 worth of tar, a figure that Sam would remember when he came to write his masterpiece forty years later.

He passed through a childhood dominated by a grim, fearful Calvinism, superstition, and the frequent presence of death—two siblings, his father, characters on Hannibal's streets, and above all the drunk in the town jail who begged Sam for matches for his pipe but later set fire to his blankets and burned to death, laying a guilt-inducing claim on the boy's conscience that haunted his dreams for years.

Though Sam grew up on the northern limits of the South, he took part in a specifically Southern culture that was sharply different from the mercantile Northeast. In the end, he would profoundly disavow it, turning his comic genius on it to mock it to death. But he could never escape being a Southerner.

In the words of C. Vann Woodward, the South was "not quite a nation within a nation, but the next thing to it." In 1793 Eli Whitney cemented cotton into the history of the South by inventing the cotton gin and making the crop much more profitable. Before Whitney, the South was a wilderness except for Virginia and clusters around Charleston, Savannah, and New Orleans. In 1808, the South shipped 10 million pounds of cotton; in 1846, it shipped 535 million pounds. Cotton ruled, defining the South as a one-crop economy.

The plantation system had enormous social as well as economic consequences. "One of the effects of the plantation system was to perpetuate essentially frontier conditions long after their normal period had run," wrote W. J. Cash in his classic *The Mind of the South*. Individualism flowered, to the point of violence, and there was a general agreement that a man had the perfect right to "knock hell out of whoever dared to cross him." Given the self-sufficiency of the plantation system, there was little social infrastructure like police to enforce other approaches.

Physical courage became the sine qua non of all Southern virtues. This independent taste for violence would find its "ultimate incarnation," said Cash, in the Confederate soldier. Working-class whites were generally pawns for the ruling elite; the poor Southern white man might be economically squeezed, but because of his color he was part of the ruling class. No matter how unsuccessful a white man was, the reasoning went, he was at least white.

The Cavalier myth, the specious notion that the Southern ruling class was derived from the values and traditions of the English Cavaliers, led to an air of romanticism and hedonism, in stark contrast to the utilitarian work ethic of the North. The lack of higher education—only the University of Virginia was a true college—was matched by a lack of lower education. Some 73 percent of the children of Massachusetts were enrolled in school; in South Carolina and Virginia, the figure was 9 percent. The illiteracy rate was 1 percent in New England, 25 percent in the South.

It was a static system of custom, of one generation succeeding another without change, with little sense of profession (other than the military) or of growth (other than the cotton). Women probably had the worst of it. Intelligence in women was distrusted, and in the upper class, marriages of cousins to preserve family fortunes were a way of life. As the nineteenth century passed, Northern women began to articulate an agenda. Southern women, by contrast, could only fulfill their destiny in marriage, sacrificed to the notion that they were worshiped high up on a pedestal. But the pedestal rested on shaky foundations, on a deep double standard that called for a truly remarkable level of denial.

In the Victorian North, women were assumed to be without passion. Southerners accepted that women had erotic desires, but because they were enshrined on the pedestal, they could not express their desires. And so the perfect double standard emerged, in which sexual desire outside marriage was acceptable for the Southern male gentry, "not even disapproved but almost sanctified," wrote one scholar, but

absolutely condemned for women. Which brings us to the root of the South's racial dilemma, because the white Southern male had at his disposal the ability to satisfy his desires with black women, with slaves, in what was de facto rape.

In the North, men were free to work, if often alienated from each other. Forced into community by the need for unity when greatly out-numbered by slaves, the South would cherish rules of behavior created by consensus that would center on family and community, all of it governed by the rule of honor.

Honor—as opposed to, say, responsibility—requires that someone else do the scut work; it's ideally suited to slavery. It seems inherently hierarchical, certainly as it played out in the South, where the father ruled the family, whites ruled blacks, and planters ruled their white subjects.

At present, it is hard to associate honor and slavery. We tend to assume a sense of paradox or irony or guilt in assessing the behavior of antebellum Southerners, and that is ahistorical and false. Over time, wrote historian Bertram Wyatt-Brown, "white man's honor and black man's slavery became in the public mind of the South practically indis-tinguishable." That linkage inherently made abolitionist criticisms of slavery insults rather than political arguments.

Consequently, the South withdrew. The religious leadership of the South separated themselves from their Northern brothers in defense of slavery. Soon, they came to see the South as the true home of Christianity, in contrast to a godless, scientific, materialist North: In the words of Dr. J. H. Thornwell in 1850, the Yankees were not merely abolitionists but "atheists, socialists, communists, red republi-cans, Jacobins."

By contrast, Southern men were gentlemen, like the classic film depiction of Hatfield, the character played by John Carradine in John Ford's *Stagecoach*. They were aristocrats who were the product of a happy feudalism run by a Cavalier planter aristocracy, gallant men in white mansions, script by Sir Walter Scott.

It was precisely that fantasy that Sam Clemens, as he grew up and became Mark Twain, would flatly reject. He would have a more complex relationship with the Northern half of this conundrum, a peculiar bond between white and black men that emerged as a thing called minstrelsy.

3

Antebellum Black Music and White Minstrelsy

C APTIVE ON A foreign continent after surviving a horrific sea jour-
ney in which one-seventh of them died, the kidnapped African
slaves found themselves in fantastically dire circumstances. They were
the property of a people whose language was unintelligible and whose
predominantly rationalist worldview was unimaginable to Africans, a
people whose lives were ruled by the gods. By and large, the masters
regarded the Africans as not entirely human. The odds against the sur-
vival of any fraction of their heritage past the second generation were
extraordinarily high. Yet they managed to hold on to their identities
and in the end exert quite as much cultural influence as they received,
which documents the remarkable resilience and vitality of the tribal
cultures of West Africa.

Music and religion and a fragment of kinship networks were all
that was left to Africans on the shores of America, and against all
probability they used these elements to build a culture.

Our knowledge of the process is flawed not only by the biases of
the earliest scholars but also by the careful, survival-based self-cen-
sorship of the earliest sources: As one interviewee recited, "Got one

mind for white folks to see, / 'Nother for what I know is me; / He
don't know, he don't know my mind." But we can make some fairly
sophisticated guesses.

Many different cultures came to America from Africa. The slaves
came first from Senegambia, from Senegal and Gambia, and then from
farther along the West African coast to Nigeria, and finally all the
way south to Angola. There was indeed a common worldview, an
African metaphysic that included a supreme god (which would later
make Christianity much easier to accept) presiding over lesser divini-
ties, orishas, and ancestor spirits. It was a pre-Enlightenment world of
spirits that allowed no distinction between the sacred and profane. The
spirits—of the visible environment, of the ancestors, of the Great Spirit
and subsidiary spirits—controlled all and needed to be propitiated.
Done with a pure heart, such rituals could impose order on a turbu-
lent world. There was no word for religion, because what Westerners
would call religion permeated all life.

The spiritual world was engaged by music and dance. Senegambian
cultures focused on stringed instruments—gourd fiddles, lutes—bal-
anced by drumming. From the beginning, the slave owners banned
drums among the slaves to prevent possible rebellion, and so slaves
clapped hands and drummed on their bodies. And they sang, constantly.

African music was generally group-based and participatory, with
the Western line between performer and audience blurred and indis-
tinct. It featured antiphony, which is to say call-and-response; it was
a form of conversation. The music was not separated from daily life
but was often functional, accompanying almost all work. It had an
essential relationship to dance. It generally built on pentatonic (five-
note) scales versus European seven-note diatonic scales. Harmonies
were natural rather than fixed-pitch and included what came to be
called "blue notes," flatted thirds and sevenths that the Senegambians
had learned through long contact with Arab desert cultures. The result
sounded odd to European ears. In the 1860s, the abolitionist Lucy

McKim Garrison would compare it to the "singing of birds, or the tones of an Aeolian Harp."

Finally, it was built on improvisation. Improvisation, the creation of variations, became the sorcerer's stone of what was now African American (as opposed to African) music, the element that transformed all it encountered. Because the slaves of North America were initially much more widely dispersed and in smaller numbers than in Brazil or the Caribbean, they were in closer contact with white culture and much more open to a syncretistic fusion of forms. Among the first such syncretistic results—there would be many more—was the spiritual, what W. E. B. Du Bois rightly called "the most original and beautiful expression of human life and longing yet born on American soil."

The spirituals emerged from the encounter between slave culture and Christianity that began in the era of the Great Awakening in the 1740s. Earlier, slave masters had tended to think that Christianizing slaves would give them daft ideas about their own humanity, and let well enough alone. What Africans did together to propitiate the gods and preserve their own sanity would be called the "ring shout." Standing in a circle like the world and the seasons themselves, the slaves used song and dance as a vehicle to convey ancestor worship, teaching by means of storytelling and trickster folk tales and songs. Circularity led to repetition, and repetition led to the alteration of consciousness, so that slavery was almost left behind.

West Africans often adopted the religion of the conqueror, so conversion to Christianity, once offered, was a fairly smooth transition. The Baptists were especially successful, since their primary rite made a comfortable fit with people whose river gods were extremely popular. Now called a "praise meeting," the ring shout came right along. First came singing, using the Protestant lining-out style that was exactly congruent with call-and-response, and then the dancing began. It was specifically African dancing, in which the feet weren't crossed, a circular shuffle that led its participants into a spiritual consciousness and trance.

An early white witness described an antebellum ring shout follow-
ing a church service. "The benches are pushed back to the wall when
the formal meeting is over, and old and young, men and women,
sprucely dressed young men, grotesquely half-clad field hands . . . all
stand up in the middle of the floor, and when the 'sperichil' is struck
up, begin first walking, and by-and-by shuffling round, one after the
other, in a ring. The foot is hardly taken from the floor, and the pro-
gression is mainly due to a jerking, hitch motion, which agitates the
entire shouter, and soon brings streams of perspiration. Sometimes
they dance silently, sometimes as they shuffle they sing the chorus
of the spiritual, and sometimes the song itself is also sung by the
dancers. But more frequently a band, composed of some of the best
singers and of tired shouters, stand at the side of the room to 'base'
the others."

Black conversion to Christianity had many consequences. During
the Great Awakening of the 1740s, black and white worshipped
together in the revivals, and the influence of black singing on the
Protestant hymns and ballads was considerable. What came out was
highly rhythmic, percussive, and syncopated, and often featured call-
and-response patterns—a perfectly synthesized form.

The most obvious difference between the races was that white
spirituals tended to focus on Jesus and white sermons on obedience
and submission, while African Americans stuck to the Old Testament,
singing of the Children of Israel and the Exodus. The slaves too were
the Chosen, and their sermons focused on heroic deeds and libera-
tions. The obvious connection to their immediate situation didn't seem
to attract a great deal of attention from the masters, given that it was
hard for even the most suspicious slaveholder to argue with the Bible.

The spirituals were not only sung in church, but also were used as
work songs, social songs, and in all facets of life, as any normal African
would. All life was sacred, not just what took place in church. In this
manner, the singer could stay in touch with his gods, and with the

possibility of rebirth—in a better place than, say, Georgia. "The ante-bellum Negro was not converted to [the Christian] God," wrote the anthropologist Paul Radin. "He converted God to himself." Lawrence Levine adds, "The spirituals are the record of a people who found the status, the harmony, the values, the order they needed to survive by internally creating an expanded universe, by literally willing them-selves reborn." In important ways, the slaves stayed African.

Along with lying, loafing, faking illness, pretending to not under-stand, breaking tools, and making subtle changes in ethics—stealing something from another slave was stealing, but from the master was only "taking"—their stubborn clinging to their African culture was essentially an act of resistance. It was not overt and it wasn't formally political, but it was resistance nonetheless. And it was the seed of a challenge to authority that could and would be communicated to sym-pathetic and sensitive white people as well, with music as the essential mode of communication, although the path of the message tended to be circuitous and very, very slow in transmission.

Not all the slave ceremonies were black-only. As cotton became the primary cash crop, the shucking of corn became a popular harvest ritual. It took place in the North as well, but there it was egalitarian and also significantly involved courtship. Cotton harvesting had to be precisely timed, but once it was complete, the farms could turn to the more flexible corn, harvest it, and then plan a celebratory corn-shuck-ing ceremony, to be held in the yard in between the master's home and the slave quarters.

If close by, slaves from other plantations might join in, and then the slaves would choose two sides, each side having a "captain" or "general" who was not only an ace shucker but also a good singer, since singing was essential to the process. Each team would sit in a cir-cle around a mountain of corn and, led by their captain, sing and shuck the corn, with the white folks observing from the porch. Afterward, the master would provide copious food and drink.

These parties accomplished many ends. They gave the master a chance to be the generous, successful patriarch of the plantation family, mixing Sir Walter Scott–inspired Cavalier lord fantasies with the emerging nineteenth-century sentimental veneration of the family. As things went along, they also provided an avenue of opportunity for the astute slave. The masters enjoyed being entertained, and that began to extend far beyond an annual harvest gathering.

As historian Roger Abrahams noted, the masters "came to regard their charges as exploitable for their capabilities as both workers and players. The planters constructed situations in which blacks played in front of whites for their mutual enjoyment. The slaves represented an exotic presence to their masters." It did not escape the notice of the slaves that dancing or playing the fiddle was more pleasant than sweating in the fields, and before too long, there were slave orchestras featuring the Senegambian instrument called the banjo.

Playing and dancing also offered the chance for the slaves to make fun of their owners, whether singing mocking songs in code or performing dances that mimicked those of the master. The minuet evolved, eventually, into the dance known as the cakewalk. The final twist came when, as observers noticed as early as the Revolutionary era, the masters began to imitate black dancing styles. The white fascination with black music wouldn't stop there; but initially it would take the form of a fascination with a white simulacrum of the music. For a majority of Americans, their introduction to African-American music came via a curious institution called minstrelsy.

The first great minstrel star, Thomas "Daddy" Rice, visited Hannibal in 1845, and young Sam Clemens became a lifelong fan. Writing in his autobiography fifty years later in a full-blown nostalgic reverie that connected him to the happiest part of his childhood, namely Uncle Dan'l, Clemens recalled the minstrel show as a "new institution" that "burst upon us as a glad and stunning surprise." In particular he recalled the blackface makeup, in which "Lips were

thickened and lengthened with bright red paint to such a degree that their mouths resembled slices cut in a ripe watermelon," and the costumes, which were "an extravagant burlesque of the clothing worn by the plantation slave at the time"—collars so high that they hid half of the head, coats with giant buttons and tails so over-long that they nearly touched shoes five sizes too large.

Named for their instruments, "Bones" (percussive clackers) stood at one end and "Tambo" (tambourine) at the other, with the Interlocutor in between. Minstrelsy had a twin foundation, both musical and comic. The music was a fairly sincere homage to African American plantation music and the versions of the form by white composers like Stephen Foster. The comedy was clearly a more complex affair, a largely racist mockery of the white perception of African American life. Over time, Bones and Tambo became the chuckleheaded country bumpkin Jim Crow and the urban con artist dandy Zip Coon, the Negro as the white person wanted or perhaps imagined him to be.

Their banter was based on malapropisms, mis-hearings, and bad, pun-filled jokes, and their main object was to ignore, mock, and generally drive crazy the gentlemanly Interlocutor, who was basically a white authority figure. The aristocratic moderator asks Bones for an "account of the perils which he had once endured during a storm at sea." Well, we had no food. What did you live on? Eggs. Where did you get them? "Every day, when the storm was so bad, the Captain laid to." The shows mixed rat-a-tat exuberance and Western energy with soothing escapist Stephen Foster nostalgic syrup, and they were stunningly popular.

In essence, the minstrel show was created by white working-class showmen as a moneymaking exercise that gave their working-class, largely Irish audiences someone lower on the social totem pole to mock. Yet there was more than a pinch of admiration in the shows, especially for the music. As the title of a recent scholarly treatment of minstrelsy put it, it was both *Love and Theft*.

Blackface minstrelsy began as an *entr'acte* display of solo song and dance in legitimate theaters, added burlesque and comic dimensions in the 1830s, became a full-fledged show in the 1840s, and was a profitable, fully established institution by the 1850s. It would be by far the most popular piece of American popular culture throughout the nineteenth century—and beyond (see Bing Crosby in *Holiday Inn*, 1942).

On a tour of the United States in 1822, Charles Matthews, an English music hall performer with a considerable gift for mimicry, saw an African American actor named Ira Aldridge performing Shakespeare. An idea took shape in his mind, and he developed a mocking caricature of black speech and Shakespeare that became a very popular bit: "To be or not to be, dat is him question . . . lift up him arms against a sea of hubble bubble and by opossum end 'em." The audience would burst out with "Opossum, Opossum," which led into a popular black song, "Opossum Up a Gum Tree."

The tragedy of all this is that Aldridge, who was sufficiently gifted an interpreter of Shakespeare to be honored by a plaque in Stratford-upon-Avon, would later be forced by his audience to include the song in his act. Such is show business. The savage dance between black and white creativity had begun.

Born in New York City around 1810, Thomas Rice was a touring actor who in 1828 or so was working in Louisville and saw a local slave called Jim Crow. Jim had a slight limp but was able to sing and dance—his song was called "Jumping Jim Crow"—and Rice was intrigued. In Pittsburgh in 1830 he borrowed some outlandish clothing from a local black man named Cuff and danced, a step he named after the song. It was a hit, and by 1832, just one year after abolitionist William Garrison established *The Liberator*, Thomas "Daddy Jim Crow" Rice was headlining a tour of New England with his minstrel act before opening at the Bowery Theatre in New York in November.

The North American Hotel happened to be just across from the Bowery Theatre, and one day some years later in January 1843,

four unemployed actors named Dan Emmett, Billy Whitlock, Frank Brower, and Dick Pelham were sitting around the lobby considering their futures. All were veterans of blackface in the circus and on stage. Among them, they played the fiddle, banjo, tambourine, and bones. Inspiration struck, and they conceived the idea of a blackface imitation of a plantation band plus comedy, with Tambo and Bones at the ends of a semicircle. The first half of the show would conclude with a stump speech/address, and the second half with a plantation number, the "walk around." It was a loose structure, largely a series of skits and sketches into which one could insert almost anything—current events, female impersonation, what have you. The next year, their competitors, Christy's Minstrels, worked in the Interlocutor, and the full-blown minstrel show was born.

Emmett and Company swiftly wangled a job at the Chatham Theatre, choosing the Virginia Minstrels as their name in homage to the Tyrolese Minstrel Family, which had just passed through New York and caused a sensation. Their first song was "Old Dan Tucker"— Emmett claimed to have written the lyrics—and it sounded far better than they had expected. The Virginia Minstrels would last only six months, but each member would make a living out of blackface for the rest of his life.

Minstrelsy was the Northern version of the plantation ideology, which argued that slaves needed to be cared for and could be happy only on the plantation—in other words, down South and not up North competing for jobs with the Irish. But minstrelsy offered even more to the white working class, which was adjusting to hard economic times, urbanization and the loss of small-town community life, and, at a time when the apprenticeship system was ending, a growing realization that they had found their place in the new economic order—at the bottom.

The new white working class needed to learn how to affirm a place for itself in the world that could replace the old verbal village culture with a new sort of community. After an era of deference in

the eighteenth century, the working class found itself in a time of overt egalitarianism, so new cultural forms had to be antiaristocratic. Newspapers, for instance, reflected this attitude by becoming considerably more informal, exploring regional humor and folk culture. In minstrelsy, this meant mocking the Interlocutor.

Abolitionism was challenging slavery in the North and made it necessary to address racial issues, and minstrelsy offered a safe, laughterfilled place to do so. After an early period in which the portraits of black people were somewhat more varied, as abolitionism gained purchase in the North in the 1850s and the specter of competing for jobs with four million hungry black people loomed, minstrelsy would settle into caricatures of happy, lazy, improvident, and silly slaves.

Minstrelsy established stereotypes so enduring that they emerged even when the creator was explicitly antislavery, as in the nineteenth century's most powerful piece of protest literature, *Uncle Tom's Cabin*. Harriet Beecher Stowe's depictions were cartoons endowed with shining virtue at the expense of anything human or genuine.

It wasn't all Mrs. Stowe's fault. *Uncle Tom's Cabin* had its largest influence not as a book but as a stage play, there being no copyright law on adapting printed material to the theater. Different producers created versions that were both pro- and antislavery; at New York's National Theatre, George Aiken produced an extremely sentimental and thus antislavery *Uncle Tom*, while H. J. Conway's version at Barnum's Museum was the "happy" version—Uncle Tom lives! The play was banned in the South. Later minstrel versions completed the job, changing the subtitle from *Life among the Lowly* to *Life among the Happy*.

The minstrel show was a very complex theater with massive racial and sexual implications. The very fact of putting on the mask of blackface raised significant questions about what was going on. The early performers acquired much of their material by going to black places of entertainment and actually listening. Of course, profiting on black

talent was yet another extension of slavery, but at the same time, the minstrels were coming to admire black art. Much of the ridicule was, consciously or no, an attempt to mask their real interest in the culture they were simultaneously exploiting. They clearly interpolated black folklore, like the animal symbolism that would later emerge in the Br'er Rabbit tales of Joel Chandler Harris, into their shows, along with banjo tunes with complex African American rhythms.

Certainly many of the urban events imposed on black victims— being swindled, getting run down by a trolley, being arrested for arcane laws—were simultaneously taking place in the lives of the white working class, so the minstrel show could pour balm on deep feelings of class insecurity by deftly reminding the white victims of their racial "superiority."

More, minstrelsy was the continuation of a long tradition of musical fusion that had begun at least by the Great Awakening, when African singing styles began to mix with Anglo-Protestant hymns. That tradition was going to flourish, leaving a significant influence on both the performers and the audience. As time went on, that influence would increasingly reflect the seeking after freedom that Thoreau had advocated.

It's hard for twenty-first-century Americans to picture Dan Emmett, who mocked African Americans and claimed to have written what would become the Southern anthem, "Dixie," as part of a freedom-seeking movement, but it's true. He would reportedly tell a fellow minstrel that "if I had known to what use they [Southerners] were going to put my song, I will be damned if I'd have written it." In the course of the coming war, he would write a fife and drum manual for the Union Army.

In fact, the creators of minstrelsy had abdicated their class status and left the Protestant ethic behind to run off and join the circus, in the process falling in with "low company" like black people whom they then proceeded to imitate. In their mobility, theatrical careers, and

(however unobvious) respect for black music, they were early bohe-
mians, even if Frederick Douglass would describe them as "the filthy
scum of white society, who have stolen from us a complexion denied
to them by nature, in which to make money."

In all this, the musicians were somewhat ahead of their audience.
But their attitudes would, over time, come to be synonymous. It was
all terribly ambiguous, as complex as the relationship of siblings, each
competing for the favor of the parent (upper class), simultaneously lov-
ing and hating the sibling (white and black working class). By mocking
the black man, the minstrel could deny his own increasing oppres-
sion and claim the potency he saw in the black man, because however
weakened by oppression, the strength of the male slave had been felt
as great virility by whites throughout American history. Even leaving
aside the frequent cross-dressing in minstrelsy, there is clearly a sexual
stew bubbling under the minstrel show.

It's an endless succession of refracting mirrors. In the 1840s,
William Henry Lane, also known as Juba, was undoubtedly the best
dancer in America, and became the first black man on white stages—in
blackface. His specialty was the Irish jig (!). Charles Dickens wrote
in *American Notes* that he seemed to dance "with two left legs, two
right legs, two wooden legs, two wire legs, two spring legs—all sorts
of legs and no legs . . ." Juba was evidently glorious, yet seeing him
would only remind much of his audience of his imitators. Seeing the
minstrel imitations could well lead to assuming that the imitation was
the real thing.

Love and theft expresses it best, because after the comedy and
the stereotypes, the heart of minstrelsy was music, African American
music, however misappropriated. Minstrel music was party music, vig-
orous and sexy in contrast to the prissy bourgeois music of the era.
That is why it succeeded.

And in succeeding, it established the central role of African
American music in American culture, one that has endured to the

present, and made a first introduction of African American culture to the greater American culture. The first minstrels violated, distorted, and ridiculed the black man's music, but they also clearly demonstrated an appreciation for it.

They were as confused about race as America has always been, but they loved the music dearly. Some things don't change.

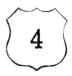

Mark Twain Grows

B ORED WITH HANNIBAL, Sam left home in June 1853 at the age of eighteen, heading first to St. Louis, then on to New York City. His first letters home made his culture shock quite clear. A small-town boy in the big city, he wrote, "I reckon I had better black my face, for in these Eastern States niggers are considerably better than white people." He had a lot to learn.

After much wandering, he found his first niche in life on February 16, 1857, when he boarded the steamboat *Paul Jones* in Cincinnati bound for New Orleans and then South America and met the pilot Horace Bixby. Ambition blossomed. Somehow, he persuaded Bixby to accept him as an apprentice, and by the time they arrived in New Orleans on February 28, he was ready to board the *Paul Jones* companion vessel, the *Colonel Crossman*, as a cub pilot. Over the next nearly four years, he would ship out on 120 voyages on between fifteen and nineteen different boats.

One important thing about his time as a pilot is a certain interesting parallel with Thoreau, wherein both were enabled in their mutual use of the pastoral form by a perception based on rigorously trained concentration. Both Thoreau and Clemens would study nature profoundly, developing powers of observation that gave an empirical

substructure to their poetic descriptions. Thoreau studied the flora and fauna and ethos of Walden. Sam had to learn the river.

It did not begin entirely well. Years later, a nostalgic Sam would recall his first lessons in learning the river from Bixby and portray himself as singularly inept. After hearing a litany of place names, none of which he recalled for a second, he was tested and found wanting. "What do you suppose I told you the names of those points for?" asked Bixby.

"Well, to—to—be entertaining, I thought," replied Sam.

"What is the shape of Walnut Bend?"

"He might as well have asked me my grandmother's opinion of protoplasm." He soon learned to keep a notebook. Over time, his memory for the river grew prodigious.

What the young Sam Clemens was doing closely paralleled Thoreau's studies at Walden; he was learning how to see. Sam's own masterpiece would succeed *Walden* as a great exemplar of the pastoral because Sam well and truly trained himself, as every pilot had to, to call up the exact shape of the river in three dimensions as stored in his own skull, and be so certain of that shape that it could override what his eyes might see. And then relearn it twenty-four hours later, because it would have changed. And so "the face of the water, in time, became a wonderful book—a book that was a dead language to the uneducated passenger, but which told its mind to me without reserve . . ."

Seemingly, Sam would have remained a pilot all his days, but it was not meant to be. All the compromises failed, Lincoln was elected because the Democrats split their votes, and the Southern states seceded. Clemens had no stomach for the war, and in 1861 he accompanied his brother to Nevada, safely distant from the fighting. There he fell into writing for the Virginia City *Territorial Enterprise* and began to find his true path in life. He combined humor based on a certain disdain for the thin line between truth and fiction with the local slang he was hearing with an ear as good as the eye he'd developed on the

river. All of it fused into a persona. On February 3, 1863, he gave the persona a name, taken from the chants of the leadsmen on the river: Mark Twain, which indicated that the water was six feet deep, the point where dangerous became safe . . . and vice versa.

He would come to fame in 1865 at the age of thirty via the success of his "Celebrated Jumping Frog of Calaveras County," which was published by Henry Clapp, the bohemian editor of *The Saturday Press*. Clapp had been jousting with the bourgeois world since his family had mocked his literary interests as a boy. He'd gone to Paris to see the original of Henri Murger's *Scènes de la vie de Bohème* and bought into the entire vision of artistic renunciation, landing at Pfaff's bar on the Bowery with Walt Whitman in the 1850s. Clapp wanted his magazine to challenge American values, and Twain's use of the vernacular suited him perfectly.

As Sam put it years later in his *Autobiography*, "I had failed in all my other undertakings and had stumbled into literature without intending it." His timing was perfect; just eight months after the close of a catastrophically grim war, the nation needed to laugh, and Mark Twain had given it something to laugh about.

It was entirely logical that Clemens, who'd experienced so much death as a boy, should become the voice of America in the post–Civil War era. All wars kill, but the American Civil War was exceptional in the history of the world to date. Of a Northern population of 20 million, 2.1 million men had entered the armed forces and 360,000 of them died. Some 260,000 Confederates died out of a population half the size of the North's, roughly 20 percent of the white adult male population of the South. In the first years after the war, one fifth of Mississippi's state budget paid for prosthetic limbs for its veterans.

It was the first total war, with more accurate weapons firing ammunition churned out by an effective industry and then efficiently delivered by railroads. The sheer scale of death simply in terms of cemeteries and military pensions helped transform the government and

American society, requiring a more centralized nation-state to orga-
nize it all. Accounting to the bereaved would extend the government's
obligations still further.

The scale of death was so vast that it had to be embraced as sup-
ported by the divine; God on our side. On both sides, soldiers were
sustained by the Christian assumption of eternal life in a heaven in
which family members would be waiting. Hot on the heels of institu-
tional religion came spiritualism, and the best-selling book in the post-
war nineteenth century was Elizabeth Stuart Phelps's *The Gates Ajar*,
which went through fifty-five printings after it was published in 1868.

Peace. From the North, the view was clear. Thaddeus Stevens,
leader of the Radical Republicans, looked at the U.S. Constitution and
realized that its bizarre assignment of three-fifths of a vote to black
people who were now citizens was over; if they were now human for
the census, they had to vote—and vote Republican, dammit, and thus
protect the North's new economic order, which was founded on taxa-
tion, a national bank, government bonds, corporations, and so forth.
Consequently, the nation passed three constitutional amendments in
the five years after the war that abolished slavery and granted civil
rights and then voting rights to the freed slaves.

In the white South, where tens of thousands who didn't even own
slaves had gone off to fight a war out of a sense of honor, only honor
remained. Systems of honor do not become penitent when proven
wrong—that is, lose a war—but rather blame the loss on fate. Forced
to declare loyalty to the United States of America, the white South
echoed what the secessionist lady told one Northern officer: "You've
sullied the purity of our integrity. You have us promise what we will
not pay, and for all this we hate you."

As to the black South: The Freedmen's Bureau went to work and did
its best, but that was little enough. Many thousands of New England's
widowed women came South to start schools in what W. E. B. Du Bois
called the "crusade of the New England schoolma'am." Du Bois went

on, "In a time of perfect calm, amid willing neighbors and streaming wealth, the social uplifting of four million slaves to an assured and self-sustaining place in the body politic and economic would have been a herculean task . . . Thus Negro suffrage ended a civil war by beginning a race feud."

FOR A LONG while, Sam's life seemed golden. His first book, *The Innocents Abroad*, firmly established his reputation as a satirical social observer on its publication in 1869, and the voyage on which it was based would lead to his marriage to the love of his life, Olivia "Livy" Langdon. Even more important, exposure to a wider world led him to grow, and his native racism began to give way to a more sophisticated attitude. In Venice on this first visit to Europe, he encountered a guide who crushed his enthusiasm by remarking, "It is nothing—it is of the *Renaissance*." Ignorant of what the Renaissance was, at least for the purposes of writing, Mark would reply, "Ah! So it is—I had not observed it before." Finally, the guide explained, and Twain concluded the story by deciding he was "the only one we have had yet who knew anything."

What made this interesting was that the guide was African American, born in South Carolina of slave parents and who'd come to Venice as a child. Fluent in English, Italian, Spanish, and French and dressing "better than any of us, I think, and is daintily polite . . . Negroes are deemed as good as white people in Venice, and so this man feels no desire to go back to his native land. His judgment is correct." It was the first stumbling step of a man raised in a heritage of racism toward a healthier judgment.

Marriage had a similar effect. The Langdons came from a radically different world than the Clemenses. They were very much upper middle class; father Jervis had prospered in lumber and then coal. More important, they were not merely abolitionists but active supporters of the Underground Railroad, which had made their hometown of

Elmira, New York, a major stop. Frederick Douglass was their good friend and close comrade.

Briefly settling in Buffalo, Sam borrowed money from his father-in-law, Jervis, and bought into *The Buffalo Express*, where his editorial of August 26, 1869, "Only a Nigger," documented the next step in the evolution of his racial understanding. It seemed that a lynched man had been posthumously exonerated. "Ah, well! Too bad, to be sure! A little blunder in the administration of justice by Southern mob-law, but nothing to speak of . . . mistakes will happen, even if in the conduct of the best regulated and most highly toned mobs . . . What are the lives of a few 'niggers' in comparison with the preservation of the impetuous instincts of a proud and fiery race?" One may well argue that the piece was written to please Jervis Langdon, but the bite is authentic Twain, and the attitude toward Southern notions of justice was one he would nourish for the rest of his life.

In that period he also took up the lecture trail. After speaking in Boston he met Frederick Douglass and wrote Livy, "I certainly was glad to see him, for I do so admire his 'spunk.'" Douglass told him of sending his daughter to an all-white school in Rochester in 1848, where she was sent home because a parent objected. Douglass went to the principal and asked for the students to vote, and they unanimously voted to include her. "There was pathos in the way he said it. I would like to hear him make a speech. Has a grand face."

Twain and Livy moved to Hartford, Connecticut, but as the 1870s passed they spent their summers in Elmira, living at Quarry Farm, the home of Livy's elder sister, Susan ("Aunt Sue") Langdon Crane. The property sat on a hill two miles east of the town center overlooking the Chemung River and beyond to row upon row of the Pennsylvania hills in the distance. It was a lovely and inspiring view. After the first summer, when Mark wrote in the living room, accompanied by a ceaseless conflagration of cigar smoke, Susan built him a separate writing study, surprising him with it on his arrival in 1874. Designed by the

same architect who'd created their extravagant Hartford home, it was octagonal and built to resemble a pilot's cabin with a 360-degree view. Perched one hundred yards or so from the house on a knoll, it was isolated and quiet, a haven of creativity that would serve him well.

All three of his daughters (Susy, Clara, Jean) would be born at Quarry Farm, growing up with neighboring children, including the grandchildren of John Lewis, a neighboring farmer and a black man, and the family cook, Mary Ann Cord, also black. The multiracial collection of children cheered him and sent his mind back to Hannibal days. He spent the summer of 1874 deeply involved with the adventures of Bob—no, he said to himself, let's change that to Tom—Sawyer. Something else he wrote that year documented his personal odyssey: "A True Story," which that summer he sent to William Dean Howells and which was published in *The Atlantic* in November.

Sound was Twain's first sensory trigger, and he was captivated by the voice of his cook, Mary Ann Cord, for she was a natural storyteller. One summer evening at twilight, they sat on the front porch of Quarry Farm, with Mary Ann on the steps, Twain teasing her mercilessly, for it was "no more trouble for her to laugh than it is for a bird to sing." Twain remarked (the published version changed the names), "Aunt Rachel, how is it that you've lived sixty years and never had any trouble?"

"Misto C—, is you in 'arnest?"

Twain stuttered that he'd never even heard her sigh, and Mary Ann drove a verbal fist through his oblivious assumptions. "I was bawn down 'mongst de slaves; I knows all 'bout slavery, 'case I ben one of 'em my own se'f. Well, sah, my ole man—dat's my husban'—he was lovin' an' kind to me, jist as kind as you is to yo' own wife. An' we had chil'en—seven chil'en—an' we loved dem chil'en jist de same as you loves yo' chil'en . . . Well, bymeby my old mistis say she's broke, an' she got to sell all de niggers on de place. An' when I heah dat dey gwyne to sell us all off at oction in Richmon', oh de good gracious! I know what dat mean!"

They put Mary Ann and her family on the block and sold them one by one, down to her baby, Henry. The years passed and the war came, and Mary Ann began cooking for a group of Union officers. One day there was a ball, which displeased her, as it involved all the troops, not merely her officers, and even, as she put it, a "nigger regiment." Miraculously—how else describe this?—one soldier in that regiment was her son Henry, who'd escaped to the North and wound up a barber in Elmira. He would survive the war and bring Mary Ann home with him.

"Oh, no, Misto C—, I hain't had no trouble. An' no *joy*!"

It is hard to imagine any Southerner accepting this story with equanimity. But it became a fundamental building block in Twain's social and emotional development, and one can almost observe his metaphorical heart expanding as he heard something utterly true, utterly moving. Whatever illusions he'd ever had about how he related to African Americans were scoured in acid truth that night and left him a wiser man. There was more.

On November 29, 1874, the same month as "A True Story," Twain published "Sociable Jimmy" in *The New York Times*. Three years before, late in 1871 or early in 1872, he had been on a lecture tour in a small town in the Midwest, most likely Paris, Illinois. A small black child, a "wide-eyed, observant little chap," was sent to wait on him. The boy's voice struck him, and he sent a description home to Livy: "The most artless, sociable, and exhaustless talker I ever came across. He did not tell me a single remarkable thing, or one that was worth remembering, and yet he was himself so interested in his small marvels . . . I listened as one who receives a revelation." "Sociable Jimmy" was his first piece written in the voice of a child, but it would not be the last.

Mary Ann and Jimmy were not the only black people to be part of his life. His butler in Hartford, George Griffin, had come to the Hartford house to wash windows and stayed, as Twain told his friend, the author and critic William Dean Howells, "for half a generation."

Interestingly, Griffin lived in a room neither at the back of the house nor in a separate building but just off Twain's third-floor study, practically in his inner sanctum. There was also John Lewis, the neighboring farmer at Quarry Farm who would be a hero forever to Twain after Lewis stopped a runaway horse pulling a carriage carrying Mark's sister-in-law Ida Langdon, her daughter Julia, and Julia's nurse.

Not all of Mark Twain's learning about African American life took place with direct human relationships. In January 1872, the Fisk University Jubilee Singers sang at his neighborhood Asylum Hill Congregational Church in Hartford, and Mark Twain attended. Twain would write a promotional letter for the Singers, one of several over the years, that read, "these gentlemen and ladies make eloquent music . . . they produce the true melody of the plantations, and are the only persons I ever heard accomplish this on the public platform. The so-called 'Negro minstrels' simply misrepresent the thing; I do not think they ever saw a plantation or heard a slave sing."

In truth, the Fisk Singers and their spirituals brought an introductory first lesson on African American culture to much of the country. One hundred thirty years later, the scholar Robert Cantwell would write that the tour of the Fisk Singers "amounted to the appropriation of this music by polite society and the further confinement of black people, in some ways, more invidiously than in minstrelsy itself, into the stereotype of Christian patience, humility, and other-worldliness that Victorian sentimentality had projected."

Although I have great respect for Cantwell's scholarship, I must respectfully disagree with this kind of after-the-fact dismissal, although it's a point of view worth considering. Leaving aside the politics of who controlled the music—the Singers were directed by a white faculty member—at the core of what they sang was a musical quality and a majesty that moved nearly everyone not already prepared to be hostile. It had dignity and grace and the essential elegance of the true. And while it had large elements of European song structure and a lesser

presence of African vocal elements, it was African American people, many of them former slaves, who made the music in a way that called for no apology—and no segregated audiences, ever.

At Emancipation in 1865, 93 percent of African American adults were illiterate. New England responded by sending teachers south. They were surely not all paragons, and they came armored with cultural assumptions, so that the rocking, shouting energy of a black church service often came as quite a shock to them. One teacher wrote, "They must know what is *right*! In order to worship aright the God of right." It was long before multiculturalism; these teachers saw themselves as emissaries of civilization out to raise up barbarians.

The first black songs to receive national attention were mentioned in the memoir "Life on the Sea Islands," by the black Massachusetts abolitionist Charlotte L. Forten, published in *The Atlantic Monthly* in May 1864. Thomas W. Higginson, an abolitionist who'd commanded black troops during the war, would follow up Forten's efforts in *The Atlantic* in June 1867. That same year, three other New England reformers, William Francis Allen, Charles Pickard Ware, and Lucy McKim Garrison (William Lloyd Garrison's daughter-in law), published *Slave Songs of the United States*, both establishing a field of scholarship and also connecting folk song to progressive social thought not only of the day (John Ruskin, William Morris) but also into the twentieth century with institutions like the Highlander Folk School.

Fisk University came from the same evangelical New England roots, the American Missionary Association. Late in 1865, Union general Clinton B. Fisk gave a Union hospital building to the AMA in Nashville. Appropriately grateful, they named the new institution, which opened on January 8, 1866, the Fisk Free Colored School. Loathed by most of the area's whites and threatened by the Klan, which made burning black schools a priority, Fisk struggled in its early days. Many of the incoming students lacked a surname and had to make one up. It was an entirely new world.

George Leonard White was a schoolteacher and choirmaster in his native New York State, a Union veteran, and then a member of the Freedmen's Bureau. As a Fisk faculty member, he saw the struggling school's financial needs and suggested a fund-raising concert, which would feature the white art music that striving black people embraced as proper. "Plantation melodies," "slave hymns," and "sorrow songs" were grim reminders of slavery and anathema to most Fisk students.

But some of the students began to sing them outside the classroom. White heard them, and began to collect songs. Born in the slow spin of the ring shout/circle dance of the black church, the spirituals fused African rhythmic call-and-response and pentatonic scales with Anglo lyrics and song structures and emerged as sorrow songs ("Go Down, Moses," "Swing Low, Sweet Chariot") and jubilees ("This Little Light of Mine").

Although he was not formally trained, White got extraordinarily polished—in a European sense—performances from his choir of nine voices, five women and four men, of whom eight had been slaves. Maggie Porter and Ella Sheppard would get the most attention over time, but no one voice predominated. It was, in the words of the Singers' biographer, "a sweet, coherent, monolithic sound that rose and soared and faded like a passing breeze."

In October 1871, they began a fund-raising tour of the Northeast, their repertoire at first predominantly the European art songs they thought suitable. It was the first time north for any of the singers, and it was hard going at first as they toured small black churches in Ohio. In November they played for a convention of Congregational Church leaders at Oberlin College, and a pianissimo rendition of "Steal Away" dazzled the audience, including Henry Ward Beecher's brother Thomas K., of Elmira, New York (who'd married Sam and Livy). Around this time, George White prayed and decided that a new name would suit, and they became the Fisk Jubilee Singers.

In December they arrived in New York City, where they were an enormous hit at Henry Ward Beecher's Plymouth Congregational Church. They had noticed that their best response came from spirituals, and in the fixed rule of show business, they began to sing more and more of them. Beecher led the fund-raising "pitch" at his church, and soon they moved on to other large New York churches. Six months after leaving Nashville, they came home with the funds to pay off Fisk's debt of $1,500 and with $20,000 more to build Jubilee Hall, the college's first building. Over the next few years, the Singers would raise $150,000 for Fisk.

To hear the Jubilee Singers was to be impaled on stereotypes. Critics were confused, expecting minstrelsy, and when they decided on a negative reaction, dismissed the singing as caterwauling. Those who were positive often slipped into the exotica stance and decided the singing was "natural" and "artless," completely missing the rigorous rehearsing that produced the seemingly effortless performance.

For white liberals, an enthusiasm for spirituals (which generally counseled patience and endurance) was a fairly easy stance. Over time, the left wing would grow critical, seeing the spirituals as "denatured," as when twentieth-century scholar Rudi Blesh dismissed the Singers' work as material "gradually transformed by the falsely sophisticated college Negroes into a white art song with only faint traces of racial coloration." Cantwell sums it up as "a kind of genteel minstrel show." The black middle class would wait until well into the twentieth century to celebrate spirituals as black folk music.

The very fact of supporting African American higher education made appreciation for the Singers a political statement. Even the most politicized critic can agree that it was the Singers' own choice to produce a synthesis, however much it meant an implicit bowing to the values of their (white) audience. The question becomes, does adding European ideas of presentation (both harmonically and in terms of visual appearance) help or hurt the material? Must it be performed in

a "natural"—which is to say, high energy, unrepressed—manner? In 1871, at any rate, the more important point seems to have been that the Singers presented black people as dignified performers of technically sophisticated art music.

Mark Twain's connection with the Jubilee Singers did not end with the 1872 concert. Visiting London in the summer of 1873, he got in line like a citizen to buy tickets to the Singers but was noticed by the theater manager, who wouldn't take his money and gave him the best seats in the house. He wrote a friend that "Their 'John Brown's Body' took a decorous, aristocratic English audience by surprise and threw them into a volcanic eruption of applause before they knew what they were about. I never saw anything finer than their enthusiasm."

The Fisk Singers' music would be a permanent part of his life. In 1897, grieving at the one-year anniversary of the death of his daughter Susy, Twain saw Maggie Porter's group in Lucerne. He wrote to his friend Joe Twichell that the Swiss audience seemed stolid and indifferent for a while; "Then rose and swelled out above those common earthly sounds one of those rich chords the secret of whose make only the Jubilees possess, and a spell fell upon that house. It was fine to see the faces light up with the pleased wonder and surprise of it. No one was indifferent any more . . . Away back in the beginning—to my mind—their music made all other vocal music cheap; and that early notion is emphasized now. It is utterly beautiful, to me; and it moves me infinitely more than any other music can."

It seems reasonable to surmise that at least part of the reason that Twain reacted so positively to the Fisk Jubilee Singers was that they stood in rather noble contrast to what was going on in the South specifically and the nation generally by the middle 1870s. In the words of the distinguished historian of the South, C. Vann Woodward, "The Union fought the Civil War on borrowed moral capital. With their noble belief in their purpose and their extravagant faith in the future, the radicals ran up a staggering war debt, a moral debt that was soon

found to be beyond the country's capacity to pay, given the undeveloped state of its moral resources at the time. After making a few token payments during Reconstruction, the United States defaulted on the debt and unilaterally declared a moratorium that lasted more than eight decades."

To extend the metaphor, the interest on that debt was paid by every black person in America during those decades, and with compounded interest. The enfranchised freedmen did not, in Woodward's sober estimation, abuse their new powers, in fairly stark contrast to the other contemporary large group of new voters, the immigrants from Eastern Europe, whose votes were largely manipulated by political machines. The newly enfranchised African Americans were, he said, "remarkably modest in their demands, unaggressive in their conduct, and deferential in their attitude." The extraordinary truth was that this abused, largely uneducated group of new citizens found a surprising number of honest and competent leaders and public servants, far better than one could anticipate.

It did not matter. The displaced leaders of the South were implacably determined to resume control of the land they regarded as their own, and wasted very little time in doing so. The Colfax (Louisiana) massacre of April 13, 1873, when Confederate veterans butchered around seventy local black people, was not atypical. Like other such incidents, it was preceded by white rumors of a coming armed Negro mass insurgency and slaughter, which justified white attacks as self-defense and protection of women from rape and children from murder.

In Colfax, the whites claimed that the black men who'd taken refuge in the courthouse had fired first at the whites who were offering them a chance to surrender. When the former Confederate general James Longstreet (then commander of the New Orleans Police Department) investigated, he was told that many of the bodies found had been shot in the back of the head. In 1875 Union general Phil Sheridan reported to President Grant that since the end of the war,

2,141 Negroes had been killed and a like number wounded—and none of these crimes had been punished.

In 1874 in New Orleans, thirty-five hundred Confederate veterans fought a pitched battle with a similar number of black Republicans for control of the city, requiring federal troops to intervene in support of the elected Republican government. On July 4, 1874, when black Republicans in Vicksburg, Mississippi, celebrated the surrender of the town eleven years before, armed whites showed up and began shooting, and Vicksburg effectively seceded from the United States once again. Sub-rosa paramilitary groups of Confederate veterans—the White League in Louisiana and the White Line in Mississippi—arose to become the military wing of the Democrat parties of both states, although the Democratic leaders archly denied any connection. Proof would come only years later, in the telegraph records of Mississippi party chairman James George.

The white supremacy leaders were not only disingenuous but also clever. They took the name "Redeemers" and wrapped themselves in a cloak of honor. Black voting was thoroughly suppressed, and white votes swept the Republicans out of office in Mississippi in 1875. General Philip Sheridan asked the secretary of war to declare the White League leaders "banditti," allowing him to arrest them, and Northern liberals like *The New York Times*, *The Nation*, and William Cullen Bryant, already tired of the "Southern problem," attacked the idea. Reconstruction was dead for lack of support. When a political tie emerged in the presidential election of 1876, the solution in the Electoral College was for the Republican Party to betray African American interests by withdrawing federal troops from the South in return for Democratic electoral votes, sealing the election of Rutherford B. Hayes.

Blaming the victim being an eternally popular solution, the national (white) consensus concluded that the fault with the situation lay with the Negroes, who were incapable of self-rule. Having turned the fault

around, the Southern Redeemers generated one last myth, the notion of the "lost cause," in which the war had nothing to do with slavery but was only about Southern rights and was lost only because of the superior resources of the North. In truth, the South *didn't* exactly lose. They lost the military war but won the political wars for the next century.

The Lost Cause and the treasured Our Dear Southern Way of Life were articles of faith, so that when the North adopted Darwin and the modern, the South would resist. "Darwin, Huxley, Ben Butler, Sherman, Satan," W. J. Cash would write, "all these came to figure in Southern feeling as very nearly a single person." The myths endured, and a century after the Civil War a Southerner could still identify the predominant white Southern emotion as "rage born of fear. Fear of change . . . Fear of perhaps never being able to heal."

Mark Twain looked at his native South and shuddered. He'd use it as grist for his literary mill, trying to keep things safe by placing his stories in a childhood context. Yet they seemed to resist his efforts. *Tom Sawyer* was his most perfectly realized dream of a sweetly sunny childhood, and even it morphed into murder, terror, and tragedy, however glossed over. Its final memorable image is Injun Joe's awful death, trapped in the dark and starving to death against an iron door.

Twain wasn't even sure it was a boy's book, and had to be so convinced by the eternally cheery William Dean Howells. Howells did persuade him, and Twain certainly knew it was a good story, and so in 1876 it was published. Unfortunately, the release was plagued by British counterfeiting (via a loophole in the copyright laws), and Twain would earn precious few royalties for the first decade after publication. Yet the enthusiastic response to his hymn to childhood made it clear that he'd located a vein of precious story material. He soon began what he thought of as a sequel to *Tom Sawyer*, this time centering on Tom's friend, Huck.

5

Huckleberry Finn

A S THE NATION celebrated its centennial, Twain returned to Elmira, took his usual postbreakfast walk with Aunt Sue, then strolled to his writing cabin. He looked west over the valley, and pondered. His morning paper reported the massacre of George Custer and the Seventh Cavalry by Crazy Horse and the Sioux and the ongoing reconquest of the South by the KKK and assorted fellow travelers, which would see slavery replaced by sharecropping and convict-lease systems that generally accomplished the same ends.

Initially, he thought of the new book as a sequel to *Tom Sawyer*, which had enjoyably centered on superstitions—how to cure warts with a bean and a midnight visit to the crossroads, blood oaths, Injun Joe's pact with the devil—and Tom's flaming imagination. But *Tom Sawyer* had depicted an almost exclusively white world.

The new book had as its seed a boy from Mark's Hannibal days by the name of Tom Blankenship. As Twain would later recall, Tom "was ignorant, unwashed, insufficiently fed; but he had as good a heart as ever any boy had . . . He was the only really independent person— boy or man—in the community, and by consequence he was tranquilly and continuously happy and envied by the rest of us." Blankenship's brother "Bence" (Benson) had encountered a runaway slave on Sny

Island, across the river from Hannibal, and had fed and hidden him for some weeks, although eventually the runaway would drown.

From the seed of Bence's experience and a consideration of whatever moral qualms a slave-state boy would confront in hiding an escaped human being came a book that would confront slavery and fundamental issues of freedom in America. It would take up the challenge of *Walden*—how to be free—and put it on the shoulders of a good-hearted twelve-year-old boy in a state that accepted the idea of human slavery.

Years later, Twain would write, "I have always preached. That is the reason that I have lasted thirty years. If the humor came of its own accord and uninvited I have allowed it a place in my sermon, but I was not writing the sermon for the sake of the humor." Twain's sermon *Huckleberry Finn* followed in the tracks of and extended the scripture that was *Walden* by considering the question of freedom in a vehicle that was the pastoral. Just as Thoreau gives us a cabin by a pond, Twain gives us a young boy and an escaped slave on an Edenic raft in the middle of a mighty river. Life on the raft is free, sheltered by nature's own river and far from the affairs of men. What *Huckleberry Finn* did was to make visible the connections between the pastoral, the pursuit of freedom, and the fate of African Americans in America—the terms set, of course, by a white man. As a Southern man who'd fled to Yankee Connecticut, Twain knew that until the sin of slavery was expiated, the country could not be whole.

Among the books in Twain's library at his passing were Thoreau's *A Yankee in Canada* and *The Maine Woods*. While Twain did not overtly comment on Thoreau in his writings beyond a passing remark, we can reasonably surmise that he read *Walden* and perhaps noted Thoreau's particular affection for huckleberries, which he regarded as ambrosia. *Huckleberry* is also nineteenth-century slang for an idle fellow, so perhaps the connection is mere coincidence—but it is lovely in any case.

One of the books at Quarry Farm was unquestionably relevant to the new project. In a copy (one of two full sets) of Thomas Carlyle's *The French Revolution* there is a line, almost certainly underlined by Twain himself: "it is the deep commandment, dimmer or clearer, of our whole being to be *free*. Freedom is the one purport, wisely aimed at, or unwisely, of all man's struggles, toilings, and sufferings . . ."

Huckleberry Finn was not destined to be a boy's book. Why write a book about so dangerous a subject as slavery? Why confront it at all? It was no coincidence that as the nation celebrated freedom while simultaneously de facto reenslaving a race of people such contradictions would arouse Twain. He could only address such an issue satirically, and with a boy as narrator.

Sitting in the cabin at Quarry Farm, he would dig deep with this book, leaving aside the nostalgia and sentiment of *Tom Sawyer* for a powerful if satirized realism. He would confront the traumas of his childhood, wounds that had led him to create an alternative persona just this side of a split personality. The genteel New England patriarch was also a guilt-ridden Western bohemian, a fraudulent pretender to the throne of the New England literary aristocracy. Years before, seeing a statue in Italy had triggered in him a disturbing memory of finding a body in his father's justice of the peace office. Now he would write of a Hannibal, as his biographer Justin Kaplan put it, "not purified of terror but shaped to embrace it."

"Mostly a true book, with some stretchers," *Huckleberry Finn* begins with Huck, whom we come to realize is several things. He is freedom personified—in *Tom Sawyer*, he is described as coming and going "at his own free will . . . he did not have to go to school or to church, or call any being master or obey anybody." He is also a handy stand-in for America itself.

Though he's living with the Widow Douglas, who has vowed to "sivilize" him, Huck is not a sunny all-American small-town boy. Rather, he is possessed by darkness throughout, the victim of violence,

child abuse, and superstition. He indulges his friend Tom Sawyer by taking part in a robber-gang fantasy drama that vanishes when grim reality in the shape of his father, Pap Finn, intrudes. Drunk and abusive, Pap kidnaps Huck, imprisons him in a shack on the other side of the river, and then delivers a racist rant that tells us that Twain is deadly serious.

Finn has encountered his worst nightmare, an educated, sophisticated black man: "they said he was a p'fessor in a college, and could talk all kinds of languages, and knowed everything. And that ain't the wust. They said he could *vote*, when he was at home. Well, that let me out."

Faking his own murder, Huck runs off to an island in the Mississippi and finds a fellow runaway in Jim (not "Nigger Jim"— that language came not from Twain but from his biographer Albert Bigelow Paine and Ernest Hemingway), who has taken flight to avoid being sold down the river to New Orleans. Much later, in an unpublished notebook, Twain would describe the book as what happened "where a sound heart and a deformed conscience come into collision and conscience suffers defeat." The deformity, of course, is the result of slavery. Huck's conscience indeed troubles him; by the lights of his upbringing, he should turn Jim in. His silence is a betrayal of Miss Watson and his entire community. But his loyalty trumps his upbringing: "I said I wouldn't, and I'll stick to it. Honest *injun*, I will. People would call me a lowdown Abolitionist and despise me for keeping mum [about Jim]—but that don't make no difference. I ain't a-going to tell . . ."

So begins one of the great mentor-student relationships in American literature. Jim is many things, and quite a lot of them are disturbing. Much of his presentation is minstrel-based comedy that cloaks profound satire. In their first conversation, after describing how he'd lost some money, he remarks, "Yes; en I's rich now, come to look at it. I owns mysef, en I's wuth eight hund'd dollars. I wish I had de money, I wouldn' want no mo'." In a society in which money is the measure,

he is really quite valuable. He immediately follows up that measure of self-worth (which Huck utterly lacks, despite his white skin), by displaying common sense about the coming rain: "Chickens knows when it's gwyne to rain, en so do de birds, chile."

Huck may *symbolize* freedom, but the concept is life-and-death reality for Jim. From the beginning, Jim is an equal partner in their journey, which alone is a triumph of sorts. Just as importantly to a Victorian like Twain so utterly invested in his family, Jim is completely committed to his role as a father, not only of his missing children, but also of Huck. Behind the self-protective minstrel mask he uses to survive, he is loyal, honorable, and wise. Early in the book Tom Sawyer plays a practical joke on him and steals his hat. Jim is presented as a stereotypically superstitious Negro who puffs the story into an epic of being ridden by witches. But the result, we learn, is that he was "most ruined for a servant." Who gets the last laugh? He constantly subverts the minstrel image.

As the book goes along we come increasingly to realize that Jim is the real hero, and the real center, of the story. Much of Twain's intentions in writing the book, to satirize Southern pretensions of aristocracy and sentimentality, come to mean less to us, even as we come to appreciate Jim all the more. Jim's not a symbol of slavery and all that was wrong with the South. He's Jim, a human being.

Ralph Ellison put it best in his essay "Change the Joke and Slip the Yoke": "Writing at a time when the blackface minstrel was still popular, and shortly after a war which left even the abolitionists weary of those problems associated with the Negro, Twain fitted Jim into the outlines of the minstrel tradition, and it is from behind this stereotype mask that we see Jim's dignity and human capacity—and Twain's complexity—emerge."

Given the conventions of antebellum America—and those of the 1870s, as well—Twain was constrained to use minstrel farce to present Jim. In part, it was a matter of language—in that era, minstrel

language was thought authentic. But as Jim stands revealed as a genuine man with a human soul, the farce is stripped of its power.

The strongest criticism of Jim concerns his supposed lack of intelligence, the minstrel-goofy, eye-bugging elements of his behavior; in fact, Jim's smart enough to survive, and he's also smart enough to save the two of them. Huck had dressed as a girl and gone into town to scout matters. The farm wife swiftly penetrates his disguise and it is clear that she's spotted signs of their presence on the island. They leap onto Jim's raft and away they go . . .

It's Jim who'd first selected a raft for his getaway—unlike a stolen skiff, "it doan' *make* no track"—and then built a wigwam on it for shelter. "Take it all round," said Huck, "we lived pretty high." The raft is Eden, and life is good. There Jim will act as moral mentor, teaching Huck what friendship means, and that is a form of intelligence that is not covered by the Stanford-Binet IQ test.

There is of course a great flaw at the center of the book's plot that can't rationally be addressed and simply must be accepted: Jim could simply have gone a few hundred yards east from Jackson's Island to the free state of Illinois; why was there a need for them to go all the way to Cairo and up the Ohio? Clearly, Twain put them through a mythic journey into the underworld that was the South as a quest for a golden fleece. This was no ordinary excursion. *Huckleberry Finn* is an indictment of the *deep* South; Jim had to go there.

They begin a series of hilarious conversation/arguments, funny because of their mutual educational limits, which in each case Jim wins by being himself. The life of a harem for instance: Jim announces that "A harem's a bo'd'n-house, I reck'n. Mos' likely dey has rackety times in de nussery. En I reck'n de wives quarrels considable; en dat 'crease de racket. Yit dey say Sollermun de wises' man dat ever live'. I doan' take no stock in dat. Bekase why: would a wiseman want to live in de mids' er sich a blim-blammin' all de time?" As Jocelyn Chadwick-Joshua points out, Jim transforms a place of female slavery and male sexual

satisfaction into his own worldview, a place of home and family. He uses his own language to confound Huck's own stereotyped perception of Jim as an ignorant "darky," and slowly begins to educate the boy.

At the end of their various arguments, they become separated in the fog, and we come to the first crisis in their relationship; Huck acts the fool and swears he was never gone, that it was all a dream. Of course, Jim would have had to be blind to miss what had happened. The very oar under his arm has been smashed—he could hardly miss that.

Jim knows Huck is lying, and his five minutes of silence is due not to confusion but to a thoughtful consideration of what to do with this boy he's been trying to teach and who has now failed him so very badly. And finally he tells the truth to Huck: "my heart wuz mos' broke bekase you wuz los', en I didn' k'yer no' mo' what become er me en de raf'. En when I wake up en fine you back ag'in, all safe en soun', de tears come, en I could 'a' got down on my knees en kiss yo' foot, I's so thankful. En all you wuz thinkin' 'bout wuz how you could make a fool uv ole Jim wid a lie. Dat truck dah is *trash*; en trash is what people is dat puts dirt on de head er de fren's en makes 'em ashamed." This is moral intelligence speaking; after all, this book is about the education of a boy.

"It was fifteen minutes before I could work myself up to go and humble myself to a nigger; but I done it, and I warn't ever sorry for it afterward, neither. I didn't do him no more mean tricks, and I wouldn't done that one if I'd 'a' knowed it would make him feel that way."

Now that he recognizes Jim as a full human being, Huck begins to confront the real implications of his commitment. Jim speaks of a happy future in which he can settle with his wife and children, either by buying their freedom or having an abolitionist steal them, and Huck is tormented by the conscience he has inherited from his "deformed" upbringing.

He cleverly deflects two men looking for escaped slaves with talk of smallpox, and then civilization intrudes into Eden, and a giant

steamboat, "looking like a black cloud with rows of glow-worms around it . . . with a long row of wide-open furnace doors shining like red-hot teeth, and her monstrous bows and guards hanging right over us . . . and as Jim went overboard on one side and I on the other, she came smashing straight through the raft."

Scholarship long had it that Twain stopped writing the novel at this point, but recent discoveries suggest that he wrote two more chapters, in which Huck finds himself in the middle of a feud, the war between the Grangerford and Shepherdson families. The feud is largely an opportunity for Twain to beat his personal bête noire, namely the Southern infatuation with the ersatz Middle Age chivalry of Sir Walter Scott, which he regarded as the root cause, among other things, of the South's obsession with honor.

He would later write in *Life on the Mississippi*, "The South has not yet recovered from the debilitating influence of his books . . . He did measureless harm . . . It was Sir Walter that made every gentleman in the South a major or a colonel, or a general or a judge, before the war, and it was he, also that made these gentlemen value these bogus decorations. For it was he that created rank and caste down there, and also reverence for rank and caste, and pride and pleasure in them . . . Sir Walter had so large a hand in making Southern character, as it existed before the war, that he is in great measure responsible for the war."

Huck is duly impressed by the wealth of the Grangerfords, with their one hundred slaves and ostentatious parties, and bemused by the feud, which his friend and peer the young Buck Grangerford can't quite recall the reason for. Meanwhile, Jim has been gathering food and organizing their escape. A female Grangerford runs off with a male Shepherdson, all-out war erupts, and soon every major character in the feud is dead. Doubtless some baby Grangerford is left to shoot at a Shepherdson when he grows big enough to hold a weapon.

Huck and Jim return to the river and sanity, and the summer of 1876 came to an end. Having created a glorious odyssey and taken

it, against all sense, into the inferno that was the deeper South, Twain was stumped. Grouchy and frustrated by writer's block, he rejected old times—"Every day that is added to the past is but an old boot added to a pile of rubbish"—in a fuming letter to his friend Will Bowen, and waited for inspiration to strike once again.

He traveled extensively in Europe and produced the travel book *A Tramp Abroad*, which came out in 1880. Twain's thoughts turned once more to the South. In need of money as always, he decided to add to the "Old Times on the Mississippi" material he'd written for *The Atlantic* in 1874 and returned to the river in April 1882. This time he brought along a stenographer, and the result would be *Life on the Mississippi*. Truth be told, the best part of it was *The Atlantic* material.

When given the chance to take a watch at the wheel he could "dream that the years had not slipped away . . . that I was still a pilot, happy and care-free as I had been twenty years before," but the river itself had changed drastically. Entire islands were gone, and the federal government had put electric lights on the river for navigation, which came as quite a shock. The Army Corps of Engineers was busily taming the river, straightening it with wing dams and dikes and grooming it with snag boats, although Twain didn't buy the Corps' sales pitch. They "might as well bully the comets in their courses and undertake to make them behave . . ."

Traveling on the river was cathartic, and his working notes on the trip tended to overlap between ideas for *Life* and for *Huck*. *Life on the Mississippi* was completed in January 1883, and after a spring in which writing was blocked by sickness, he returned to Quarry Farm in the summer ready to go. "Why, it's like old times to step straight into the study, damp from the breakfast table, & sail right in & sail right on, the whole day long, without thought of running short of stuff or words," he wrote William Dean Howells. At the same time he wrote his mother, "This summer it is no more trouble to me to write than it is to lie."

Huck and Jim return to the raft. "Other places do seem so cramped up and smothery, but a raft don't. You feel mighty free and easy and comfortable on a raft." There's a noticeable difference in Huck and Jim's relationship now; the slapstick arguments of the earlier passages are gone, and when they talk, as when they discuss the origin of stars, it's a sharing, not a contest.

Just as he eviscerated Sir Walter Scott's version of the South in the chapters on the feud, Twain now brings in the characters the Duke (of Bilgewater) and the Dauphin ("the King") to address what he saw as the average Southerner's ignorance and gullibility—as the Dauphin put it, "Hain't we got all the fools in town on our side? And ain't that a big enough majority in any town?" Of course, these characters also rope in one of Twain's other pet targets, European nobility. "But, Huck," says Jim, "dese kings o' ourn is reglar rapscallions; dat's jis what dey is; dey's reglar rapscallions." "Well, that's what I'm a-saying; all kings is mostly rapscallions, as fur as I can make out . . . Look at Henry the Eight; this 'n' 's a Sunday-school Superintendent to *him*."

The King and the Duke set up a con over a recently deceased local, with Huck adroitly stealing the boodle and giving it back before the King can make off with it, but just before the King and Duke end up tar-and-feathered and riding on a rail, they sell Jim to a good Christian farmer named Silas Phelps for $40, the same price John Clemens had gotten for Charley some forty years before.

The crisis has come. At least in theory Huck still accepts slavery, but Jim's become a real man to him. He'd heard Jim moaning about his lost children, "and I do believe he cared just as much for his people as white folks does for their'n. It don't seem natural, but I reckon it's so." He's heard Jim's painfully affecting story of spanking his daughter for not paying attention to him until he realized that she was deaf.

Huck begins to sing, as one biographer put it, "the Wagnerian aria" of what to do, what to do? Huck thinks he's a good Christian, and no proper Missouri-raised Christian could steal a slave from an

upstanding lady like Miss Watson. "The more I studied about this the more my conscience went to grinding me, and the more wicked and low-down and ornery I got to feeling. . .' There was the Sunday-school, you could 'a' gone to it; and if you'd 'a' done it they'd 'a' learnt you there that people that acts as I'd been acting about that nigger goes to everlasting fire.'"

He decides to be a good Christian, and writes a letter to Miss Watson and feels sufficiently expunged of sin that he can pray—but first he thinks. Of Jim standing Huck's watch on top of his own, of how good Jim has been to him. And in the essential sentence of the entire novel, he finally groans, "'All right, then, I'll *go* to hell'—and tore it up."

"It was awful thoughts and awful words, but they was said. And I let them stay said; and never thought no more about reforming . . . and said I would take up wickedness again, which was in my line, being brung up to it, and the other warn't. And for a starter I would go to work and steal Jim out of slavery again; and if I could think up anything worse, I would do that, too . . ."

Things become unhinged as Huck arrives at the Phelps farm on his mission to free Jim. Twain plays cute and has Huck mistaken for Tom Sawyer, who turns out to be a cousin of the Phelpses. As he exchanges greetings with his "Aunt Sally," Huck invents an explosion on the steamboat to explain why he's late.

"'Good gracious! anybody hurt?'

'No'm. Killed a nigger.'

'Well, it's lucky; because sometimes people do get hurt.'"

One would think that critics might throw up their hands at this point and abuse Twain for satire so broad, so obvious, so transparent, but no. For some historians, this is evidence that Huck (who of course is on a mission and must maintain a persona) is a racist. Or that Twain is. Clearly, the satire here is directed at the Phelpses, good Christian people who've purchased a human life and now plan to return Jim to his owner.

Tom arrives, pretending to be his brother Sid, and Huck broaches the idea of freeing Jim. He's reluctant to do so, for Tom "was a boy that was respectable and well brung up, and had a character to lose," much less his immortal soul. Huck was ready to sacrifice his own soul, but he was troubled by dragging a friend down into the pit with him. Yet his love for Jim requires that he act.

Tom knows that Jim's already free and withholds the information, which lets the plot go forward. His riotous imagination seizes on the possibilities and goes into hyperdrive. Deliriously pumping steroids into every plot element Sir Walter Scott ever invented, he fashions difficulties with the freedom of a mind utterly loosed from reality. "There ain't no watchman to be drugged—now there *ought* to be a watchman." "I wish there was a moat to this cabin. If we get time, the night of the escape, we'll dig one." "It don't make no difference how foolish it is, it's the *right* way—and it's the regular way."

Their hands grow tired digging with knives, so Tom agrees to allow the use of picks, "and *let on*" that it's knives. Tom asks for a knife and Huck hands him one; Tom throws it down and repeats the demand. Finally Huck hands him a pick, and they go forward. Tom was "just that particular. Full of principle."

They reach Jim, who tells them that Uncle Silas prays with him most days, and Aunt Sally makes sure he's getting enough to eat. Compartmentalized morality is a wonderful thing. By now, the Jim of the raft, so paternal and strong, has been reduced by Tom's antics to a minstrel mask in the full Stepin Fetchit mode. And Nat, the boy who is bringing Jim his food, makes Jim look like W. E. B. Du Bois. But he's not the only boob around—frankly, Silas and Sally aren't any brighter.

Tom fills Jim's cell with rats, spiders, snakes—Jim draws the line at rattlesnakes, so Tom figures they can tie buttons on a garter snake— and a grindstone so he can chisel his memoirs. But Jim's not the only one tortured; Tom's appropriation of Aunt Sally's spoons and sheets drives her straight up the wall, in what is an extremely funny scene.

In all, as Jim acknowledges, Tom's plan was "planned beautiful, en it 'uz *done* beautiful; en dey ain't *nobody* kin git up a plan dat's mo' mixed up en splendid den what dat one wuz."

All hell has broken loose on the Phelps farm, and even if they're clueless as to what's actually going on, Silas and Sally invite fifteen heavily armed friends to protect them; in the ensuing melee, Tom is wounded, and Jim goes from the minstrel stereotype to the Uncle Tom nobility mode, sacrificing his freedom to make sure that Tom gets treatment.

Yet one could also say that Jim is a man of principle and loyalty, who won't leave a friend—even a friend tormenting him—behind, that this is the true moral peak of the entire work, even greater than Huck's decision to go to hell. Jim's major flaw is believing in Tom, whose fantasy-driven life is perfectly happy to run his friends ragged for the sake of a good plot.

What are we to make of this looney-tune farrago? The utterly insane ending of *Huckleberry Finn* has troubled almost all the critics, going back to Ernest Hemingway's famous remark, "All modern American literature comes from one book by Mark Twain called *Huckleberry Finn* . . . If you read it you must stop where the Nigger Jim is stolen from the boys. That is the real end. The rest is just cheating." More recently, the distinguished Leo Marx indicted the slapstick of the ending as a "failure of nerve" that invalidates what precedes it.

Many current critics follow the lead of Ralph Ellison, who wrote, "without it [the ending], except as a boy's tale, the novel is meaningless." Recent thinking holds that the entire end section is a satire on Reconstruction itself—freedom offered, and then freedom withdrawn. Post-Reconstruction, the notion that black people had actually been liberated truly *was* farcical. In any case, Tom's lunacy is a send-up of Sir Walter Scott's worst plots, and given Twain's opinion of Scott, that should be quite clear and simple.

All true, but I would suggest something else. Mark Twain was notorious for being a craftsman of the sentence but not necessarily a

man who planned out the narrative plot of his work. I think he got to "All right, then, I'll *go* to hell," and became a trifle nervous. He was known as a humorist, and he'd gotten terribly serious. It had to stay; it was the linchpin of the entire book, and Twain knew it. But it was no way for a humorist to end his book, especially a humorist married to genteel Livy Clemens. He had to come up with a slapstick ending just to lighten up what he'd already done. This is close to what Leo Marx called Twain's "failure of nerve," but not quite—because I don't think that the silliness necessarily detracts from Huck's maturation. The end section is ruled by the childish schemes of Tom, a boy, who is unchanged, who will always be a boy. But Huck has grown. His "aria" is adult.

In other words, Tom is the (un)reconstructed South, Walter Scott personified. Since Huck is loyal to a fault, he lets Tom buffalo him into the mad scheme, which is explicitly a travesty, a farce.

A year or so after finishing his masterpiece, Twain wrote to the dean of Yale Law School inquiring about the merits of a young black man named Warner McGuinn, whom he'd met at a speaking engagement. Twain remarked that he wouldn't bother to help a white student who petitioned him, "but I do not feel so about the other color. We have ground the manhood out of them, & the shame is ours, not theirs, & we should pay for it."

I would not say that Mark Twain—particularly given present-day standards—was not guilty of racism. It was, as his biographer Ron Powers called it, an original sin—*is* an original sin. But Twain made his best efforts to expiate the sin, and in *Huckleberry Finn* he succeeded brilliantly in placing African American freedom at the center of what advancing America toward genuine civilization was all about. Later, he would give a speech in Boston defining civilization: "any system which has in it any one of these things, to wit, human slavery, despotic government, inequality, numerous and brutal punishments for crimes, superstition almost universal, ignorance almost universal, and dirt and

poverty almost universal—is not a real civilization, and any system which has none of them is."

Huckleberry Finn had centered on the pursuit of freedom from the moment that Huck returns to the island after failing to convince the farm woman that he's a girl. He grabs Jim and shouts, "They're after us." But they're not after Huck—he's supposed to be dead. They're after only the escaped slave. But Huck and Jim are one, and will stay one. And that's why the last sentence makes so much sense: "But I reckon I got to light out for the territory ahead of the rest, because Aunt Sally's she's going to adopt me and sivilize me, and I can't stand it. I been there before."

AFTER A YEAR of tinkering, Twain published *Huck* in February 1885. The initial response was appropriately Victorian; it was thought crude, its hero antisocial. Daughter Susy did not approve of Huck, and Livy was ambivalent as well. Twain's great friend William Dean Howells chose not to review it. Louisa May Alcott sniffed, "If Mr. Clemens cannot think of something better to tell our pure-minded lads and lasses, he had best stop writing for them." Better still, as Twain wrote his publisher Charley Webster in March, "The committee of the Public Library of Concord, Mass., has given us a rattling tip-top puff which will go into every paper in the country. They have expelled Huck from their library as 'trash and suitable only for the slums.' That will sell 25,000 copies for sure."

Twain was correct; sales were strong, even if the earliest reviews were ambivalent. As time went on, critics changed their mind. By 1913, H. L. Mencken would describe it as "a truly stupendous piece of work, perhaps the greatest novel ever written in English." T. S. Eliot, a child of the river himself, thought it a "masterpiece." Lionel Trilling said it was "one of the world's great books." Arthur Miller's tribute is rather perfect: "He wrote as though there had been no literature before him."

Hemingway was at least partially right; *Huckleberry Finn* would be an essential building block, perhaps *the* essential block, in American literature. If nothing else, it (along with *Leaves of Grass*) established the vernacular as central to the American style.

It was intrinsically egalitarian. Huck was, in Leo Marx's phrase, "a rebellious, democratic barbarian"—and his voice had to be consonant with who he was. As Shelley Fisher Fishkin has so persuasively argued, that vernacular voice is substantially a black voice. The bright little chap he'd written about as "Sociable Jimmy" clearly influenced Twain in creating Huck's voice. Twain wanted to tell a great American story in the American vernacular—and as his story came from elements of his childhood, so did the sounds of the voices. Hearing "Sociable Jimmy" simply took him back to Hannibal, and to Uncle John's farm in Florida, to Uncle Dan'l and other black voices.

THE GREATEST CRITICISM of the book over the past thirty years has centered on charges of racism, ranging from the minstrel forms that Jim uses to survive to explicit objections, largely from African American parents, about the use of the word *nigger*—more than two hundred times, someone counted. How one might re-create the atmosphere of the antebellum South without using the word is not addressed. It was Elijah Wald who perceptively noted that the usage endures—unlike, say, *darky*—because it's urban and aggressive. But it remains demeaning and wretched. As Malcolm X acidly joked, "What do they call a black PhD?"

Twain loved minstrelsy to the end of his life, and thought elements of it a "happy and accurate" portrayal, and that is indeed a more ambiguous element in his racial attitudes. Certainly he uses minstrel stereotypes, ranging from the clownish to the affectionate and sacrificial, and though he often uses these stereotypes to demolish themselves, there's often more than a hint of belief at the base of Twain's portrayals. Jim is convinced Huck is a ghost when they first meet on the island, all but breaking into "Feets, do your stuff."

Even his positive stereotypes—Jim is clearly the most decent person in the book—are suspect. Attributing greater sensitivity and feeling to a racial group, however well intentioned, inevitably twists into condescension. Some would see this fondness for minstrelsy operating in Twain's approval of Edward Kemble's drawings of Jim in the original publication. Kemble's depiction of Huck and Jim's first meeting shows Jim on one knee, hat in hand. Interestingly, this view was almost identical to a widely known abolitionist graphic symbol. It's never simple . . .

It's not simple because Twain's a prankster, and you can never trust a prankster. The very notice that begins the book—"PERSONS attempting to find a motive in this narrative will be prosecuted; persons attempting to find a moral in it will be banished; persons attempting to find a plot in it will be shot"—is a sly joke. The narrator, of course, is not Twain but a twelve-year-old boy who doesn't always get the joke—see his description of the circus.

In the end, perhaps his best statement on his racial attitudes came in an unpublished sketch Twain wrote in 1906. He visited a magazine office with his former butler, George Griffin, and the clerks stared at them. "The glances embarrassed George, but not me, for the companionship was proper; in some ways he was my equal, in some ways my superior; & besides, deep down in my interior I knew that the difference between any two of those poor transient things called human beings that have ever crawled about this world & then hid their little vanities in the compassionate shelter of the grave was but microscopic, trivial, a mere difference between worms."

And that is true, and wisdom.

In the tradition of Thoreau, *Huckleberry Finn* had made freedom and the pastoral concrete in the perfect image of Huck and Jim on the raft and carried forward the notion of the alternate voice as linked with the fate of African Americans; so long as they were not free, the white majority would be enslaved as well. Those futures would remain intertwined.

Just as *Huckleberry Finn* was published, the first generation of African Americans raised in the postslavery era began to come of age. Among them were people with musical talent, and at first they went to work in minstrelsy, in the well-worn patterns of show business they'd inherited.

Soon after, that relative freedom would allow them to experience one of the great explosions of creativity in American history. The response from mainstream America would be merciless.

6

Black Minstrelsy and the Rise of Ragtime

MARK TWAIN CONTINUED to enjoy minstrelsy to the end of his days, and in 1894 he promoted the work of a new performer, Polk Miller. In years to come, Miller would be joined by the Old South Quartette. A former Confederate officer, he would bill their show as an authentic re-creation of life on the plantation, part of the Lost Cause ethos. "It has been my aim," Miller said, "to vindicate the slave holding class against the charge of cruelty and inhumanity to the Negro of the old time." This group didn't require painting up; the members of the Old South Quartette were black men, one of them an old family retainer. It was a job.

In the late nineteenth century, African Americans with musical talent had three available vehicles to make a living; "Uncle Tom's Cabin" (UTC) shows, which were so popular they outlasted slavery by thirty years, jubilee acts like the Fisk Jubilee Singers, and minstrelsy.

By the 1890s, the stereotyped confines of the minstrel show were about all that was available to black performers. It was their salvation and their curse. The great singer Matilda Sissieretta Joyner Jones, nicknamed the "Black Patti" in reference to the preeminent

nineteenth-century opera star Adelina Patti, had headlined at Carnegie Hall and worked with Antonín Dvořák, but by the '90s she was forced to create what was essentially a minstrel show, the Black Patti Troubadours (later the Black Patti Musical Comedy Company).

After the Civil War, black singers and dancers like James Bland, Billy Kersands, J. Rosamond Johnson, and finally Bert Williams would take over the minstrel shows, blacking up their faces and subordinating themselves to the stereotypes and patterns created by the original white minstrels. Ironically, they tended to be superior entertainers to their predecessors, thereby keeping the minstrel tradition alive and flourishing. Their father figure was Charles B. Hicks, who launched the Original Georgia Minstrels in 1865. Along with entertaining countless thousands, the minstrel shows would incubate great talents. Mahara's Minstrels would include a young W. C. Handy in its orchestra; Silas Green's show from New Orleans would showcase the young Ma Rainey. F. S. Wolcott's Rabbit Foot Minstrels would include Louis Jordan and Rufus Thomas. It was a first foothold in show business.

Black minstrelsy spread notions of black music around the country, although the music itself, while black in earliest origin, had subsequently been performed by the white minstrels and then imitated by professional songwriters. By the 1890s, black minstrel performers were singing both originals and Tin Pan Alley's newest imitations and sounded to the music historian Robert Palmer like "close cousins to white country music." Musicological miscegenation was an ongoing process.

Black minstrelsy reflected the post–Civil War America that now had national transport systems requiring uniform standards and national businesses with increasingly sophisticated marketing and promotional methods. As a result, the minstrel show had become an elaborate all-day affair. First came a parade through town with a brass band, walking gentlemen in silk hats, and a "rube" or "pickaninny" band, followed by a baseball game, an outdoor concert, and then the actual show.

The new shows were much larger and somewhat more refined, emphasizing nostalgia above all. The humor remained corny, like the takeoff on *Macbeth*, "Bad Breath, the Crane of Chowder." The middle section of the show, the olio, emphasized solo acts and would evolve into "vaudeville" in 1883 when Benjamin Franklin Keith and Edward Franklin Albee coined that phrase and began to present clean family entertainment in their Boston theater that year. Black quartet singing in minstrelsy was also the source of the national fad of "barbershop" quartet singing.

Other elements of the black minstrel shows began to seep out into the American popular mass culture. By 1889, the "cakewalk," originally an antebellum imitation of minuets by slaves, had become a popular dance. Sissieretta Jones would headline the "Jubilee Spectacle and Cake-Walk" at Madison Square Garden in 1892, a commercial event with black dancers performing in front of a white audience. In 1896, the great black minstrel team of Bert Williams and George Walker danced the cakewalk in a vaudeville show, and by the next year it was a craze.

Even more influential than the cakewalk was the "coon song," which had the advantage of being spread by the latest technological advance in America, the recording, which had become practical with the introduction of the wax cylinder in 1888. Edison had thought of it as a business tool, but in 1889 the Columbia Phonograph Company was incorporated to sell music. At first the phenomenon was displayed in arcades, where a nickel would allow you to listen to a song. It was an effective way of integrating outsiders like black people into the mainstream society, since the exotic was less threatening in a once-removed recording. Then as forever, the first recording executives cared a great deal more for what sold than for racial rules.

So one of the first hit "records" in the land was recorded by George W. Johnson, a black Virginian who by the 1880s was singing and whistling for tips at the ferry landing in Manhattan, where Victor Emerson

of the New Jersey Phonograph Company noticed him. In June 1890, Emerson brought out Johnson's "The Laughing Song"—he apparently had a very infectious laugh—and it became a hit.

"Coon songs," a genre that ultimately had only the minstrel stereotype to define it, dated at least from 1880. One of the great black minstrel stars, Billy Kersands, introduced "Mary's Gone wid a Coon," one of the earliest examples. Another black minstrel star, Ernest Hogan, produced "All Coons Look Alike to Me." And in 1898, black songwriters Bob Cole and Billy Johnson wrote, produced, and starred in *A Trip to Coontown*, the first modern "legitimate"—it had continuity and a plot—black musical comedy on Broadway.

The ultimate in black talent on Broadway in this era was the team of Williams and Walker. Egbert Austin Williams, whom W. C. Fields would describe as "the funniest man I ever saw—and the saddest man I ever knew," was born in Nassau in 1874 and came to San Francisco in 1893 to study engineering. Show business called, and Williams began to develop exquisite gifts in physical comedy and witty delivery. He soon found his comedic partner in George Walker. At first Williams was the urban dandy and Walker the rural "coon," but when they switched roles and billed themselves as "Two Real Coons," they discovered a formula that trapped them in success for the rest of their careers.

In 1903 Williams and Walker brought *In Dahomey*, written by the poet Paul Laurence Dunbar with music by Will Marion Cook, to Broadway. It was a roaring hit. Painfully, it was performed in a segregated theater. Their follow-up, *Abyssinia*, featured a Williams song called "Nobody," a comically doleful masterpiece that became his theme song: "When life seems full of clouds and rain, / And I am filled with naught but pain, / Who soothes my thumping, bumping brain? / [pause] . . . Nobody." It made Williams by far the best-selling black artist in America before 1920.

After Walker fell ill and retired from the stage, Williams pushed on and found solo stardom, working for what would become impresario

Florenz Ziegfeld's *Follies* in 1910, the lead in a show that would also feature Fanny Brice, Eddie Cantor, Will Rogers, and W. C. Fields. Fields observed Williams's sadness up close, for his comic gifts were tarnished with blackface cork, and he was trapped. Black theater slang used the phrase "the ghost walks" to signify regular paydays. The ghost walked all over Williams and ate him alive.

Minstrelsy kept black entertainers eating through the end of the nineteenth century, but it exacted a terrible price in self-esteem. Something better was coming. Black creativity was flowering, most visibly at first in St. Louis and Sedalia, Missouri.

Not long before that, on May 21, 1893, *The New York Herald* published "The Real Value of Negro Melodies," an interview with the celebrated visiting Czech composer, Antonín Dvořák. Dvořák told the *Herald*'s readers, "I am now satisfied that the future music of this country must be founded upon what are called the Negro melodies . . . These are the folk songs of America, and your composers must turn to them . . . There is nothing in the whole range of composition that cannot be supplied with themes from this source."

Dvořák was right.

AT THE TURN of the twentieth century, St. Louis represented decorous gentility, precisely reflected in the 1904 St. Louis World's Fair, especially as depicted in Judy Garland's *Meet Me in St. Louis*. Even though the fair celebrated the arrival of electricity and virtually invented fast food—hot dogs, ice cream cones, and iced tea—it drifts in our memory in a warm, hazy, Edwardian glow, the era of another nostalgic film, *The Music Man*.

After the Civil War, most music in America focused on romantic escapism, with vague allusions to the classical, flowery ornamentation and truly damp sentimentality: Victor Herbert's "Ah! Sweet Mystery of Life," Charles K. Harris's remarkably maudlin "After the Ball," Harry Dacre's "A Bicycle Built for Two." All this fused with Victorian

repression and absolutist notions of propriety to create a rigid sense of what was acceptable.

Ragtime was a rock flung into that still pond, creating cultural ripples that are still having an effect. Even though it was largely European and frequently quite elegant, ragtime was the first music in America to reflect African concepts of polyrhythmic syncopation and would be part of a sheaf of cultural elements that would end the Victorian era—the queen herself died in 1901—and introduce the modern. It is hard for someone in the twenty-first century to imagine, but ragtime— lilting, gentle ragtime, about which the preeminent composer Scott Joplin wrote, "It is never right to play ragtime fast"—was perceived as a catastrophic and revolutionary force attacking the very foundations of society.

Though no proof exists, it is a common assertion that ragtime was introduced and dispersed in America by the 1893 Chicago World's Columbian Exposition, which somewhat tardily celebrated the "discovery" of America by Christopher Columbus. It's assumed that the piano players then syncopating in the saloons of the Midwest found work in the entertainment area—"the First Ward Levee District"— outside the official grounds. One historian of ragtime suggests that ragtime offered a happy alternative to the depression that began that year, which explains its instant popularity. I'm more than a bit skeptical about this, since the real impact of ragtime comes later in the decade. Still, the Columbian Expo is an extraordinarily illuminating portrait of the late nineteenth-century America that ragtime would confront, and well worth examining.

The main grounds of the fair were called the "White City," and nothing could be more revealing. The fair celebrated the arrival of the "white man" in the Western Hemisphere, the triumph of capitalism and of Western civilization. At a time when the British Empire encircled the globe, the fair implicitly and at times explicitly sought to prove the superiority of the white race, not least with the Dahomean village,

which displayed Africans in their natural, "barbaric" state and was ghettoized by its placement far in the back of the fair.

Another feature of the mile-long sequence of exhibits called the Midway Plaisance was "The Streets of Cairo," which included sixty shops operated by various North African people and also a theater that presented belly dancing, specifically that of one Farida Mazar Spyropoulos, "Little Egypt." Farida's gyrations caused a predictable outcry about lewd and lascivious exhibitions; even the hula dancers at another exhibit managed to offend. It also stimulated interest. Two dances, the "hootchie cootchie" and the "bombashay," spun out of the fair into popularity.

The music formally presented by the fair itself was directed by Theodore Thomas, conductor of the Chicago Symphony, and was limited to classical presentations and John Philip Sousa. Frederick W. Root, a minor composer, addressed the Folk-Lore Congress that was part of the fair and delineated the assumptions that underlay the fair and the congress, describing music as developing "from the formless and untutored sounds of savage people to the refined utterances of our highest civilization." So "the utterances of the savage peoples were omitted, these being hardly developed to the point at which they might be called music."

The American Historical Association, then only nine years old, also met in Chicago as an aspect of the fair. The main address was Frederick Jackson Turner's seminal "The Significance of the Frontier in American History," which explained the American character as a part of the triumph of the independent frontier spirit. That most settlers brought their old-world assumptions with them, that the West was largely settled by railroad corporations supported by government handouts and by the spirit of cooperation implicit in wagon trains, and that independence seemed to elude Native Americans, African Americans, women, and the working class was not yet evident to historians.

In fact, Turner's essay was end-of-the-century flag-waving along with an acknowledgment that the frontier had closed. The real base of the speech was recognition of the looming presence of the modern era. Though the fair tried to celebrate the hegemonic white culture of the nineteenth century, it inevitably revealed the increasing diversity of the real world, in which America was rapidly filling up with immigrants from non-Anglo-Saxon nations. Turner's celebration of an independent spirit also rang hollow in an era of depression, labor strife, and a deepening class system.

The American cultural scales were teetering, with the stable orthodoxy of WASP assumptions being challenged by the unwashed hordes of immigrants, African Americans, and working-class people along with intellectual and aesthetic developments broadly known as "the modern." Ragtime would help tip the scales.

THE WORD *ragtime* is a contraction of *ragged time*, in which African American musicians began to apply sophisticated African concepts of polyrhythm to American marching band music. As early as 1891, black newspapers referred to dances as rags. In the words of Eubie Blake, who played it from the 1890s to the 1980s, "Ragtime is *syncopation* and *improvisation* and *accents*." It was also a genuinely and explicitly American music, a synthesis of European and African elements, and specifically arose in an area between St. Louis and Kansas City, Missouri. It was an urban music just as the country was becoming urban. It took the country by storm; those accents put a wiggle into the music, which activated a long-repressed sensuality. And any proper Victorian would tell you it's been downhill ever since.

As it evolved, ragtime took at least three forms—minstrel/"coon" songs, ragtime dance material, which ranged from small string bands to John Philip Sousa's grandest marching bands, and finally the classic form, Scott Joplin's exquisite piano compositions.

The first song ever labeled a "rag" was Ernest Hogan's 1896 "All Coons Look Alike to Me," which included a measure of syncopation (in which accents produce multiple rhythms working against each other—the "wiggle"). The year before, Hogan had written a dance tune, "La Pas Ma La," which adapted a black vernacular dance and introduced the process of syncopation that would become ragtime. Even earlier, in the area west of Kansas City in eastern Kansas, the Leavenworth newspaper had written, "Kansas City girls can't play anything on pianos except 'rags,' and the worst kind of rags at that. 'The Bully' and 'Forty Drops' are their favorites." "Bully of the Town" was associated with St. Louis levee roustabouts and a brothel singer named "Mama Lou." "Forty Drops" was a syncopated string band tune later adapted to piano.

Syncopated music was bubbling out of the saloon-oriented black underclass by the mid-1890s in the Midwest, specifically the area spanned by St. Louis and Kansas City. One of those saloon pianists was named Scott Joplin.

Born in Texas in 1867 or 1868 to a railroad worker and a domestic, Joplin learned music from a formally trained German music teacher named Julius Weiss, who'd been brought to the area to tutor the children of a local major landowner. By the middle 1880s, Joplin had hit the road, working from Texas to Ohio and most spots in between as an itinerant honky-tonk pianist, soaking up the folk music of the day, from jigs, reels, and other dances to ballads, plantation melodies, and war songs.

At some time in the mid-1890s, Joplin settled in Sedalia, Missouri, a booming nexus for several railroad lines with substantial local support and repair facilities, which supported "Battle Row," the town's red-light district. He found work there in Lottie Wright's and then Nellie Hall's houses. He was also a regular at a black social club that opened in 1898, the Maple Leaf Club.

Though Sedalia was segregated downtown, its residential neigh-
borhoods were not. The town was the home of a black college and an
active black community led by an antilynching group called the Grand
United Brothers of Equal Rights and Justice. And at least one event,
a cakewalk in 1897 for hospital and railroad people, included both
black and white participants.

In general, nineteenth-century Victorian mores seemed to be slip-
ping in Sedalia; the newspaper defended theatergoing against evangeli-
cal criticism, and everyone seemed to be going to dances and shows.
The local white elite supported the local African American musicians,
hiring them for socials and dances. It seems to have been a fairly pro-
gressive and benign place. Like many American towns of the era, the
city had its brass band, the Queen City Concert Band, and Joplin
joined it on second cornet, while studying harmony at the local college.
He also put together a dance band and began touring with the Texas
Medley Quartette. They seemingly got at least as far as Syracuse, since
in 1895 he published two sentimental "parlor songs" there. In 1896 he
put out a march and a waltz.

Although he would work in many forms, his best songs were
labeled rags. By the time he began writing them in the late '90s, at least
one hundred had been published by a variety of writers, a combina-
tion of coon songs and syncopated instrumentals. Not surprisingly, it
was a white person, Ben Harney, who had the first hit, with his 1895
"You've Been a Good Old Wagon, but You've Done Broke Down."
Billed as the "Creator of Ragtime," he introduced it to New York City,
opening in 1896 at Tony Pastor's music hall. He later conceded that
his billing was an exaggeration, explaining the actual origins: "Real
ragtime on the piano, played in such a manner that it cannot be put
in notes, is the contribution of the graduated Negro banjo-player who
cannot read music." Harney added that the right-hand little finger of
a former banjo player now playing piano would reach for a string,
which would throw it off, resulting in syncopation. "He is playing two

different times at once." While Harney was probably too literal, it's true that ragtime on piano—the steady bass left hand playing against the triplets of the right hand—rather resembles the banjo.

Ernest Hogan's hit "All Coons Look Alike to Me" was the first use of the phrase *ragtime* on sheet music. The first instrumental that was completely a ragtime song and so titled was W. H. Krell's "Mississippi Rag," in January 1897. The first published rag written by a black person was Tom Turpin's "Harlem Rag" later that year. One of the prime sources for ragtime was the music of minstrelsy, and Kerry Mills, a white Tin Pan Alley composer, drew on this to write a cakewalk, "Rastus on Parade." He followed that up with the 1897 hit "At a Georgia Camp Meeting," which blended an old song, "Our Boys Will Shine," with march structure and minstrel rhythms.

By the late 1890s, ragtime had become a national fad, one of the first American pop crazes. John Philip Sousa began to program ragtime-influenced material in his band's repertoire, and string bands played for dancers across the country.

Scott Joplin had higher goals. Many years later, one of Joplin's finest interpreters, Joshua Rifkin, would observe that Joplin was "working *from* a folk realm, but it was not what he was working *to*." Though the sources of ragtime were the bars and whorehouses of the black working class, Joplin wanted something more stately, more uplifting, more of the theater than the brothel. He began to create art music, syncopated to be sure, but elegant and formal; he gave strict instructions that his music was to be played as written, no improvisations allowed, thank you. In 1899 he wrote his second rag, "The Maple Leaf Rag." Though dignified, it had an irresistible groove.

A local white music storeowner named John Stark became Joplin's publisher, and it was fortunate for Joplin that he did, even though Stark's previous business experience was in selling ice cream and reed organs. It was also fortunate that Stark was wrong in thinking that sales would not likely be large since the piece was too difficult for the

average player. Stark's sales methods were high-toned and aimed at
the respectable middle class, with an eye on the future. He was honest
in his accounting and respectful of Joplin as a person; he capitalized
Negro in advertising, and the cover of the music featured an elegant
maple leaf and no coons. Sales started slowly, with only four hundred
in the first year, but by 1905 "The Maple Leaf Rag" had sold one
million copies of sheet music, the first instrumental piece to do so. All
across the nation, white people as well as black people were dancing
to a black man's tune.

Joplin's ambitions grew. His last project in Sedalia was a folk
ballet called "The Ragtime Dance." It failed to sell, and his follow-
up, an opera called "A Guest of Honor"—presumably about the
lunchtime visit of Booker T. Washington to Theodore Roosevelt's
White House—failed to get sufficient backing. In 1901 Joplin moved
to St. Louis, where he gave lessons and spent much of his profes-
sional time at John (father of Tom) Turpin's Rosebud Café, in the
Chestnut Valley red-light district. While in St. Louis, Joplin wrote
"The Cascades," a tribute to the lagoons and waterfalls of the water
feature at the 1904 St. Louis World's Fair (actually, the Louisiana
Purchase Exposition). Mystifyingly, the fair failed to invite the
nationally known Joplin to perform.

That may well have been a consequence of the backlash to rag-
time and its most famous name generated by the partisans of musi-
cal orthodoxy in America. Ironically, these classical institutions—
the New England Conservatory (1867), the Peabody Institute in
Baltimore (1868), *The Musical Courier* (1880), *The Etude* (1883),
the Boston Symphony Orchestra (1881), and the Metropolitan Opera
(1883)—were relatively young, but that lent them neither flexibility
nor generosity.

The guardians of orthodoxy saw classical music as one of the
moral foundations of society. In that light, Chicago Symphony con-
ductor Theodore Thomas would call symphonic music "the language

of the soul," while "light music, popular music so-called, is the sensual side of the art and has more or less the devil in it." Using terms like *orthodoxy* and *canon* was not casual; there was a reverential aspect to their devotion. Since ragtime caused people to feel their bodies and dance, it was seen as a purveyor of chaos and discord leading to a subversion of rationality, which made it terrifying to the orthodox. "A person inoculated with the ragtime-fever is like one addicted to strong drink," wrote Leo Oehlmer in the *Musical Observer* in 1914.

It was not only sensual but also African American. "Can it be said that America is falling prey to the collective soul of the negro through the influence of what is popularly known as 'rag time' music?" wrote the *Musical Courier* in 1913. "[The] music is symbolic of the primitive morality and perceptible moral limitations of the negro type. With the latter sexual restraint is almost unknown . . ." *Metronome*, 1903: "It perpetuates and embodies the rhythm of those crude instruments of noise and percussion, which, in their original African home, awakens the fanatic enthusiasm of the natives for their religious and grotesque dances . . . Two centuries of continued importation of slaves naturally checked the spread of civilization among them."

In the words of the song "Ya Got Trouble," from Meredith Willson's *The Music Man*: "Libertine men and scarlet women and ragtime / Shameless music that'll grab your son, your daughter / into the arms of a jungle animal instinct . . ." Willson didn't need to mention black people, since there were none in his River City, but it was implicit with the word *jungle*. From the beginning of the twentieth century, black music was seen as otherworldly, trance-inducing, a form of voodoo, and thus sacrilegious (to the orthodox) or sacred (to followers). As such, the churchgoing black middle class rejected it as vehemently as any follower of the symphony.

RAGTIME WAS ONLY the first of the turn-of-the-century African American musical developments, although it was the first to have an

impact on white America—jazz would not touch the white world until the 1920s, while blues, excepting its partnership with jazz and one supreme star, would largely wait until the '50s and '60s.

Interestingly, all these forms emerged on or near the Mississippi River, and their sequence follows the river's path. The first and most European form came first and farthest up the river. The farther down the river, the more potent was the music, from the blues—formalized in Memphis but likely created in Mississippi—to jazz, which would be by far the most complex and far-reaching of these developments, and thus logically came from the most complex Southern place, New Orleans.

The river itself seemed a part of these creations. Certainly the black men and women who worked on and around the river shared that music as an audience, and the music was played on the steamboats. But there was more. There in the stable, dependable center of America was a pathway of phenomenal energy, a dynamic river that grew only stronger as it approached the gulf. From St. Louis south, music would manifest itself alongside it.

II

AFRICAN AMERICAN MUSIC AND THE WHITE RESPONSE

Race in America from the 1890s to the 1920s

THE STIRRINGS OF black creativity in the late nineteenth century met with a generally hostile reception from the white world, and a newspaper hoax of that era illustrates why. In 1890, the *Chicago Tribune* published a story about the Indian rope trick, in which a magician supposedly caused a rope to rise up, stiffening to the point that the magician's assistant could climb it until out of sight. Despite a retraction some months later, the legend took hold and became an article of faith.

The hoax worked because of the West's absolute belief in its superiority to people of color; if a savvy Westerner could not explain such a trick, it must be real. The rope trick filled a cultural need—and revealed the gullibility that such delusions of superiority inevitably create.

Around 1890, as European empires ruled the bulk of what we now call the third world, white assumptions of their own superiority held absolute sway from the academic world to the legal system, which in America was called Jim Crow. Complete segregation—that is, separation—had been impossible in antebellum America, since slavery required nearness, if only to supervise. Although many antebellum

institutions (hotels, restaurants, public buildings) were segregated, people tended to live in sufficiently close proximity as to make residential patterns a free-for-all.

Jim Crow was actually born in the North, where by 1830 there was no slavery but a great deal of segregation of transportation, theaters, hotels, and restaurants, leading Alexis de Tocqueville to observe in that time that race prejudice was strongest in states without slavery. Into the 1890s, Southern segregation patterns were varied and inconsistent. Former Union Army commander Thomas Wentworth Higginson visited the South in 1878, and with "the eyes of a tolerably suspicious abolitionist" saw black people with rights and no need to cringe. Many Southern black people could vote, and between 1876 and the end of the century Negroes served in the legislatures of North Carolina, South Carolina, and Louisiana. Professional baseball was commonly integrated until the International League drew the color line in 1887.

In historian C. Vann Woodward's analysis, "The South's adoption of extreme racism was due not so much to a conversion as it was to a relaxation of the opposition. All the elements of fear, jealousy, proscription, hatred, and fanaticism had long been present," but they'd been held in check by the concerns of Northern liberals, the control of Southern conservatives, and the initially color-blind activities of the Southern agrarian radicals known as the populists.

In the end, the populists discovered that the only effective strategy in the South was the race card, and played it. Northern liberals listened to Northern business interests and eventually concluded it was easier to blame black people for their problems, sweeping the racial situation under the rug. The conservatives went along with the prevailing currents. The United States Supreme Court also chiseled away at the protections enacted in the 1860s, finally establishing in *Plessy v. Ferguson* (1896) "separate but equal" as the law of the land, followed in 1898 by *Williams v. Mississippi*, which approved the disenfranchisement of

African Americans in that state by finding no discrimination in the application of poll taxes and literacy tests.

The unquestioned leader of African Americans in the South, Tuskegee Institute president Booker T. Washington, surrendered to the tidal wave of segregation with an address to the 1895 Cotton States and International Exposition, the "Atlanta Compromise," that argued that Negroes should seek blue-collar jobs rather than justice and accept segregation: "In all things purely social we can be as separate as the five fingers, and yet one as the hand in all things essential to mutual progress."

The main black voice objecting to Washington's program was William Edward Burghardt Du Bois, a Massachusetts-born Harvard Ph.D. who'd also spent time teaching school in the South. His 1903 *The Souls of Black Folk* made plain, among many other things, the price that Washington's conciliation would exact—no political power, civil rights, nor higher education for Negro youth. "Voting is necessary to modern manhood . . . color discrimination is barbarism . . . black boys need education as well as white boys." His opposition to Washington was not radical, except within the stunningly regressive tenor of the times.

An elite intellectual by inheritance and education, he advocated the leadership of black people by what he called the "Talented Tenth," but he also championed the strength of the folk roots of African Americans as revealed, among other ways, in their music. "There is no true American music but the wild sweet melodies of the Negro slave . . . Will America be poorer if she replace . . . her vulgar music with the soul of the Sorrow Songs?"

The best-known phrase in *The Souls of Black Folk* speaks of the "two-ness" of black Americans, of being both black and American. That double consciousness is a painful thing to reconcile, but the pain can also generate a wider vision, which Du Bois called "second sight." That wisdom could be shared. Over the coming century, communicated particularly in music, it would have profound effects.

Wisdom and vision were desperately needed, because as the nine-teenth century neared its end, things were going to get even worse for African Americans.

Fought initially on the issue of Cuban independence, the 1898 Spanish-American War soon became an opportunity for America to get into the empire game, bringing eight million nonwhite people into the Union from places like Puerto Rico and the Philippines, people who were not going to be permitted to vote. If Filipinos were so treated, black Mississippians could expect the same.

In the South, this meant not only total disenfranchisement but also the extension of segregation to seemingly everything. South Carolina pro-hibited the races from working together "in the same room or using the same entrances, pay windows, exits, doorways, stairways . . . lavatories, toilets, drinking water buckets, pails, cups, dippers or glasses." A joke documents this. "A white deacon in Mississippi walks into his church and finds a Negro standing there. 'Boy,' he calls out. 'What you doin' in here? Don't you know this is a white church?' 'Boss, I only just got sent here to mop up the floor,' the black man informs him. 'Well, that's all right then,' the deacon responds. 'But don't let me catch you prayin'.'"

White supremacy ruled not only social policy but the cultural realm as well. The Reconstruction legend now emerged to succeed the older mythologies of the Southern identity. In Woodward's phrase, it was the "common historic grievance, the infallible mystique of unity," in which weary, noble Redeemers rose up to defend their pil-laged homeland and smite the carpetbaggers, scalawags (collaborat-ing Southerners), and alternately lazy and brutal Negroes. This lore was most powerfully expressed by Thomas Dixon, a Baptist minister and later a lawyer and state legislator, who between 1902 and 1907 produced three potboiler novels: *The Leopard's Spots: A Romance of the White Man's Burden—1865–1900*, *The Clansman: An Historical Romance of the Ku Klux Klan*, and *The Traitor: A Story of the Fall of the Invisible Empire*.

This ideology permeated loftier realms as well. Columbia University professor William Archibald Dunning was a founder of the American Historical Association and its president in 1913, and was the leading scholar of Reconstruction in his era. His views were an academic version of Dixon's. Per Dunning, the freedmen were inferior, lacked the ability to govern themselves, should never have been allowed to vote, and had made segregation a necessity. Dunning taught a generation of scholars and defined a view of Reconstruction that would endure until after World War II and beyond—John F. Kennedy would treat the Redeemer Lucius Lamar as a hero in his Pulitzer Prize–winning *Profiles in Courage*.

Elsewhere in academia, white supremacy colored the social sciences. Racial pseudo-science had been invented in eighteenth-century Germany, when Johann Friedrich Blumenbach divided the races by color but then decided that North Africans and South Asian Indians were Caucasian because of linguistic roots. (This assumption patently did not impress the British Empire.) Such theories were widely accepted, and so the "Nordic-Aryan-White" "race" was enshrined as the peak of evolution.

At the beginning, the development of folklore studies was somewhat more benign. Late in the eighteenth century, intellectuals like Johann Gottfried von Herder began studying vernacular culture, specifically the rural peasantry and their songs, which he dubbed *Volkslieder*—folk songs. In the United States, this became the special province of Harvard professor Francis James Child, a Shakespearean scholar and a lover of English ballads. Studying the texts rather than the tunes of the songs, he began to classify English ballads, the older the better; his preferences leaned to the ancient and away from contemporary mass culture. Though he was known in at least two instances to alter the original texts, censoring stanzas that he found "tasteless," he established a high standard for succeeding collectors of American folk songs.

The American Folklore Society (and its publication the *Journal of American Folklore*) was founded in 1888 and focused on Appalachian Mountain songs, numbering them à la Child. Armed with an impressive reputation for his earlier research on English folk culture, Cecil Sharp came to the United States in 1916 to study Appalachian folk songs. Sharp romantically perceived the mountain culture as entirely isolated and idealized it as something racially pure, untainted by African American or non-Anglo-Saxon European cultures.

Since some 13 percent of the Appalachian population was black, this seems most unlikely. Given that Appalachian music, in addition to English ballads, involved string bands that included, among other instruments, the African-created banjo, the notion of isolation and racial purity is transparently flawed. The many songs that both white and black singers shared, from "Casey Jones" to "Railroad Bill" to "John Henry," complete the argument. Purity never existed. What was really extraordinary was that black music, despite its exposure to white music, would manage to stay distinctive, absorbing influences and yet remaining identifiably black.

The consequences of Sharp's biases were far-reaching, because he established a dichotomy of pure, uncorrupted (white) American folk music versus pop-influenced black music. Black music was thereby excluded from the folk canon. Sharp and the early folklorists also skewed their studies radically with their genteel biases, laundering out much of the magic and darkness (incest, sex in general) in the songs, a pattern that the distinguished historian Lawrence Levine called "denial, dilution, repression, sentimentalization, and trivialization."

Howard Odum, the first major twentieth-century researcher of African American song, was the grandson of Confederate soldiers and a racist who thought black culture was inferior; he pursued his studies as a weirdly exotic specimen. A graduate student at the University of Mississippi, he became the first person to field-record African American singers, trundling a gramophone around Lafayette County

in the Oxford area to capture "musicianers" and "songsters" playing what can only be described as very early blues on guitars, fretting them with slides or knives, and improvising their lyrics. Revolted by his informants, whom he regarded as dissolute, obscene, and immoral, Odum would earn his PhD and move on to other studies. In the process, alas, he disposed of his recorded cylinders.

The next major figure in black music studies was also a white Southerner handicapped by peculiar notions of how to conduct research on African American music. The daughter of a Confederate general, Dorothy Scarborough earned a doctorate at Columbia and taught there. Hearing the hit record "Crazy Blues" in 1920, she became convinced that old-time black Southern folkways were in danger of being lost to memory and set out to document them. Certain that living Negroes were unreliable sources for slavery-era material, she instead went exclusively to whites like herself who had learned black songs as children.

The result of her research was *On the Trail of Negro Folk-Songs*, which depicted what she called "the lighter, happier side of slavery." The fantasy of the old sweet South drove much of the American Folklore's Society early research into black music, including the distinguished founder of the Archive of American Folk Song (later at the Library of Congress), Robert Winslow Gordon, who told of elderly white ladies speaking of begging their black maids or nannies to "shout for her, and, if no men were present, had joined in with them—thus herself learning the art."

Scarborough's work, however flawed by her operating assumptions, was at least positively intentioned. In the nineteenth century, those assumptions were so nearly universal that only one writer wrote about African American life without imposing assumptions of exoticism or worse. (Melville might well be cited as another exception to this rule, particularly as to Native Americans, but I lack the space to do him justice.) Ironically, Lafcadio Hearn's clear vision came at

least in part because he had lost an eye as a teen. He always felt an outcast from conventional society, and it led him to avoid a lot of very wrong ideas.

Working as a journalist in Cincinnati in the 1870s, he wrote a number of articles on black levee life there, pieces remarkable for the absence of stereotyping. From Cincinnati he'd wander, first to New Orleans, where he became fascinated by the Gothic and managed to write dispassionately about even voodoo, and later to Japan. He wrote of himself, "I ought never to have been born in this century, I think sometimes, because I live forever in dreams of other centuries and other faiths and other ethics . . ."

Perhaps only someone properly from another century could have avoided the ferocious racism of the 1890s, a culture so virulent that when President Theodore Roosevelt invited Booker T. Washington to dinner at the White House, newspapers in the South found it unforgivable, placing him in line with Ulysses S. Grant and William T. Sherman as a race traitor.

The divine resolution came in 1910, when white supremacists confronted their most awful imagining, a black world heavyweight boxing champion named Jack Johnson. Johnson was the archetype of what the racists feared, a potent (he burnished the reputation by stuffing extra padding into his boxing trunks) black man who drove flashy cars, danced the cakewalk on stage with his white girlfriend, and generally made every effort to aggravate his critics. Led by the Anglo-Saxonist Jack London, the sporting press sent up a cry for a "white hope," who turned out to be Jim Jeffries, the previous champion, who'd retired undefeated some six years before.

On July 4, 1910, in Reno, Nevada, Johnson mauled Jeffries and was declared the winner in the fifteenth round. That night a black man walked into a New Orleans restaurant and said, "Gimme eggs, beat and scrambled, like Jim Jeffries"—and was shot. Like his fan in New Orleans, Johnson would pay a price to white America for his

attitude. In 1912 he took up with a nineteen-year-old white woman named Lucille Cameron, which offended Lucille's mother and led to the Mann Act, which made it a crime to take a woman across state lines for immoral purposes. Although his activities had taken place before the bill was passed, Johnson was found guilty and sentenced to a year in jail. He left the country for some time, but eventually returned to the United States and served his sentence.

His victory was an enduring one. Lionized in the Broadway play and film *The Great White Hope*, he also earned a memorial from Miles Davis, who named an album after him and closed it with the spoken lines, "I'm Jack Johnson. Heavyweight champion of the world. I'm black. They never let me forget it. I'm black all right! I'll never let them forget it!"

Fifty years after Emancipation, in 1915, President Woodrow Wilson held the first-ever screening of a motion picture at the White House, for a film titled *The Birth of a Nation*. Based on Thomas Dixon's *The Clansman*—Dixon had been a classmate of Wilson's at Johns Hopkins—*The Birth of a Nation* was a landmark in film history, featuring not only Lillian Gish but also technical innovations that the critic Harper Barnes cited as "multiple cameras, fast cutting, parallel editing, accelerating pacing, and point-of-view cinematography."

It also presented images of black people (played by whites in black-face) as maniacal, apelike rapists and the Klan as noble defenders of the Southern way of life. "The real big purpose of my film," said Dixon, "was to revolutionize northern sentiment by [our] presentation of history . . . Every man who comes out of our theaters is a Southern partisan for life." Ugly as *Birth of a Nation* was, it was not so far off the reality of race for black people in the South at this time. Between 1890 and 1915, 2,190 Negroes were lynched in the United States. Almost none of these crimes were ever prosecuted.

As the nation's economy ramped up for World War I and the ensuing restrictions on immigration and the military draft led to a labor

shortage that opened up jobs to black people, the North became ever more attractive to Southern African Americans, and they left. It was one of the great migrations in modern history. From 1900 to 1910, 170,000 black people departed the South. In the next decade, 454,000; in the 1920s, 749,000. The black population of Chicago rose from 44,000 in 1910 to 233,000 in 1930.

Encouraged by the black *Chicago Defender* newspaper, which launched an explicit "Flee the South" campaign in 1917 and sent copies in the hands of Pullman porters all over the region, Mississippians got on the Illinois Central in Clarksdale at 3:15 p.m. and arrived the next morning at the Twelfth and Michigan Street station in Chicago. In Cairo, Illinois, they could move to the front of the train.

Their reception was mixed. Much of the work they found was at the bottom of the industrial system, in meatpacking and steel, where they served as cheap and disposable fill-ins. Northern-born black people didn't always welcome the newcomers, and color and caste distinctions affected many—King Oliver, for instance, was troubled by the darkness of his complexion. Contrarily, Alberta Hunter admitted that she was a favorite of the dicty (snobbish): "Lord, Bessie Smith, they wouldn't think of looking at Bessie. Bessie was too raucous like, you know." Worse still, there were places such as Pittsburgh where the black community had been small and there was little discrimination until the migration, at which point there was a severe bump in trouble.

That was nothing compared with what happened in East St. Louis. Woodrow Wilson had orchestrated a fear-mongering propaganda campaign that demanded 100 percent Americanism to support the war and backed it all up with a Sedition Act. Postwar attacks on the left and on unions would lead to the November 1919 and January 1920 Palmer Raids, in which thousands of "dangerous aliens" were arrested—and three or four guns and no explosives were found. The atmosphere of fear and intolerance was extreme across the country

and found a particular outlet before the war in East St. Louis, the major nexus of twenty-two Southern railroad lines heading west.

East St. Louis was an industrial town, and like much of the United States, it was the site of considerable labor strife in this era, as unions found that they had a certain amount of leverage. As elsewhere, local corporations used black men as strikebreakers, and white workers were consumed with fears of being displaced. White mobs randomly attacked black people in East St. Louis all the spring and summer of 1917. On July 2, two white cops pulled up in front of a large mob of armed black men intent on defending themselves; shots rang out, the cops were dead, and all hell broke loose all over the city.

Social scientist Gunnar Myrdal would call it a "mass lynching." *St. Louis Post-Dispatch* reporter Carlos Hurd described it as "like nothing so much as the holiday crowd, with thumbs turned down, in the Roman Coliseum, except that here the shouters were their own gladiators, and their own wild beasts." They torched shanty homes and killed those who tried to flee, including a four-year-old boy. The militia was leaderless and did not intervene until one competent officer took charge of the troops at nightfall and began to arrest rioters, and the killing stopped. The official toll was forty-eight dead, but it seems far more likely that the proper figure was closer to two hundred.

Eighty white men, including eight police officers and later the mayor, and twenty-three black men were prosecuted in the first wave of charges filed. In the first trials, ten black men were railroaded into prison, along with a few of the whites. The police and the mayor were protected by the system and pleaded out.

But the riot in East St. Louis had longer-range consequences. On July 18, 1917, Madame C. J. Walker, the millionaire skin and hair products queen, organized a silent march of 8,000 to 10,000 people down Fifth Avenue in New York, the first civil rights march in American history. The membership of the NAACP went from 9,200 to 44,000 in the next year and to 90,000 by 1919, and its influence grew.

They needed to organize very badly, because the postwar era would be even more ugly. The demons loosed by Wilson's jingoist flag-waving and the Palmer Raids' attacks on anyone deemed insufficiently patriotic were fueled by the horrors of a war that had ingloriously butchered many millions. One reaction would be the rise, especially in the South, of an unworldly, sometimes hysterical evangelism that viewed anything unfamiliar as threatening, as in the Scopes trial.

The ground was fully ripe for demagogues like William Simmons. A failed preacher, Simmons had seen *The Birth of a Nation* and been inspired to revive the Klan, and after studying the Reconstruction Klan's "Prescript," he drafted a plan. On August 16, 1915, a mob in Marietta, Georgia, gave him further inspiration when it lynched Leo Frank, who had been convicted in 1913 of the murder of thirteen-year-old Mary Phagan, largely because of a media frenzy driven by a newspaper war between *The Atlanta Journal* and William Randolph Hearst's *Georgian*. Frank was Jewish and a Yankee, and that was good enough for the newspapers.

When the governor commuted his sentence (his own law firm had defended Frank), a mob of twenty-five armed men—"the Knights of Mary Phagan"—took him from prison, drove 175 miles to Marietta, and hanged him. The mob included a former governor of Georgia, the mayor of Marietta, the sheriff of Cobb County, a former superior court judge, and a future mayor of Marietta.

In celebration, the Knights then climbed Stone Mountain, north of Atlanta, and burned a cross, an image taken from the film, which Dixon had derived from Sir Walter Scott; the original Klan did not burn crosses. Simmons brought together a group that included many of the Knights of Mary Phagan as well as two elderly veterans of the first Klan, and on Thanksgiving 1915, some of them returned to Stone Mountain to burn yet another cross. Simmons gave himself the rank of Imperial Wizard and began recruiting.

Little happened until 1920, when Simmons hired Edward Clarke and Mary Elizabeth Tyler of the Southern Publicity Association. They set up a pyramid in which the $10 Klan membership fee would be shared. Simmons got $2 and Clarke and Tyler took $8, paying half to their salesmen, the Kleagles. They soon had twelve hundred Kleagles, and membership exploded. Within a couple of years, there were three million members, each declaring that African Americans, Jews, Roman Catholics, and anybody not white, native-born, and Protestant was the enemy. They elected mayors from Portland, Maine, to Portland, Oregon, along with dozens of other officials.

The real enemy was of course change, the eternal problem that all absolutists face, but no one was admitting that. Eventually, the Klan would fall apart when the leadership started squabbling over profits, but the fear of change would endure, as would the human propensity to attribute all that is wrong with the world to the Other—whichever Other one cares to choose.

8

The Primal Blues, Their First Popularizer, Their First Star

THE BLUES WOULD not touch the white world at all until W. C. Handy put them on paper and they were recorded in 1915, and then only faintly. But they would undergird jazz, the black music the greater world would increasingly listen to from 1920 on. The blues were powerful, perhaps not least because their origins are full of mysteries and unanswerable questions.

Late one night in 1903, while leading a brass band based in Clarksdale, Mississippi, W. C. Handy found himself drowsing as he waited for a much-delayed train at the station in Tutwiler, fifteen miles away. Everyone who has ever written about the blues has quoted the following lines from Handy's autobiography:

A lean, loose-jointed Negro had commenced plunking a guitar beside me while I slept. His clothes were rags; his feet peeped out of his shoes, his face had on it some of the sadness of the ages. As he played, he pressed a knife on the strings of the guitar in a manner popularized by Hawaiian guitarists who used

steel bars. The effect was unforgettable. His song, too, struck me instantly. *Goin' where the Southern cross' the Dog* . . .

Handy asked him what the words meant, and the man told him that some forty miles south, at the town of Moorhead, the Southern Railroad and Yazoo and Mississippi Valley Railroad (whose yellow cars had inspired the nickname the "Yellow Dog") lines crossed.

The song was very possibly "Poor Boy, a Long, Long Way from Home," more commonly "Poor Boy." Jug band musician Gus Cannon, born in 1883 and living in Clarksdale after 1895, recalled hearing a man named Alec or Alex Lee playing slide guitar around 1900. One of his tunes was "Poor Boy."

The origins of the first blues are indeed a mystery. The precise facts, the where and when, are a matter of guesswork based on this fragmentary information. Some things are clear. The primal blues originated in the period from roughly 1885 to 1900 and spread like wildfire from Texas to the Carolinas and from Missouri down to New Orleans. They contained flatted thirds and sevenths, a I-IV-V, tonic, subdominant, dominant chord structure, and a variety of other elements that came and went and varied tremendously but eventually included the AAB three-line verse form. As much as any formal set of musicological categories, the blues were the musical expression of black life.

As such, their purpose was the maintenance of cultural identity and implicitly a resistance to white authority. Their impact was social and spiritual as much as musical, and they maintained community. In that, the blues closely resembled black church life, although with dramatically different trappings. Not the least of the reasons the church so deeply objected to the blues was that they encroached on the church's turf by offering the same sort of emotional relief. More than anything being written in America at the time, the blues were universal and realistic, especially on the primary subjects of love and death.

The earliest and best information available on the origin of the blues is four stories committed to paper, most well after the fact—Handy's, Charles Peabody's, Ma Rainey's, and Jelly Roll Morton's. (We can note and dismiss as irrelevant that the first published song with *blues* in the title was "I Got the Blues," by a white New Orleansian named Antonio Maggio, in 1908.)

Charles Peabody was a Harvard archaeologist excavating Native American burial mounds in Stovall, a hamlet outside Clarksdale, in 1901 and 1902, and he heard his black workers singing. Their music so fascinated him that he reported on it to the *Journal of American Folklore* in 1903. The workers started with Sunday's hymns, sung in call-and-response style, "hymns of the most doleful import. Rapid changes were made from these to 'ragtime' melodies . . ." The music was "weird in interval and strange in rhythm, peculiarly beautiful." They sang of many things, from murder—"They had me arrested for murder / And I never harmed a man"—to humorous remarks about their white boss: "I'm so tired I'm most dead, / Sittin' up there playin' mumbley-peg."

Gertrude Pridgett, who married William "Pa" Rainey and became Ma Rainey for life, was born in Georgia in 1886, and by 1904 was part of a vaudeville team with her husband. She told researcher John Work that in 1902 she was in Missouri when a young local girl came and sang her a song that she liked so much she used it for her encore. It went over so well, Ma said, that it soon took a central part in her repertoire. Asked what kind of music it was, she finally said that it was "the blues," although no one ever thought to ask her why she used the word.

Finally, Ferdinand "Jelly Roll" Morton recalled a working woman by the name of Mamie Desdoumes singing the blues while playing piano in dance halls on Perdido Street in New Orleans in 1902.

These stories don't give enough information to satisfy the historian. Not only are the origins uncertain, but also the name itself is a misnomer, because blues songs were by no means always sad. Nor were they, for instance, apolitical. Given the realities of turn-of-the-century

black life, dissenting opinions required subtlety—the relevant phrase is *signifying*. *Signifying* meant commenting, often obliquely, on the subject at hand. It is African in nature because it is intimately related to improvisation and call-and-response group communication. What the blues signified for the singer was autonomy, the right to sing his own song in his own way. In 1900, that was a political statement. As it went along, the blues acquired associations of rambling—the freedom to travel was a particularly cherished right at this time—a celebration of pleasure, especially sexual pleasure, and a total lack of concern for any authority not actually pointing a gun at the singer.

The first blues songs signified any number of things. They were truly African American rather than African in that they were largely an individual matter, although they contained so many African elements other than group singing that the connection is clear. The blues are also part of the pastoral impulse in America. Hard as it may be to think of connecting them to *Walden*—I suppose *Huckleberry Finn* is an easier stretch—the blues took up the same impulse for freedom and autonomy that the two books represented. The blues celebrated the African elements of a traditional, rural, and natural value system and a people then coming into their own creativity now thirty-five years after Emancipation.

It's more than a little bit convoluted, because it's the freedom portion of the pastoral that the blues players would celebrate most—their pastoral landscape involved a lot of chopping cotton, and their interests often lay in catching a train and riding. But that's the nature of freedom of choice. Ironically, the call to freedom implicit in the pastoral led African Americans in large numbers to flee the land and settle in cities.

One of those cities was Memphis, just across the state line from Mississippi, and it would become the first urban nexus of the blues and home to W. C. Handy, the man who would introduce those blues to white America. Beale Street was his headquarters. Around 1910 or so, 315 Beale Street housed Pee Wee's (the sign read P. WEE'S), a

poolroom and craps joint where musicians gathered and collected their messages; the phone number was 2893. The Monarch Club was at 340 Beale Street, and you could find more musicians there. Known as the "Castle of Missing Men," the Monarch was run by the "Czar of the Memphis Underworld," Jim Kinnane, with help from Bad Sam, his bouncer. You could buy whiskey, cocaine, or a game in the Monarch, and it never closed.

One of the regulars at the Monarch was harmonica player Will Shade, who recalled one group of people on Beale Street: "Sportin' class o' women runnin' up and down the street all night long . . . git knocked in the head with bricks and hatchets and hammers. Git out with pocket knives and razors and so forth . . ." Memphis would later be particularly known for jug band music, led by Shade's Memphis Jug Band and Gus Cannon's Jug Stompers, which featured Noah Lewis on harmonica and Cannon on banjo. But that was still a few years away. Before that, there was a man named William Christopher Handy.

Son and grandson of preachers, Handy was born in 1873 in Florence, Alabama, and proceeded as a young boy to fall in love with and buy a "box of sin," a guitar, which his father demanded he exchange for a dictionary. "I'd rather see you in a hearse," his elder said. "I'd rather follow you to the graveyard than to hear that you had become a musician." Nonetheless, dad paid for organ lessons, and Handy's school had a Fisk graduate music teacher who taught them to sing Wagner, Bizet, and Verdi a cappella.

Handy progressed to a cornet without his father's knowledge and then made his father's worst nightmare real by joining a hometown minstrel show. He formed a singing quartet that set out for the 1893 Chicago World's Fair but made it only as far as St. Louis before they disbanded, broke. Handy found himself sleeping on the cobblestones beneath the city's Eads Bridge and heard vagabond guitarists. He wrote, "picking out a tune called 'East St. Louis.' It had numerous one-line verses and they would sing it all night": "I walked all the way

from old East St. Louis, / And I didn't have but one po' measly dime."
There was a rich, dark tonality to those voices, and he would come to
realize later that he was hearing the sound of a new music being born,
a precursor to something even more catalytic.

In 1896 he joined Mahara's Minstrels on cornet, traveling through
a dangerous, lynch-happy South with a gun in his pocket, then settled
into teaching music at Alabama A&M, the black college in Huntsville,
Alabama. He might have stayed there forever except for what he
recalled in his autobiography as "an odd new vogue called 'ragtime,'"
which he began to introduce into his classes. After two years, he was
back with Mahara's.

Minstrel show or no, he was a classically trained musician and
suspicious of "low folk forms." But he was also a working musician
interested in paydays, and one night in Cleveland, Mississippi, he had
an epiphany. A local string trio (guitar, mandolin, bass) filled in for his
nine-piece brass ensemble during a break. He found their music, the
sort of thing associated "with cane rows and levee camps," monoto-
nous, although not "unpleasant." It seemed limited to his schooled
ear, unappealing to any but small-town "rounders and their running
mates." Then a "rain of silver dollars began to fall . . . There before
the boys lay more money than my nine musicians were being paid for
the entire engagement. Then I saw the beauty of primitive music. They
had the stuff the people wanted." It wasn't easy for him to admit that
"a simple slow-drag and repeat could be rhythm itself," but the sight
of that money was persuasive. "That night a composer was born,"
Handy wrote, "an *American* composer."

One of his first compositions was a campaign song for investment
banker Edward H. Crump, mayor of Memphis from 1910 to 1915
and the city's political boss from 1909 into the 1940s. Handy had
been listening to the honky-tonk music of the black working class,
and it had a shape: twelve bars, three lines, and three chords (tonic,
subdominant, dominant seventh, with flatted thirds and sevenths). To

Handy, the form "had become a common medium through which any such individual might express his personal feelings in a sort of musical soliloquy." After playing the Crump campaign song for three years, he published it on September 28, 1912, under the title "Memphis Blues."

Why he called it a blues we cannot say. "Having the blues" has signified hard times in the English language at least since the Elizabethan era, but by no means were all the songs in this form songs of despair, and at this time the performers usually called them reels. Perhaps Handy chose it because he wanted to sell his songs to Tin Pan Alley, and sentimentality was an essential element of TPA marketing. Somehow, the proper name sticks, and the term *blues* stuck as though welded. Immediately, songs that would have been rags the year before became "blues." "Memphis Blues" wasn't the first published song referred to as a blues—"Baby Seals Blues," a pop song by Baby Seales, was published in August 1912; and "Dallas Blues," the only song ever written by a white guy named Hart A. Wand, was registered earlier in September than Handy's song—but "Memphis Blues" was certainly the first popular blues.

Much to his chagrin, Handy would not profit greatly from "Memphis Blues" because he'd sold it outright to a music publisher, Theron Bennett. Bennett added lyrics, hired a (white) minstrel star named Honey Boy Evans to sing it, spent a fair amount of money promoting it, and got a hit. Feeling misled, Handy promised himself it would be the last time he ever sold a copyright.

He began working on a new tune, which he initially called the "Jogo ("Colored") Blues." Feeling that ragtime was already passing as a popular form, he wanted this new song to be genuine, and a blues— "I aimed to use all that is characteristic of the Negro from Africa to Alabama." After his experience with Bennett, he also wanted to write his own lyrics, and his mind turned to memories of sleeping on the cobblestones under the bridge in St. Louis. "I hate to see the evening sun go down . . ."

The "Saint Louis Blues" was a blues and more. It had a basic twelve-bar structure with a sixteen-bar bridge that he called a tango and what he called a habanero (*sic*; habanera) rhythm—given the Moorish effect on Spanish music, it was all part of the African tradition. It used standard blues harmonies throughout. Handy connected the harmonies to black church music, saying they were "plagal [church] chords to give spiritual effects . . ." There were breaks for improvisation and sections of ragtime syncopation.

First recorded in 1915 at Columbia by "Prince's Band"—Charles Prince was the label's director of music—it became an enormous hit when Al Bernard, a white vaudevillian from New Orleans billed as "The Boy from Dixie," recorded it in 1921 backed by the Original Dixieland Jazz Band. It sold two hundred thousand copies and helped put the song and the concept of the blues into the American mainstream.

Handy was not the *Father of the Blues*, as his autobiography's title had it, but a critical bridge between the folk culture that created the form and the mainstream world of recording and publication. Having gone into Mississippi and listened to indigenous music, then translated it into notes and written structure and given the genre a name, he was what one writer called a folklorist familiar with copyright law and, as such, terrifically important.

What had been going on just south of Memphis in Mississippi was more than a little remarkable. Some of the most oppressed people on this green earth, deprived of almost every cultural advantage, had created something that was so enormously potent it would affect all of American music for the next one hundred years and beyond.

NOT EVERYONE WOULD agree with some of the preceding comments. At least one dissenter, Elijah Wald, holds that the blues were for fifty years "primarily black popular music," a professional music that white people took up in the 1960s using criteria quite different from

those of the original African American audience, most notably the '60s interest in less commercially successful rural forms.

As a *popular* music, it unquestionably began with Handy as the name-giver and flowered with Ma Rainey as the first great blues singer. Wald writes, "To say that the artists who gave the music its name and established it as a familiar genre are not 'real' blues artists because they do not fit later folkloric or musicological standards is flying in the face of history and common sense." This is a moderately clever bit of casuistry. By beating up the straw man that is the silly suggestion that Ma Rainey is not a "real" blues artist, he covers up his first misleading assertion, which is that blues were *always* primarily a professional genre, "primarily black popular music."

It's inarguably true that, starting in the 1920s and running into the 1950s, the blues were a popular African American genre that sold records and tickets to shows. But Handy didn't create it; he named something that already existed, and that music emerged around the turn of the century played by rural amateurs—of that we can be sure.

A second dissenting voice is that of Marybeth Hamilton, who wrote in her *In Search of the Blues* that the canonization of the Mississippi Delta as the source of the blues is because the Delta was the most backward place, the most frozen in time. She faults the idea that the Delta was backward by pointing to the research of John Work and Lewis Jones in Clarksdale in 1941, when people there felt that life was "fast-paced and worldly," with people moving around looking for better wages and buying cars and recorded music. Since this evidence comes perhaps fifty years after the origins of the blues, her argument is entirely anachronistic. That's a pity, because her research in analyzing why the white blues fans of the '60s were so drawn to the early rural blues is superb.

It is quite true that no one can say for certain where the blues began. My assumption that they began in the Mississippi Delta is, I freely acknowledge, based on post hoc logic, although the weight of

evidence is considerable. When it becomes possible to document such things, around the time of World War I, there were so many blues players in the Delta and blues were so clearly a part of the regional culture there that it vastly outweighs other places as a likely source. It is also true that the first recorded rural blues was by a Texan (Blind Lemon Jefferson), that the first hits came from Piedmont pickers who'd moved to Chicago, that Mamie Smith had the first hit with a pop tune that contained some blues coloration, but so what?

This we know: In 1916, a twenty-year-old musician named Tommy Johnson married and moved to a plantation near Drew, Mississippi. Other musicians in his circle included Nathan "Dick" Bankston, Fiddlin' Joe Martin, and a man named Charlie (this is the way he spelled it; his record company changed it to *Charley*, which is why it's more familiar that way, but it's time to get it right) Patton. Patton was the oldest, born between the late 1880s and 1891, and all of that circle, wrote the historian Robert Palmer, "sang and played Patton's brand of music—on this much the survivors seem to agree." This was before recording began to spread styles across the country.

According to Bankston, by 1910 Patton was already playing the tunes he'd record in the late '20s, songs like "Pony Blues," "Banty Rooster," "Down the Dirt Road," and "Screamin' and Hollerin'." The jug band player Gus Cannon, who'd been taught music by Clarksdale's Alec Lee at the turn of the century, was recorded in 1927, and that music, says musicologist Stephen Calt, "reveals that nothing fundamental took place in the realm of blues structure between the turn of the century and the 1920s." The formation of the blues didn't happen all at once or with any one person, and if it did not happen on the Delta's plantations, it surely found its most favorable reception there.

Through the late 1890s, the Delta was still semiwilderness, and black people migrated there as a place of economic promise. Patton's family came to Will Dockery's plantation on the Sunflower River in 1900, when Charlie was around ten years old and already exposed to

ragtime and country dance music at his birthplace near Bolton, one hundred miles south. The music he'd develop over the next decade was different, darker and more percussive, and it would largely define what came to be called the Delta blues.

The Delta, as James C. Cobb's title has it, is *The Most Southern Place on Earth*. It's not the Mississippi River delta (which is below New Orleans at the Gulf), but the Yazoo River delta, about 70 miles wide at Greenwood, and 220 miles from Memphis to Vicksburg. It is 7,000 square miles of land left by millennia of flooding, a collection of sediment that goes fifty feet deep in some places, accumulating and concentrating the power of the river in the land. Once cleared, it is geometrically flat and nothing but straight lines, and it is fertile beyond imagining.

In 1820, the Treaty of Doak's Stand shifted control of the Delta from Choctaw to white hands, and the first settlements began to emerge along the Mississippi; the Stovall plantation outside Clarksdale dates from the 1840s. Along with disease and raging animal life, the Delta's supreme fertility made it a brutally difficult place to clear for farming, which meant that from the beginning a large African American labor force working on sizable plantations would be required. After the Civil War, the landowners had enormous problems with credit and turned to sharecropping as a way of ensuring a labor force, which black people saw as a step toward land ownership. Through adroit manipulations of the economic system, the owners made sure that their 'croppers were fairly well stuck in place. Nothing would change terribly much for the next ninety years.

By the turn of the century, at which time only perhaps a third of the Delta had been cleared, the levee system was largely in place. The levees were an enormous wall a thousand miles long and perhaps thirty to forty feet high, built by mules and manpower—black manpower. The disenfranchisement of black people (and also many poorer white hill country people) gave the Delta planters an extraordinary control

over the state of Mississippi and made for a rigidly fixed social system. Until the federal government began to send investigators into the Delta in the 1930s, it was an extremely isolated place.

Though portrayed as the Old South incarnate, the Delta was in fact a fairly efficient sweatshop financed largely by Wall Street, which furnished credit to the planters and owned the railroads that would take the cotton to ports for shipping to textile factories, at first in England and New England, and later in North Carolina. Those factories were part of the "New South," which emerged in the twentieth century to give the poor whites a place to make a living. They were quite similar to the plantations, with a parallel paternalistic social organization in which entire families went to work together, with mill schools, mill churches, and mill stores advancing food against wages.

For most Delta African Americans, the result was either cotton feudalism or homelessness, and there were vagrancy laws that meant if you weren't working in the fields, you were going to work in the fields at Parchman Farm prison. One bluesman, David "Honeyboy" Edwards, recalled it as the "hog law"—have a job or don't be seen on the streets in daylight. Honeyboy, who was much more interested in playing guitar than anything at all to do with cotton, did chores for the local chief of police in order to stay out of jail—"That's Honey, that's Chief White's nigger."

The feudalism began with the "furnish," which was the planter's investment—seed, tools, a mule, a shack to live in, and credit at the company store for food—and ended with the "settle," when the cotton crop was harvested and weighed, and the sharecropper would get his share. Not uncommonly, this was anything from a pittance to a debt. In between, from "Can" (see) to "Can't," six days a week, the sharecroppers prepared the land, planted cotton, chopped (weeded) it, and picked it.

That was life in the Delta. Schools barely existed, and churches were the only social institution available. There, ring shouts provided

a framework for courtship for people who'd be married in their very early teens with the nourishing tradition of African-style dancing, "a two-phrase tune to a steady beat," wrote Alan Lomax, "a leader improvising against an overlapping chorus, a syncopated offbeat rhythm that made both the words and the youngsters dance."

Now that there was at least a theoretical shard of freedom possible, a tiny percentage of footloose wandering musicians drifted off the land, finding a way to live on their skills. Henry "Ragtime Texas" Thomas, born in 1874, was one of the first of whom Mark Twain spoke: "These poor people could never travel when they were slaves; so they make up for the privation now." Thomas fled his parents' work on the cotton farms of East Texas and rode the rails for many years, strumming his guitar and singing a variety of songs—spirituals, reels, minstrel numbers—each melting into the next, a jumble of fragments that would appear and reappear in songs like "Honey Won't You Allow Me One More Chance," "Don't Ease Me In," and "Don't Leave Me Here" ("I'm Alabama bound"). He called himself a "songster" or a "musicianer," not a bluesman.

Actually, none of Thomas's successors would play only blues songs. They made their living as entertainers, and as musicians always have, they gave their audiences what they wanted. The music started with church sounds and rhythms, and even the heaviest bluesman sang spirituals—many of them would play on Saturday night and preach on Sunday morning. "The blues is kinda like workin' in the church, I guess," said Booker Miller, who played with Patton. "Whatever the 'spirit' say do, you do it."

But they also sang ballads, ragtime comedy, Tin Pan Alley, and whatever made people dance and brought coins their way. Different regions produced different sounds, so that Tidewater playing was much more influenced by ragtime, and the East Texas style much more variable in rhythm, which is audible when Blind Lemon Jefferson throws in complexly picked single-note flourishes to answer his own sung lines.

When the music began to be recorded in the 1920s, the recording process would influence content, codifying it to some extent but also spreading techniques around the country. The fact that it was easier and cheaper to record solo musicians in the postcrash era of 1929 to 1931 led to the recordings of acoustic blues that we're able to study.

We can be reasonably certain that the primal blues were born before the turn of the century and spread quickly all around the South, there to diversify into endless variations. Most likely in the neighborhood of Dockery Plantation, there emerged something that we can characterize as the Delta blues. It was dark in content, with lyrics that frequently pondered questions of faith and death. It was African, with extreme singing styles that used lots of moans, whoops, and hollers, and it had a powerful, percussive beat. It allowed for an exceptional amount of improvisation, so that lyric lines would float from song to song. A lot of it was about love; as Son House put it, "Ain't no kind of blues excepting between a man and a woman."

The first star of the Delta blues was unquestionably Charlie Patton. He was small—five feet five, 135 pounds—and frail, with a limp and some missing teeth. But his voice was the voice of a giant, and it sounded like thunder.

Dockery Plantation was new when the Patton family arrived in 1900; Will Dockery had graduated from the University of Mississippi in 1895, and the Boyle and Sunflower branch of the Yazoo-Delta ("Yellow Dog") Railroad reached Dockery's only in 1897 (and later became the subject of Patton's "Pea Vine Blues"). Dockery's not only had its own train stop but also a commissary that employed six people, a gin, a sawmill, blacksmith's works, two churches, two elementary schools, and an on-site doctor (who treated both black and white patients), but no jook—Will Dockery was a moral man.

So was Charlie's father, Bill, a church elder and hard worker who managed to save enough to buy his own land. When Charlie began to fool around with the guitar while hanging around with the Chatmon

family around Bolton before they moved to Dockery, Bill beat him, even threatening him with a bullwhip, because popular music was un-Christian. It didn't work. Charlie, as his protégé Son House said, "hated work like God hates sin. He just natural-born hated. It didn't look right to him." Eventually, he wore his father down, and Bill bought him a guitar. He might have picked some cotton when he needed to, but mostly, as one friend said, "He was just a loafer . . . Just a loafin' musicianer."

Once in Dockery, he began to find players to learn from, especially one Henry Sloan, whom Charlie followed for some years. At this point, black dance music tended toward a square dance rhythm, which you can hear in the songs "Make Me a Pallet on the Floor" and "That's No Way to Get Along." Charlie would tend toward syncopation, accenting the two and the four (second and fourth beats), although not exclusively.

Songs started coming to him. "Green River Blues," "Pony Blues," "Tom Rushen Blues," "Jim Lee Blues"—but not just blues. There were comic ragtime numbers like "Shake It and Break It," his version of the popular ballad "Frankie and Albert (Johnny)," and even his take on pop, "Some of These Days." And he still played older slide tunes like "Spoonful." Also plenty of gospel tunes. He was a full-range entertainer, as a player had to be, complete with theatrics that dazzled his audience. "Charlie Patton was a clowning man with a guitar," recalled Sam Chatmon. "He be in there putting his guitar all between his legs, carry it behind his head, lay down on the floor, and never stopped picking."

The showmanship only decorated a repertoire and performance styles that were fantastically good. "Green River Blues" is archetypal, linking women trouble with references that let you travel around the Delta. He hears the *Marion* steamboat whistle blow—"and it blew just like my baby getting on board"—and then he's in Moorhead, "where the Southern cross the Dog." Then he considers the blues themselves: "Some people say the Green River blues ain't bad / Then it must-a not been the Green River blues I had." Patton manages the trick of being

personal but not autobiographical—the lyrics are mythic and as such often make him an observer more than a participant.

Patton was a focused, purposeful man; he liked to play the guitar and enjoy its side benefits, which were whiskey and women. He was not a tranquil soul. According to Son House, he'd "fuss all night" in his sleep, tossing and turning. Drunk, he was a loon, flirtatious to the point of suicide—jook joints were no place to come on to women when their armed boyfriends/husbands/dates were watching—and verbally aggressive when challenged. As bluesman David "Honeyboy" Edwards said later, Charlie was known to "break up his own dances. He'd drink that white whiskey [moonshine]) . . . Yeah, that boy really raised hell." When the fights broke out, Patton was out the window or up the chimney, whatever it took.

Periodically, just to confuse the enemy, he would renounce the blues and take up preaching, which comported with his strict disapproval of cursing around women, although not the song "Elder Green Blues," which mocks the Holiness churches, who called their ministers "elders."

He kept getting better and better, able to improvise on guitar in synch with his voice, no easy trick. His friend Ernest Brown said, "I've seen him playin' that guitar an' that guitar sound like it just talkin' . . . Look like them strings sayin' what he said." While most of his peers—Tommy Johnson, Willie Brown, Rube Lacy, Memphis Minnie—would play in fixed patterns, Patton managed to create a fusion of both picked riffs and strums that made him unique. Where he truly excelled, however, was his sense of rhythm, which was complex and subtle. In "Down the Dirt Road Blues," he's picking, tapping on the guitar, and singing—all in slightly different but complementary rhythms. It's a bravura performance.

Those very performances could vary tremendously in content and approach, with his vocals either roaring or whispering, his tempos breakneck or tranquil. As Patton's biographers Stephen Calt and Gayle Wardlow point out, this practice kept the focus on him as a performer

and made it impossible for onlookers to copy him. He was also impulsive. Booker Miller would recall him playing church music in the middle of a barrelhouse gig. "Right there in the middle of a dance," Miller recalled, "it didn't make him no difference: if it hit him, he just go to playin' church songs right there. They'd just back up in a corner and listen, 'cause they couldn't turn him down."

Behavior like that left him free, which was probably the point.

9

The Birth of Jazz, in New Orleans and New York City

B LACK MUSIC DIDN'T stop with the blues in Mississippi but followed the river to its end, to New Orleans, an island in a swamp created by the natural levees the river left behind after centuries of floods. It was the only place for miles around dry enough for Jean-Baptiste Le Moyne de Bienville to stand on and establish it in 1718, naming it for the regent of France, Philippe II, Duc d'Orléans. Philippe was a truly debauched man who slept late and never worked hard and loved food and sex, and the city has honored his memory ever since.

Its fusion of French, Spanish, and African (Bambara, Mandingo, Mandinka, and Wolof) cultures makes it unique in the United States, and that mixture is what eventually created jazz. European music arrived in 1727 with the Ursuline Sisters, who came to establish a convent. The Roman Catholic influence would be essential to New Orleans, because, post-Inquisition, the Roman Catholic empires tended to rule the culture of their possessions much more tolerantly than, say, the British.

Under the French, slaves were able to buy their freedom, and so emerged the world of the New Orleans Creole, free people of color. The Creole world was further affected by *plaçage*, in which free women of color would act as concubines for white patrons, creating a prosperous, property-owning class of women. *Plaçage* was built on the highly popular New Orleans ritual of octoroon balls, held as often as ten times a month in the late eighteenth century. The South's miscegenation anxieties don't seem to have reached New Orleans.

As New Orleans became an American city after the Louisiana Purchase, it became the slave-trading center of the country, with at least one hundred thousand people sold there in the nineteenth century. Outside the slave market, it was a black city, with 37 percent of its seventeen thousand inhabitants of African descent, one-third of them free. Given an urban setting in which many of the slaves were artisans, there was a fair degree of freedom to black life in New Orleans. It was black house servants who did the shopping, and it was black people who did the selling in the Sunday markets. After the market closed, black people gathered to dance in Congo Square—so named because many slaves had come from the Kongo (Angola).

They danced to the beat of drums, not for entertainment but ultimately for religious reasons. There was no mind/body disconnect in African thought; religion was experienced in both realms. Dancing *was* worship. The music came from West African secret societies like the Arara from Dahomey (which in Haiti became the Arada, practitioners of vodun) or the Yorubans, who mixed vodun with Western gods and saints and created voodoo.

Edward Henry Durell visited antebellum New Orleans and came to Congo Square to watch the dancers. There were many circles within the square, each with a drummer at the center astride a barrel drum and the dancers, male and female, around him. It went on for hours, and the goal was clearly trance/possession. "The head rests upon the breast, or is thrown back upon the shoulders, the eyes closed, or

glaring, while the arms, amid cries, and shouts, and sharp ejacula-
tions, float upon the air, or keep time, with the hands patting upon the
thighs, to a music that is seemingly eternal."

Thirty years after the Civil War, the world of the Creoles encoun-
tered the United States Supreme Court. Homer Plessy, of *Plessy v.*
Ferguson, was a New Orleans Creole, and the idea of being a sec-
ond-class citizen had never occurred to him. Backed by a local Creole
political committee, he deliberately sat in a white-only railroad car
to challenge Louisiana's new segregation laws. The court's approval
of segregation based on "separate but equal" in his case devastated
the entire Creole world. Jim Crow now blurred the superiority that
they had assumed toward African American slaves, and their status
dropped painfully.

Musically, the Creoles tended to be formally trained in the European
tradition, both for "classical" music in the concert hall and for march-
ing band music in the streets. In contrast, the African Americans from
Uptown (across Canal Street from the old French part of the city, the
French Quarter and the Marigny) generally had little formal training
but were more open to improvisation and the new sounds blowing
around America. As the twentieth century approached, ragtime and
blues swept New Orleans, and a few stray Creoles began to fall in with
the Uptowners and play the new music.

They first played these new sounds for funeral parades. The post–
Civil War period had seen the growth of black fraternal orders as
benevolent and mutual aid societies providing camaraderie, sick ben-
efits, and burial expenses. Parades in general were endemic to New
Orleans. The French military tradition had joined with the Roman
Catholic Lenten rituals to create Mardi Gras, an essential element of
the city's culture, but parades went on year-round. Creole culture met
Uptown culture and spawned something quite new—the second line.
Basically a derivation of the sanctified church's ring shouts, in which
children on the fringes would imitate the adults in the center ring,

second-line dancing was part of the participatory African tradition in which everybody danced.

After the turn of the century, they became known as "jazz funerals." As Louis Armstrong wrote it, "Yeah Pops—jazz actually arose from the dead . . . the real music came from the grave. That was how jazz began. That's why it brings people to life."

After the funeral ceremony, the body would be put on a hearse to go to the cemetery, and the band would form up. On the way out, they played slow tunes like "Just a Little While to Stay Here," or perhaps "Just a Closer Walk with Thee." Swaying side to side, the band would approach the gravesite in two lines, then part and allow the hearse to pass between them. The burial. "Ashes to ashes, dust to dust." A respectful pause. The musicians would flip their sashes and buttons back up to reveal colors, remove the muffle from the snare drum, and break into "Didn't He Ramble." "Even police horse—mounted police—their horse would prance," recalled Bunk Johnson. "Music done them all the good in the world. That's the class of music we used on funerals."

The jazz funeral was many things. It was a connection back to Africa, a profound ritual that linked participants with their ancestors. It was a masculine ritual and an assertion of cultural autonomy. And it was soulfully, uniquely, New Orleans. All of the dozen cultural strands that made the city went into it.

Another strand unique to New Orleans was its new red-light district, which became legal on January 1, 1898. The city had tried to tax prostitution in 1857, but the courts had held against them, leading to the unchecked dispersion of bawdy houses. In 1897 Alderman Sidney Story created "the district" to control the spread by limiting prostitution to a fifteen-square-block section running from present-day Iberville Street to Saint Louis Street and from Basin Street to North Robertson. Alas for poor Sidney, he also gave his name to the project, and it will be forever known as Storyville.

Storyville certainly had a role in the development of jazz piano, but it was otherwise only a racy, eye-catching gloss on the fundamentals of New Orleans culture. The real musical developments took place in the street funerals and in dance halls, where a new fusion came together.

Around 1900, with Congo Square long gone, the black outdoor social center of New Orleans was Lincoln Park, along with Johnson Park across the street, on the downtown side of Canal Street. People came there to see vaudeville and baseball games, watch balloon launches and parachute returns . . . and dance to music at the pavilion. The main attraction was frequently John Robichaux's society orchestra, which had a regular gig at the city's most patrician restaurant, Antoine's.

Then Charles "Buddy" Bolden, the city's most powerful cornet player, would count off the tempo by smacking his instrument down on the stage across the street at Johnson Park, and his band—Willie Cornish, valve trombone; Willie Warner, C clarinet; Frank Lewis, B-flat clarinet; Cornelius Tillman, drums; Jimmy Johnson, bass; Brock Mumford, guitar—would launch into the blues tune "Make Me a Pallet on the Floor." It was said that you could hear Bolden for miles, and you could certainly hear him in Lincoln Park. His playing soared and caressed the ear; as his phrase had it, he was "Calling the Children Home," and soon enough, they came. What they heard was something new. George "Pops" Foster, who would in the future be one of the city's outstanding bass players, recalled seeing Buddy at Johnson Park, "where the rough people went . . . He played nothing but blues and all that stink music, and he played it very loud."

Which was the least of the objections raised by the trained Creole musicians. Sidney Bechet's brother Leonard remarked, "Some of the Creole musicians didn't like the idea of mixing up with the—well, with the rougher class, and so they never went too far. You see, [Alphonse] Picou—Picou's a very good clarinet, but he ain't hot. That's because he wouldn't mix so much. You have to play real *hard* when you play

for Negroes. You got to *go* some . . . Bolden had it." Over the next few years, the lines between Creole and Uptown would melt.

The new music in New Orleans was largely a consequence of urbanization, of a social flux that generated massive energy as black people began to leave plantations and head to a city where there were schools and work—especially work for musicians. Between 1860 and 1910, the black population of New Orleans grew from twenty-five thousand to nearly one hundred thousand. Having started in family bands, players like Pops Foster (born on the McCall Plantation near Donaldsonville), Edward "Kid" Ory (Woodland Plantation, near LaPlace, ten miles upriver from N.O.), and Joe Oliver (Aben, near Donaldsonville) came to New Orleans. The relatively untrained immigrants brought an African energy from the plantation to the city, where it met the technically sophisticated music of the Creoles and catalyzed an exceedingly fruitful synthesis, an urban music that positively hummed with creativity.

The emblematic Creole musician was one Ferdinand Joseph LaMothe, a.k.a. Jelly Roll Morton. He wasn't the greatest pianist— that honor goes to the epileptic, alcoholic, homosexual genius named Tony Jackson, who never recorded; only his song, "Pretty Baby," survives him. But as the twentieth century passed, Jelly would write songs that defined the basic grammar of jazz.

Jelly's egotistical personality and ambivalence about his own racial identity would divorce him from his own musical community and greatly diminish his reputation in years to come. The usually generous Louis Armstrong wrote, "He claimed—he was from an Indian or Spanish race. No Cullud at all. He was a big Bragadossa. Lots of big talk. They had lots of players in the District that could play lots better than Jelly . . . he still had to eat in the *Kitchen*, the same as *we* Blacks."

Most likely born in 1885, Jelly was playing serious piano by the time he was in his teens. The streets beckoned, and he began to frequent

a musician's lair in the District called the Frenchman's. One day he got hired for a job, made what seemed a fortune in tips, and was hooked. In 1902, at seventeen, he began to play parlor piano at Hilma Burt's and later Lulu White's houses in Storyville. He claimed to be a great pool hustler and all-around gambler, complete with a diamond set in his teeth. Pops Foster didn't think much of his pool game or his left hand. "He just talked too much."

Between 1900 and 1907 Buddy Bolden played most often at Union Sons Hall (founded in 1866 at 1319 Perdido near Liberty), more commonly known as Funky Butt Hall in tribute to its odor, and the Odd Fellows and Masonic Hall (1116 Perdido near Rampart). His world was generally played out in the black version of Storyville, in the vicinity of South Rampart and Perdido, on the Uptown side of Canal Street. It was a rough neighborhood, where most men carried a razor or a gun, and contained "dozens of New Orleans' most dangerous and ill-famed barrel houses, tonks, cribs and dives," said Danny Barker, a New Orleans guitar player who'd come to prominence in the 1930s. "Murders were common day and night occurrences. The cautious police patrolled the area in groups: couples, trios and quartets." The customers, he recalled, were "real primitive" "yard and field" immigrants from the plantations.

They were what the Creole Isidore Barbarin famously called "the ratty people." Barker elaborated, "So, ratty music is bluesy, folky music that moves you and exhilarates you, makes you dance." That's what Buddy Bolden's Band gave them. First the sugar; after "Make Me a Pallet," they'd play sweet songs like "Sweet Adeline" or "Bird in a Gilded Cage," then perhaps some church music, like "Go Down, Moses," "Flee as a Bird," or "When the Saints Go Marching In." They began by playing it straight, but with embellishments. As the night progressed, it got looser, more ragged—like the instrumental "Don't Go 'Way Nobody, My Bucket's Got a Hole In It" (later copyrighted as "St. Louis Tickle"), and, of course, trombone player Willie Cornish's

own "I Thought I Heard Buddy Bolden Say" ("Funky Butt, Funky Butt, Take it Away").

What Bolden was doing was different in many ways. First, he had what was seemingly the first small brass group—there had been small string bands before, but brass tended toward large marching bands. He was the first to use his own name for the band. The one photo of the band makes it clear that it's a band rather than an orchestra—no uniforms, no poses. What he was doing with the music was even more significant.

Absent any recordings and theorizing from the collective memories of many witnesses, we can surmise that Bolden played what can best be described as a precursor to jazz, a fusion of improvisation, ragtime syncopation, and the blues—especially the blues, which gave the music its emotional content. In the words of Big Eye Louis Nelson, "The blues? Ain't no first blues. The blues always been. Blues is what cause the fellows to start jazzing."

It started with improvisation. Aside from the fact that it was an inherent element of African music, improvisation was the signifier of the freedom principle that made jazz what it was. Just as the whip came back down ever harder, black people created an art, a music, centered on freedom. It was a giant moment in cultural history. Bolden and his band took their ideas from down-home black life, from church and levee camp. Ragging the tune, which was partly the African concept of ornamentation and partly blues concepts like pitch bending, went back to plantation music.

Now the Bolden band took European instruments and song forms, marching band four-beat measures and four-bar basic units, and mixed in African blue-note harmonies and improvisation to produce something new. It was his ability to "fake," to improvise, that made Buddy popular—he couldn't read music and was playing by ear in the first place. As his biographer Don Marquis wrote, "if he forgot a passage he would introduce embellishments that his listeners often enjoyed more than the music originally written."

The rhythm section held down the basic beat, but the horns played off it, and by the time they were finished soloing, there were polyrhythms going in all directions. It started from an elegant, stately rhythm, the languid feel of New Orleans in the summer; not often fast, but always with unstoppable rhythmic propulsion. Inside that accommodating New Orleans rhythm there was room for infinite spontaneous improvisation.

JUST AS BOLDEN intuitively created something new, Jelly Roll Morton began to translate the synthesis into polished songs. As early as 1905 he had written "New Orleans Blues," complete with a loose rhythm that echoed what Bolden was doing. Soon after came the "King Porter Stomp," which would become legendary. Morton was up against even better pianists, and he had to define himself with something different, something his biographers Howard Reich and William Gaines described as "multi-themed compositions too complex to sing, with an orchestral array of colors, techniques, and riffs compressed into a universe of eighty-eight black and white keys. In effect, Morton wasn't just crafting new compositions but helping to invent a musical language that could accommodate them . . . its restlessly syncopated rhythms and blue-note colorations had not yet been fully codified . . . [he was] helping to write its underlying syntax."

At his hands, the admixture of blues loosened up ragtime, and ragtime melodies made the blues a great deal more complex. He freed up the left hand of ragtime, threw in blue notes, operatic art trills, and new harmonies including what he called "the Spanish tinge," and produced a fusion halfway between European classicism and Bolden. "I started using the word [jazz] in 1902 to show people the difference between jazz and ragtime," he told Lomax almost forty years later, and while that's unlikely, it is unquestionably true, as Lomax said, that he was the "first true composer of jazz, the first who devised and notated jazz arrangements." In 1915 he would publish the first jazz

composition on paper, "Jelly Roll Blues," and dozens more over the next twenty years, although he would never gain the recognition he felt was his due.

Bolden didn't last nearly so long. After perhaps ten years of creativity, he fell apart around the age of thirty and was sent to Jackson State Hospital, where he would remain, incoherent, for the rest of his days, dying in 1931.

He left a remarkable legacy. Paul Dominguez, one of the Creoles, wasn't any too happy about it. "If I wanted to make a living, I had to be rowdy like the other group. I had to jazz it or rag it or any other damn thing," he told Alan Lomax. "Bolden cause all that . . . He cause these younger Creoles, men like Bechet and Keppard, to have a different style altogether from the old heads like Tio and Perez."

Jazz had come, and it was going to change not only American music but also American life. In order to do that, it would have to move to the center of American culture. In Duke Ellington's words, "New York is a dream of a song, a feeling of aliveness, a rush and flow of vitality that pulses like the giant heartbeat of humanity. The whole world revolves around New York, especially my world."

That world had earlier included Scott Joplin, and in 1907 he moved to New York City. There, he mostly worked on his holy grail, an opera called *Treemonisha*. Though he was part of the Colored Vaudeville Benevolent Association, he seemed to have little contact with the black entertainment elite of the day, people like theatrical stars Bert and Lottie Williams and George Walker, the composer and vocalist Harry T. Burleigh, poet Paul Laurence Dunbar, composer Will Marion Cook, and bandleader James Reese Europe. There was a celebratory reception when Joplin published *Treemonisha*, but the stars did not attend. *Treemonisha* was a variant on Booker T. Washington's world, rural and striving, and these people were urban. His overweening desire to take part in the formal classical world left him rejected by both black and white establishments, both of which wanted him to stick with

ragtime. The one performance of the opera was a flop, and it would consume him until his death in 1917.

In the height of irony, just as he struggled to enter the sacred portals of high (white) culture, other people, most notably James Reese Europe, were taking ragtime into the (white) mainstream culture in ways Joplin could never have anticipated. Born in 1880, Europe had come up through the black musical theater. He would organize a black musicians' collective, the Clef Club, which from 1912 to 1915 would not only produce annual benefit concerts at Carnegie Hall, but also go far toward controlling the society dance band business in the city.

His timing was superb, because something remarkable was happening in the society dance business. In 1910, a ragtime dance craze broke out in the Barbary Coast vice district of San Francisco, in large part because it was noticeably friendlier to black owners and customers than almost anywhere else in America outside New Orleans. The dancers were black working-class people, and the dances had names like the "Texas Tommy" (from Texas but popularized in S.F.), the "turkey trot," the "grizzly bear," and the "bunny hug." The ballerina Anna Pavlova passed through the city and went slumming, discovered the dances, loved them, and spread them nationwide.

The dances fed into an enormous early twentieth-century expansion of the entertainment industry in general—amusement parks, dance halls, and motion picture theaters—occasioned by a dramatic loosening of public behaviors, the earliest triumph of the modern. Immigrants (both rural Americans streaming into the city and the European variety) were making new rules for themselves in the city. Among other things, more women now worked outside the home, and the ensuing increase in income meant they could also go out and dance. They danced to ragtime.

Then Vernon and Irene Castle, an English American dance team, introduced ragtime dances to Paris at the Café de Paris and became the rage of Parisian society. The café had a New York branch, so it was

not a stroke of genius to take the act to New York. The Castles were the ideal front for ragtime. Married, in part English, elegantly chaste, they removed all hint of earthiness from the dances and kept only the fun. To keep that fun, they knew they had to have a swinging band behind them; Vernon had been an amateur drummer, and he understood syncopation. They had a good white band for the waltzes, but for the ragtime material they wanted, and got, James Reese Europe and his very hip, showy black drummer, Buddy Gilmore. Their first gig with the Castles introduced their newest dance, the fox trot, with the tune "Memphis Blues." High society danced ragtime, and the brothers of the Clef Club had work aplenty.

The Castles were not the only white people finding work in ragtime. Tin Pan Alley—so named in 1908 for the single block on West Twenty-Eighth Street that had twenty-one music publishing firms and produced, when summer heat made for open windows, a cacophony of pianos all playing different songs—never overlooked a way to make a buck. The man who would lead the way was one Isidore Baline, also known as Irving Berlin.

A poor child whose father had died when he was eight, Berlin worked as a song plugger for star songwriter Harry Von Tilzer ("A Bird in a Gilded Cage," "I Want a Girl [Just Like the Girl That Married Dear Old Dad]") and then as a singing waiter. Berlin was working at Seminary, Scott Joplin's New York music publisher, and his big hit was going to slightly resemble the "Real Slow Drag" in *Treemonisha*. In 1911, he put together a slightly syncopated song that fused black and Jewish elements and called it "Alexander's Ragtime Band."

It's a very important song, not least because it was such an enormous hit that Berlin was immediately dubbed the "King of Ragtime." It contains a standard blues progression, but at the same time the singing sounds more like a cantor than anything else—as the eminent jazz critic Gary Giddins put it, "The synergy between cantorial singing and African American music—the minor third, pentatonic scale, expressive

vocalisms, spare harmonies, improvisation—was widely noted." It was not minstrelsy. It was a form of appropriation to the point of integration—white guys were recognizing the value of black music and stealing it, but with respect.

AMONG MUSIC'S LITTLE mysteries is the origin of the word *jazz*. One source says it derives from the French phrase *chasse beaux*, or dandy. My personal favorite comes from musician Garvin Bushell, who noted that the French had brought perfume making to New Orleans, and that "They used jasmine—oil of jasmine—in all different odors to pep it up. It gave more force to the scent. So they would say, 'let's jass it up a bit,' when something was a little dead. When you started improvising, then, they said, 'jazz it up,' meaning give your own concept of the melody . . . It caught on in the red light district, when a woman would approach a man and say, 'Is jazz on your mind tonight, young fellow.'"

Jazz entered print in the pages of the *Los Angeles Times* on April 4, 1912, in a piece about a pitcher who'd dubbed his new pitch a "jazz ball because it wobbles." The next year he joined the San Francisco Seals, and a piece in the *San Francisco Bulletin* on March 6, 1913, described how the team trained on "ragtime and 'jazz'"—which is what they'd nicknamed the local mineral water, possibly in homage to their hard-drinking pitcher. Their evening's entertainment included Art Hickman, the orchestra leader at the St. Francis Hotel, who was a huge baseball fan and had come up to play for them. Hickman was a regular visitor to Purcell's, a black dance hall in the Barbary Coast, and was hip enough to ragtime to add a banjo to his group.

Whatever the source of the word, jazz was destined—perhaps inevitably—to enter the American mainstream played by white men. "Papa" Jack Laine's Reliance Brass Band was the best-known white group in New Orleans, playing a style derived from the Uptown black guys that featured staccato syncopation but little blues, and one of

Papa's stars was trombone player Tom Brown, who in 1915 took his group Brown's Band from Dixieland to Chicago, opening at Lamb's Café on May 17. In an interview in the *Chicago Tribune* soon after, he said that the "trade name" for blue notes was jazz, and that jass (the spellings seemed to be interchangeable) had vague connections to sex and prostitution.

The year after Brown arrived in Chicago, he was followed by another white New Orleans group, Stein's Band from Dixie, composed of Alcide "Yellow" Nunez on clarinet, Henry Ragas on piano, Nick LaRocca on cornet, and John Philip Hountha ("Johnny Stein") on drums. One night a drunk kept urging them to "Jass it up, boys," and they became Stein's Dixieland Jass Band. Legend has it that small boys would black out the *J* on advertising posters, so they changed the spelling to *Jazz*. Finally, the four of them split from Stein over their low pay, replaced Nunez with Larry Shields from Tom Brown's band and Stein with Anthony Sbarbaro, and became the Original Dixieland Jazz Band ("ODJB").

They moved on to New York City, where they opened at Reisenweber's Restaurant on Columbus Circle on January 15, 1917. New York was jittery about the war in Europe and welcomed diversion; the Originals played music that was loud, fast, and syncopated, and after a few days, they hit—and hit enormously. LaRocca had a keen sense of promotion, and when Charlie Chaplin's film *The Good for Nothing* came to Reisenweber's to shoot a nightclub scene, the band managed to get in the shot. Hundreds of job offers followed, including the chance to record.

On February 26 they went to Victor's Studio and recorded "Dixieland Jazz Band One-Step" and "Livery Stable Blues." The latter wasn't really a jazz tune but rather a minstrel song with novelty tricks, like the sound of a horse neighing. It was snappy (one historian theorized that it was played extra fast to get the song under the three-minute recording limit) and fun and had a nice, bouncy syncopated

dance rhythm—and it sold 1.5 million copies. "Jazz" had arrived. It wasn't the first recorded tune to use the word *jazz*, but history remembers the hits, and "Livery Stable Blues" was a hit of the first order.

Sidney Bechet would later dismiss them as lucky. "Those are numbers you've got to *do* something with," he wrote. "You've got to make them original. All these Dixieland musicianers could do was play what they learned from us, and after that there wasn't anything more for them to do." However one might think that Bechet's ego was involved, it was true that the ODJB played syncopated music with little improvisation and less blues.

Just to muddy the waters, LaRocca would also go on to claim that the Original Dixieland Jazz Band had created jazz and that Bolden, Morton, and Handy had learned to syncopate by copying him, a ludicrous notion that another white New Orleans player, Paul Mares of the New Orleans Rhythm Kings, would dismiss. "They had no white bands which could really play. Everybody followed the colored bands."

Before we dismiss the ODJB as racist (though LaRocca clearly was), derivative of black creators (which they largely were), and lucky guys with good PR skills (ditto), the band's most sophisticated defender, a fine historian named Richard Sudhalter, urges a different verdict. His defense relies on recordings made in 1919 and 1936 to say that the ODJB was better than the verdict history has given it. Since the group's impact was in 1917, that's largely what they're to be judged by.

In any case, once again large groups of white youth were dancing to black-based music, part of a growing set of cultural forms that had emerged in the twentieth century in opposition to traditional culture: a somewhat lowered regard for wealth and social status, increased informality in clothing, looser social mores in general, talk of free love, advocacy of birth control, suffrage, even women smoking in public (!).

One incident in the early part of the century gives a hint as to what the new culture was resisting. In 1906, Maxim Gorky visited New York to raise funds for the Russian Revolution and was celebrated by

a dinner party hosted by A Club, a group of slightly bohemian young writers that also included Mark Twain, who lived up the block from A Club at 21 Fifth Avenue and very much enjoyed socializing with these young rebels. When it emerged that Gorky was not divorced from his first wife and was traveling with his long-time common-law wife, Twain withdrew from the official Committee of Welcome (what would Livy have said?!) and the campaign came to an end.

A Club was only one of a series of institutions, publications, and phenomena that emerged between roughly 1912 and the release of "Livery Stable Blues" to manifest bohemian opposition to mainstream values. Most of them were in Greenwich Village. Rent and restaurants were inexpensive there, and those inclined toward freedom liked the quaint, irregular street patterns and rich Italian street life. One good example, the Golden Swan, was a bar also known as either Wallace's or the Hell Hole. Its patrons included the organized crime gang known as the Hudson Dusters; the bisexual modernist writer Djuna Barnes; the arch-bohemian and future founder of the *Catholic Worker*, Dorothy Day; and the playwright Eugene O'Neill. Only in the Village . . .

The pre–World War I Village had a number of major nodes. *The Masses* was a journal founded in 1911 by a socialist named Piet Vlag. It was boring, and soon suspended publication. Max Eastman, a suffragist and student of John Dewey's at Columbia, received a note that read, "You are elected Editor of *The Masses*, no pay." He took the magazine over and made it, as he wrote in the first editorial, "A revolutionary and not a reform magazine: a magazine with a sense of humour and no respect for the respectable . . . a magazine whose final policy is to do as it pleases and conciliate nobody, not even its readers." He advocated free love and birth control alongside left-wing politics and was sufficiently provocative that the U.S. government felt compelled to shut down the magazine for its opposition to entrance into World War I.

Among his associates at *The Masses* was a remarkable woman named Mabel Dodge, whose greatest influence was felt through her salon, a regular gathering of some of the most interesting minds in America—Eastman, the anarchist Emma Goldman and Big Bill Hayward of the IWW, the poets Edwin Arlington Robinson and Amy Lowell, birth-control advocate Margaret Sanger, the novelist Frank Norris, and journalist and man-about-town Carl Van Vechten.

Since many newspaper reporters were part of the evenings, the topics discussed there tended to flow into the wider culture. Members of the salon helped introduce modern art—Brancusi, Duchamp, Matisse, Picasso—to America at the *Armory Show* in 1913 and changed American theater forever with the work of Eugene O'Neill and the Provincetown Players, another Village institution.

The principle of freedom was alive and well and thriving in Greenwich Village and would continue to do so for much of the rest of the century. Yet jazz would reach many more people in the coming decade and change many more lives. Addressing the National Education Association in February 1921, Dr. Henry Van Dyke said, "Jazz music was invented by demons for the torture of imbeciles. The State has the same right to protect its citizens from deadly art as it has to prohibit the carrying of deadly weapons, but I do not think the law can reach the matter. It is spiritual."

Anything that provoked such a rhetorical frenzy was clearly onto something.

Louis

THE MAN WHO would come to define the art form known as jazz in the early twentieth century began life in New Orleans on a street called Jane Alley in a neighborhood called the Battlefield, the black vice district near Storyville. He was born on August 4, 1901, although he would always rather elegantly claim the Fourth of July, 1900. He grew up in his grandmother's Baptist church hearing ecstatic singing, emotional preaching, and the sound of splashing baptisms.

Louis Armstrong attended Fisk School for Boys, across the street from Funky Butt Hall—he claimed to have heard Buddy Bolden play, and it may have been true. An unsupervised child of the streets, he found work selling newspapers and then coal to hookers in their cribs, and became a proficient gambler as well. He lived for the funeral parades and the chance to be part of the second line, and soon sought opportunities to carry the star's horns, especially his hero Joe Oliver's. Music permeated New Orleans in 1910; there were almost no cars or tall buildings, and in the humid air the sound traveled far—and there was always music playing somewhere.

Louis found work with the Karnofsky family, working on their rag-and-bone junk wagon, and picked up the Kress horn, a tin horn

that the junk sellers used to announce their presence, growling and bending the notes and essentially playing the blues. He got a loan from the family and bought a pawnshop cornet. "After *blowing* into it a while I realized that I could play 'Home Sweet Home'—then *here* come the *Blues*. From *then* on, I was a *mess* and *Tootin* away."

His musical education got an enormous boost after he was arrested on New Year's Eve 1912 for firing off a blank pistol and was placed in the Colored Waifs Home for Boys. The orphanage was run by a veteran of the black Tenth Cavalry and ran to military discipline, but it also featured the Maple Leaf Band and serious music instruction. Louis started with the tambourine, then a snare drum, then an alto horn. He responded well to the discipline and father figures there, and when the boy who played the bugle went home, Louis earned the job. Eventually, the Maple Leaf Band took part in a parade through his old Third Ward neighborhood, and his old friends came out and watched him march proudly by.

Only one musician in his generation would rival Louis Armstrong, and that was Sidney Bechet. Though born to the Creole culture in 1897, Bechet was a lifelong contrarian who refused to learn to read music, although playing was in his soul. He "wouldn't learn notes, but he was my best scholar," said Big Eye Louis Nelson.

He was supposed to take lessons from George Baquet, who had a considerable reputation around town, but Bechet felt that Baquet wasn't a real "ragtime" (the current phrase) or jazz player because he didn't improvise. "He stuck real close to the line in a way," Sidney wrote. "He played things more classic-like, straight out how it was written," with none of the "growls and buzzes which is a part of ragtime music," nor the "moans and groans and happy sounds." Shown a song on sheet music, Bechet would "see the whole thing. The notes, they were nothing: I'd seen them already. I'd take a look at the page and from there on I'd be on my own just playing and improvising." From then on, school was problematic and Sidney was more a part of

the uptown second-line scene than the Creole trained-musician culture. He was headstrong and certain of his way.

Louis was released from the Waifs Home in 1914, quickly finding work both on the coal wagon (15 cents a load) and at Henry Ponce's tonk ($1.25 in tips a night). He was still learning and could play pretty much only blues at this point, as Pops Foster noticed when he hired him to replace a drunk on a wagon advertising an upcoming show. Still, it was good blues, and you needed only a couple of tunes on the wagons.

As the years passed, New Orleans music grew in a specific direction. The rougher bands, like Kid Ory's or Frankie Dusen's Eagle Band, thrived; they were the "routiners," the improvisers who worked from their ear rather than reading music. One day in 1916 or so, the drummer/second-line brawler Black Benny told Bechet that there was someone who could outplay him on "High Society," the very piece that had brought Bechet fame when he transposed Alphonse Picou's piccolo part to clarinet. Benny then produced Louis Armstrong, who could now play that part on cornet. Impressed, Bechet hired him for an advertising job. For whatever reason, they never became terribly friendly, though, and treated each other with diplomatic caution.

Bechet briefly left town with the Williams and Wade Stock Company, getting as far as Chicago but ending up broke and riding the rails home to New Orleans after a night in jail. Louis did better; he found a musical father. Joseph "King" Oliver and his wife, Stella, essentially adopted young Louis, who ran errands for Stella to pay for kindly lessons in improvisation from Joe. "Everything I did," said Louis, "I tried to do it like Oliver."

By the end of the decade, the music scene had changed considerably. Storyville was gone, closed by the navy in 1917. In 1918 Louis married Daisy Parker, "the prettiest and the 'bad'est 'whore in Gretna Louisiana." The same year Oliver, now playing with Kid Ory, left town for Chicago to join Bill Johnson's Creole Jazz Band. Bechet also left for

Chicago that year, joining Duhe and Smith's band at the De Luxe Café before hooking up with Will Marion Cook's Southern Syncopated Orchestra and leaving for London.

Oliver's departure left an opening in Ory's band, and the seat went to Louis. He had earned a real reputation in town by now, and soon he was working with the Creoles in Papa Celestin's Tuxedo Brass Band as well as with Uptowners.

Then Fate stepped in with an opportunity to widen his musical horizons dramatically. Not fate but Fate: Fate Marable, a ragtime player from Kentucky who'd visited New Orleans and been captivated by Kid Ory's Cooperative Hall Band (Ory on trombone, Warren "Baby" Dodds on drums, George "Pops" Foster on bass, Johnny St. Cyr on banjo, David Jones on mellophone, Johnny Dodds, clarinet). Soon he would hire them and Louis Armstrong to work for the Streckfus line of Mississippi riverboats.

John Streckfus had chosen riverboat life as a conscious reaction to his authoritarian father and in explicit homage to Huckleberry Finn. In 1901 he switched from cargo "packet" boats to excursion boats that included ragtime music for dancing. Music on the water made for romantic magic, and the passengers, said historian William Kenney, "danced their dreams." The boats were like swans on the water, floating palaces that evoked nostalgia for the era of Twain's characters. They were also at least a little cooler than the land during the summer.

Only seventeen years old, Louis started playing on the SS *Sidney* in the fall of 1918, staying with Streckfus for the next three seasons. From 1919 on he and the Metropolitan Jaz-E-Saz Orchestra were on the SS *St. Paul* out of St. Louis, with occasional trips north. Working for Marable, said Zutty Singleton later, was like "going to the conservatory." In particular, Louis learned a fair amount of sight-reading from David Jones, the mellophone player.

He also learned how to play in a larger—ten- to twelve-piece—ensemble than he was used to, with Streckfus himself playing them

Art Hickman records to teach them large group musical values. The repertoire was a mix of old favorites and current hits that carefully synthesized black and white elements. Marable and Streckfus were particularly concerned with tempo; they wanted it slow like a swan, but not belly-rubbing slow. One day, Streckfus said, Louis told him, "'We's got it.' I said, 'What do you mean?' He said, 'We played it slow like you wanted it, and I's put in a little swing, and did they like it.'"

He also learned, for the first time, what it was like to play for white customers—black customers were permitted only on Monday nights. They were often the first black band to come to the small towns along the river, and people were not used to seeing well-dressed, dignified black musicians. The musicians of the Streckfus line were the leading edge of a migration that was to follow.

Louis was growing dramatically and wanted to be the featured soloist and vocalist for Fate's band. Streckfus and Marable resisted any idea of stars and wouldn't listen, so in 1921 Louis quit and went to work at Tom Anderson's cabaret back in New Orleans. Although Storyville was history, Anderson remained a legislator and still had forty women working in his joint. It was a topflight, good-paying gig, and Louis was content.

Once more King Oliver sent for him to come to Chicago, and this time it felt right. On August 8, 1922, Louis played a funeral in Algiers with the Tuxedo Brass Band and then got ready to leave. Both Fate and the Tuxedos came to the station to see him off, and he boarded the night train to Chicago with one of his mother May Ann's trout loaf sandwiches in his pocket. Oliver missed him at the station, and a kindly cop put him in a cab to Lincoln Gardens at Thirty-First and Cottage Grove avenues. Louis paid his way in and stood listening to the music, so deeply impressed that he was not at all sure that he was good enough to play with this band. Fortunately, he found Papa Joe at the intermission and went on and played anyway.

ONE MONTH AFTER Louis arrived in Chicago in 1922, F. Scott
Fitzgerald published *Tales of the Jazz Age*. Fitzgerald touched some-
thing with the phrase, although the simple syncopations he'd heard
at Princeton bore only a slight resemblance to the music to come. In
the course of the decade, Fitzgerald's prescient title would become
artistic reality.

In Chicago, Louis had come to a black subcity of two hundred
thousand, triple the number of black people in New York City, with
black police, firemen, teachers, and doctors. "The Stroll" on South
State Street from Twenty-Sixth to Thirty-Fifth Street was packed with
more black-oriented (although sometimes white-owned) theaters and
clubs than anyone had ever seen before—the Sunset Cafe, Elite #2
Café, the Panama, Dreamland Café, the Lincoln Gardens, the Owl and
Vendome theaters, and many more.

Blues and jazz there were already so comingled as to be insepa-
rable. As visiting New York pianist Willie "The Lion" Smith would
say of the Chicago jazz players, "The one thing those instrumentalists
could do was to play the blues so that you could dance on a dime."

The music had first come to Chicago from New Orleans in 1915
with the arrival of the Original Creole Orchestra, organized by bass-
ist and Storyville veteran Bill Johnson, with Sidney Bechet's teacher
George Baquet on clarinet, Freddie Keppard on trumpet, and a singer
and dancer named Henry Morgan Prince up front.

Prince had been a student of W. C. Handy's at Alabama A&M
and then toured with Sissieretta Jones's "Black Patti" company and
was practically a walking textbook of black theater history. This was
appropriate, because the Original Creole Orchestra was a blackface
minstrel act, complete with a plantation stage set of cotton fields and
a cabin.

Behind the overalls and makeup were some gifted musicians who
had come together to play New Orleans blues-inflected ragtime; after
1917, they adopted the "jazz" label. Along with Jelly Roll Morton and

Joe Oliver after them, they were an essential part of the dispersion of ragtime/jazz out of New Orleans. Unfortunately, they never recorded, either because, as jazz lore long had it, Keppard didn't want his riffs stolen, or as Baquet would assert, because they wouldn't work for the pittance that Victor offered them.

Joe Oliver would hook up with Bill Johnson at the Royal Gardens Café in 1918, and by 1920 it was King Oliver's Creole Jazz Band at the Dreamland Café (and after 1:00 a.m., at the Pekin Café). After a year on the West Coast, they returned to Chicago's Lincoln Gardens. The band was a New Orleans powerhouse.

Drummer Warren "Baby" Dodds would define the early pulse of New Orleans music in Chicago when Oliver's band came to record in 1923 by playing figures on the woodblock that would be both audible on primitive early recording equipment and somehow perfectly expressive of New Orleans.

With Bechet as his first model, Baby's clarinetist brother Johnny Dodds had studied with Lorenzo Tio, toured with Kid Ory, worked the riverboats under Fate Marable, and joined Oliver in Chicago in 1919. Honoré Dutrey on trombone. Johnson on bass, Joe Oliver on cornet.

The unique element of the band was Lil Hardin on piano, the only woman of the era to achieve fame as a player. A Fisk music major, she'd come to Chicago and sat in with the Creoles and was shocked to find out they didn't play from written music. Later, Louis would admit that she had limits. "As an improviser—*Hmmm*—terrible." But she was beautiful and competent and a solid part of the band, and the band was something else. A musician friend of the Dodds brothers, Garvin Bushell, said of them much later, "I'd say they regarded themselves as artists, in the sense we use the term today. They had a sense of doing something new and special."

Joe Oliver may have been King, but he thought he was working too hard, and once more he sent for his adopted musical son. Louis joined them onstage at Lincoln Gardens, and on first look, Lil, for one, was

not impressed. "Everything he had on was too small for him. His atro-
cious tie was dangling down over his protruding stomach and to top it
off, he had a hairdo that called for bangs, and I do mean bangs. Bangs
that jutted over his forehead like a frayed canopy."

Then they started to play. "The first number went down so well we
had to take an encore," said Louis. "That was the moment Joe Oliver
and I developed a little system whereby we didn't have to write down
the duet breaks." Oliver would silently move the valves on his trumpet,
signaling to Louis what he was going to play. "I was so wrapped up in
him and lived his music that I could take second to his lead in a split
second. That was just how much I lived his music . . . I did not actually
take a solo until the evening was almost over. I never tried to go over
him, because Papa Joe was the man . . . To me Joe Oliver blew enough
Horn for the both of us."

Armstrong's humble love for Papa Joe was genuine, but the truth
was soon clear—the student had surpassed the teacher. In Louis's
hands, jazz was becoming remarkably flexible, both as to harmony
and to time—in Stanley Crouch's words, there was a "sense of infinite
plasticity" in his art now; the African aesthetic, the freedom principle,
was in his fingers. As a vocalist and an instrumentalist he was bringing
a black vernacular voice to the art, with an emphasis on bent, twisted
blue notes, church rhythms, and improvisation.

When asked one night to describe his plan for playing, Louis
replied, "Well, I tell you . . . the first chorus I plays the melody. The
second chorus I plays the melody 'round the melody, and the third cho-
rus I routines." Theme, paraphrase, and the closing buildup; nobody's
improved on his plan yet. Jazz was in its adolescence, and Louis was
the great explorer of possibilities. Over the next three years he would
develop amazingly.

In April 1923, King Oliver's Creole Jazz Band went to the Gennett
studios in Richmond, Indiana, to record. They were constricted by the
acoustic nature of the recording—Louis was so powerful that he had

to play twenty feet away from the recording horn to avoid drowning out everybody else—and by the three-minute time limit of the era, rather than the seven or eight minutes they usually played songs. Still, "Froggy Moore" and "Chimes Blues" were an exceptional debut, with Louis playing quarter-note triplets above the rock-solid four beats of Baby's woodblocks while Johnny Dodds's sinuous clarinet wound among the cornets. Over the course of the year, they'd record thirty-seven tracks.

It was the beginning of serious jazz recording. In New York in July, Sidney Bechet would lay down "Wild Cat Blues" and "Kansas City Man Blues." In Chicago, Jelly Roll Morton would join with the (white) New Orleans Rhythm Kings and record for Gennett. Caught up in disputes over his music publishing with Walter and Lester Melrose, Jelly wouldn't make great records until 1926, when he'd hook up with old New Orleans players like Kid Ory (trombone) and later Baby and Johnny Dodds for his Red Hot Peppers work, songs like "The Chant," "Doctor Jazz," and "Wild Man Blues." These would be great indeed.

Louis was not featured in the advertising for the Creole Jazz Band recordings, nor did he get much solo time; the King was protective of his royal status. Moreover, Oliver was skimming on the band's salaries, collecting $95 and paying only $75 for sidemen, and not showing them the royalty checks he was getting from Gennett. All but Louis and Lil quit. Louis might have stayed forever, but on February 25, 1924, he married Lil Hardin, who had enough ambition for both of them. In June Louis quit Oliver and went to New York to play for Fletcher Henderson.

The genteel son of a schoolteacher, Henderson was a graduate student in chemistry at Columbia who decided he was more likely to succeed in music than in the laboratory. His band was a large orchestra, and the repertoire of light classics and pop songs included a medley of waltzes and "By the Waters of Minnetonka." But he wanted a hot soloist, and Louis fit the bill.

Once again, Louis made a poor first impression. His hooked, thick-soled cop shoes shouted *rube* to the slick urbanites in Henderson's band. At their first rehearsal, he revealed the limits of his music reading. When asked why he'd ignored the *pp* notation that indicated pianissimo (soft), he replied, "Oh, I thought that meant pound plenty." Soon enough, his playing began to open ears.

Band member Coleman Hawkins, who'd started on classical cello and become the first virtuoso jazz saxophone player, would later say that his greatest moment as a musician came in 1925 at the Roseland Ballroom, as Armstrong played "Shanghai Shuffle" at a level beyond comprehension. "There were thousands of dancers, all yelling and clapping . . . they made him play ten choruses . . . Fletcher Henderson kept on beating out the rhythm on his piano and I stood silent, feeling almost bashful, asking myself if I would ever be able to attain a small part of Louis Armstrong's greatness."

Armstrong's genius established the hot solo as the focus of jazz and replaced the ragtime two beat with the flexible 4/4, and consequently challenged Hawkins to liberate his style. In one critic's words, "[Hawkins's] lines grew more legato, his rhythms percolated, and he drew on the harmonic understanding his childhood lessons had instilled. The tenor saxophone had left vaudeville's barnyard mimicry to become a jazz voice."

Armstrong, Hawkins, and the Henderson outfit would record forty sides (songs) in the year-plus that Armstrong would spend in New York, and they would take the town by storm. But Louis did lots more in New York. Over the next year or so he would record with his old New Orleans friend Clarence Williams under various names (Clarence Williams's Blue Five, Red Onion Jazz Babies), bands that included Sidney Bechet (who blew Louis out on "Cake Walking Babies from Home"), and also with Bessie Smith (the "Saint Louis Blues" for all time), Ma Rainey, Bertha "Chippie" Hill, Sippie Wallace, and more. His talent was everywhere as African American music spread out.

Limited to the occasional solo in a horn section, and not permit-
ted to sing—and once more pushed by Lil to stand up for himself—
Armstrong left Henderson in 1925 and returned to Chicago, where he
went into the Dreamland Café on November 9 billed as the "World's
Greatest Cornet Player." Three days later he collected some old pals
from the King Oliver days that he called the Hot Five and went into the
OKeh studios to record under his own name for the first time.

After a year of New York sophistication, he returned to his musical
roots, slathered himself in New Orleans funk, and proceeded to record
some of the archetypal music in the history of jazz, laying down sixty-
five tracks over the next three years.

Mainstream musical taste still called for large dance band/orches-
tras, and Louis was making his money by fronting Erskine Tate's
orchestra at the Vendome and Carroll Dickerson's outfit at the Sunset
Cafe. It was often rather gooey music; one of Louis's featured pieces
was from Mascagni's *Cavalleria Rusticana*. Milt Hinton, who would
join Cab Calloway on bass in the next decade, said of the European
overtures at the Vendome, "It was like we were emulating white folks,
like it was a big white theater . . . We were going to be just like down-
town." Then Louis would get up and play "one of his great solos, you
could see everybody letting their hair down and say[ing], 'Yeah, that's
the way it should be. This is it.'"

It was no wonder that in the studio Louis turned to the more inti-
mate configurations of the Hot Five and later Hot Seven. The Hot Five
included Lil Hardin on piano, Kid Ory on trombone, Johnny Dodds on
clarinet, and Johnny St. Cyr on guitar and banjo. Strictly a studio band,
they never played together in public, instead recording classics that
emphatically defined jazz as a solo-driven art. In February 1926, they
put down "Muskrat Ramble," introduced scat singing with "Heebie
Jeebies"—Louis swore it was an improvised response to dropping
the lyrics—and delivered the classic "Cornet Chop Suey." In 1928 he
replaced Lil Hardin with Earl Hines for a latter-day Hot Five session.

Along with Sidney Bechet and perhaps Warren "Baby" Dodds, Hines was the only musical peer Armstrong would record with in this era, and they struck gold together. It was no coincidence that Hines was from Pittsburgh. The town was a Streckfus line stop where jazz came in on the boats and some of the most famous names in jazz would call it home, including Erroll Garner, Art Blakey, Kenny Clarke, and Mary Lou Williams. Hines's earliest training had been classical, particularly Chopin, and his sophisticated improvisational style reflected a conscious imitation of trumpet players rather than the syncopations of ragtime piano. He was also extraordinarily adventurous with his rhythms, which made him a great fit for Armstrong. They'd learned to play well together while working with Dickerson, and they also liked each other. "Louis was wild and I was wild," said Hines, "and we were inseparable."

Together, they recorded "West End Blues." The last stop on the train to Lake Pontchartrain, the West End was a happy memory for Louis, and though it was a rather ordinary Joe Oliver song that the King had recorded just a few weeks before, Armstrong would make a diamond of it. His introductory break is a stunning display of elegance and energy before the song slides into a relaxed blues groove. A trombone solo and then a clarinet-scat duet and piano break follow, and then Louis picks up his horn and begins to wail. He holds a single note (B-flat) for four bars and it simply shimmers, then floats down like a feather to the close; Hines drops the tag, and Louis and the band answer amen.

It took at least four takes and was carefully mapped out in advance. "Only the coda was left to chance," said Hines. He added, "When it first came out, Louis and I stayed by that recording practically an hour and a half or two hours and we just knocked each other out because we had no idea it was gonna turn out as good as it did."

In 1929, Louis would record Fats Waller's "Ain't Misbehavin'" and cross over into pop stardom, bringing Tin Pan Alley into the jazz

world as he made music—and frequently hits—over the next four decades. Singing made him accessible to people for whom instrumental music was not sufficient, and it made him truly famous. Critics would later see his turn to singing as a betrayal of art to commercialism, which ignored the fact that he wanted to be a complete entertainer. Yet another misnomer interpreted his brilliant smile as Uncle Tomming, although Dizzy Gillespie would comment that it was merely his "absolute refusal to let anything, even anger about racism, steal the joy from his life."

He was indeed from an earlier time, and his willingness to quote his old friend Black Benny on the subject of a white mentor—"always have a *White Man* (who like you) and can + will put his Hand on your shoulder and say—'This is "My" Nigger' and, Can't Nobody Harm Ya"—certainly proves it.

But his personal take on minstrelsy removed the demeaning caricatures and replaced it with what Gary Giddins called a "sexy, stylish, African American joker-artist whose music's undeniable splendor projects an equally undeniable spirit of freedom." As the outstanding Armstrong scholar Thomas Brothers added, "His goal was not to *be* like white people; the goal was to *get paid by* white people."

Armstrong had taken jazz from folk to popular to art music in one fell swoop and placed it at the dead center of American culture, where it would stay for the next two decades. He transformed banal Tin Pan Alley songs into art and made the performer and the process of performing superior to the text from which he/she operates. In other words, he set the music free.

The Blues Women

PERRY BRADFORD HAD been wearing his shoes out up and down Broadway for years trying to get the record companies to record his songs and acts, and one day in 1920 he got lucky. Bradford was a black show business veteran who said he'd joined his first minstrel show at the age of twelve in 1907. In 1918 Bradford was part of a show at Harlem's Lincoln Theater called *Made (Maid?) in Harlem*, which featured a popular vaudeville singer named Mamie Smith.

Later, Danny Barker would say of Bradford, "Every blues ever written, he claimed he wrote it; if anyone recorded, Perry was there: 'I wrote that!'" There *was* one time he was definitely in the room. In February 1920 he went to Fred Hager, the music director of OKeh, which had been established during World War I by Otto K. E. Heinemann, who worked for a German-owned company and thought there should be an American-based fallback operation. The name derived from his initials. Through 1920, OKeh had aimed at immigrant communities. Bradford pitched Hager on the idea of appealing to the Southern black market, and Hager decided to give Perry's client Mamie Smith a chance.

In February 1920 she recorded "That Thing Called Love" and "You Can't Keep a Good Man Down" with Hager's house orchestra, and it sold well enough for a second session. This time, Bradford

convinced Hager to use a black band, dubbed the Jazz Hounds, which would include Willie "The Lion" Smith, one of Harlem's leading pianists. They went into the studio in August. In Bradford's telling, the band was lit on gin and loud enough to destroy test pressings, but when the engineer asked them to quiet it down, Bradford told Hager, "our folks want something loud and hot that'll move 'em," and Hager agreed.

The result that day was "Crazy Blues," which had been, per Bradford, "Harlem Blues" in the *Made in Harlem* revue. It was basically a pop vaudeville song with blues accents. Garvin Bushell, who would play in the Jazz Hounds the next year, said Mamie was a "shouter," but "not a real blues singer like Bessie Smith. She didn't get in between the tones." But Mamie sang it strongly and the Hounds supported her well.

Together, they certainly did the job, because "Crazy Blues" sold seventy-five thousand copies in the first month after release and went on to sell a million. To that point, blues had been recorded by the Victor Military Band and the white Al Bernard and Marion Harris, and their songs were more pop novelty than anything else. "Crazy Blues" was the first blues recorded by a black person, and it alerted the recording industry to an entirely new market. Bradford had blamed their previous refusal to record black singers on boycotts threatened by reactionaries, but with profits like that, the record companies found it easy to be brave, and the hunt for other women blues vocalists was on.

It is easy to see why the companies sought only women. Record company executives are rarely adventurous; they market what they're confident will sell, and that means looking at what has already sold. They looked at the emerging black entertainment network, TOBA (Theatre Owners' Booking Association, nicknamed Tough on Black Asses), which Anselmo Barrasso had founded in 1909 in Memphis, and which now had a string of black theaters across the South. To that point, women dominated singing in black vaudeville, just as men

ruled comedy. Women performers could be sexy or romantic or simply emotive, whereas a sexy black man pushed buttons deep in the American psyche.

With Mamie's example, the decisions for both the record companies and the singers were simple; the companies looked for black women vocalists, and the singers looked for blues songs.

Gertrude Pridgett was born in Columbus, Georgia, in 1886, and by the age of fourteen she'd hit the stage in a show called Bunch of Blackberries. At eighteen she married William "Pa" Rainey and toured with Tolliver's Circus and Musical Extravaganza, billed as "Rainey and Rainey, Assassinators of the Blues." Soon she was Ma Rainey. Her blues tended to be rural, about boll weevils and moonshine, and about the pains and joys of women and the dubious ways of men, and she sang them in every tent in the South. Whatever she sang, she had a profound connection with her audience.

The curtains would part and there on the stage would be a giant Victrola. A young girl would put a record on it as the lights dimmed; a door would open, and Ma would step out into the spotlight wearing a flashy sequined gown and a necklace of gold pieces, with diamonds glittering at her ears, neck, and hands. She wasn't beautiful but, my, she had style.

Then she would proceed to murder the audience. They screamed, they cried, they wailed, and they did exactly what she wanted them to do. As Sterling Brown put in his elegy, "When Ma Rainey Comes to Town," "I talked to a fellow an' the fellow say / 'She jes' catch hold of us, somekindaway . . .'"

She began recording in 1923 for Paramount, and the records sold well. She worked in the studio with Louis Armstrong ("Counting the Blues," "Jelly Bean Blues," and "See See Rider"), Coleman Hawkins, and Fletcher Henderson, but the music stayed down-home; she also recorded with banjo, kazoo, jug, and washboard. There were good reasons why she was called the "Mother of the Blues."

There were, of course, many other blues women. They ranged from country and church-oriented Beulah "Sippie" Wallace to the pop star Ethel Waters, who so convincingly blended stylistic elements from singers like Nora Bayes (a white woman who had written "Shine On, Harvest Moon"), Fanny Brice, and Sophie Tucker with black styles that she was tabbed the "Ebony Nora Bayes."

But in the 1920s and '30s, one woman ruled the blues. Her name was Bessie Smith, and she was quite deservedly acclaimed the "Empress of the Blues." Simply put, she had one of the great voices in the history of American music, and while she sometimes sang pop material, she focused, brilliantly, on the blues. She also happened to be the first blues singer to attract the interest of white Americans, beginning a process that continues to this day.

She was born in 1894 to a family of eight in a one-room shack in Chattanooga, Tennessee. She sang in the street for coins as a child and, at the age of eighteen, followed her elder brother into show business as a dancer for the Moses Stokes minstrel company, which featured Ma Rainey. By the early 1920s, Bessie had established a significant reputation not only on the Southern TOBA circuit, but in the North as well. She did a show with Sidney Bechet called *How Come?*, and thanks to him or perhaps someone else—stories varied—she connected with all-around music business *macher* Clarence Williams, who eventually brought her to Frank Walker at Columbia.

Her first release, a cover of Alberta Hunter's "Downhearted Blues," was a massive hit, and she stood at the top for the next decade. Her only rival was Ma Rainey, but Bessie had one considerable advantage there, because the recording quality at Columbia was greatly superior to what Ma received from Paramount, especially after electrical recording began in 1925.

Bessie's relationship with Clarence Williams exactly illustrates her personality, which was strong indeed. Her initial contract was not with Columbia but with Clarence, and he took half. On learning this, she

proceeded to slap him silly until he released her from the contract. She then went to Walker and got a new contract, which called for $125 a side, $1,500 a year guaranteed. Walker even gave her money that he would have given to Clarence, but also eliminated the royalty clause, which in the end cost her a fortune. At the same time, she asked him to be her manager.

She took her act on the road, mostly in the South, giving them "love, sex, and misery," as her biographer put it, with a little "slap-stick hokum and hilarity." Langston Hughes would write that her music was the essence of "sadness . . . not softened with tears, but hardened with laughter, the absurd, incongruous laughter of a sadness without even a god to appeal to." There was a little god too; as guitarist Danny Barker pointed out, her show had a "church deal mixed up in it." She improvised a fair amount with both rhythm and melody, and she moved audiences as though she were an evangelist. Barker added, "She could bring about mass hypnotism."

She was so popular that the second night of that first tour was broadcast in its entirety on WSB in Nashville, which meant a largely white audience, since black ownership of radios was still pretty rare. In fact, theaters frequently asked her to schedule extra white-only nights.

She was tough enough to defy the Klan when it messed with her show one night, but she had a soft touch for those in need. Mostly, she was without pretensions. As Alberta Hunter observed, "The thing about Bessie was that she was always herself. Some of us were always trying to be little stars, but not Bessie."

The next year the *Chicago Defender* dubbed her the "Empress of the Blues," and by 1925 she was the best-paid black entertainer in America. On Thanksgiving that year, she gave a show at the Orpheum in Newark, and one member of that audience in particular, critic Carl Van Vechten, was besotted. Van Vechten's admiration for Bessie was going to establish her reputation with white café society and help introduce Bessie and the blues to white audiences in America.

Born in Iowa and educated at the University of Chicago, he'd moved to New York in 1906 to become the assistant music critic of *The New York Times*, mostly covering opera. He became America's first dance critic, covering Anna Pavlova and Isadora Duncan. He fell in with Mabel Dodge, who introduced him to Gertrude Stein, and was in Paris for one of the first performances of Stravinsky's *Sacre du Printemps*, with Monteux conducting and Nijinsky dancing. He had a taste for newness and enthusiasm, and was once quoted as saying that "only amusing things [are] really essential." Dodge said that his life was a "fastidious circus."

What made him unusual was that he had an openness to and delight in African American culture that was absolutely unique in his time. His home would become what NAACP president Walter White called the "mid-town branch" of the organization, and his friendship with White led him to close relationships with the leading black poets of the day—Langston Hughes, Countee Cullen, and James Weldon Johnson. That year he wrote that jazz was the "only music of value produced in America . . . not the last hope of American music nor yet the best hope, at present . . . its only hope."

He wrote in *Vanity Fair*, "The Blues are not yet as famous as the Spirituals, but all the world is now learning about their beauty," and that Johnson's *The Books of American Negro Spirituals* was the "most important contribution America has yet made to the literature of music . . . [containing] every element of modern jazz, save the instrumentation." He did well by his friends, not only in print but also in person. His parties mixed members of the Algonquin Hotel group with Hollywood royalty like Mary Pickford, Douglas Fairbanks, and Noël Coward, along with his black friends Paul Robeson, James Weldon Johnson, and Langston Hughes.

Later Sterling Brown would see him as a "voyeur" and "decadent aesthete" who sought satisfaction with "an abominably primitivized image of blackness," and there certainly were aspects of that in his

sensibilities. While *Time* might sniff that "Van Vechten has been play-
ing with Negroes lately; writing prefaces for their poems, having them
around the house, going to Harlem," he was also helping Hughes and
Johnson get published while acting as a talent scout for Alfred Knopf.

Of Bessie Smith, he wrote in *Vanity Fair*, "Her face was beautiful
with the rich ripe beauty of southern darkness, a deep bronze, match-
ing the bronze of her bare arms. Walking slowly to the footlights, to
the accompaniment of the wailing, muted brasses, the monotonous
African pounding of the drum . . . she began her strange, rhythmic
rites in a voice full of shouting and moaning and praying and suffer-
ing, a wild, rough, Ethiopian voice, harsh and volcanic, but seductive
and sensuous too . . . powerfully magnetic personality of this elemental
conjure woman with her plangent African voice, quivering with pas-
sion and pain, sounding as if it had been developed at the sources of
the Nile: 'Yo' brag to women I was yo' fool, so den I got dose sobbin'
hahted Blues.'"

Though he was unquestionably a worshipper in the cult of the
primitive, Van Vechten also developed a personal relationship with
Bessie. A gay man named Porter Grainger was her new musical direc-
tor, and Porter was hot to be accepted by Van Vechten, who had an
apartment in Harlem for himself and suitably attractive young men. As
a favor to Grainger, Bessie attended a party at Van Vechten's home;
Gershwin was there, possibly Adele Astaire. Smith asked for a drink
and received a pint of gin in a glass. Tossing it off, she sat down next
to Grainger on the piano bench and sang "Work House Blues." Van
Vechten was stunned. "This was no actress; no imitator of a woman's
woes; there was no pretence. It was the real thing—a woman cutting
her heart open with a knife until it was exposed for us all to see, so that
we suffered as she suffered, exposed with a rhythmic ferocity, indeed,
which could hardly be borne."

Bessie not only sang the blues; she lived them. Her fraught relation-
ship with husband Jack Gee was an ongoing source of pain that led her

to affairs with men and women, bouts of drinking, and seriously physical fights. There was always anxiety and turmoil in her life, as she sang in "Blue Spirit Blues," where she dreamed of being dead, with evil spirits surrounding her bed ready to drag her down into brimstone, their teeth bared, their eyelids dripping blood. By 1929 Jack was producing a second show in addition to Bessie's, this one featuring his mistress Gertrude Saunders, and with Bessie's money. After all the theatrics, their marriage was over.

She responded to their parting by recording "Nobody Knows You When You're Down and Out," one of the great heartbreak songs of all time. It was released on September 13, 1929, and just six weeks later the stock market crashed, triggering the Great Depression. The arrival of sound movies in 1927 with *The Jazz Singer* had already severely challenged vaudeville, and the Depression would kill TOBA and paralyze the record industry. Her recording career seemed at an end, although Bessie could still tour.

In early 1935 she was working at the Apollo Theater, a former burlesque house on 125th Street in Harlem. She'd come to realize that she needed to update her approach, and she'd done so with a vengeance, singing current material with a swing beat. A bout of food poisoning led to an offer for her to substitute for Billie Holiday at Connie's Inn (by now at Forty-Eighth and Broadway) in February 1936, and she took the audience by storm. She was back.

In September she accepted an offer to tour the South as the featured artist with E. S. Winsted's *Broadway Rastus* show, and after doing good business in Memphis, she left for the next gig, in a small town near Clarksdale, Mississippi. Highway 61 was dark, and her car ran into a truck parked on the side of the road. Bessie's arm was nearly torn off, and a tragedy of errors including a second accident slowed her arrival at the hospital in Clarksdale. She died eight or ten hours later, at eleven thirty in the morning on September 26, 1937. She was only forty-three.

She was a complex, magnificent woman who lived a life of fabulous achievement and great pain, and it was the logical final twist that the story of her death would be mistold by a man who would make great contributions to both American music and black civil rights. A month after the accident, John Hammond wrote in *DownBeat* that Bessie had been refused treatment at a white-only hospital in Memphis, citing as his source members of Chick Webb's band who had been in the area shortly after. The black press ran with the story. After protests from Memphis, *DownBeat* fact-checked the piece and wrote, accurately, that she'd been taken to the African American hospital in Clarksdale and died of loss of blood; however racist Mississippi was, it did not cause her death. No one ever seemed to notice that correction.

You could write a song about that kind of tragedy, but it would have to be a blues.

12

White People and Jazz and Its Flowering in New York

IN THE SUMMER of 1923, two young men named Hoagland Howard "Hoagy" Carmichael and Leon Bix Beiderbecke took two quarts of gin (Prohibition prevented buying at the table) and a package of marijuana ("muggles") to a black Chicago music hall to hear King Oliver. When the second trumpeter, one Louis Armstrong, went into "Bugle Call Rag," Carmichael dropped his cigarette and gulped his drink. Bix stood, pop-eyed, his gaze riveted on the player. "Why," moaned Carmichael, "why isn't everybody in the world here to hear that?" He meant it, he said later. "Something as unutterably stirring as that deserved to be heard by the world."

Hoagy and Bix would not be alone. A cluster of young white Chicagoans would gather at the feet of King Oliver, Louis Armstrong, and Bessie Smith and reach out to black music as a new sacrament, many of them becoming serious performers who would significantly influence American music over the next two decades. Behind them, an entire generation of young white Americans would listen to jazz, just as a large portion of the preceding generation had appreciated ragtime. The evolution of modern values that had begun with urbanization, the

rise of science, and the wholesale acceptance of Darwin and Freud had been set in stone by the insane massacres of World War I. Add prosperity and the opportunity for leisure, and a new world had opened up, with jazz at its center.

Not everyone was happy about this. Just as with ragtime, the guardians of culture who were the stewards of musical and social orthodoxy were outraged by jazz. These essentially Victorian guardians didn't like the modern, and jazz was by far their easiest target. Rhythm was the least important aspect of high culture–approved music, and jazz, where rhythm had been set free, was a threat.

Culture equaled refinement and tradition; jazz was rough and new. A proper classical art implied restraint, discipline, and hard work. Jazz seemed excessive and formless. Proper music emphasized an orderly harmony, while jazz was improvisatory. Worse still, jazz stimulated carnal thoughts and activities. Just as sexual mores were changing for many different reasons, jazz was there to help. That of course appealed greatly to youth, black people, and intellectuals, each of whom saw itself as a separate group seeking independence and finding it in the free expression of improvisation. Because it celebrated the life force, jazz was a protest music of sorts—and as such, dangerous.

When one factored in the association of jazz with black people and brothels, the response flowered into borderline hysteria. "Jazz originally was the accompaniment of the voodoo dancer, stimulating the half-crazed barbarian to the vilest deeds," wrote Ann Faulkner, the National Music Chairman for the Federation of Women's Clubs, in *The Ladies' Home Journal* in 1921. "The weird chant, accompanied by the syncopated rhythm of the voodoo invokers, has also been employed by other barbaric people to stimulate brutality and sensuality." Since good music supported the moral order, and sex outside marriage was bad, and since contemporary social theory held that black people were exceptionally sexually promiscuous, black music . . . was bad.

For actual followers and players of jazz, the music was more like a religion. Louis Armstrong was its prophet, and a small group of true believers made up a sect that followed him. They had intuitive, Gnostic certainty about the value of the music, and like most sects, they tended to withdraw from the mainstream into a world with their own rituals and language. Over the next twenty years the followers of jazz would diversify into a subculture with varying roles, from the priest-like authority figures of critics to fans in varying dimensions, from those who merely listened and danced to those who collected and studied and developed institutions.

By 1935, that included the United Hot Clubs of America, established by Milt Gabler, a Jewish boy from Harlem whose father was in the radio business, and Ivy League students John Hammond and Marshall Stearns. Gabler's small, shabby Commodore Music Shop on West Forty-Second Street, founded in 1936, was the place banjoist Eddie Condon labeled "a shrine. The crummiest shrine in the world." The Commodore sold old records with information that hadn't been included on the original, material like the personnel lists that collectors craved.

Freedom had bobbed up again. Hoagy Carmichael summed it up: "It said what we wanted to say though what that was we might not know." Jazz touched the sacred, not only because it played with the rhythms of the black church, but also because at the heart of improvisation is mystery, and occasionally magic. The great French jazz violinist Stéphane Grappelli put it, "Great improvisers are like priests: they are thinking only of their god."

Jazz was many things. It was urban and symbolized the speeded-up twentieth century, which was a supreme irony, given the racial stereotypes of black people. It was primal, and therefore of the past, yet it was also American, which made it fresh and new. And it was also a commodity introduced into an American culture that could absorb and adapt any commodity if there was a chance for profit.

At the same time that the true believers went to hear King Oliver and Louis Armstrong, trained professionals eyed the success of "Crazy Blues" and the earliest jazz and considered the possibilities of a compromise, one that would take the syncopation from jazz and blend it with the orchestral dance music that was their bread and butter. Improvisation and blues were unacceptable, but a modern version of dancing that brought in customers was quite all right. Society dance-band leader Meyer Davis distinguished between "modern syncopation" and "savage syncopation. The savages syncopate without melody, while melody is preeminent in modern dance music."

The man who would best produce this hybrid was named Paul Whiteman. In truth, he was a professional looking for a paycheck who took a highly successful formula created by someone else, used arrangements executed by someone else, and produced a music based on the notion that jazz wasn't really music per se but a style, a technique. He wrote in his book *Jazz*, "Not that I mean to imply that there was any real musical value in our jazzing the classics. Of course not. It was partly a trick and partly experimental work. We were just fooling around with the nearest material, working out our methods." He wanted to tame jazz, he said, "remove the stigma of barbaric strains and jungle cacophony" from it, and produce something respectable. He succeeded beyond his wildest dreams.

The son of the supervisor for music of the Denver public schools, Whiteman played first viola in the Denver Symphony and landed in San Francisco after World War I. He spent time on the Barbary Coast listening to ragtime/early jazz, tried to play jazz fiddle, and was fired because he couldn't improvise. After seeing Art Hickman's band at the Fairmont Hotel, he took the Hickman formula (three brass and three reeds in sections, playing pop songs with rhythm) and created what he would call *jazz classique*. Hiring Ferde Grofé as his arranger, he introduced symphonic jazz in Los Angeles and moved on to the Palais Royal Hotel in New York, where he recorded "Whispering"

and "Japanese Sandman," which became enormous hits. By 1922, he controlled dozens of bands under his name and was grossing a million dollars annually.

His group was a jazz band in that it included banjo and saxophones, but in reality it was an orchestra that played bits from "Samson and Delilah," the "Meditation from Thais," and "Dance of the Hours" from *La Gioconda* as well as bouncy fox trots for the hotel dancers. In 1922 that was enough to make it "jazz." The classical musician and jazz historian Gunther Schuller would defend Whiteman's music, especially the orchestrations, which were "often more than merely slick. Excellent intonation, perfect balances, and clean attacks do not necessarily equate with superficiality."

Whiteman's most recent defender, Elijah Wald, has listed as his achievements that he "defined the arranging style" of big band music (although he'd largely taken it from Hickman), that his was the first band with a vocal group and the first with a female vocalist, and that Whiteman would sponsor an important concert that would see jazz recognized as significant art music. Wald also concedes that Whiteman's work was a "rear guard holding action" to maintain European harmonic standards against the twentieth-century onslaught of African American rhythm, the first of a series of challenges to European cultural hegemony.

Whiteman was nothing if not ambitious, and he wanted to make a grand statement about symphonic jazz, documenting the progression he saw from "primitive" jazz to the superior work of his orchestra before closing the show with a major composition. It was to be written by a young composer named George Gershwin, whom he'd met when they worked on a Broadway revue in 1922. Though classically trained, Gershwin had gone to work in Tin Pan Alley and had his first hit with a novelty rag called "Rialto Ripples"; he'd also been hanging out in Harlem listening to the great stride pianists James P. Johnson and Willie "The Lion" Smith. Whiteman commissioned a symphonic

piece from Gershwin, and when he learned that his rival Vincent Lopez was also planning a concert, they worked like hell to beat him. George Gershwin wrote "Rhapsody in Blue" in three weeks, with Ferde Grofé arranging it page by page as Gershwin created it, just in time for the February 12, 1924, concert.

The show poster read, PAUL WHITEMAN WITH HIS PALAIS ROYAL ORCHESTRA. AN EXPERIMENT IN MODERN MUSIC ASSISTED BY ZEZ CONFREY AND GEORGE GERSHWIN. AEOLIAN HALL, 34 WEST 42ND ST., TICKETS $.55 TO $2.20. Aeolian Hall was a major home of classical music in New York at the time, and Whiteman's invited audience included the lions of American symphonic music—Walter Damrosch, Victor Herbert, Jascha Heifetz, Fritz Kreisler, Sergei Rachmaninoff, and Leopold Stokowski—as well as the ubiquitous Carl Van Vechten.

Whiteman augmented his orchestra with extra violins and French horns, and the lineup included flügelhorn, euphonium, celesta, and octavina. They opened with a five-member group from the orchestra performing a deliberately burlesqued "Livery Stable Blues," and Whiteman grew deathly nervous when he realized the audience actually liked what he thought of as the "crude jazz of the past." (Ironically, Olin Downes in *The New York Times* thought it was "a gorgeous piece of impudence, much better in its unbuttoned jocosity and Rabelaisian laughter than other and more polite compositions that came later.") Pop tunes like "Yes, We Have No Bananas" and "Alexander's Ragtime Band" followed, along with light classical pieces by Elgar and Friml arranged for dancing, and a special dance suite Victor Herbert composed for the occasion. Finally, Gershwin came on to premiere the "Rhapsody in Blue" and the audience was enraptured, establishing Whiteman as the "King of Jazz."

What of the "Rhapsody"? It was not jazz, but a great piece of jazzed-up symphonic music. It was not a full synthesis of jazz and classical, if that's even possible, and significantly it has no successors; even Gershwin's later jazzed-up long pieces like "An American in Paris" or

"Concerto in F" aren't as good as the "Rhapsody." The fusion apparently did not have much of a future, not least because improvisation and symphony orchestras don't mix. Still, the night at the Aeolian was a benchmark in the development of American music by acknowledging that jazz could be art music.

Whiteman wanted things both ways. He wanted respect from the high culture his father represented, which is why the classical world had been invited. He also wanted commercial success, and he knew that he needed to use African American elements to get it. This does not make him any more racist than other white musicians of the era who were playing jazz; as the critic Gerald Early points out, Whiteman wanted to present jazz as American music, and that meant it had to be thought of as white—otherwise, he'd have had to play it in blackface. Implicitly, he needed to demonstrate the superiority and triumph of white civilization. In the end, the music played at Aeolian Hall, supposedly a review of the history of jazz, made no reference to black people.

Two years later Whiteman would produce a book called *Jazz* that did not mention the black origins of the music and argued that it was essentially "syncopated classical music." Whiteman was honest enough to admit that "I know as much about real jazz as F. Scott Fitzgerald did about the Jazz Age," and he was also smart enough to buy arrangements from the black composer William Grant Still and from Don Redman, then playing and arranging for Fletcher Henderson. Actually, he'd wanted to hire various black stars—Duke Ellington, Eubie Blake, Fletcher Henderson—as performers, but was vetoed by his managers. Instead, by the end of the decade he was hiring the best young rising white stars, like Red Nichols, the Dorsey Brothers, and Bix Beiderbecke, energizing his orchestra with a constant flow of new talent.

Since only a few young cognoscenti in the white world were listening to black musicians, jazz became a white music to the general public, just one of the frauds that America was circulating at this point.

It is at least interesting to note that just at this time the advertising industry in America shifted its overall technique to presentations based on manipulating envy. No longer did one buy and sell based on thrift, need, or functionality. Now (and ever since) things were sold based on needing products to define one's personal worth, one's sexual attractiveness, and one's social status. What David Riesman would call the "other-directed personality" had begun to replace the Protestant ethic of hard work.

At any rate, symphonic jazz gave the music respectability and offered it an occasional home in the concert hall as well as the saloon. Fritz Kreisler added a jazz number to his repertoire; classical musical journals like *Etude* began to soften their attitude. But in the long run it was a group of white kids who genuinely liked jazz as their first great musical inspiration, who recognized it as a black form and found this an attraction rather than a hindrance, who would truly introduce jazz into the white American mainstream. In the words of LeRoi Jones, "The Negro had created a music that offered such a profound reflection of America that it could attract white Americans to want to play it or listen to it for exactly that reason. The white jazz musician was even a new *class* of white American."

It began in a soda fountain in a prosperous suburb of Chicago called Austin, Illinois. Jimmy and Dick McPartland, Frank Teschemacher, Bud Freeman, and Jim Lanigan would go to the Spoon and Straw after school to listen to records. They started with Paul Whiteman and Art Hickman, and then one day they heard "Farewell Blues" by the (white) New Orleans Rhythm Kings (NORK), and it changed their lives.

Though formed in Chicago, the Rhythm Kings were raised in New Orleans. Clarinetist and leader Leon Roppolo was a graduate of "Papa" Jack Laine's Reliance Brass Band, but unlike the Original Dixieland Jazz Band, he acknowledged his debt to the black creators; his father had owned a black-patronized saloon, and Leon had grown up listening to some of the earliest jazz players.

After the Original Dixieland Jazz Band had departed for New York, a call went out for more New Orleans–style players, and the Rhythm Kings settled in at Chicago's Friar's Inn, playing for their well-known customers, the gangsters Al Capone and Dion O'Banion. Off-nights, they haunted the Lincoln Gardens listening to Joe Oliver, taking notes on the cuffs of their shirts, and one of the results was Roppolo's "Farewell Blues," which they recorded in 1922. Said the Kings' trumpet player, Paul Mares, "We did our best to copy the colored music we'd heard at home. We did the best we could, but naturally we couldn't play real colored style." The Kings didn't last very long, breaking up in 1924, but their record had a powerful influence on the Austin High Gang.

A number of the Austinites had begun by playing violin, but after hearing "Farewell Blues," they were inspired to pick up new instruments and, bar by bar, learn the song from the record. Actually, they learned the song before they learned their instruments. Jimmy McPartland on clarinet, brother Dick on banjo and guitar, Bud Freeman on C melody and later tenor saxophone, Jim Lanigan on piano, Frank Teschemacher on clarinet; in a month they knew the song, and a few months later they knew nine or ten from the classic New Orleans repertoire—"Tiger Rag," "Bugle Call Rag," "Tin Roof Blues," "Panama." One day at a social at the Austin High School gym they met Dave Tough, a young drummer from the next town over, Oak Park. His hero was Warren "Baby" Dodds, so he fit right in. In homage to the New Orleans Rhythm Kings' home venue, they became the Blue Friars.

McPartland would later express his gratitude for music, because, as he put it, he could have fallen in with a "different kind of mob." He'd been raised in the tough West Side of Chicago and lived in an orphanage for some years, and the placid quiet of suburban Austin did not suit him: "Jazz supplied the excitement we might otherwise have looked for among the illegal activities which flourished then in

the neighborhood." In truth, most of the Austin High Gang's members were second-generation Americans fleeing their parents' old-world roots via jazz. None of them would graduate high school, and when Northwestern college boys mocked their music, they often replied with their fists.

They buttressed their disaffection with reading. Dave Tough was in love with modernist fiction, especially his fellow Oak Park resident, Ernest Hemingway, as well as H. L. Mencken and George Jean Nathan's *American Mercury*, especially the section called "Americana," where, said one friend, "all the bluenoses, bigots, and two-faced killjoys in this land-of-the-free got a going over they never forgot." In the course of the decade Tough would spend time with Chicago bohemians like Max Bodenheim and Kenneth Rexroth, who would much later describe him in his autobiographical novel *Green Mask* as the "first and greatest of the hipsters and one of the few really great musicians in the history of jazz."

As they began to grow musically, they learned of the sources behind the Rhythm Kings and took themselves off to the South Side of Chicago, where, Bud Freeman said, the enormous doorman at the Lincoln Gardens would greet them: "I see you [white boys] are all out here to get your music lessons tonight." Lil Hardin Armstrong would notice that it was "Mostly white fellows [who] would line up in front of the stand," lads like the Austinites, Dave Tough, Hoagy Carmichael, and other young white Chicagoans like Eddie Condon, Muggsy Spanier, Gene Krupa, Jess Stacy, and a clarinet player named Benny Goodman.

In 1924, Condon ran into Bud Freeman and Jimmy McPartland, who took him to a fraternity dance to hear King Oliver. Condon heard "Canal Street Blues" and fell in love. "It was hypnosis at first hearing," he wrote later. "The tone from the trumpets was like warm rain on a cold day . . . the music poured into us like daylight running down a dark hole." Condon began to go to Lincoln Gardens to listen, sitting

there "stiff with education, joy, and a licorice-tasting gin." In the sum-
mer, the Pekin Café's windows would be open, and Spanier would sit
on the curb outside and listen. Sometimes the music would be inter-
rupted by gunshots, but he'd be back the next night. On very special
nights, Louis and the King would let him sit in.

Clarinet players Benny Goodman and Joe Marsala studied Jimmie
Noone, absorbing a sequence of development that had started in New
Orleans with Lorenzo Tio and Bechet. By 1912 Noone was playing
with Freddie Keppard, and later with Kid Ory and the Eagle Band. He
joined the Original Creole Orchestra in Chicago in 1917 and played
with King Oliver's Creole Jazz Band before rejoining Keppard.

Bessie Smith had an equally powerful impact on them. As Condon
sighed, "She had timing, resonance, volume, pitch, control, timbre,
power—throw in the book and burn it; Bessie had everything."

It was a love affair, but for the most part it was a love for black
music, not blackness. With exceptions, the young players of Chicago
were not juvenile Carl Van Vechtens chasing the exotic, seeing them as
less repressed and therefore more childlike than white people. What they
revered was creativity, and they were good enough musicians to know
quality when they heard it. In historian Burton Peretti's words, "no other
identifiable group of white Americans of this era approached black cul-
ture with such openness and repaid it with comparable gratitude, praise,
and emulation." They weren't civil rights advocates, and in coming years
they would get jobs that black players couldn't, but the young white
Chicagoans were surely a first step toward a healthier new attitude.

One member of their group definitely went further in his relation-
ship with black music. Milton "Mezz" Mezzrow was a Chicagoan
who'd gone for a joy ride in a stolen car and ended up in reform school,
the Pontiac Reformatory, where he began to learn music. When his
teacher played them "Livery Stable Blues," and he then listened to the
black inmates sing, it "all hit me like a millennium would hit a philoso-
pher." Once out, he began to haunt the South Side music joints.

Soon he met the Austin High Gang, and although Mezz was not a great player and never would be, he played well enough for Bud Freeman to say, "He plays just like the colored boys!" Mezz couldn't imagine a finer compliment, because he'd fallen in love with blackness. His accent went from Chicago to black, and "Every word that rolled off my lips was soft and fuzzy." In later years, he would become convinced that his complexion had darkened. In his fascinating 1946 memoir *Really the Blues*, he could even write of the black man, "His whole manner and bearing was simple and natural. He could outdance and out-sing anybody, in sports he could out-fight and out-run most all the competition, and when it comes to basketball, don't say a word, just listen." Oy!

Jimmy McPartland was tolerant: "We didn't take Mezz too seriously that way. We just let him talk. He was good company, knew everybody. Played a little. So it was okay."

About music he was rabid and dogmatic; the black New Orleans way was the only way. For him, the Chicagoans had erred in dropping the tailgate trombone in favor of the tenor saxophone, throwing the harmonies too high. "They got too fancy, sometimes, too ornate and over-elaborate, full of uncalled-for frills and ruffles . . . They got a lot of flash, musical fireworks; but the *rightness* wasn't always there." In general, the Chicago version of New Orleans was a little more tense and nervous than the original, louder and faster. It was, after all, Chicago and not New Orleans.

To Mezz, what had spread the gospel of jazz was "the rebel in us. Our rebel instincts broke music away from what I'd call the handcuff-and-straitjacket discipline of the classical school, so creative artists could get up on the stand and speak out in their own honest and self-inspired language again . . . A creative musician is an anarchist with a horn, and you can't put any shackles on him."

Perhaps the most creative and unshackled of them all, although he would stray sufficiently far from the New Orleans gospel to make

Mezz ambivalent about him, was Bix Beiderbecke. Brilliant, tormented, self-destructive, ever obsessed with a quest for the perfect sound, he wrenched an angelic tone from his horn and was the perfect doomed romantic artist-hero, especially when he managed to drink himself to death at the age of twenty-eight. Eddie Condon described playing with Bix for the first time and hearing a sound that "came out like a girl saying yes." Mezz said, "I had never heard a tone like he got before or since . . . every note packing a solid punch, with his head always in full control over his heart."

If his head was in control when he played, it was only then. Jimmy McPartland would say of him, "His main interest in life was music, period. It seemed as if he just existed outside of that." Born in 1903 to an upper-middle-class family in Davenport, Iowa, he refused all lessons but learned piano by ear. When his brother returned from the army in late 1918 with separation cash and bought a phonograph and the Original Dixieland Jazz Band's "Tiger Rag," Bix was hooked. A month or two later he borrowed a cornet and taught himself to play.

His interest in jazz appalled his family; in later years, he would discover that all the records he'd been part of and sent home had never been opened. That sort of insensitivity fueled his rebellion, and by the age of eighteen he was working in the Plantation Jazz Orchestra on the Streckfus boat *Majestic*. He didn't last very long on the *Majestic*, though, because his sight-reading was very poor. His ear was so good that he didn't need sheet music, and his rebellious attitude preempted any willingness to learn how.

Shipped off in the fall of 1921 to Lake Forest Academy, a disciplinary boarding school in Chicago, he spent more time boozing and playing with the Rhythm Kings at the Friar's Inn than he did with books and was expelled in the spring. He worked days on a Lake Michigan excursion boat while spending nights at Lincoln Gardens listening to King Oliver, and in 1923 joined the Wolverine Band. In the fall of 1924, the Wolverines took up residence at the Cinderella Ballroom in

Manhattan, at Forty-Eighth Street and Broadway. One block north was a joint commonly called the Kentucky Club, home to a young man named Duke Ellington and his band, the Washingtonians. Another three blocks north, Louis Armstrong had joined Fletcher Henderson at Roseland. Early jazz had come to a boil.

The vocalist Hoagy Carmichael would reflect that this period was "the great time of experimentation in jazz, with only enough precedents to stimulate individual and original exploration but not enough nailed down examples to set any definite patterns as rigid rules." Beiderbecke played a lot of exotic piano, ninth- and eleventh-chord voicings, and listened to impressionist composers like Debussy, Ravel, and Stravinsky. His tone was beautiful and built on a classical sense of form and construction, very different from the blues-based New Orleans sound.

After a stint with Jean Goldkette's group, one of the better dance orchestras, Bix would join up with Frank "Tram" Trumbauer in St. Louis in 1925. Despite the segregated nature of St. Louis at the time, Bix mostly spent his time hanging out with black players at the Chauffeurs' Club. The local trumpet player Louis Metcalf remarked that Bix, like Benny Goodman, the Dorseys, and Jack Teagarden, "didn't care nothin' about color, or that jazz had a bad stamp to it. Why, Bix would come uptown and blow with us, eat with us, sleep with us. He was one of us." As Pops Foster put it, "The colored and the white musicians were just one."

In 1927 Bix and Trumbauer recorded with a small group, tunes that included the Original Dixieland Jazz Band's "Clarinet Marmalade" and "Singin' the Blues," which fully established Bix as a soloist, essentially creating the idea of a jazz ballad. With Trumbauer's help he also recorded a piano solo, "In a Mist," that beautifully joined ragtime rhythms and impressionist harmonies with an Apollonian sense of perfect form. It was lovely art music and a radically divergent stream within jazz, revealing a wide range of potential directions.

One direction was the giant orchestra, and that fall Bix and Tram joined Paul Whiteman, where Bix's crystalline solos would dominate recordings for the next several years. It also brought him into contact with a rich variety of music. Maurice Ravel was in town conducting the New York Philharmonic and came to a Whiteman rehearsal. Bix caught the Symphony and even joined Ravel for a long conversation in a handy speakeasy afterward.

In Chicago, it was Louis Armstrong, who stayed up all night and caught an early Paul Whiteman show, enjoying even Whiteman's version of the *1812 Overture*, impressed that Bix's pure tone made him audible even among the cannons and bells. Conversely, Bix would come to the Sunset Café after the last Whiteman show to jam. Louis mused that they weren't cutting sessions, but "We tried to see how good we could make music sound which was an inspiration within itself."

Whatever demons Bix's rebellion from Davenport had stirred, they never went away. By 1929, his health began to crumble, and he had to leave Whiteman. He convalesced in Davenport, returned to New York, tried and failed to rejoin Whiteman, and died, probably of a seizure from trying to stop drinking cold turkey. He left behind music and a legend. As he told Jimmy McPartland, he'd found freedom in jazz, which is why he could never repeat himself. "It's impossible," he said. "I don't feel the same way twice. That's one of the things I like about jazz, kid, I don't know what's going to happen next. Do you?"

It wasn't only Bix who wrestled with freedom. The great black migration had transformed Harlem from a small middle-class neighborhood with housing designed for sixty thousand into a city-within-a-city of three hundred thousand, mixing poor immigrants with the more prosperous residents of Sugar Hill and Strivers' Row. Then came the rise of the glamorous and exotic nightlife of Harlem, the (segregated) Cotton Club, Connie's Inn, and Small's Paradise, where white celebrities like Dorothy Parker and Eugene O'Neill came to play, as well as more outré attractions like Hazel Valentine's sex circus on 140th

Street, which was definitely not open to the public although available to those with discriminating tastes. If people wanted exotic Harlem, they could buy it.

Intellectually, black minds stretched ever further away from the nineteenth century's horrors. Having fought and contributed significantly to the American war effort, a minority became interested in Marcus Garvey's Pan-Africanism, but almost all were ready to grow. Among other responses, Howard University professor of philosophy Alain Locke published *The New Negro* in 1925, and what came to be called the Harlem Renaissance bloomed. Unfortunately, the intellectual basis of the movement was severely constricted, bound up in the inherently elitist concept of uplift.

Locke was a Harvard graduate and Oxford Rhodes Scholar who wanted high culture to "lift the race," and thought jazz would be great—once it had been absorbed into symphonies, like the work of William Grant Still. As Sterling Brown summed him up, "For Locke, if Stravinsky liked it, it had to be good. And that's bad."

W. E. B. Du Bois, perhaps the preeminent mind of the day, black or white, had the same conflicts. He and Locke, for instance, celebrated the career of Roland Hayes, who was able to sell out Carnegie Hall with a program of European art songs and spirituals so Europeanized that the spirit appeared lost to many. Du Bois respected the spirituals, but jazz brought out his genteel Victorianism. Just as (mostly young) white people were celebrating the twentieth-century jazz attack on Victorian repression, Locke and Du Bois defended, as one scholar put it, "sublimation, Western rationalism, and the Protestant work ethic." Du Bois was revolted by what he saw as Carl Van Vechten's primitivist sexual fantasies, and saw him as a vampire preying on black people.

Van Vechten was the great white patron of the Harlem Renaissance, and he would deserve great credit for his championing of various black artists. His friend James Weldon Johnson would say so, writing to him that "you have been one of the most vital factors in bringing about the

artistic emergence of the Negro in America." Johnson would also won-
der at the callous thoughtlessness that would go into Van Vechten's
choice of title for his most famous book, *Nigger Heaven.*

Among the best-known black intellectuals, folklorist and Barnard
graduate student Zora Neale Hurston and poet Langston Hughes would
reject the Locke/Du Bois assumptions about high culture. Hughes saw
the blues as having their own power as "urban folk music, and a pro-
letarian art form rich in political implications." Hurston objected to
Du Bois's characterization of the spirituals as "sorrow songs," seeing
a much wider world within them, and criticized concert spirituals as
"squeezing all of the rich black juice out of our songs and presenting a
sort of musical octoroon to the public."

Hughes was of special stock; his maternal grandmother's husband
had been one of the five black men killed with John Brown. Raised by
a strong grandmother, he projected a proud racial consciousness that
presided over a diverse black folk culture. His blues poetry seemed
spontaneous, and he championed the blues, "as fine as any folk music
we have." Perhaps it was simply that Hurston and Hughes were of a
new generation, a little more comfortable with the world.

In the end, the primary impact of African American culture on
mainstream America in the 1920s was through jazz, and the true flower
of the Harlem Renaissance and the "New Negro" was the work of one
Edward Kennedy Ellington, the greatest American composer of any
stripe, who did exactly what Locke wanted—create a polished African
American art that used the elements of blues and jazz among other
forms to create one of America's most remarkable bodies of music.

THOUGH MANHATTAN WOULD become the jazz capital of America
by the late 1920s, it would take Fletcher Henderson of Georgia and
Duke Ellington of Washington, D.C., to bring jazz bands to the city.
Before they arrived, the black music of New York was largely played
by solo pianists, who took their approach primarily from ragtime,

heavily affected by the proximity of Tin Pan Alley and the Broadway theater district. Garvin Bushell would recall, "There wasn't an eastern performer who could really play the blues. We later absorbed it from the southern musicians we heard, but it wasn't original with us. We didn't put that quarter-tone pitch in the music the way the southerners did. Up north we leaned toward ragtime conception—a lot of notes."

The New Yorkers were very good at what they were playing, good enough that when Jelly Roll Morton rolled into New York, they were not impressed. Perry Bradford would see Jelly going against Stephen "The Beetle" Henderson and report that the man from New Orleans had faded. Duke Ellington said much the same thing. It was true that all opinions of Jelly tended to reflect his abrasive personality, but it was also true that New York piano players were a special breed.

They called it stride. From before World War I until nearly the next world war, a collection of New Yorkers named Kid Sneeze, the Beetle, Richard "Abba Labba" McLean, Charles "Lucky" Roberts, Fats Waller, Willie "The Lion" Smith, and above all James Price Johnson played a shouting style of piano that added blues melodies and Southern rural dance rhythms to a ragtime left hand. Stride was improvised ragtime in which the left hand played single notes on the first and third beats and chords on the second and fourth, with the right hand playing counterrhythms.

The greatest of the stride pianists was James P. Johnson, who as a teen in 1908 would move from New Jersey to San Juan Hill (possibly named for the black Tenth Cavalry, which had fought in Cuba), a black area of Manhattan in the West Sixties later razed to create Lincoln Center. A friend of Johnson's had learned to play Scott Joplin's "Gladiolus," and James was transformed. His mother got him a piano, and he learned harmony and counterpoint from a friend studying opera. "I was on Bach," he said, and "double thirds need good fingering."

That came on top of church songs, pop songs, and classic rags, and also hearing Jelly Roll Morton while still wearing short pants. There were docks near San Juan Hill where boats from Savannah and Charleston came in, and where the dockworkers were frequently Gullah (low country South Carolina and Georgia) and Geechee (the Ogeechee River of Georgia) people. They brought music with them, and dances, and James P. took that and created a song called "The Charleston," which he put in the 1923 Broadway play called *Runnin' Wild*. The song was a thundering hit. Along with his "Carolina Shout" (as in ring shout), it established him as a popular songwriter.

His chief competition was Willie "The Lion" Smith, who'd earned his nickname as an artillery gunner during the war. The Lion was a special man, as he revealed in his wonderful autobiography, *Music on My Mind*. Born in 1897 in New Jersey, he attended various churches as a child and particularly liked Baptist singing and ring shouts, but spent so much time at a neighbor's Hebrew classes that he was bar mitzvahed. He also took a serious interest in astrology. By 1913 Willie was working saloons in The Coast, Newark's vice district. Postwar he held forth at Leroy Wilkins's place at 135th Street and Fifth Avenue, the center of black Harlem.

Generally, Willie played in New York and stayed in New York— he avoided the South, he said, because "The weather down there just didn't fit my clothes." But he did travel with a show to Chicago in 1923. When stranded there, he decided to stick around for a while, playing at the Flume Café, and consequently was able to hear King Oliver, Louis Armstrong, and so forth. "The bands proved to be the real treat because we hadn't heard groups in the East that could play the blues and stomps like these guys in the Middle West . . . a brass-player's paradise."

Back in New York, a black entertainment district sprang up between Lenox and Seventh avenues, and between 131st and 133rd streets, with places like Connie's Inn, the Lafayette Theatre, the Nest, Tillie's

Chicken Shack, and the Rhythm Club, where the musicians gathered
to loaf, schmooze, and find jobs. A tree grew in front of the Lafayette
on Seventh Avenue and became known as the Tree of Hope, a lucky
wishing tree something like a similar tree in Congo Square the previous
century, and the block became known as the Corner, the Boulevard of
Dreams, or the Stroll. One major feature of the Stroll by 1930 was one
Milton "Mezz" Mezzrow, purveying the best marijuana in Harlem.
(Mezz sold to white people too; one of the people he turned on was a
white man named Jerry Wexler, who in the 1950s at Atlantic Records
would go on to be one of the great producers of black music in history.)

When the Lion left Leroy's club, he was replaced by an up-and-
coming youngster, a student of James P.'s named Thomas "Fats"
Waller. By the early '20s, a very young Fats was at the Lafayette
Theatre, which had a fine organ. New York being the center of the
recording industry of the day, he was soon writing songs and head-
ing midtown to work in the studios. What Mamie Smith had kicked
off in 1920 would have lasting reverberations. Ralph Peer, the music
director at OKeh, had first labeled the music "Negro Records" and
then "Coloured Records," neither of which caught on. Then he saw
the term *race* in the *Chicago Defender* and created the phrase *race
records*, and it stuck. Soon he brought in Clarence Williams, whom we
first encountered trying to hustle Bessie Smith, but who would have a
lasting career in New York as a producer and not terribly good piano
player (the Lion said he played as though wearing mittens).

Clarence Williams's Blue Five, which featured Sidney Bechet,
recorded the classic songs "Wild Cat Blues" (written by Clarence and
Fats) and "Kansas City Man Blues" in its first session, in 1923. In
partnership with Spencer Williams, Clarence would put out the clas-
sic "Royal Garden Blues," and Spencer would write (though Clarence
would claim it) Fats's first hit, "Squeeze Me." The next year, Sidney
would pair with Louis Armstrong on Clarence's "Cake Walking Babies
from Home" before departing for Europe to work with Josephine Baker.

Fats would go on to meet one Andriamanantena Paul Razafinkarefo, also known as Andy Razaf, and by the end of the decade, with Andy as lyricist, begin recording hit after hit, including "Honeysuckle Rose" and "Ain't Misbehavin'," which would be part of the show *Connie's Hot Chocolates*, sung by Cab Calloway and Margaret Sims onstage, and later by Louis Armstrong from the pit. The same show also had his "(What Did I Do to Be So) Black and Blue." Fats's combination of brilliant composing, equally brilliant playing, and humor—his line "Hmm, I wonder what the poor people are doing tonight," delivered with a cocked eyebrow and a sly smile, became part of the American joke bank—made him a national treasure for black and white people alike.

Before he went off to Europe in 1925, Bechet played a show in Washington, D.C., that would have lasting consequences. In the audience was one Edward Kennedy Ellington; it was the first time that he'd heard New Orleans music, and it would transform him. Bechet even briefly played with Duke, and Ellington would take the counterpoint, romance, and beats of New Orleans music and build a compositional cathedral.

Duke was in some ways the oddest of ducks. Born in 1899, he'd been raised in a totally bourgeois family, yet he had no formal musical education. He would eventually write symphony-like extended jazz compositions that were still very strongly racially conscious, telling *DownBeat* in 1939 that he wasn't interested "primarily in the playing of jazz or swing music, but in producing musically a genuine contribution from our race . . . We try to complete a cycle."

Over the 1920s, building on Art Hickman and the white dance orchestras, Fletcher Henderson had developed the primary elements of the jazz orchestra, and Ellington would bring them to an absolute peak. He would ensure that the form would stay vigorous and not too sweet by hiring what one author called "hard-drinking and combative bad boys for his band, who produced the funky timbre, blues, and wails of the rural tradition." The orchestra was his instrument, and he

played it masterfully. He was artist and patron both, composing pop tune hits to finance more ambitious pieces, and all this while touring. By the time he was done he would copyright fifteen hundred pieces.

The most important of those pop tune hits came in 1930. Duke had three songs ready for a small group recording date but needed a fourth. While waiting for his mother to finish cooking dinner, he whipped the tune out and called it "Mood Indigo." They recorded it in the afternoon and played it that night at the Cotton Club, and it was established as a hit forever. Duke would take the revenues from that song and so very many others and use them to finance the band, putting them on a tour bus—and plane and train—to wander the world and create music, in his own phrase, that was "beyond category," but central to American culture in the twentieth century.

13

The Flood, and the Blues
That Followed

THE ARTISTIC ACHIEVEMENT and urbane elegance that were
Duke Ellington were aspects of black American life, but extraor-
dinary ones. As he began the residency at the Cotton Club that would
make him famous on December 4, 1927, most African Americans
still remained in the South doing agricultural work. Many were in the
Mississippi Delta, and they were coming to the end of a truly disas-
trous year.

The rain had begun in August 1926 in Nebraska, South Dakota,
Kansas, and Oklahoma, and by New Year's Day 1927, the Mississippi
was at flood stage in Cairo, the earliest that this had ever happened. It
would remain at flood stage for 153 consecutive days.

The greatest flood after 1927 would see a million cubic feet of
water per second (cfs) pass St. Louis. By April 22, 1927, three mil-
lion cfs were passing Greenville, Mississippi. The levees crumbled. On
April 21, the Mounds Landing levee twenty miles north of Greenville
broke, and double the volume of Niagara Falls poured through, put-
ting an area fifty by one hundred miles under twenty feet of water.
Somewhere between 250 and 500 people died; 16.6 million acres and

162,000 homes were under water. It was the greatest natural disaster in American history to that point.

The secretary of commerce, Herbert Hoover, was put in charge of relief efforts, and would do so well—at least in terms of his public relations efforts—that he'd be elected president in the next election. It was another of America's frauds. The black sharecroppers of the Delta were confined to camps on the levee and not allowed to get on boats sent to evacuate white people, the planters having decided that if their work force was permitted to leave, it might never return. Under threat of National Guard and police weapons, black men were forced to work unloading food for refugees farther inland. When they demanded pay for their labors, the weapons were pointed at them. Emancipation might never have happened.

In Greenville, the head of the Red Cross and the man in charge of relief efforts was Will Percy, son of the planter LeRoy Percy, the Delta's most powerful man. Will reacted to criticism by telling the black workers that they were lazy and their problems were their own fault and then quit, going off to Japan for a long vacation.

It couldn't get much colder than that. How else respond but with art? Bessie Smith had been caught on the edge of the flood in Cincinnati. She went into the studio in February 1927 backed only by James P. Johnson and recorded "Back Water Blues." An even more intense evocation of the flood came from Charlie Patton, whose "High Water Everywhere" communicates a suffocating sense of doom. He almost sounds as though he's drowning: "Lord the whole round country, / Lord, river has overflowed . . . [spoken aside] 'You know I can't stay here, I'll go where it's high, boy'/ I would go to the high country, / but, they got me barred."

By the time of the flood, the recording industry had begun to expand its blues recording to include men, first with Paramount's Papa Charlie Jackson, an old timey/minstrel/vaudeville entertainer, whose "Salty Dog Blues" was a hit. With that success, the record company naturally

looked for more. Paramount was a subsidiary of the Wisconsin Chair Company of Grafton, a suburb of Milwaukee. They'd begun selling phonographs in 1914 but needed records to enhance their product, so in 1917 they went into the record business. They had a "sound laboratory" (studio) in Port Washington, just north of Grafton, but for reasons either technological or in their personnel, their recordings tended to be of inferior quality.

The man in charge of Paramount's "race" catalog was J. Mayo Williams, a former football player who would earn a reputation as a legendary thief whose name would appear as co-composer on far too many songs. In 1924, the Paramount catalog, over a picture of Williams, invited customer input: "What will you have? If your preferences are not listed in our catalog, we will make them for you, as Paramount must please the buying public." The next year Paramount got a letter from someone at a Dallas store that sold their records recommending a man named Blind Lemon Jefferson, and the era of recording rural acoustic blues—by and large, a man and his guitar—began.

Born with the first name Lemon in 1897 or perhaps 1893 in a hamlet called Coutchman about one hundred miles south of Dallas, sightless from birth or shortly after, Jefferson adopted music as the classic blind man's career choice by the time he was in his early teens. His guitar style was distinctive, using single note runs that would have a major influence in later years, and he had a high-pitched, melancholy voice. He moved between spirituals and the blues with equal facility—his first recorded tunes were spirituals—and the tale is told that at a church picnic he was lectured by the preacher about the sinfulness of playing the blues until, the sermon having reached its high point, Lemon began to play the blues, and the congregation stopped listening to the preacher and came to Lemon.

In 1912 he left home and moved to a district in Dallas called Deep Ellum, near the railroad stop at Elm and Central Avenue where day laborers lined up for a ride to the fields. According to one black

newspaper writer, Deep Ellum was "The only place recorded on earth where business, religion, hoodooism and gambling and stealing go on without friction."

There Lemon found a "lead boy," someone to guide him around. His name was Huddie Ledbetter, and he could play some too. Later Huddie would say of their time together, "We like for women to be aroun' cause when women's aroun' that bring men's and that bring money. Cause when you get out there, the women get to drinkin' . . . that thing fall over them, and that makes us feel good and we tear those guitars all to pieces." After Huddie went to prison in 1918, there were other lead boys, all of whom could play, including Josh White and Aaron "T-Bone" Walker. "My whole family was crazy about him," said Walker. "He'd come over every Sunday and sit with us and play his guitar, and they sang and had a few drinks."

Electrical recording using microphones, a great improvement over the much cruder acoustic recording, became widely available in 1925, which meant that recording relatively quiet guitars was much easier. It also made the entire process more portable, which facilitated field recording. Lemon went to Chicago and recorded a couple of spiritu-als under the name of Deacon L. J. Bates, and they did well enough for him to return to the studio in March 1926. There he recorded "Booster Blues" and "Dry Southern Blues," which did very well indeed; Paramount then released two other songs from the session, "Got the Blues" and "Long Lonesome Blues," which became an enor-mous hit.

Over the next three years, he'd record around one hundred songs, of which more than forty would be released. Many concerned poverty, like "One Dime Blues," and came from hard experience. Lots of his songs addressed prison, which was a flight of imagination for him— blues singer Henry Townsend would later say that Lemon could "take sympathy with the fellow." What was perhaps his greatest song, "See That My Grave Is Kept Clean," took only a slight bit of creativity for

a Christian-born sinner to envision his own death and ask for just one kind favor. An adaptation of "Two White Horses in a Line" sung to the tune of "Careless Love," it would be great enough to be covered repeatedly over the next forty years and more.

He briefly left Paramount for OKeh in 1927, recording big hits in "Match Box Blues" and a cover of Victoria Spivey's "Black Snake Blues" that he called "That Black Snake Moan." Later Spivey would swear that her version was about a literal snake in the fields, but no one would doubt that Lemon had something else in mind: "Mmmm, mmmmm, black snake crawlin' in my room / Some pretty mama better come and get this black snake soon."

Lemon wandered the South, playing and spreading the blues from St. Louis to Louisiana to Mississippi to Alabama, following the harvest and seeking farmhands flush with pay in their pockets. In December 1929 he died in a snowstorm on the streets of Chicago, perhaps of exposure, or a heart attack, or a mugging.

Late in that decade, as the market for race records boomed, the blues became an acknowledged genre. Set in a racial landscape frozen into an ongoing prison by racism and economics, it prized mobility above all: "When a woman takes the blues, / She tucks her head and cries; / But when a man catches the blues, / He catches er freight and rides." Unbeknown to most white listeners, the blues also had deep layers of double meanings, using wit and indirection to broadcast protest.

The very fact that an individual black man was singing his own music was an implicit protest and a comment on American apartheid. But a song like "Grey Goose," which Lemon's lead boy Huddie Ledbetter would sing, had hidden meanings. It was explicitly about a goose so tough that it wouldn't die, and when it did, was too tough for knives and forks, but it was also Huddie's tribute to the enduring resilience of his fellow prisoners. There were also overt comments about hard times, floods, cops, fires, and disasters of all sorts. Sex was always a prime topic, presented with a grit and reality that stood in

extreme contrast to the sugary fantasyland of mainstream pop songs. In the words of an early-century Alabama railroad gang song, "White folks on the sofa / Niggers on the grass / White man is talking low / Nigger is getting ass."

Lemon's commercial success ensured that the record companies would continue marketing blues to black people, and in 1928 there were three hit acts, all of them oriented toward a broad urban audience; what got called the blues was by now open to a variety of interpretations. One was the New Orleans–born Streckfus line veteran Alonzo "Lonnie" Johnson, an improvising guitarist who would record with Duke Ellington and Louis Armstrong, but whose smooth, wistful delivery of "Careless Love" established his career as a vocalist.

The duo of Leroy Carr and Francis Hillman "Scrapper" Blackwell combined Leroy's bluesy but light piano and Scrapper's melodic guitar for an urban, sophisticated feel, first on the 1928 Vocalion hit "How Long, How Long Blues." The last act of these first three hit-makers was the combination of Hudson Whittaker, better known as Tampa Red, and Thomas "Georgia Tom" Dorsey. Their risqué double-entendre song "It's Tight Like That," a remake of Papa Charlie Jackson's "Shake That Thing," made them and Vocalion, now being run by the ubiquitous Mayo Williams, lots of money.

In a manner of speaking, Dorsey was just passing through the pop world. He'd already served as Ma Rainey's music director, and in 1932 he would quit the world of blues and go back to church, creating what he termed "gospel music" and writing one of the greatest of gospel songs, "Precious Lord." Gospel updated the spirituals with blues riffs and a solid beat delivered by instruments. It was more for the choir than the congregation, and as such was basically a professional music. It was modern, pretty much leaving the Old Testament behind for 100 percent Jesus all the time.

The gigantic chasm that supposedly separated church and blues never seemed to bother Dorsey. "No, when I was singing blues I sang

'em, and I sang 'em with the Spirit. Now I've got gospel songs, I sing 'em with the Spirit, see . . . I don't care what you're singing." There was a good reason for his lack of discrimination. When asked later in life if he'd ever consider singing the blues again, he replied, "No . . . I was makin' more money [working with gospel]."

Just as the distance from God to the devil seemed to be not much more than the distance from side A to side B of a record, most of the developed structure of music genres was a system of classification for sales purposes created by record companies. Since the record companies (and the folklorists, as well) wanted to define matters by seeking out the unique and the original, and since most musicians did what the record companies told them to do, a man who might sing a dozen types of songs would be known for his hit; if it was a blues, he was a bluesman for life.

Following in the dismal tradition of Cecil Sharp, the record companies and musicologists made distinctions not only of genre, but of race. The fact that a good part of the standard Southern fiddle repertoire was African American in origin came to be forgotten when black people (mostly) stopped playing fiddle and took up guitars late in the nineteenth century. That the white creator of bluegrass, Bill Monroe, would learn a great deal from a black fiddler and guitarist named Arnold Shultz was overlooked; bluegrass was "white music." For that matter, the touchstone family of white Southern music, the Carter Family, learned many songs from a black songster named Lesley Riddle—the color line was always easily breached, especially in the common religious music of both races.

Two more of the most obvious examples of how these distinctions made no sense are the careers of Bob Wills, star of western swing, not a music associated with black people, and the "father of (white) country music," Jimmie Rodgers. Wills emphasized to his biographer that he'd grown up working in cotton fields alongside black people and that the blues were an essential part of his musical DNA. As an adult, he

would combine old-time frontier breakdown fiddle music—his father, grandfather, and uncle were all fiddlers—with blues and the popular jazz-based dance music of the day to create western swing. The seminal Light Crust Doughboys band that created the genre adapted a black song, "Eagle Riding Papa," for their theme song, and over his career, Wills would record the Mississippi Sheiks' "Sittin' on Top of the World" (six times!), "Basin Street Blues," Count Basie's "Four or Five Times," and above all, any number of songs by his favorite singer ever, "the greatest thing I ever heard," Bessie Smith.

Rodgers was a blackface medicine show veteran singing a variety of material, much of it old-timey, but the song that broke his career was "Blue Yodel" (also known as "T for Texas"); his first title was "America's Blue Yodeler." The origins of that yodel were clearly not from the Alps, although where Rodgers got it isn't absolutely certain. Most likely, though, he derived his yodel from the field hollers used by black railroad workers—"gandy dancers." It was the blues part of his repertoire that his producer Ralph Peer had first noticed, so it was no surprise that when Jimmie came to record "Blue Yodel #9" ("Standing on the Corner"), he did so with Louis Armstrong on trumpet and Lil Hardin Armstrong on piano. However much he fathered country music, Jimmie's music was not at all lily-white.

THE RECORD COMPANIES would be devastated by the Depression and by the early 1930s would stop sending people down South. Now most recording was done in Chicago or New York, with a circle of professionals who could do it efficiently and well, however homogenized the results. In Chicago, that meant, among a number of others, Big Bill Broonzy. One of seventeen children, Bill grew up behind a mule and a plow. After a drought ruined his land, he mined coal, joined the army during World War I, moved to Chicago, and worked as a Pullman porter and a piano mover while playing lots of rent parties. Then he met Lester Melrose.

Melrose had begun by working with King Oliver and Jelly Roll Morton for Gennett in the 1920s, but by 1934 he was concentrating on blues. He used a tight group of session players that was led by Broonzy, who played guitar and wrote many of the songs, and included pianist Roosevelt Sykes, vocalist Memphis Minnie, and John Lee "Sonny Boy" Williamson on harmonica. What came to be called the "Bluebird sound" emerged—fully arranged ensemble playing with a rhythm section.

Aside from the Bluebird sound, popular recorded blues music in the late '20s and '30s came primarily from two places, Memphis and the Piedmont. Fulton Allen, better known as Blind Boy Fuller, was from North Carolina and, along with the Reverend Gary Davis, Blind Blake, Blind Willie McTell, and Saunders "Sonny Terry" Terrell, emerged from the Piedmont country to national fame in the 1930s and after. The Piedmonters were heavily influenced by ragtime, which led to gentler, more delicate rhythms than the Delta, and leaned toward brilliant finger picking.

Memphis produced—God knows why—string bands and jug bands, most notably the Memphis Jug Band, led by guitarist Will Shade, and (Gus) Cannon's Jug Stompers, whom OKeh's Ralph Peer found and began recording early in 1928 (a good year for music, 1928). Cannon was an old medicine show man who played banjo and jug and had an extraordinary partner in harmonica player Noah Lewis. The Stompers combined a blues feeling with a countrified dance beat and had a brief period of popularity.

The Delta blues tended toward the harsh and percussive and plainly would never be the smooth and commercial pop sound that record companies generally looked for. But race records had expanded their potential market so widely that by the late '20s, music that earlier had no chance now seemed to have much more promise. The first Delta musician to emerge was a medicine show veteran from Hernando, Mississippi, named Jim Jackson, who recorded "Kansas City Blues

Part 1 & 2" for Vocalion in October 1927. When it was a huge hit, the idea of exploring Mississippi for blues talent gained credence.

Henry Columbus (H. C.) Speir was the guy that almost all the record companies used as their talent scout and man-on-the-ground in Mississippi. (A man named Frank Lembo in Itta Bena ran second to him.) Speir sold records in his furniture store, which was located on Farish Street in a black neighborhood of Jackson. He *really* sold records, stocking three thousand 78s and selling three hundred to six hundred on a good Saturday, which made it a significant outlet indeed. In the process he became genuinely interested in the music, which he later described as "a lonesome sound . . . I *knew* what this Negro singin' was doin': I *knew* it was good." The acetate recorder at his store was for customers; for $5, they could record greetings or whatever, but Speir also used it to audition musicians. Ralph Peer required a "tape"; Paramount took whomever Speir sent. By the time he was done, Speir had found almost every major Mississippi talent to come to notice, missing only Mississippi John Hurt.

In 1929 Speir got a letter from Charlie Patton of Dockery Plantation and went to see him. Speir recalled Charlie's manner on their meeting as "kinda forward," but the audition proceeded, with Charlie leaning against a tractor as he played "Pony Blues." It was a voice that would carry, thought Speir; "He had a regular ol' Mississippi River voice, that's all there was to it," and the song had a rhythmic pulse. Speir liked his guitar playing, and Charlie had a number of originals, which was good—most guys had only one or two. In fact, Speir liked Charlie so much that later he'd go to Dockery just to hear him play, even after their business was concluded.

On June 14, 1929, Patton laid down fourteen sides at the Gennett studio in Indiana, working with a Stella guitar tuned a step above concert pitch, which ensured that it cut through the usual fog of Paramount recording and caught people's ears. Among the songs he recorded that day were "Screamin' and Hollerin' the Blues," "Pony Blues," "Banty Rooster Blues," and "Tom Rushen Blues."

As the musicologist Stephen Calt points out, this wasn't like anything else recorded in the era. Charlie "was the only singer-guitarist capable of embellishing his voice as he played and the only dance guitarist who played improvisatory figures," "Screamin' and Hollerin'" was "the only blues song with a basically improvisatory melody," and "Pony Blues" was "the only dance blues without a constantly repeating melody." "Pony Blues" is driven by a structure in which what seems like a three-beat measure is followed by a five, overlaid on clear four-beat measures—all in thirteen and a half bars; in other words, rhythms are stacked on top of each other to create an extraordinarily complicated rhythmic tension. It worked. "Pony Blues" would sell respectably when it was released in July. The real-deal Delta blues had gone out into America.

A second session for Paramount later that year in Grafton yielded "Green River Blues," "Heart Like Railroad Steel," "Some These Days," and "High Water Everywhere." "High Water" was a hit when it was released in April 1930, and for good reason. The delivery was over the top and the foot stomping and guitar pounding finished it off.

Charlie had moved to the hamlet of Lula, which happened to be near Clarksdale, and also near the ferry to the very active music town of Helena, Arkansas. There he met his last musical running partner, Eddie "Son" House. Born in 1902, Son began to play guitar only in his twenties, after his planned career as a preacher was derailed by a two-year stretch in Parchman Farm for shooting a man. It's somewhat difficult to see how they played together; Son's work at this time was largely one-chord bottleneck material, not dance oriented at all. As personalities they clashed, with Patton always joking and Son reveling in the gloom of his guilt for playing blues. What they definitely did together was drink.

With Lemon's death the previous December, Charlie was Paramount's leading blues act, and label boss Arthur Laibly personally came to Lula to organize a return to Grafton. In May, Patton, Son

House, and Willie Brown got in a car and went off to Grafton, stopping at the Kirby Plantation north of Robinsonville to pick up Louise Johnson, a sweet young thing who played piano and sang a little.

Speir was at the session working on studio alterations to improve the sound, which cut the amount of time for recording; in four to six days, they managed to get only twenty-one tracks down; Louise did four, Son did nine takes of six songs, and Patton, backed by Willie, played only four songs, none particularly great. Considering that they were recording in the morning, it must have been a good party, because Patton's remarks are all captured: "Do it a long time baby! Good and wild, good and wild. Lordie have mercy! Ain't that a *shame*. Boy, let's have a party! Get right, get right! Play 'em!"

It was Charlie's high point. His record sales vanished in the Depression, and by 1932 Paramount had folded. He recorded once more, for ARC, the cheapest and crummiest of the record companies. Over three ferociously cold days in New York City in late January 1934, Charlie and his wife, Bertha Lee, put down twenty-six sides, including eight religious duets. He was sick with a cold, so it wasn't his best work, although his guitar playing holds up decently.

Charlie went home to the Delta, and life went on as it always had. The year before, his triflin' ways with women had resulted in his getting his throat cut at a dance in Holly Ridge, and on April 8, 1934, he had to make a fast exit from a gig after a couple quarreled and the woman dropped her lover cold dead with an axe. On April 17, two days after ARC issued the song "Stone Pony," Charlie went to see the doctor and was diagnosed with mitral valve heart disease as a result of scarring from childhood rheumatic fever. He was dead nine days later, having spent his last week on earth preaching. He was buried in a small cemetery in Holly Ridge, in the shadow of a cotton gin.

Swing

THE STOCK MARKET collapse of October 1929 cost America $40 billion in stock values, halved the national income, and triggered a depression that flattened the country. Three million people were out of work in 1930, and fifty-five hundred banks and one hundred thousand businesses failed. In 1931, seven million were unemployed; in 1932, eleven million. At the bottom of the cycle, roughly a quarter of the country was looking for a job.

The Depression ate the music business alive. Ma Rainey's show was stranded, and the Mother of the Blues scrambled to join Boisy DeLegge and his Bandana Girls for the winter. Bessie Smith deserted her own stranded company. Of the black big bands, only Duke Ellington and Cab Calloway's outfits survived. Record sales went from $104 million in 1927 to $6 million in 1932.

Among white bands, only the "sweet" bands prospered, most notably Guy "The Sweetest Music This Side of Heaven" Lombardo and Fred Waring and the Pennsylvanians. As the decade passed, more and more white working musicians, sick and tired of playing treacly charts, began to look for something a little hotter, the classic example being clarinet virtuoso Artie Shaw, who was doing quite well at CBS, but preferred going to Harlem to jam with the Lion.

In the course of the '30s, music would come to reflect the reigning New Deal with a populist and inclusive attitude to culture that discarded the old orthodox disdain for hot (black) music. In a triumph for the Austin High Gang, jazz would become America's unquestioned popular music. The original Austinites were now seasoned professionals with unchanged attitudes about playing music in the "hot" style, and many more white musicians now absorbed their point of view. They played what had come to be called swing.

Earl Hines opined that swing was "nothing but New Orleans jazz dressed up." *DownBeat*, which would become the ongoing journal of jazz, would debut in 1934 as a proponent of swing. The big radio network shows remained the home of sweet, which never went away. Instead, the audiences divided, with fox trotters going to see sweet bands, and the youngsters, soon to be called jitterbuggers for the way they danced, off to see the swing bands.

DownBeat would also cover the black bands from the beginning, although a racial divide in the audience remained apparent. When their reader's polls began in 1936, the white musicians predominated, although in England, by contrast, *Melody Maker* in 1938 chose Duke Ellington's band as #1, Louis Armstrong over Bunny Berigan, Coleman Hawkins over Bud Freeman, etc. In general, the decade would see the beginnings of serious jazz criticism, first in Europe with the work of Hugues Panassié, who established the first canon in jazz with his 1936 *Le Jazz Hot*. Critics like John Hammond, writing for *New Masses* and *DownBeat*, and George Simon at *Metronome*, made names for themselves.

What really spread jazz was radio, which had itself matured. KDKA, the first commercial radio station, had begun broadcasting in 1920, and within two years there were 200 more stations. By 1925, the radio audience numbered fifty million. In 1926, NBC lined up the first coast-to-coast network, with 19 stations. By 1938, it had 110, and 80 percent of the country could tune in to the same show if it so desired.

The Depression accelerated radio purchases, since music was free once the hardware was paid for; there were fifteen million radios in the United States in 1931 and fifty million in 1939.

Nationwide shows meant national tours, and bands moved to New York to be near the center of the radio business. Radio flexed its power in other ways, buying up record companies to make sure it had plenty of material just as film companies were doing the same thing with music publishing. So the Radio Corporation of America (RCA) bought the Victor Talking Machine Company, and CBS bought ARC (which included Columbia, OKeh, Vocalion, and Brunswick).

Swing bands played for dancing quite as much as sweet ones, only with considerably more energy. The standard swing orchestration of five brass, four reeds, and a four-piece rhythm section had thump and power, able to produce the volume required to fill large halls. The sections used age-old call-and-response patterns, now called riffs.

And one major barrier to a good time out ended: On December 5, 1933, Utah became the thirty-sixth state to ratify the Twenty-First Amendment, ending Prohibition. The absolute bottom of the Depression had passed, and the stage was set for something new.

Mezz Mezzrow would say that the word *swing* came about because "the unhip public took over the expression 'hot' and made it corny by getting up in front of a band snapping their fingers in a childish way, yelling 'Get hot! Yeah man, get hot!'" Another story held that the BBC thought *hot jazz* was suggestive and created the phrase *swing music*.

However the term came about, it was personified by the work of Benjamin David "Benny" Goodman. Born to poor immigrants in Chicago in 1909, he discovered the clarinet at the age of ten and had a union card by the time he was thirteen. He followed the same path as the Austin High Gang, studying the black creators, but perhaps as a function of social class was not quite so romantic about the process as the more prosperous kids from suburbia. Some of his less charming character traits, like cheapness and the rude bullying of his musicians,

might be attributed to the personal drive that he employed to escape poverty. Like Whiteman, he was a white guy playing black dance music so well that he earned a "King of" nickname, but he was considerably more honest about where he got his ideas, giving full credit to his black arranger, Fletcher Henderson.

He had only two years of formal musical education, but he'd played as a sideman for twelve years before he grew bored with session work and formed his own band. In 1934, the National Biscuit Company decided to launch its new Ritz cracker with a national radio program called *Let's Dance*, which featured three bands—Xavier Cugat doing rumbas, the sweet Kel Murray, and Benny Goodman representing swing. They alternated from 11 p.m. to 2 a.m. on Saturday night in New York, which of course meant 8 p.m. to 11 p.m. on the West Coast.

The massive national exposure required new arrangements, and Goodman listened when his friend and advisor (and future brother-in-law), the critic and now producer John Hammond, suggested he get them from Henderson. Not only did Benny get his material from Henderson, but also members of Henderson's band tutored members of Benny's band. Combined with Goodman's extremely demanding leadership—his legendary glare at erring musicians was known as "The Ray"—and his superb clarinet playing, Henderson's charts made the group extraordinary. They followed up the radio exposure in July of 1935 with a recording of Fletcher's arrangement of "King Porter Stomp," and it was a hit, with great reviews in both *DownBeat* and *Melody Maker*.

After getting fired from the Roosevelt Grill in New York for not being sweet enough, the Benny Goodman Orchestra set off on tour that summer, and it went badly until they reached McFadden's Ballroom in Oakland, California, where the place went nuts. Pismo Beach the next night was a stiff, so they dismissed Oakland as a fluke. They began their three-week engagement at the enormous Palomar Ballroom in

Los Angeles on August 21, and they were by no means sure they'd be allowed to finish the run.

The night is part of American musical history. They played stock arrangements in the first set, and the crowd was blah. They'd been listening to the Henderson charts on *Let's Dance*, as well as the "King Porter Stomp" record on local radio, and they wanted some heat. At intermission, drummer Gene Krupa, part of the Austin High Gang generation in Chicago, said to Goodman, "If we're gonna die, Benny, let's die playing our own thing." They kicked into Henderson's charts of "Sugar Foot Stomp," "Sometimes I'm Happy," and "King Porter Stomp," and the young audience went wild. When they weren't clustered, hypnotized, in front of the bandstand, they danced the Big Apple and the shag, black dances invented at Harlem's Savoy Ballroom. Swing and the jitterbug era had arrived.

The jitterbuggers marked a significant step in American social history. The progressive era reforms that had limited child labor and required a high school education had created something new: the teenager. No longer expected to go to work at thirteen, young people in their teens in the 1920s and '30s gradually acquired a new identity that was neither child nor adult but something intermediate.

One of their fundamental attributes was their dancing, which was distinctly different from that of their parents. Their taste also influenced (and was influenced by) the two great modes of music listening of the day, jukeboxes and disc-jockeyed (rather than live) music on the radio, most commonly first associated with Al Jarvis in Los Angeles and Martin Block's *Make Believe Ballroom* program, which debuted on New York's WNEW in 1935. Both jukes and DJs on the radio helped revive the record industry, and it was teenagers who were buying the new records.

Dance bands had replaced vaudeville in America, and very quickly it was a large business, one that grossed $100 million annually and employed thousands of musicians, bookers, promoters, and so forth.

In January 1938, Goodman crowned all his successes with a con-
cert at Carnegie Hall. The music was hot, and also integrated; Benny
had attached a small group to his regular shows, one that featured
Lionel Hampton and Teddy Wilson, and at Carnegie Hall he included
musicians from the leading black bands of the day, including Count
Basie, Walter Page, and Lester Young, and Johnny Hodges, Cootie
Williams, and Harry Carney from Duke Ellington's group.

In addition to contemporary swing pieces, Goodman went deep
into jazz history, playing material by Will Marion Cook and Ford
Dabney from the James Reese Europe era of the late teens. In the
words of critic Gerald Early, the show legitimized jazz in a concert
setting, and "effected the transformation of hot jazz music to an art
music and reoriented the public to accepting jazz as high art without
the trappings of classical European art music."

At a time when the nation was still recovering from the Depression,
swing brought a burst of pride in a homegrown American art and,
wrote critic Gary Giddins, "reflected the nation's new vision of itself in
the arts—earthy, democratic, and homegrown and, at the same time,
refined, virtuosic, and international." By the end of the decade the
country was awash in swing bands, seven of them led by Goodman
alumni alone. Swing also led to the revival of Fletcher Henderson's
outfit in 1936; Duke and Cab Calloway prospered as well. Another
black big band would emerge in the swing era and earn a reputation as
quite possibly the best of them all.

Bill Basie was a New Jersey kid born in 1904, who as a teen got
himself a job playing piano in a (silent) movie theater and found him-
self hooked for life on show business. By the 1920s he was a ragtime/
stride pianist listening carefully to Willie "The Lion" Smith and Fats
Waller. After years in vaudeville, in the middle of the decade he found
his future one night on the road.

He was staying in the Red Wing Hotel in Tulsa when he heard a
big band rehearsing a song called "In the Barrel." His ear landed on

a particularly good trumpet player who sounded like Armstrong and proved to be one Oran "Hot Lips" Page. The band was led by the bass horn/baritone player, Walter "Big 'Un" Page, Hot Lips's half-brother. The Blue Devils, as they were called, played the blues, and Basie fell in love. To this point, his bands mostly "just followed what the dancers did," and while he knew about Bessie Smith and Ida Cox, "I hadn't ever really paid any attention to them, and I hadn't ever played the blues."

By 1928 Basie was a Blue Devil and had settled in Kansas City, Missouri, a city so politically controlled that it boasted an enormous music scene in its flourishing and very protected vice district, dozens of places like the Sawdust Trail and the Yellow Front Saloon offering women, music, liquor, food, and marijuana (per Basie, three sticks for a quarter, and $3 to $5 for a tobacco can full) around the clock. Music was everywhere—at the Sunset, even the bartender sang; his name was Joe Turner, and he'd hook up with the house boogie-woogie piano player, Pete Johnson, for some serious blues.

By now, in emulation of King Oliver and Duke Ellington, Basie had adopted "Count" as his title. As time went on he played with Bennie Moten's band in Kansas City, which had such great players as saxophonist Ben Webster, Hot Lips and Walter Page from the Blue Devils, and vocalist Jimmy Rushing. Moten died, and eventually Basie began a smaller, seven-piece group at the Reno Club in Kansas City that included Rushing, Walter Page, and Jo Jones, a drummer so good, said the great drummer of the next generation, Max Roach, that "For every three beats a drummer plays, he owes Jo [Jones] five."

Something very special was growing in Basie's band, and then he added the critical piece to the puzzle, Lester Young, who was the per-fect prophet not least because he was so mysterious. John Hammond would explain, "I was not alone in finding it next to impossible to carry on a conversation with him. His world was a special one, and I was never to be a part of it."

Young would be nicknamed "Prez" by Billie Holiday because royalty was royalty, but there was only one president; he was superstitious and eccentric, the quintessential hard-drinking, pot-smoking hipster dressed in a porkpie hat, suede shoes, and an ankle-length topcoat. He was also a brilliant performer. He was sweet and chivalrous toward women, called everyone "Miss," called his instrument "pound cake," and invented the phrases *have eyes for* to indicate desire and *burn* as in cooking; "Can the lady burn?" At least apocryphally, he coined the adjective *cool* to describe something approved.

He was born in Woodville, Mississippi, in 1909 and raised from the age of ten in Louis Armstrong's "Back o' Town" neighborhood of New Orleans. He started in music as a second-liner in the parades and played drums before he switched to the saxophone. His first two models on the sax were Frank "Tram" Trumbauer and Bud Freeman, which made him an heir of the Austin High Gang and gave him a lighter tone than that of Coleman Hawkins, to that point the reigning king of jazz saxophone. Lester said of Tram that "Trumbauer always told a little story," and his sax had the quality and sensitivity of the human voice, a part of the African oral tradition.

He toured with his family's carnival/vaudeville/minstrel act for a number of years, hooked up with the drenched-in-the-blues Blue Devils, joined King Oliver for a short stint, then heard the Basie band on the radio, W9XBY, in 1934. "I knew they needed a tenor player," Prez said, and joined up. He briefly went off with Fletcher Henderson, then settled down with Basie in 1936.

Lester wasn't the only guy to hear Basie on the radio. The critic John Hammond heard Basie broadcasting from the Reno Club and soon after showed up in Kansas City, a fan for life. He would connect Basie with the important booking agent Willard Alexander at MCA, and soon the bookings for the Basie band would rise above the tiny Reno. Unfortunately, Basie also signed a truly horrible contract with Dave Kapp at Decca, which would hamstring his band until it lapsed.

Late that year Hammond introduced the guitarist Freddie Green to Basie, and he came to stay. The year 1938 was the band's turning point. They had their first gigantic hit with "One O'Clock Jump" and a national radio hookup at the Famous Door on Fifty-Second Street in New York, and they quickly became known as the strongest swing band of them all.

They had a most distinctive sound, the product of many factors, the first of which was that they frequently relied not on charts but on "head arrangements"—which is to say, improvisation. Basie remarked in his memoir, "I have my own little ideas about how to get certain guys into certain numbers and how to get them out. I had my own way of opening the door for them to let them come in and sit around awhile. Then I would exit them. And that has really been the formula of the band . . . "

His spare, Fats Waller–inspired piano and the best rhythm section in the history of jazz—Jo Jones on drums, Walter Page on bass, Freddie "Quiet Fire" Green on guitar—made for a simply incomparable dance groove. What came out, said Gary Giddins, was the "hand-clapping elation of a Southern Baptist church stylized into a complicated art . . . He made the blues a disarming flatland of infinite possibility." The Count prodded his musicians into creating ideas that could be channeled into sectional riffs that would serve as perfect platforms for the soloists, and his soloists were monsters.

Swing was now the predominant music form in America, so mainstream that an entire movement of increasingly purist jazz fans developed in large part to research its origins. The effort began with record collectors. Serious jazz record collecting seems to have begun on Ivy League campuses in the 1920s, with Albion Patterson, Albert McVitty, Squirrel Ashcraft, and Augusto Centeno at Princeton in 1927, and Marshall Stearns, Wilder Hobson, and John Hammond at Yale a couple of years later as the first names identified with the phenomenon. As collectors tend to be about their passions, they were deadly

serious disputants about what was good and what was not, what was authentic and what was pop trash, although at least in the early days there was no party line. Seemingly from the beginning, the collectors recognized the black origins of jazz and dismissed symphonic jazz out of hand.

Formally organized New Orleans jazz music collecting clubs sprang up in Europe by the late '20s and early '30s, and in October 1935, John Hammond (president) and Marshall Stearns (secretary) founded the United Hot Clubs of America, with outposts located in New York (Milt Gabler), Yale (Stearns), Chicago (Helen Oakley and Squirrel Ashcraft), and Boston (George Frazier).

A bit earlier, Frederic Ramsey had entered Princeton in the class of 1936, already familiar with being on the social fringe; his father had been fired from his job as director of the Minneapolis School of Art for being a socialist. At Princeton Frederic became a devoted fan of Jelly Roll Morton, and around the time he graduated, he sent a letter asking for information about record collecting to WABC's *World of Swing* show. The show's scriptwriter, Charles Edward Smith, was the jazz critic for the *Daily Worker* and the author of a 1934 *Esquire* article, "Collecting Hot." Perhaps because Albion Patterson of Princeton had once tutored him in collecting, Smith responded to the letter.

Eventually, the two of them connected with William Russell, already an established modernist composer in the avant-garde classical percussion vein, a friend of John Cage and Henry Cowell and an associate of Edgard Varèse. One of Russell's students had introduced him to "Shoe Shiner's Drag" by Jelly Roll Morton and His Red Hot Peppers, and he was hooked. Haunting midtown music stores, then dime stores, then junk shops and the Harlem Salvation Army store, he became ever more serious a collector, and in 1936 he founded the Hot Record Exchange in New York.

In 1937, Smith, Ramsey, and Russell found Jelly Roll Morton in a dump of a bar called the Jungle Inn in Washington, D.C. The three of

them encouraged Jelly—it was not difficult—to tell his stories. Smith was hanging around in the same left-wing bars as Alan Lomax and told him about Jelly's great anecdotes. In late May or early June 1938, Lomax booked Coolidge Auditorium at the Library of Congress for recording sessions with Jelly and hit a musicological bonanza; all he had to do was turn on the recording device and keep Jelly's glass filled. The result was *Mr. Jelly Roll*, a captivating if egocentric ride through a spectacular career.

That fall of 1938, Smith, Ramsey, and Russell got a publishing contract for their history of the music, *Jazzmen*, which would be released in October 1939. It was the first history of jazz by American writers and it was a major benchmark in the relationship of white people to black music. What had once been simply enjoyed—dancing to the ragtime-based fox trot or later jazz dances—was now deemed worthy of serious study. The freedom principle, as it related to white attention to black music, had grown self-aware.

Although they would unsurprisingly be fascinated with the glamorous vice of Storyville, at the very least they consciously and sophisticatedly avoided any thought of primitivism. Smith would write to Ramsey on June 21, 1939, that he'd consulted with Sterling Brown, the black scholar and poet at Howard University, and agreed that their approach was similar to Brown's. "That is, where heritage is legitimate, such as pentatonic scale, ok, but don't try to explain his hot virtues by his savage breast—in other words, environment shapes us . . . [Negroes] do not care to be set apart anthropologically even when this is supposed to be a compliment."

Jazzmen was also the first book based on research, although at least in the case of Bunk Johnson, whom they'd tracked down to New Iberia, Louisiana, the inquiry was a tad credulous. Imbued with the New Deal "folk history" concept, they were more interested in presenting the story than fact-checking some of the details. Bunk was simply too perfect a find, a presumed-lost witness to the turn of the century who'd popped up alive in a swamp almost forty years later.

The trio selected E. Simms Campbell, a black commercial artist
and cartoonist whose "Harem Girls" and watercolors were a promi-
nent feature of *Esquire* in that era, to write about the blues. Curiously,
Campbell noted the cruelty of the Southern aristocracy but went on
to say that "both sides have profited . . . Without pain and suffering
there would have been no blues, and without an understanding white
America there would have been no expression for them." I have to
assume that it's some sort of back pat for his book confreres, because
it otherwise seems to make little sense.

Not least of the motivations for all this documentation was the
inescapable fact of the passage of time. As the *Jazzmen* trio set to work,
jazz in the form of swing was now recognized as the unchallenged great
American music, a music created by black people. But one of its fun-
damental progenitors, Joe "King" Oliver, was falling apart. Pyorrhea
had taken his teeth and thus his ability to play. The Depression had
cost him his savings, and he worked as a janitor in a poolroom, which
he opened at 9 a.m. and closed at midnight. "If the money was only
a quarter as much as the hours I'd be all set," he wrote his sister. His
health was worse than the state of his wallet. Since he could not afford
proper care, he was in a closed loop.

Louis Armstrong put it best when he said that it wasn't a heart
attack but a broken heart that killed Joe, who died alone on April 10,
1938, in a rooming house in Savannah, Georgia. Buddy Bolden had
died seven years before. Though jazz was hardly forty years old, it had
already lost its first creators.

Robert Johnson

TWENTY-NINE SONGS (AND thirteen alternate takes). That is what we really know about Robert Johnson, and it was enough to make the rock critic Peter Guralnick write that Johnson was "the personification of the existential blues singer, unencumbered by corporeality or history, a fiercely incandescent spirit who had escaped the bonds of tradition by the sheer thrust of genius."

Almost literally unencumbered—there's very little hard evidence to Johnson's life other than the outlines; he is tremendously elusive, wraithlike. Though his life has become the object of enormous curiosity and has generated great mountains of research, they rest on very limited (and often doubtful) bits of evidence. "Investigators have hidden material, attacked each other's research, and squabbled over every detail until by now there are few quotations or documents that someone will not argue are at least in part fabrications or liable to error," wrote Elijah Wald, who himself has posed interesting challenges to all sorts of perceived wisdom about Johnson.

There are only two photographs of him, the formal portrait taken at Hooks Brothers in Memphis and a casual one in a photo booth with a cigarette drooping from the corner of his mouth. What indubitably does exist is a body of work, those twenty-nine songs, which have

made him the object of near canonization by (mostly white) music crit-
ics over the past fifty years.

Before addressing the art, let us consider the history.

Robert Johnson was the eleventh child of Julia Major Dodds, an "out-
side child" fathered by Noah Johnson, and was born on (as his family
recalled) May 8, 1911, in Hazlehurst, Mississippi, some forty miles south
of Jackson. Julia's husband, Charles Dodds, had left town—fleeing a
lynch mob, it was said—after a dispute with a local white farmer, changed
his name to Spencer, and settled in Memphis. When Robert was three, he
and Julia and his siblings moved to Memphis to stay with Charles. For a
number of years in his childhood, Robert would go by "Robert Spencer."

In 1918, Robert joined his mother and her new husband, Dusty
Willis, at the Abbay and Leatherman Plantation in Robinsonville,
Mississippi, only thirty miles down Highway 61 from Memphis. There
he attended the one-room Indian Creek School. He fooled around
with the Jew's harp and a diddley bow (one string attached to a fixed
object), and became fairly good at the harmonica.

He began to follow the Robinsonville musician Willie Brown
around, in the process meeting Charlie Patton, who spent a fair
amount of time with Brown. In June 1930, Eddie "Son" House moved
to Robinsonville, and Johnson became even more attentive, sneaking
out of his home after his folks went to sleep to listen to Son and Willie,
moved in particular by Son's slide playing, which was deep, raw, and
emotional. He began to imitate his hero, picking up Son's guitar when
the performers would take a break, but he showed no great aptitude.
"Such another racket you never heard!" said Son. "It'd make people
mad, you know. They'd come out and say, 'Why don't y'all go in there
and get that guitar from that boy!'"

Willie would remonstrate with him, but as soon as Willie would
return to his break, said Son, and "get to laughing and talking and
drinking, here we'd hear the guitar again, making all kind of tunes:
'BLOO-WAH, BOOM-WAH'—a dog wouldn't want to hear it!"

With that sort of response, and with nothing but cotton fields to hold his interest in Robinsonville, Johnson moved on. At the age of eighteen he married Virginia Travis and settled down to the family occupation, sharecropping. This life was shattered in 1930 when Virginia died in childbirth at the age of sixteen. Around this time, he adopted the name of his natural father, whom he had never met, and became Robert Johnson.

Eventually he turned up roughly 250 miles south in Martinsville, near his birthplace of Hazlehurst. There he studied the guitar with a man named Ike Zinermon, an Alabama-born player. He might also have spent time with Tommy Johnson, a well-known bluesman from just a few miles up the road in Crystal Springs.

He also spent a lot of time with records, perhaps more than any up-and-comer to that point, studying Lonnie Johnson's jazzy figures, Leroy Carr's melodies and chords, Kokomo Arnold, Peetie Wheatstraw, and Skip James. It was an extension of the traditional songster process, in which fragments of many different songs were swapped around for the singer's own version. In the end, how he absorbed the information hardly seems very important.

He learned the songs, and he made them his own. He listened and adapted and he practiced, making himself a servant of his guitar. Playing in jook joints and barrelhouses, alone and in front of an audience, he transformed himself.

Some time in 1931 or possibly 1932 he returned to Robinsonville, perhaps to visit his mother. He sought out Son and Willie at a show in Banks, a few miles east, and asked Son, "This your rest time?"

"I [Son] say, 'Well, we can make it our rest time. What you want to do, annoy the folks?'"

He say, 'No, just let me—give me a try.'

I say, 'Well, ok.' I winked at Willie. So me and Willie got up, and I gave him my seat. He set down. And that boy got started off playing. He had an extra string he'd put on, a six-string guitar made

into a seven-string, he'd put it on hisself. Something I had never saw before, none of us. And when that boy started playing, and when he got through, all our mouths were standing open. All! He was gone!"

Son also told the musicologist Alan Lomax about that night. "And play, that boy could play more blues than air one of us. What little I know, I taught him, but he put his own sound in it, and sing with it, sing all night."

He was an acknowledged performer now, and a semipermanent vagabond. He had family members scattered from Memphis to Jackson and circulated among them, but mainly seemed to base himself out of Helena, Arkansas, thirty miles north and across the river from Clarksdale, in part because of the hospitality he got there from a lady named Esther Reece. By the mid-1930s, Helena would be home to many bluesmen, including a man named Johnny Shines. Johnson traveled with Johnny from time to time, and Shines would come to know him about as much as anyone ever did.

Aside from being a traveling minstrel playing his original blues— and anything else the customer wanted to hear, from Bing Crosby to Gene Autry to Fats Waller—who was this man named Robert Johnson? Rather ghostlike, actually. Secretive, guarded, a man who apparently had no close relationships, he was a wanderer making rounds. He wasn't a big talker. "He wasn't gonna increase the conversation," said the blues player Henry Townsend.

It was a naked existence, his food, drink, and bed entirely dependent on the success of the day's playing. Somehow, Johnson always managed to stay neat in his appearance. "Robert could ride highways and things like that all day long," said Johnny Shines, "and you'd look down at yourself and you'd be as filthy as a pig and Robert'd be clean—how, I don't know."

He was more a lover than a fighter, said Shines. "He couldn't punch hisself out of a wet paper sack . . . He wasn't a scrapper or a fighter, but he tried . . . 'Cause he'd jump on a gang of guys just as

quick as he would one, and if you went to defend him, why, naturally, you'd get it!'"

Most of all, he was a rambler. He and Johnny would play all night, sleep, and wake up. "'Robert, I hear a train; let's catch it.' He wouldn't exchange no words with you, he's just ready to go . . .'" They covered a lot of ground: Chicago, Texas, Canada, Kentucky, Indiana, and farther east. Johnny continued, "We never had much trouble finding places to play. In New York there were quite a few speakeasies and places like that. In Buffalo there were several places."

Shines was along because he was fascinated with Robert's playing. "Now I had Wolf's style at the beginning, and I was beginning to pick up on quite a few different guys' styles as the time went along, but I thought Robert was about the greatest guitar player I'd ever heard. The things he was doing was things that I'd never heard nobody else do, and I wanted to learn it, especially a lot of his slide stuff."

Townsend was also impressed. "I liked his finger style as well as his slide style. He done more slide when I was there with him, because we was playing together . . . He really had some sweet, sweet sounds . . . you didn't hear too many people doing it." Specifically, Johnson developed a style using his thumb to play bass that included what the players called a "turnaround," walking the bass line down the neck and using the first string as an octave note drone.

He was an extremely quick study, able to master a tune from the radio or a record in one hearing, from blues hits like Lonnie Johnson or Blind Boy Fuller to waltzes and polkas. "He'd be sitting there listening to the radio," said Shines, "and you wouldn't even know he was paying any attention to it—and later that evening maybe, he'd walk out on the streets and play the same songs that were played over the radio. Four or five songs he'd liked out of the whole session over the radio and he'd play them all evening, and he'd continue to play them . . . And I know that he was making chords that he never heard before." "Now, you take that some musicians is great artists, but they

don't take with the public like others. Well, Robert was one of those fellows who was warm in every respect—in *every* respect."

How warm? A player from the next generation, McKinley "Muddy Waters" Morganfield, would recall what it was like to hear Johnson. Morganfield saw him in Friar's Point. "People were crowdin' 'round him, and I stopped and peeked over. I got back into the car and left, because he was a dangerous man . . . and he really was using the git-tar . . . I crawled away and pulled out, because it was too heavy for me."

Shines recalled a time when Robert played his song "Come On in My Kitchen." Something made Johnny look up, and he realized that everyone in the room was crying.

FINISHED WITH HIS apprenticeship, Robert Johnson followed in Charlie Patton's footsteps and contacted H. C. Speir in the fall of 1936. Speir connected him with Ernie Oertle of ARC and its subsidiary label, Vocalion. In November, Johnson traveled to San Antonio, Texas, to the Gunter Hotel. Producer Don Law turned on the recording machine on November 23, and Robert began to lay down tracks.

"Kind Hearted Woman Blues" came first, a nicely ambivalent paean to a good woman—"who studies evil all the time." The guitar playing is solid and the vocal is understated, but the voice is distinctive, at times surging high into a keening falsetto. The song is a response to Leroy Carr's "Mean Mistreater Mama," itself covered by Tampa Red, Josh White, and Amos "Bumble Bee Slim" Easton. Lyrically, it is far more complex than most blues, with a full lyric rather than a selection of floating verses.

The pace began to accelerate. Next up was "I Believe I'll Dust My Broom," an archetypal "I'm hitting the road because my woman's no good" complaint, indebted to slide guitarist Kokomo Arnold both in melody (from "I Believe I'll Make a Change") and lyric ("I believe I'll go back home" from "Sissy Man Blues"). What makes the song exceptional is the stripped-down, driving guitar riffs in opposition to

a propulsive boogie bass line that generates a perfect shuffle. Later, Elmore James would apply slide guitar to the high-end riffs and create a classic. In fact, the boogie shuffle in general would become a funda-mental element in a great deal of music in the future.

"Sweet Home Chicago" came third, another tribute to Kokomo Arnold, in this case his "Old Original Kokomo Blues." Johnson's ver-sion lacks Kokomo's slide-guitar fire but has a relaxed, locked-in swing. "Ramblin' on My Mind" is Johnson's first slide song, complete with the stinging triplets that Elmore James would use in "Broom." It's also seriously arranged, complete with a train imitation on the bass strings.

Recent revisionist criticism of Johnson focuses on the inarguable fact that his songs are, in the blues tradition, considerably derived from others. "Come On in My Kitchen" is a case in point, with a verse from Skip James's "Devil Got My Woman" and a melody modeled on Tampa Red's "Things 'Bout Coming My Way," itself loosely based on the Mississippi Sheiks' "Sittin' on Top of the World." There's even a bass riff from Charlie Patton's "Pea Vine Blues." Trust me; "Kitchen" is far superior to Tampa Red's song. It's got the full emotional range of pain and loss and the human dilemma wrapped up in two minutes, fifty seconds. Johnson's voice is superb and remarkably intimate. It is, as critic Elijah Wald writes, an "unquestionable masterpiece, a hyp-notic lament." No wonder Johnson left people in tears with it.

Interestingly, Law did not like the subtle first version and asked Johnson to do it again, this time somewhat more up-tempo. The sec-ond take does have energy, but lacks the finesse of the first. The pro-ducer makes the rules: Version #2 was what was released, and #1 was heard only twenty-five years later.

The first day ended with two double-entendre songs, "Terraplane Blues" and "Phonograph Blues," witty metaphors on sexual difficul-ties: "I said I flashed your lights mama / your horn won't even blow . . . Got a short in this connection / hoo-well, babe, its way down below." "Terraplane" would be the closest thing to a hit for Johnson, selling

perhaps five thousand copies. "Phonograph" would not be released, although it was at least as amusing as "Terraplane": "Now we played it on the sofa / we played it 'side the wall / My needles have got rusty babe / they will not play at all."

Law would recall Johnson as shy, facing the wall to conceal his fingerings if another player was in the room, although more recently, musicians have suggested that he was using the wall as a resonator to improve the sound. Interpreting his guardedness as naïveté, Law surmised that Johnson had never left the plantation. The producer would also say that he received a call from Johnson one day during the week asking a favor. "I'm lonesome, and there's a lady here. She wants fifty cents and I lacks a nickel."

Returning to the studio on Thanksgiving, Thursday, November 26, Johnson would record only one song, "32-20 Blues," a cover of Skip James's "22-20 Blues." On Friday he resumed in earnest, starting with "They're Red Hot," his only recorded comic song. Soon he got to "Cross Road Blues," where the trouble starts for recent critics.

It is African tradition that a crossroads, an intersection, is a place of magical and transformative power. In African American folklore, there are tales of meeting the devil at the crossroads and making a Faustian bargain, trading one's soul for consummate artistic talent. Because Johnson had improved dramatically, there was doubtless someone superstitious enough to remark that his talent had come from such a deal. But "Cross Road Blues" has nothing whatsoever to do with the devil. The critics heard the blistering raw emotion in Johnson's performance, a bleeding voice over slashing guitar strokes, and invoked the supernatural. But Bob cries out for mercy to the Lord, not a more nefarious power. And a black man looking for a ride in a state that posted signs saying NIGGER DON'T LET THE SUN GO DOWN ON YOU IN THIS TOWN had good reason to be worried.

"Walking Blues" is a deft take on the tune of Son House's "My Black Mama." "Preaching Blues (Up Jumped the Devil)" feeds the

critical idea of demonism, although again it has nothing to do with the supernatural—it's a superb blues where the blues go "walkin' like a man" or come as a "low down shakin' chill." The first session ended with "If I Had Possession Over Judgment Day," another source of supernatural theorizing, although in the lyrics the phrase applies only to Johnson's desire for revenge on an unfaithful lover.

In June 1937, Robert Johnson would go to the Dallas offices of Brunswick Records for his second recording session. Working in between the Crystal City Ramblers and Zeke Williams and His Rambling Cowboys, he recorded thirteen more songs in two days.

Later, Muddy Waters would talk about Johnson's ability to play almost any kind of style, and "Malted Milk" (which refers more to beer-type malt than what comes from a cow) was a good example. The tune is a copy of Lonnie Johnson's "Live Saver Blues" and it includes a verse from "Blue Ghost Blues." Lonnie's smooth and sophisticated tones were a long way from the Delta, but Robert brings the song off extremely well.

"Little Queen of Spades" answers Peetie Wheatstraw's "King of Spades" with a protofeminist gender inversion wherein Robert admires a woman gambler. "From Four Until Late" is a smooth ballad with a Piedmontese ragtime guitar sound. Clearly, Johnson was trying to demonstrate his range.

There were also three masterpieces. "Love in Vain Blues" is in the Leroy Carr realm, but in its own way, it's a perfect portrait of lost love, a complete short story of the end of a romance—but this time, it's the woman who catches the train and blows town, leaving behind a distraught Johnson.

The sound of Johnson's voice in "Stones in My Passway" defines existential dread. "I got stones in my passway and my road seem dark as night . . . I have pains in my heart / they have taken my appetite." Playing slide guitar, when he sings the word *heart* he stings a quavering note that seems to shimmer as it reverberates and sinks into your chest cavity.

Finally, there's the song that for so many critics documents a super-natural connection in Johnson's music, "Hellhound on My Trail." Derived melodically from Skip James's "Devil Got My Woman" and using James's open-E tuning, the song includes a reference to "hot foot powder" sprinkled around his door, suggesting voodoo to some—although I would suggest that it's more about the conventional meaning of a hot foot. Wald also suggests that because "Hellhound" was recorded in the second session, it was a lesser item in Johnson's repertoire. There are a number of other possibilities; that he wrote it in the interval, or as Stephen LaVere suggested, he had to get in the mood or that he simply saved his best for last.

None of that really matters. Johnson sings "Hellhound" in Skip James's very high range, whether consciously as homage, or with some other plan in mind, and the result is a tour de force of anxiety, a hymn to fear. If your skin doesn't crawl at some point in listening to it, you aren't paying attention. "Blues falling down like hail" is simply one of the most effective similes in the history of the blues. It's no surprise that on first hearing it in the early 1960s young critics attributed super-natural power to the song, although there's no inherent need—the hellhound could simply be the cops. Their take is at the least a tribute to the power of the material.

Having completed his second recording session, Johnson returned to the Delta and wandered on, coming that fall to Itta Bena, where he met a bluesman by the name of David "Honeyboy" Edwards. Honeyboy was not destined to become a famous musician, in part because he recorded very little. He said of himself, "I used to run around a whole lot and one of the things I missed was recording . . . I liked to gamble more than I did playing, because I could always beat somebody out in a levee camp or somewhere, and I made more money gambling." What actually would become the most famous moment in Honeyboy's life was his presence with Johnson in Greenwood, Mississippi, in August 1938.

Greenwood was a substantial city as Delta towns went, the former home of the late (he'd died in 1930) James K. Vardaman, governor and senator, who'd once announced, "We would be justified in slaughtering every Ethiop on the earth to preserve unsullied the honor of one Caucasian home." Greenwood had a substantial black district, Baptist Town, and apparently Johnson spent a good part of 1938 there. He played a show most likely some time in July at a jook joint located at the T intersection of Highways 49 and 82. He got sick. He died on August 16.

Over the years, Honeyboy's testimony has grown details with repeated questioning. His original remarks were that Johnson had died in Itta Bena, then later he said Greenwood, a fact confirmed by the death certificate. The cause of his death is one of the mysteries; so, for quite a while, was the location of his grave. A note on the back of the death certificate from Cornelia J. Jordan, Leflore County registrar, states that she asked the plantation owner "on whose place this negro died" for his opinion of the cause and that he suggested syphilis. Given the planter's lack of a medical degree and the fact that Johnson was a stranger passing through his land, that doesn't seem terribly credible.

Honeyboy and others advanced the theory that a jealous husband had poisoned Johnson. That's certainly romantically right, but there's little proof. Researcher Stephen LaVere's evidence suggests that he was poisoned and then caught pneumonia, was taken to a place north of Greenwood at Star of the West Plantation, and died there.

Dr. Patty Johnson, a health care professional, blues producer, and consultant, has a less romantic view of the death. Her friend Willie Coffee had been a boyhood pal of Johnson's, and Willie understood the death to be from pneumonia.

The two reliable facts of Robert Johnson's symptoms were that he died in great pain and at the end in dementia. Patty suggests that this could be from multiple organ failure, either from pneumonia or some other cause; the shutdown of kidneys and liver is extremely painful,

and dementia is a consequence of sepsis. In that sense, Johnson was indeed poisoned—by his own body. It's all speculation, and it will remain so.

No fewer than three sites have been cited as Johnson's burial place, although Stephen LaVere finally located an eyewitness named Rose Eskridge who stated that he was laid to rest north of Greenwood (the other two are west of town in Quito and Morgan City) at the Little Zion Missionary Baptist Church. LaVere donated the marker there.

So we're not entirely sure of his cause of death and there's confusion about his place of burial. Mystery begets mystery. Throw in hints and allegations of the supernatural, and the legend of Robert Johnson was established. Just as Johnson was being buried, the critic John Hammond, having heard his releases and then been impressed by the masters of Johnson's work stored at Columbia in New York City, decided he would be ideal for a concert he was planning and began looking for him. He wouldn't be the last.

Having made little impact on the black record-buying world, Johnson left the earth having seemingly left no mark. Twenty-three years later he, or at least his music, would rise again—with a vengeance.

"Spirituals to Swing" and After

DANNY BARKER, WHO in the 1930s was Cab Calloway's guitar player, told a particularly revealing story of working at the Nest Club, a Harlem after-hours joint. Business would be dead when the doorman buzzed three loud rings to indicate that they had prospects coming. The band would strike up "Oh, Lady Be Good," the waiters, all smiles and movement, would start beating on their trays, and the unsuspecting party would enter "amid finger-popping and smiling staff. ('Make believe we're happy.') . . . and then the show on the stage starts . . . Whites would come to Harlem to see this massive act of put-on make-believe." Barker thought of Harlem as "special slave quarters."

In contrast, on December 23, 1938, some of the very best black musicians in America played Carnegie Hall. Though there was misinformation and the very act of selection was influenced by cultural bias, the music was legitimate and the audience was given a superlative tour through the history of African American music. It was the brainchild of John Henry Hammond, a man who would dramatically influence white America's knowledge and appreciation of black music from the 1930s on.

Born in Manhattan in 1910, he was raised in a six-story mansion in the East Nineties with two elevators, a ballroom, a squash court on

the fourth floor, and sixteen servants. Hammond would also inherit his Presbyterian mother's ambivalence concerning the truly extraordinary wealth of the Vanderbilts, writing, "She inherited the guilt they never felt themselves" as he followed in her reformist footsteps. He also inherited her love of music and began listening to the servants' Grafonola record player, which introduced him to Paul Whiteman, the Original Dixieland Jazz Band, and what was called "race" music. On a 1923 trip to London he saw the African American stage show *Dixie to Broadway*, which starred Florence Mills and featured Sidney Bechet in the band. Once back home, John began going to Harlem, not far from his Ninety-First Street house, to buy "Worried and Lonesome Blues" by James P. Johnson and Bessie Smith's "Saint Louis Blues" with Louis Armstrong.

By his early teens he was sneaking out to the Lincoln Theater in Harlem to see the cream of black talent. At Yale, in the fall of 1929, he became a prominent figure in the hot jazz movement and quickly came to understand the political implications of his good taste.

"Despite the influence of early teachers, the books I read, and what I had seen for myself in the South, the strongest motivation for my dissent was jazz. I heard no color line in the music. While my early favorites were white players, the recorded and live performances of Negroes excited me more. The fact that the best jazz players barely made a living, were barred from all well-paying jobs in radio and in most nightclubs, enraged me. There was no white pianist to compare with Fats Waller, no white band as good as Fletcher Henderson's, no blues singer like Bessie Smith, white or black. To bring recognition to the Negro's supremacy in jazz was the most effective and constructive form of social protest I could think of."

After dropping out of college and moving to Greenwich Village, he financed some recording projects and wrote about black musicians for the English journal *Melody Maker*, worked with John Dos Passos and Edmund Wilson in support of striking miners in Harlan County, Kentucky, and then covered the trial of the Scottsboro Boys for *The*

Nation. In the course of the trial he became acquainted with NAACP president Walter White and soon become a member of the NAACP Board. It was a comfortable fit for him as an aggressive but not doctrinaire civil rights activist.

Hammond's idea for a formal music history lesson at Carnegie Hall had a successful dry run earlier in the year with Benny Goodman's triumphant concert there, and now Hammond went all out. "From Spirituals to Swing" would be sponsored by *New Masses*, which promised not to use it ideologically—evidently, the NAACP was unsure about aligning itself with popular musicians.

The show came with a lengthy formal program, which included advertisements for the starving children of Spain, the Commodore Music Shop, and the Soviet Film Group. There were points in Hammond's essay "The Music Nobody Knows" that delineate the limits to his largely sophisticated and positive point of view. Noting that the music "has thrived in an atmosphere of detraction, oppression, distortion, and unreflective enthusiasm," he cites the Austin High Gang approvingly and maintains his purist hot jazz roots by calling it "the most important cultural exhibit we have given the world" even as he dismisses jitterbuggers and commercial swing.

That's largely a matter of taste. Certain misstatements of fact are more troubling. Though a number of knowledgeable people had contradicted his version of the death of Bessie Smith, he repeated the same misinformation he'd printed on deadline the year before. Thirty years later he would maintain that stance in his memoirs, never entirely conceding that he'd been mistaken. That Hammond was, as he noted in his memoirs, a virgin on his wedding night documents a certain puritan righteousness to his personality.

Hammond's description of Johnson in the program as shy, that "I don't believe that Johnson had ever worked as a professional musician anywhere," can be attributed to Don Law, his (and everyone's, at this point) primary source. God only knows who made up the melodrama

that Robert Johnson "died last week at the precise moment when Vocalion scouts finally reached him and told him that he was booked to appear at Carnegie Hall," so perhaps that wasn't Hammond's responsibility. But his later description in his memoirs of how Bill Broonzy, "who farmed in Arkansas with a pair of mules, shuffled out and sang about a dream," was not consistent with a man who'd been in Chicago for nearly twenty years. And Hammond's reaction to Ida Cox, who was a huge hit in the 1939 follow-up show, wearing "heavy make-up and false eyelashes, not exactly what I thought a blues singer should look like," was another example of a paternalistic as well as puritanical tinge to his mentality.

The major flaw with "Spirituals to Swing" was who was missing. The greatest black musician in America, Louis Armstrong, didn't get invited, presumably because his act was too pop and didn't comport with Hammond's idea of blackness. Apparently, more or less the same is true of Duke Ellington. It's certainly true that Hammond controlled the narrative, although how this music could have gotten to the mainstream public in anything resembling genuine form without someone like Hammond is a mystery.

What the above-capacity audience did get was rich. He opened the evening by playing a recording of African drumming before giving way to Albert Ammons, Meade "Lux" Lewis, and Pete Johnson playing jumpingly percussive boogie-woogie piano, the "Honky Tonk Train Blues." Next came gospel star Sister Rosetta Tharpe's "Rock Me" and "That's All," her swinging, shouted vocals backed by her own guitar and James P. Johnson on piano. Bessie Smith's niece Ruby stood in for the fallen Empress—the evening was dedicated to her—with "Nobody Knows You When You're Down and Out." Mitchell's Christian Singers ended the spirituals segment with powerful call-and-response, solo/ensemble interplay on three songs, including "What More Can My Jesus Do?" Sonny Terry's "Fox Chase" demonstrated the remarkable range of the harmonica.

The music turned to New Orleans. James P. Johnson, Tommy Ladnier, Sidney Bechet, Dan Minor, Jo Jones, and Walter Page (the last three from Basie's band) performed "Weary Blues" and two other songs as the New Orleans Feetwarmers. The rhythm section and Minor stayed on stage, joined by Buck Clayton, Lester Young, and Leonard Ware on electric guitar as the Kansas City Six, doing more recent jazz classics like "Oh, Lady Be Good." Bill Broonzy, backed by Albert Ammons on piano, Jo Jones on drums, and Walter Page on bass, gave the audience his tragicomic "It Was Just a Dream" to close the first half of the show.

Fronted by his vocalists Jimmy Rushing and Helen Humes, Count Basie brought his band out and tore the place apart with a set that included a jam session with James P. Johnson and Sidney Bechet and a reunion with former Basie band member Hot Lips Page. The show closed with Basie's hit song, "One O'Clock Jump," and the audience went home exceedingly happy. But the music didn't stop there.

After the show, many followed Hammond down Broadway to the opening of a new nightclub in the Village, Café Society, which that evening featured Billie Holiday, Teddy Wilson, comedian Jack Gilford, and a boogie-woogie group. Hammond, who would book the entertainment there, had met the owner Barney Josephson that summer. They shared a desire for an integrated, politically hip nightclub, what Josephson would term "The Wrong Place for the Right People." The club was groundbreaking in its politics and managed to keep a high standard in its art. Holiday would debut her haunting antilynching anthem "Strange Fruit" there; Hammond thought it too polemical and wouldn't record it, although he allowed her to go to another label to do so.

"Spirituals to Swing" had yet another significant spinoff. A month after the Carnegie concert, a refugee from the Nazis named Alfred Lion and his friend Francis Wolff started Blue Note Records to record Albert Ammons and Meade "Lux" Lewis, fueling a boogie-woogie fad

that (along with Tommy Dorsey's 1938 "Pine Top's Boogie Woogie") would bubble through the next several years.

"Spirituals to Swing" was a major event in the introduction of black music to white people in New York, but, of course, it did not burst forth into a vacuum. Though jazz was by now a popular music—*the* popular music—the white people who first listened to black jazz saw it at least in part as folk music. Another example of this confused blurring of pop, folk, and race came with the introduction of Huddie "Lead Belly" (Lead Belly spelled his name as two words) Ledbetter to the city a few years before Hammond's concert, in 1935.

Huddie was born around 1888 in northwest Louisiana, spent time in the cotton fields, got a girl pregnant for the second time, and ran away to The Bottoms, the vice district on Fannin Street in Shreveport, where he sang everything—blues, church songs, breakdowns, work songs, ballads, pop, you name it. He tried farming for some years, and then settled in Dallas, where he took up the twelve-string guitar, prizing it for its volume in noisy bars. In 1918 he was sentenced to a term of seven to thirty years in Sugar Land, Texas, state prison for murder and was released in 1924 after six years served. Six years later he knifed a white man, which put him in Angola, Louisiana, prison for a stretch of six to ten years as prisoner #19469.

In June 1933, Ledbetter was called to the warden's office and introduced to a folklorist from Texas named John Lomax, a meeting that would change both their lives. As a boy, Lomax had become friendly with a black man who worked on his father's ranch on the Chisholm Trail, in the process learning a number of African American songs along with the cowboy songs that were all around him. After attending a small college and a stint of school teaching, Lomax entered the University of Texas in 1897 at the age of thirty and eventually went to Harvard to do graduate work. There, George Lyman Kittredge, the intellectual heir to Francis Child as a folklorist and musicologist, thought that cowboy songs were an excellent

topic for study and got Lomax a fellowship. Though Lomax ignored many academic standards—he edited songs without saying so, cited no sources, and seemingly did a large part of his research by mail— his *Cowboy Songs and Other Frontier Ballads* put him in the Child song-collecting tradition.

Returning to Texas, he took up other work until his wife died in 1932. Feeling the need for a new start in life, he resumed song collecting. Equipped with a contract from Macmillan for another folk song book and some grants from the Library of Congress that covered a "portable" recording device that weighed several hundred pounds, he set out to find authentic, uncorrupted African American folk songs, which made him one of the first folk music scholars in America other than Zora Neale Hurston in that field. Having decided that the most fertile place for such material would be in prisons, where he presumed the singers were isolated from popular culture, he arrived at Angola and met Huddie Ledbetter in 1933.

Though he found a treasure trove of songs in Huddie, the idea that the man was an uncontaminated folk source was ludicrous, and Lomax should have known that. He'd already had one of his discoveries, "Home on the Range," debunked as a folk song by a lawsuit that concluded that a Kansas doctor had composed it in 1873. Within Lead Belly's own repertoire, "Alabama Bound" was a folk song, but the "Backwater Blues" he sang had been written by Bessie Smith, and "Tight Like That" by Tampa Red. And the song that would make him famous, "Goodnight Irene," may well have been taught him by his Uncle Bob, but it had been written by a man named Gussie Davis and circulated widely in the minstrel show world of the 1880s.

Lomax had thought of the cowboys as nineteenth-century chivalrous knights, and he did not lose his romanticism with Huddie. He ignored evidence to the contrary and presented Lead Belly as the pure embodiment of a new folk canon, a black one full of richly engaging songs. In a letter from that time, he wrote, "The songs would make a sensation

in cultured centers if it were possible to present them in their native, primitive style." His later autobiography would be titled *Adventures of a Ballad Hunter*, and he clearly saw himself in a Hemingwayesque Great White Hunter light, complete with black porters.

Soon after Lomax's visit, Ledbetter was released from prison for good behavior (and not, as Lomax would later claim, because Lomax had delivered a recorded plea from Lead Belly to the governor). Needing a job, he applied to Lomax. Lomax's son Alan had been his driver, but Alan was ill, so Huddie assumed the role. He also acted as an intermediary for Lomax with other prisoners. Lomax's deliberate blindness to the appalling conditions in Southern prisons remains troubling. After a 1931 exposé by John Spivak titled *Georgia Nigger* made access to prisoners difficult for Lomax, he would write his wife-to-be, "the hospitality of the Prison Board has been shamefully abused by visitors from the North." He also made sure to expunge from his own field notes anything that smacked of criticism of the prisons.

Lomax's ambitions grew, and he decided to act as impresario and present Lead Belly's story to the world. As part of the promotion for his newly published *American Ballads and Folk Songs*, Lomax had Huddie perform at the late-December 1934 Modern Languages Association conference in Philadelphia as well as at a tea at Bryn Mawr. Their PR blitz presented Lead Belly as authentic and original, but exotic—an untamed animal newly freed from prison. They even required that he perform in convict garb or bib overalls, although he was in fact a very dapper dresser.

Signing Huddie to a management contract that called for a fifty-fifty split, Lomax then brought his son Alan into the deal so that Huddie was getting one-third. They quickly signed a recording contract with Art Satherley at ARC and Huddie set to work. Unfortunately, Satherley saw him as a blues singer for race records (after all, he was black, wasn't he?), ignoring the media buzz that showed him as the link between nineteenth-century folk music—he was singing things like

"Bring Me Little Water, Silvy" and "Take a Whiff on Me"—and the contemporary era of radio and recording. Though he recorded forty songs for Satherley, many of them older and traditional, only the country blues would be released.

Withdrawing to a borrowed house in Connecticut, the Lomaxes undertook to train Lead Belly in how to perform in front of white people. They worked to clarify his diction and began to create what John would call *cante fables*, storytelling introductions to be interspersed with the songs that would help white audiences connect—show biz, in other words. They discouraged any song that didn't correlate with blues, blackness, or prison life. Lead Belly wanted a career and was certainly a willing collaborator in this part of the process.

Lomax would claim that the friction that arose between them and Huddie was because they wanted to keep Huddie's music pure, writing home that "We [Alan and I] are disturbed and distressed at his beginning tendency to show off in his songs and talk when his money value is to be natural and sincere as he was while in prison." Lomax also wrote to a friend at this time, "Leadbelly is a nigger to the core of his being. In addition he is a killer. He tells the truth only accidentally . . . He is as sensual as a goat."

Their arrangement swiftly came unglued in Buffalo when Huddie pulled out a knife in the course of negotiations. Per their agreement, the Lomaxes claimed two-thirds of his concert earnings and deducted his room and board. After settling, Huddie was to receive $300 from a $1,500 gross, half in cash, half in postdated checks. Huddie went back to Louisiana, hired a lawyer, and eventually won a better settlement, but in the meantime Lomax had copyrighted Lead Belly's songs in his own name.

Because he could not perform on the radio until his suit over copyrights was settled, Lead Belly was unable to capitalize on the book of his songs published in 1936. *Negro Folk Songs as Sung by Lead Belly* was already hobbled by a title imposed by George Herzog, the

Columbia ethnomusicologist who had transcribed the songs, but it was still the first book about an individual folk singer published in America. It also produced a new nadir in PR, an April 1937 piece in *Life* titled "Bad Nigger Makes Good Minstrel."

Lead Belly's image tapped into the Depression-era celebration of outlaws (Bonnie and Clyde, John Dillinger, Pretty Boy Floyd) and the marginalized common man, part of a continuum that included Steinbeck's *The Grapes of Wrath*, James Agee and Walker Evans's *Let Us Now Praise Famous Men*, WPA murals, and the Popular Front. The Folk, in fact, had become a central element of the New Deal, with the Resettlement Administration (Charles Seeger), the Writers' Project (B. A. Botkin), and the Federal Music Project (Seeger again) all including folk music as elements of their work. There were folk concerts at the White House, most notably featuring Josh White and Bascom Lamar Lunsford. Folk music had become part of the nation's official culture. Having grown tired of workers' choruses and other such stale "proletarian" art, the political left reached out to a genuine refugee from the American South and adopted Lead Belly.

Returning to New York in 1936, he hooked up with Mary Elizabeth Barnicle, an NYU folklore professor he'd met through Lomax, and her roommate Margaret Conklin, dubbing them Conkle and Bonkle. Though not a party member, Barnicle was an activist and moved in left circles. She helped him find jobs and introduced him around, among others to Margot Mayo, founder of the American Square Dance Group (which also sang folk songs), and Aunt Molly Jackson, a Kentucky miner's wife who'd come to New York in 1929 to raise funds for miners.

Soon Lead Belly connected with a young Richard Wright, who wrote him up as a people's artist in the *Daily Worker*, including a blistering attack on Lomax, "one of the most amazing cultural swindles in American history." The left gave Lead Belly an audience, but ideology and art don't mix well; when he went to the party's Camp Unity and

sang "Ella Speed" and "Frankie and Albert," the doctrinaire among them weren't sure whether to censure Huddie or his host, or both.

He began singing protest and topical songs, and when he and a number of white people with him, including Barnicle, were refused service on a visit to Washington, D.C., he responded with "The Bourgeois Blues." There was also a song about the Scottsboro Boys. By late in the decade, he was a regular part of a circle of politicized left-wing folk singers, but it was as much of necessity as anything else. His race defined him as a blues singer, but his audience was white. The left thought of him as pure and anticommercial (doing the same with Woody Guthrie, ignoring his long career in radio), but his "purity" wasn't for lack of trying, just lack of success. He was stuck, and would effectively remain caught in this dilemma for the rest of his life. In truth, he was neither a purist folkie nor exclusively a bluesman. He was an entertainer, but only the (mostly) white left would have him.

By now and dating back at least to the IWW in 1910, the very concept of folk music had become indissolubly welded to the idea of a proletarian left movement. All this was perfectly summed up in Woody Guthrie's "This Land is Your Land," written on February 23, 1940, in response to hearing Kate Smith sing "God Bless America."

Ten days later, the folk song movement had its official commencement. On March 3, 1940, the actor Will Geer (then on Broadway in *Tobacco Road*) organized a "Grapes of Wrath Evening" to raise money for California migrant workers. It was a midnight show at the Forrest Theatre, where *Tobacco Road* was running, and featured Geer, Alan and his sister Bess Lomax, Aunt Molly Jackson, Lead Belly, the Golden Gate Quartet, Woody Guthrie, Pete Seeger, and Margaret Mayo's Square Dance Group. It was a watershed moment—Woody Guthrie's introduction to New York and Pete Seeger's debut as a performer. And it was a triumph.

That year Lead Belly would work on an Alan Lomax radio show on CBS, "The American School of the Air"—his conflicts with his old

"managers" had always centered on John Lomax, so he found it easy
to forgive Alan; besides, he needed the work. He recorded for RCA
Victor and then Folkways and finished a major recording project at the
Library of Congress with Lomax. Shortly after the Will Geer Benefit,
Huddie and his wife, Martha, would invite Woody Guthrie to stay
with them in their apartment on East Tenth Street, sealing a socio-
cultural relationship with the folk movement that would endure until
Huddie died.

The ongoing heart of that folk movement would prove to be
Woody's protégé Pete Seeger. Born in 1919, Seeger was the son of
composer and ethnomusicologist Charles Seeger, who despite his left-
wing politics had given his son as isolated and repressed an upper-
class New England childhood as one could imagine. Pete would
become an heir to transcendentalism, reverent toward nature, con-
temptuous of materialism, and morally committed, better "with ideas
and enthusiasms," wrote one biographer, "than with intimacy." He
began playing the ukulele at eight and then became hooked on the
four-string tenor banjo in boarding school, playing jazz standards in
the hot jazz tradition while he read Mike Gold and *New Masses* and
learned about "people's music." In 1935, Seeger père took his son
to Bascom Lamar Lunsford's Mountain Dance and Folk Festival in
Asheville, North Carolina, where Pete saw and heard the five-string
banjo and indigenous people's music for the first time. His future
became clear.

Dropping out of Harvard, he fell into the New York left-wing
folk circle and began a lifelong study of the folk canon, initially as
a student of Lead Belly, then progressed through an even wider slice
of the canon by means of a job helping Alan Lomax catalog and
transcribe his collection. Seeger developed a flexible, gentrified varia-
tion on the original folk frailing style of playing banjo, and grew. In
February 1941 he joined with Lee Hays and Millard Lampell to form
the Almanac Singers.

▼ Mark Twain, who made Thoreau's impulse toward freedom real in fiction.

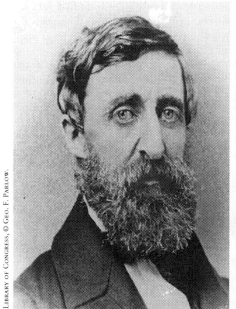

▲ Henry David Thoreau, America's first great social critic and the spiritual source for American dissent ever after.

▶ Twain's boyhood home. Nowadays, it's the Tom Sawyer fence that gets the most attention.

▶ The River at Hannibal. No one ever captured it better than Twain.

▼ The minstrel era, America's first encounter with black music.

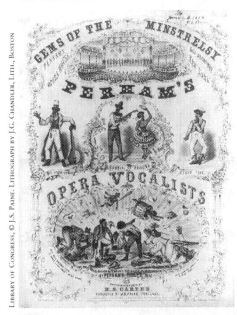

▼ The ring shout: how African Americans retained their identity.

▲ The Fisk Jubilee Singers, who presented black music as art music with gravitas.

▼ Bert Williams and George Walker, great entertainers enslaved in the tradition of blackface.

▼ Scott Joplin, the first great black American composer.

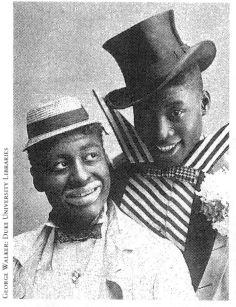

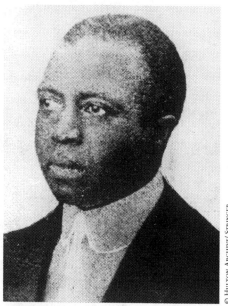

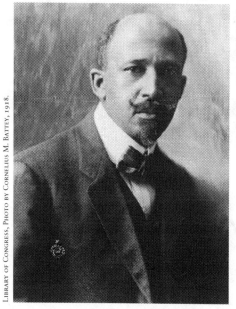

▲ W. C. Handy and His Orchestra. Handy was the intermediary between the primal blues and the white world of sheet music and copyrights.

▲ W. E. B. Du Bois, whom I often think must have been the loneliest intellectual in America in 1903, since much of what he said wouldn't be fully appreciated for many years.

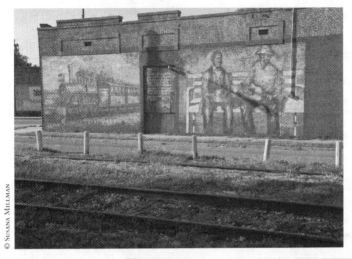

◄ The wall in Tutwiler, Mississippi, that depicts Handy's encounter with the blues.

© Susana Millman

▶ "Where the Southern Cross the Dog," the intersection of the Yazoo and Southern railroads in Moorhead, Mississippi.

© Susana Millman

◄ Dockery Farms, early home of Charlie Patton.

© Susana Millman

▼ Charlie Patton's gravestone. He was known as the first great country blues singer.

▼ The view from Patton's gravestone.

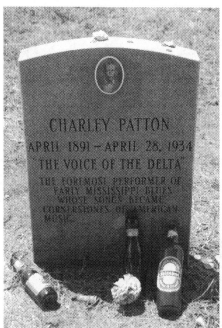

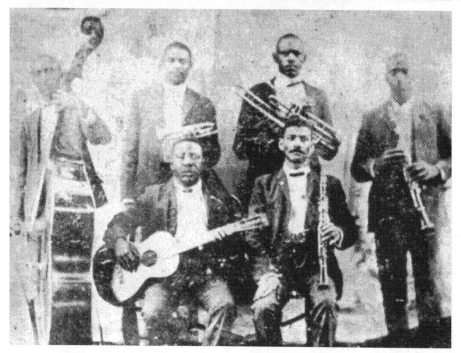

▲ Charles "Buddy" Bolden and his band . . . if not the creators, they're the ones their peers chose to remember.

▼ Louis Armstrong. The Master.

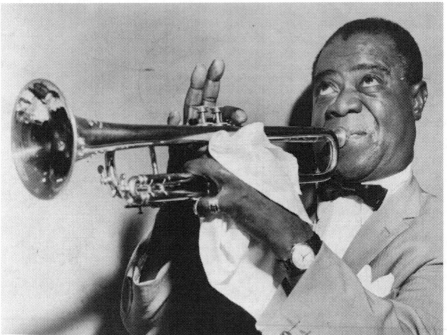

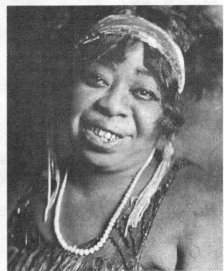

▲ Joseph "King" Oliver, his mentor. ▲ Ma Rainey, Queen of the Blues.

◄ Bessie Smith, as portrayed by Carl Van Vechten. There was a reason they called her the Empress of the Blues.

▼ The Original Dixieland Jazz Band, who introduced the word "jazz" to the wider world.

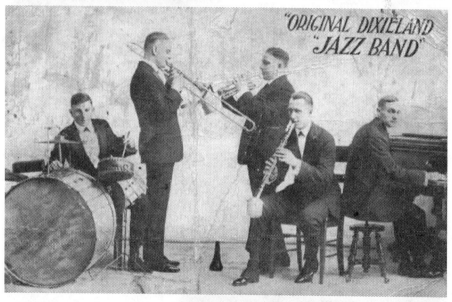

▶ Paul Whiteman, the so-called "King of Jazz." He definitely knew the right people to work with.

▶ Bix Beiderbecke, the doomed hero of early jazz.

▼ The Austin High Gang, the true believers who would take jazz into the wider world.

▲ Jimmie Rodgers, "Father of Country Music," whose sources were interestingly varied.

▲ Willie "The Lion" Smith, master stride pianist and incredibly interesting man. Read his autobiography, *Music on My Mind*.

► Parchman Farm.

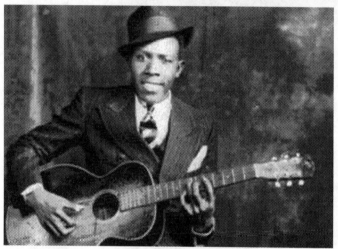

◄ Robert Johnson, the most vital "ghost" in the history of American music.

► It is possible that this is the cabin in which Johnson died; now part of Tallahatchie Flats, north of Greenwood.

▼ John Lomax, pioneer American musicologist. Promoter of Lead Belly.

▼ His son Alan Lomax, who would be the first to record Muddy Waters and promote folk music both in the U.S. and England.

▲ John Hammond, critic and producer, who consciously advanced black music as a way of civilizing America.

▲ Huddie "Lead Belly" Ledbetter and his wife Martha, taken during the time he was being coached by the Lomaxes.

▼ Woody Guthrie, one of the fundamental voices of the American people in the 1930s and 1940s.

▼ Pete Seeger, Woody's first heir, who would keep America singing well into the 21st century.

◄ Thelonious Monk, the composer who made jazz into art music while never leaving its roots behind.

◀ Muddy Waters, the bridge between rural acoustic blues and the electric Chicago blues of the '50s.

▲ Chester "Howlin' Wolf" Burnett, Muddy's only peer, The Voice. "Stronger than 40 acres of crushed garlic."

◀ Ahmet Ertegun and Jerry Wexler, mainstays of Atlantic Records, who introduced R & B and early rock to a wider America.

▼ Elvis Presley, the white guy who was the heir of black music.

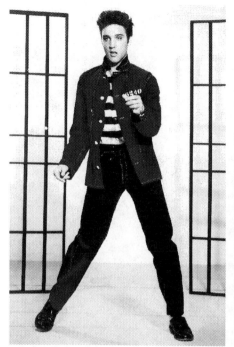

▼ Chuck Berry, who put the guitar at the center of rock 'n' roll.

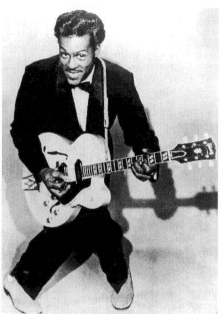

EMMETT TILL
Multi-Purpose Complex
Tallahatchie County Parks & Recreation Dept.
Tourism

▲ Emmett Till's name has not been forgotten in Mississippi.

▶ John Coltrane, who helped Miles move jazz . . . and then moved it into another stratosphere.

▼ Miles Davis, who brought jazz to the center of American culture.

◀ The Butterfield Blues Band, heirs to the Austin High Gang and Muddy and Wolf's Chicago electric blues—a highpoint of black/white musical reconciliation.

▶ John Hurt was the great success story of the Blues Revival. His OKeh recordings in 1928 went nowhere, but he delighted audiences in the 1960s.

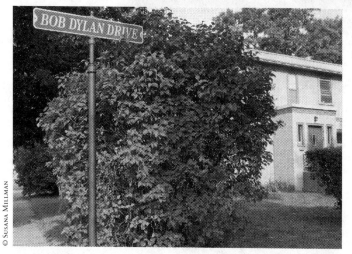

© Susana Millman

◀ Bob Dylan's childhood home in Hibbing. The street sign's recent.

▶ The Hull-Rust-Mahoning mine, one of the greatest man-made holes ever made.

© Susana Millman

▼ Bob Dylan and Joan Baez at Club 47 in Cambridge.

▼ Joan Baez and Bob Dylan at Newport, 1964. Dylan is playing Joan's guitar.

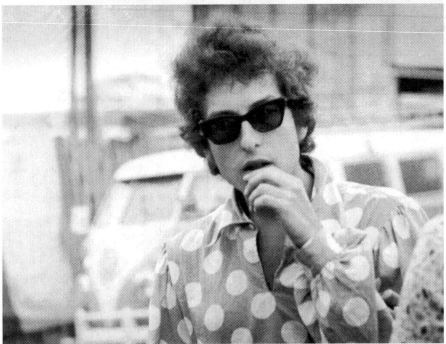

▲ Bob Dylan goes rock 'n' roll at Newport, 1965.

The Almanacs had many floating members and were based largely at a communal household at 130 West Tenth Street, where the cream of the New York folk world would come to play, including Lead Belly, Woody Guthrie, Josh White, Sonny Terry, and Brownie McGhee. The color boundaries in American folk music imposed by Cecil Sharp and the other musicologists at the turn of the century did not exist on Tenth Street. Black and white players were all familiar with black music as well as the Anglo strains of mountain music. Everyone studied Lead Belly, but Lee Hays, for instance, had already spent two years at a labor college in Arkansas and learned a great deal of Southern black music in the process.

There were different flavors within black music. Josh White, for instance, had begun as a lead boy for John Henry "Big Man" Arnold in the Carolinas and ended up as a Piedmont-influenced guitarist with a smooth, urban vocal style. He'd recorded with Paramount in the late '20s and then with ARC. When a hand injury prevented him from playing for several years, he got a job in Paul Robeson's *John Henry*, a politically progressive 1940 Broadway play about the folk character. It flopped, but put White in the center of the New York left folk scene. He recorded for Blue Note with Sidney Bechet, played Café Society, formed a quartet that John Hammond signed to Columbia, and recorded an album called *Chain Gang* for the white liberal audience. He became a musical favorite and personal friend of President Roosevelt's, and would also play guitar on the first Almanac album, *Songs for John Doe*.

Guthrie was from Oklahoma, the son of a genteel family shattered by his mother's dementia and a fire that killed his sister. Set to wandering, he'd encountered radical politics and become a self-educated intellectual as well as a country-western professional, a man of words and a natural songwriter who was obsessive—he was known to play a record one hundred times over—about his studies of Blind Lemon Jefferson. Though he was, along with Seeger, a Communist Party member, he

was far too much of an individual to be trusted by the party structure, which found his opinions unreliable. At heart he was an heir of Walt Whitman, with a vision, said one biographer, that was "pastoral and mythical, echoing Christian eschatology and rooted in the Gospel according to Matthew."

Almanac House became a progressive nexus, bringing together people like Nicholas Ray, the producer of Alan Lomax's radio show and later the director of *Rebel Without a Cause*, mystery author Dashiell Hammett, the painter Rockwell Kent, and people from *New Masses*, along with the painters Jackson Pollock and Willem de Kooning, the acting teacher Stella Adler, and the actor Franchot Tone. When Hitler invaded the Soviet Union in June 1941, the party line reversed itself; peace songs gave way to Guthrie's "Reuben James," which honored the first U.S. ship sunk in World War II.

As what would become World War II approached, the attention of white music fans to black music had become widespread and complex. Hardly twenty years after the Austin High Gang first saw the value of black music, there were now a number of major subgroups. Jazz fans understood the black roots of jazz and were growing curious about blues, in some ways the mother of jazz. The record collectors wanted to study in depth the divide between jazz and blues—how it had happened and how valid it was and wasn't. The socially disaffected, the urban hipsters, were reaching out into African American music, both jazz and blues, for some sort of affirmation of the American experience that didn't involve kowtowing to authority. Folk music fans listened to Lead Belly and Josh White and began to see the artificiality of any separation between so-called white folk and black blues.

Inside the folk music world, black and white had so combined that the edges had become thoroughly blurred. In other forms of black music, things were about to undergo a major mitosis. The acoustic rural blues had come to some sort of apotheosis with Robert Johnson; no one of towering creative ability would succeed him in the genre.

Instead, the rural blues would trace the path of the great migration and land in Chicago, where the players would add electricity and do something somewhat different.

Big band jazz had achieved a remarkably high status as a popular music that was often played at the very highest level. Now it would throw off two different small-group derivations. One would start with the Kansas City blues shouters like Jimmy Rushing and Joe Turner, emphasize entertainment values, and come to be called rhythm and blues. And one would take jazz and turn it inward into art music, diving into vast depths of rhythmic and harmonic complexity. It would take its name, the consensus holds, from the nonsense syllables of scat singing, and be called bebop, bop for short.

17

Bop and the Music of the '40s

IN DECEMBER 1939, an unemployed saxophone player named Charlie Parker and a guitarist named Bill "Biddy" Fleet sat in Dan Wall's chili joint on Seventh Avenue between 139th and 140th Street jamming on the chord changes to "Cherokee." Parker, who would soon become known as "Bird," was from Kansas City and had been playing with a small group led by pianist Jay McShann. After Bird briefly landed in jail, he'd moved on to New York, where he was washing dishes at Jimmy's Chicken Shack, mostly for the chance to listen to Art Tatum there, and playing in dime-a-dance halls. Fleet wasn't necessarily a great guitarist, but he knew a lot about harmonic theory, and his voicings were unique. "I'd play the original chords to the tune, and I'd invert 'em every one, two, three, or four beats so that the top notes of my inversions would be another tune," said Fleet. "And Bird had a big ear, and he listened. He say, 'Biddy! Do that again!'"

Parker grew fascinated with the higher intervals of chords, a harmonic area that included fifths, ninths, elevenths, and thirteenths, which to this point had largely been ignored as dissonant and obscure. Seized with a quasi-Faustian ambition to play through all of a song's potential chord changes, Bird found that "by using the higher intervals of a chord as a melody line and backing them with appropriately

related changes, I could play the thing I'd been hearing. I came alive."
Soon after, he got a telegram telling him that his father had died, and
he returned to Kansas City. He spent two years in Jay McShann's big
band, then joined Earl Hines in November 1942.

One of the other members of Hines's band was a young man from
South Carolina named John Birks "Dizzy" Gillespie. Danny Barker,
who'd been playing with Dizzy in Cab Calloway's band for the previ-
ous couple of years, would remark that Gillespie "wasn't dizzy at all,
just young, vigorous, and restless . . . He would play and experiment
with what seemed to me to be distant sounds and extensions—surpris-
ing things . . . He went out through the front door, went round the
house. You expect soloists to make a familiar pattern, but when you
expected him to come in the back door, he came in the side through
the window."

Dizzy would invite Danny to jam sessions at a club called Minton's
in Harlem, but Danny was a fairly old-fashioned player and found
himself out of his depth. Even so, he was fascinated with what he was
hearing there. Minton's Playhouse, which had become the epicenter of
musical creativity in jazz, occupied the ground floor of the Cecil Hotel
at 210 West 118th Street. It had a bar in front and a cabaret with
a stage in the back, the wall covered with "strange paintings depict-
ing weird characters sitting on a brass bed, or jamming, or talking to
chicks," recalled the pianist Mary Lou Williams. It had been founded
in 1938 by Henry Minton, the first black delegate to the Musician's
Union, which was significant, since the union fined players for taking
part in unpaid (and therefore not subject to union dues) jam sessions;
Henry and his place had immunity. He treated it as a club for musi-
cians and not customers and was generous with food for the players,
so they liked hanging out there.

He hired bandleader Teddy Hill as musical director, and Hill
brought in Kenny "Klook" (his nickname came from a drum term)
Clarke to play drums. Clarke viewed Teddy as "a benefactor since

work was very scarce at that time. Teddy never tried to tell us how to play. We played just as we felt." The pianist at Minton's was a young New Yorker named Thelonious Sphere Monk who'd been raised on San Juan Hill, a black neighborhood in the West Sixties, where one of his neighbors was James P. Johnson. When his sister got piano lessons, Monk was the one who benefitted. After touring with a woman evangelist, he returned to New York where he won the amateur musician contest at the Apollo Theater so often he was banned.

His extraordinarily distinctive and highly percussive playing and composition style, which Mary Lou Williams would call "zombie music . . . screwy chords that reminded us of music from *Frankenstein*," would introduce to jazz composition elements like the half-diminished chord, augmented chords, whole tone scales, and flatted fifths. Monk was a genius composer who found at Minton's an ongoing workshop, which was perfect for him. "I wanted to play my own chords. I wanted to create and invent on little jobs."

Monk *really* baffled Danny Barker: "At Minton's Monk and Kenny Clarke ("Klook-a-mop") set up a mind-boggling diffusion of rhythms and sounds. It was like going into sudden fast rapids in a canoe on the river of sounds, daring and dangerous." Benny Goodman's gifted guitarist Charlie Christian fit right in, and soon people like Lester Young would make a practice of stopping by. Minton's became a place where the coolness and creativity quotients were off the charts, which meant lots of lesser talents wanted in too.

"So on afternoons before a session," Dizzy explained, "Monk and I began to work out some complex variations on chords and the like, and we used them at night to scare away the no-talent guys . . . After a while, we got more and more interested in what we were doing as music, and, as we began to explore more and more, our music evolved." It should be added that when a legitimate player like Benny Goodman dropped by, they would "convert our style to coincide with his," said Clarke. "We did that for others too."

When Dizzy met Bird in Hines's band, he found a musical brother, although they had different approaches. Pianist John Malachi would play with the duo later and would recall running through a new song, "All God's Chillun Got Rhythm." Gillespie heard it and liked it, and asked John to call out the chord changes as he played. After a few choruses, he had it down. Bird walked in, and John started calling the changes. Bird said no thanks, "Just play the tune." That was the difference between the two; Dizzy had the formal grasp of architecture while Parker had an innate and intuitive genius; together with Thelonious Monk's compositional sense, they were about to take jazz to a new place.

"I think I was a little more advanced, harmonically, than he was," wrote Dizzy later. "But rhythmically, he was quite advanced, with setting up the phrase and how you got from one note to another . . . Charlie Parker heard rhythms and rhythmic patterns differently, and after we started playing together, I began to play, rhythmically, more like him . . ."

Bird was so profoundly rooted in the blues and so gifted that he made things seem effortless. What made him distinctive, thought Gillespie, was "his phrasing. And his bluesiness. He played blues better than anybody. I mean, he played blues like T-Bone Walker would sing, and then Bird would put some little extra things in there. He was the most fantastic musician I ever heard." Jay McShann agreed. "Bird could play anything because, primarily, Bird was the greatest blues player in the world." This fundamental connection to the blues was at the root of bop. This is what permitted Bird and Diz to play bop while touring the deep South with Billy Eckstine in 1944; "They're not particular about whether you're playing a flatted fifth or a ruptured 129th as long as they can dance," said Dizzy.

They had no name for it, said Clarke. "We called ourselves modern. That bop label started during the war." Wrote critic Gary Giddins, "Harmonically, bebop took the large, ineluctable leap from a diatonic,

riff-based music of few chords and fewer keys to a labyrinthine chro-
maticism with elaborate chord substitutions and a marked preference
for the diminished scale." It required virtuosity to play, and that was
just the harmony side. Where bop really challenged jazz was in the area
of rhythm.

Beginning with Kenny Clarke, bop drummers shifted from keeping
time with the sock cymbal of swing to the more subtle top or "ride"
cymbal. It happened, Klook said, accidentally: "We were playing a real
fast tune once . . . and the tempo was too fast to play four beats to the
measure, so I began to cut the time up. But to keep the same rhythm
going, I had to do it with my hand, because my foot just wouldn't do
it. So I started doing it with my hand, and then every once in a while
I would kind of lift myself with my foot, to kind of boot myself into
it, and that made the whole thing move." They called those accents
bombs, and they had an explosive effect on jazz drummers everywhere.

Bop, said Bird, was a "combination of the Midwestern beat and
the fast New York tempos," which was, said one scholar, "another
way of saying that it incorporated formally the migratory impulse."
It was definitely the product of a certain time in black life. There were
patent social advances in view, with wartime increases in income and
educational opportunity. Black workers had succeeded in unioniz-
ing the Ford Motor Company in 1941, and defense plants in 1943
were desegregated thanks to the pressure orchestrated by A. Philip
Randolph. CORE was founded in 1942. Though the army was still
segregated, it had a considerable number of black officers. There was
even the "Double V" campaign, which advocated victory over both
Hitler and racism.

These rising expectations scraped hard against the experiences
of hundreds of thousands of black men, many from the North, who
were being sent to Southern-based army posts and encountering
extreme racism. Frustration grew. On August 1, 1943, a black soldier
intervened with a police officer in the lobby of Harlem's Braddock

Hotel when the cop arrested a black woman for disorderly conduct. The soldier ended up shot in the shoulder. Rumors spread and a riot broke out, destroying $5 million in property, killing six, and injuring four hundred; it required eight thousand National Guardsmen to restore order.

Diz and Bird were not overtly political and were mostly concerned with things like being well paid for good work. Still, the social dislocations that the Harlem Riot suggested were clearly at the root of the music. Bop was a radical evolutionary step musicologically, but its social implications were downright revolutionary.

For the first time, black musicians were seeing themselves as artists, not simply entertainers. They were realistic in thinking that music was a mode that they could use for socioeconomic advancement, a path black musicians had already pursued for seventy-five years, and they posed no challenge to mass-market capitalism. But they were also playing music that, while deeply involved with rhythm, wasn't dance-based; it was instead a contemplation of rhythm, a metarhythm. The melody wasn't always obvious. There was no sentimentality. In sum, the modernists were moving in a substantially different direction from all that had preceded them. "We just figured," said Dizzy, "we felt like we were liberated people and we acted like liberated people."

Having incubated at Minton's, bop made its public debut with a group led by Dizzy Gillespie at the Onyx Club on Fifty-Second Street in November 1943. Playing Monk's "'Round Midnight" and Dizzy's "Salt Peanuts" and "Night in Tunisia," the group briefly included Lester Young. It was an important moment, made even more memorable to many because it came at a time when New York City, thanks to the diminution of street traffic due to gas and tire rationing, was oddly quiet.

Bop would be first recorded in 1945, with the earliest prime benchmark being Charlie Parker's November 26 take of "Ko Ko." The song would transform jazz in the way Louis and Earl Hines's "West

End Blues" had in 1928. The ecstatic liquid flow of notes combined with the subtlety of rhythm and capacity for musical irony that they employed would establish an entirely new level of what could be called virtuoso playing.

"Ko Ko"'s label, Savoy, also reflected a number of significant changes in the music business. The process had begun before the war, when ASCAP had challenged the radio networks for a higher royalty rate. In response, the networks created BMI and settled the issue in 1941, with the only adjustment being how songwriter royalties were collected.

This did not help the average working musician, and the Musician's Union (AFM) responded. AFM's Chicago boss, the mobbed-up James Petrillo, had negotiated great contracts for his men and so became the union's national head. In an effort to raise royalty rates for performers, in 1942 he banned union members from recording. Because of the war, shellac, an essential component of records, was also hard to find. The war made travel difficult, crippling the big bands. Solo vocalists moved into the gap.

Decca, which had no backlog of previously recorded material, signed first with the AFM in 1943, and in 1944 had fifteen of the seventeen #1 hits on the *Billboard* list. In Decca's wake, small labels began to sign, like Milt Gabler's Commodore, Alfred Lion's Blue Note, and Herman Lubinsky's Savoy. The major record companies would not sign until Armistice Day, November 11, 1944, by which time the new companies had had the opportunity to establish themselves.

Bop also changed location, moving from Minton's and Harlem to Fifty-Second Street in Midtown, which had evolved into an entertainment strip over the previous decade. In 1930, owner Joseph Helbock had asked Willie "The Lion" to play at his speakeasy on Fifty-Second Street, and it quickly became a hangout for musicians working at the nearby Radio City Music Hall complex, which included NBC's studios. When Prohibition ended in 1933, Helbock moved downstairs

and across the street to a bigger place, which he called the Onyx. By 1934, the Famous Door and the Hickory House had joined it. A riot in Harlem in 1935 further shifted nightlife to Fifty-Second Street. By 1945, "Swing Street," the block of Fifty-Second Street between Fifth and Sixth, was lined with clubs, all of them in the ground floors or basements of brownstones, which meant that they were small, with a capacity of around 135. This intimacy made them a great place to hear acoustic music. New Orleans, swing, bop, Billie Holiday, and the sui generis Art Tatum all shared the block on a given night, and it was a musical cornucopia.

The fans came, many of them white. Swing had generated national interest, and once it was accessible on recordings and in public clubs, the more rarified bop followed suit, if to a slightly smaller audience. One of the earliest visitors was a fairly typical postswing fan by the name of Jack Kerouac.

Kerouac had come to New York in the fall of 1939 to attend the Horace Mann School in the Bronx for a year prior to joining the football team at Columbia. While at Horace Mann, he became friendly with an English war evacuee by the name of Seymour Wyse, who introduced him to Harlem and black life, from Father Divine's restaurants to the Mt. Olivet Baptist Church and the Savoy Ballroom, and especially to black bands like those of Fletcher Henderson, Count Basie, and Duke Ellington. Seymour also took Jack to see Jimmie Lunceford at the Apollo and Count Basie somewhere else, and Jack was transformed. A fairly conventional swing fan of his generation, he now confronted the black version for the first time and began to study jazz seriously.

Kerouac had a classmate named Albert (later Aram) Avakian, whose brother George, also a Horace Mann graduate, was part of the Hot Club scene at Yale and already a published jazz critic. In 1940 George would discover some unissued Louis Armstrong Hot Five and Hot Seven material and produce Columbia's first reissue.

Meantime, Kerouac would interview him at Nick's, a Greenwich Village jazz club that featured old-time New Orleans music. It was an enlightening moment for Jack. Avakian told him that he couldn't select one All Star Band, but two, one for each race, since at the time the races rarely got to play together. So Dave Tough was great, but so was Baby Dodds; Muggsy Spanier was fine, but Louis Armstrong was incomparable, and so forth. Avakian was a particular fan of the Austin High Gang, and that spring of 1939 he would produce the *Decca Chicago Style Album*, featuring Austin High confreres Eddie Condon and Pee Wee Russell.

Kerouac was becoming a young recruit to the developing antiswing reaction. So when he reviewed the Decca album, he wrote "most of today's swing is a sensationalized carbon-copy of jazz! It lacks both purity and sincerity." He'd add that for him jazz was "music which has not been prearranged—free-for-all ad lib. It is the outburst of passionate musicians, who pour all their energy into their instruments in the quest for soulful expression and super-improvisation."

Kerouac did not reject all swing; Basie suited him just fine. "Count Basie's swing arrangements are not blaring, but they contain more drive, more power, and more thrill than the loudest gang of corn artists can acquire by blowing their horns apart." Having now tasted the blues of Lester "Prez" Young, he'd be a devoted fan for life, presciently writing that Young would transform the role of the tenor saxophone in jazz. Edie Parker, Jack's wife later in the decade, would recall much later that around 1944 Young even took the two of them to Minton's and turned Jack on to his first joint of marijuana. A working-class kid at the elite Horace Mann, Jack felt displaced and between things, and black jazz, and black culture in general, gave him an identity he desperately needed. Prez would also lead him to bop, rather sooner than later.

One of Kerouac's other friends at Horace Mann was named Jerry Newman, who joined him at Columbia in the fall of 1940. Newman

was an aspiring record producer and owned a recording device, and in the spring of 1941 he began taking it to Minton's, possibly taking Kerouac along. A few years later, Newman would have a record label, Esoteric Records, and would name a Dizzy Gillespie piece "Kerouac." (Dizzy liked the sound of that better than "Ginsberg.")

Some purist fans rejected both bop and swing and declared that jazz began—and ended—in New Orleans. In September 1939, Sidney Bechet recorded with Jelly Roll Morton, Zutty Singleton, and Wellman Braud. The recording, along with the "discovery" of Bunk Johnson, kicked off the great New Orleans revival of the 1940s. Headquartered at Nick's in the Village and Jimmy Ryan's on West Fifty-Second Street, the revivalists were dubbed "moldy figs" by *Metronome*, which was edited by English critic Leonard Feather and Barry Ulanov, a Barnard College professor of English. A host of smaller pro-revival magazines sprang up, most notably the *Record Changer*, *Jazz Record*, *Tempo*, and *Jazz Forum*. They saw jazz as an authentic folk music character-ized solely by collective improvisation and African American melodies and rhythms as opposed to mass-market swing with its Tin Pan Alley songs and written charts.

That jazz had stopped being a folk music at least by the time King Oliver began to record in 1922 was ignored. Though New Orleans to the bone, Louis Armstrong was no fig. "To me as far as I could see it all my life—Jazz and Swing is the same thing . . . In the good old days of Buddy Bolden . . . it was called Rag Time Music . . . Later on in the years it was called Jazz Music—Hot Music—Gut Bucket—and now they've poured a little gravy over it, called it Swing Music . . . Haw Haw haw . . . No matter how you slice it—it's still the same music."

Many of the criticisms the revivalists directed against swing would be turned on bop musicians, who would be accused, said one histo-rian, of "fetishizing technique, of introducing excessive harmonic and rhythmic complications, and of being too mesmerized by the devices and concepts of European art music. They were reprimanded for their

preoccupation with showmanship, their undignified publicity stunts, their mannerisms and argot." But the criticism did get people to thinking in terms of "modernistic" and "avant-garde." Little did the figs know . . .

The figs wouldn't last long, since objecting to change and evolution has a way of being swept away by . . . yet more change. What seems exotic and revolutionary soon comes to be the norm. The major elements of bop—small groups improvising with a revived concern for the blues—would be the fundamental basis of '50s jazz. In fact, jazz would pass from being an art music to being America's classic music by the end of the decade before transforming itself yet again.

As jazz became art music, the blues also morphed, this time in two directions. One stream would mix jazzier elements and entertainment values and become labeled rhythm and blues. And one stream, primarily in the city of Chicago, would add electricity to the blues and become legend.

18

Muddy Waters and Louis Jordan Change the Blues

S TOVALL PLANTATION, NEAR Clarksdale, Mississippi, August,
1941: Alan Lomax had teamed with John Work, a Fisk University
professor of music, and come to the Delta in search of songs. Always
politically far to the left of his father, he also had a wider vision about
his work. Having succeeded his father in 1937 as assistant curator
of the Archive of American Folk Song, he'd included jazz (Jelly Roll
Morton) in his studies and pushed for acquiring commercially recorded
material for the Archive, notions his father dismissed as heretical.

The idea of "folklore in the making," which would investigate
contemporary phenomena, was emerging in New Deal circles, and it
was that approach that had brought Lomax and Work to Coahoma
County, Mississippi, to explore, Lomax explained in a memo to the
Library, "the musical habits of a single Negro community in the Delta."

Clarksdale was the ideal site for their work, since it was the larg-
est town in the Delta in a county that had three times as many black
people as white. The Illinois Central train station there would be a
major portal in the great migration. Thousands had already left by the
time in 1944 that International Harvester would put on the first public

demonstration of a working mechanical cotton picker, at the Hopson Plantation just west of Clarksdale. It could pick two bales (one thousand pounds) an hour. A skilled human could manage twenty pounds. An era was about to end.

As of 1941, though, the combined economic and political systems of sharecropping and segregation endured, and life was in some ways largely unchanged from 1900. As of 1940, 77 percent of black people in America remained in the South, and 50 percent were in the rural South. Still, tractors were replacing mules, and alongside radios at home, jukeboxes—the best-known company, Seeburg, had become in Mississippi tones the "Seabird"—had brought Duke Ellington, Cab Calloway, and Louis Jordan to Clarksdale. One-third of the tenant farmers owned cars.

Just across the river in Helena, Arkansas, radio station KFFA had in 1940 established a noon-time program that advertised King Biscuit Flour during the field hands' lunch and featured Aleck Rice Miller, who had appropriated the name Sonny Boy Williamson for promotional purposes, and Robert Junior Lockwood. Though barely paid, the musicians used it to promote area shows and regarded it as invaluable. The first generation of Patton and his peers was now being superseded by a new generation born between 1910 and 1925 that would include Miller and others.

After recording two church congregations, Lomax and Work found Son House in Robinsonville and recorded him with their five-hundred-pound "portable" device. Son told them about a man at Stovall Plantation, between Clarksdale and Friars Point, named McKinley Morganfield, better known as Muddy Waters. Lomax and Work went to Stovall and found Muddy.

Late August is "lay-by time," when the cotton is strong enough to not require much weeding, so Muddy, who drove a truck for the plantation at 22.5 cents an hour, had some free time. He also had secrets to be concealed from outsiders, like the moonshine he made

and sold at his jook down the road from Stovall, and a white man asking questions about him was guaranteed trouble. Talking with plantation hands without first consulting with the owner or overseer was risky for Lomax too; he would be assumed to be a labor organizer and be run off, or worse.

Lomax spoke first. John Work stood in the background, and Captain Holt, the plantation overseer, wasn't around. So Waters went into survival mode. "Yassuh?"

Lomax responded, "'Hey, hey, don't *yassuh* me. Say no and yes to me . . . Where's your guitar at?"

"It's down in my house."

"Come on, get it. I want you to play for me."

As Muddy recalled it, "I didn't know whether he was one of them smart police coming after me, or what the heck was goin' on. I couldn't handle this white man going to put me in *his* car and drive me around . . .'Uh-huh, revenue man trying to get into me.'"

Lomax played a little guitar, and then said, "I heard Robert Johnson's dead and I heard you's just as good and I want you to do something for me. Will you let me record some of your songs, and I'll play them back . . . I want to take it to the Library of Congress."

Muddy wasn't sure what the Library of Congress was, but he agreed, playing what Lomax would call "Country Blues" and what Muddy would call "I Feel Like Going Home" when he came to record it some years later. The tune came from Son's "My Black Mama" and Robert Johnson's "Walking Blues," and the words were Muddy's, he told Lomax, created some three years before as he fixed a flat tire and pondered his mistreatment by a lover. A second song followed, which Lomax labeled "I Be's Troubled," Work called "I've Never Been Satisfied," and Muddy would later title "I Can't Be Satisfied." Of course, he played blues because that was what Lomax was looking for; Muddy's repertoire also included "Home on the Range" and the "Missouri Waltz."

It was an extraordinary moment. As Muddy's biographer Robert
Gordon pointed out, Lomax and Work had captured a sonic photo-
graph of a pivot in musical history, with a musician whose roots went
back to Patton but who would in years to come change music history
by applying electricity to the blues.

It took a while, but eventually Lomax fulfilled his promise and sent
Muddy a record of his performance, and he thrilled to hear his own
voice, putting the record in the jukebox at his joint. "Man, I can sing."
His voice would take him a long way.

Born in Issaquena County, Mississippi, most likely in 1913 and
raised by his grandmother Della after his mother died, Muddy had
come to Stovall around 1920. School was over by third grade, but
music was always part of his life, and by thirteen he was a fair har-
monica player, despite his grandmother's warnings that he was sin-
ning by playing the devil's music. At the age of seventeen he sold a
horse for $15, and after giving his grandmother half, he spent $2.50
on a Stella guitar from Sears & Roebuck. He learned Leroy Carr's
"How Long How Long Blues" first. He had the opportunity of study-
ing with Son House and, briefly, Charlie Patton, and he made the
most of it.

By 1943, Stovall was starting to feel quite small. When Muddy
asked for a raise to 25 cents an hour, the overseer's reply was along the
lines of "If you don't like twenty-two and a half, get off the tractor."
Muddy got off. Two days later on a Friday in May, carrying a guitar
and a suitcase of clothes, he got on the 4:00 p.m. northbound train.
Arriving in Chicago at 8:00 a.m. on Saturday, he soon found a place
to live through a Clarksdale/Stovall network of friends. That Monday
he found a job at a box plant, where with overtime he'd earn in a
week—$100—what he'd been making in a year.

Soon he was also playing at house parties. He met and jammed
with a guy named Jimmy Rogers, who was from Ruleville, near
Dockery Plantation, and they became partners. Jimmy had already

amplified his acoustic guitar with a pickup, which Muddy resisted for a while; he was selling nostalgia to immigrants with his music, and he wasn't sure about the change. Two things would move him. The veterans who returned to Chicago were ambivalent about rural blues; it implied passivity to them, and it did not reflect the freedom for which they'd been risking their lives. The times demanded something fiercer. The sheer volume in Chicago taverns sealed the deal, and eventually Muddy would get an electric Gretsch.

He had a number of commercial misses. He was a sideman for Sonny Boy Williamson I, but that ended with Sonny Boy's mugging death in 1948. He recorded a tune for the ever-present Mayo "Ink" Williams and some sides for Lester Melrose, but nothing happened.

One of the places he and Jimmy Rogers would play was "Jewtown," the Maxwell Street Market, which ran eight blocks long and a block deep on each side, with pushcarts, stores of all sorts, back rooms for gambling and women, and from daybreak to 5:00 p.m. on Saturdays and Sundays, lots of busking musicians. There he found Marion Walter Jacobs, "Little Walter," a crazed young rounder whose harmonica playing would propel Muddy's evolving band. By now, around 1948, they were ensconced at the Zanzibar Club, which had providentially opened half a block from Muddy's home and would be his professional home base until 1954.

The next big piece of Muddy's puzzle clicked into place when he connected with Leonard and Phil Chess, Jewish immigrants from Poland who'd opened a liquor store, then a nightclub called the Macomba that catered to black people, and then in 1946 a record label called Aristocrat, which became Chess Records in 1949. In 1948 Muddy cut Aristocrat 1305, "I Can't Be Satisfied," backed with "I Feel Like Going Home," as part of a duo with Big Crawford on bass and Muddy playing truly nasty electric slide guitar. Released on Friday, the first pressing was sold out by Saturday night. Muddy's music had changed from folk to pop, a hybrid of Delta blues charged with electricity.

Still a sharecropper at heart, Muddy never did sign a contract; his understanding was that "I belongs to the Chess family." Yet the freedom principle was implicit in his music, with sex as the medium he used to express it. Musically, the process toward freedom was slowed by Leonard's initial insistence on using him only with Big Crawford. "They were trying to make a Lightning Hopkins out of me," said Muddy. It would take one more piece of the puzzle to make him a star, and that would come in 1954. In the interval, he added the great pianist Otis Spann to the band and lost Little Walter to fame, fortune, and a hit song they'd recorded called "Juke," replacing him with Junior Wells.

Then Willie Dixon showed up to teach Chess how to record Muddy Waters, and Muddy became a pop star singing songs with a recurring chorus, stop-time breaks, and lyrics that formed a coherent beginning-middle-end story, far more structured than Delta blues. Dixon was from Vicksburg, a wanderer who'd first come to Chicago after escaping from a county farm near Clarksdale, where he'd been arrested for being a hobo. Dixon was not an average hobo; when drafted, he refused to go and claimed conscientious objector status. At his trial, "I said I wasn't a citizen, I was a subject. I was telling them about the Fourteenth and Fifteenth Amendment."

In Chicago, he won the Golden Gloves and also haunted the Maxwell Street Market, then became a session musician for Lester Melrose. Finally, Willie went to work for Chess. "My job was to assist. I did everything from packing records to sweeping the floor to, every week, I'd have to damn near fight or beg for the money." He also had a song he'd written called "Hoochie Coochie Man." Chess okayed Muddy recording it if he liked it, and Willie went off to the Zanzibar, grabbed Muddy at intermission, took him into the washroom, and said, "Man, this song is a natural for you. Now remember this: The gypsy woman told my mother / Da-da-da-da-Da / Before I was born / Da-da-da-da-Da / You got a boy child coming . . ." After fifteen

minutes in the washroom, Muddy gathered his band and taught them, and they played it for the audience—which went wild.

Along with Willie's material, Muddy absorbed and reproduced Willie's occult shtick brilliantly in his own songs, creating "Mannish Boy," "Got My Mojo Working," and "Evil," giving the black men of Chicago songs that beefed up their egos and pumped up their pride. And in so doing, he became a star—*the* star, with only one peer, Mr. Chester Burnett, more commonly known as Howlin' Wolf.

Wolf was a complex, enigmatic man who'd been driven into a dual nature by a childhood of abuse. The wildest stage performer of his time, he was, in his biographer's words, "the soul of conventional propriety offstage. Tough on the outside, he was tender on the inside; suspicious to the point of paranoia with strangers, yet comfortable revealing his darkest thoughts to them in song . . . threatening one minute, deeply sentimental the next—a sheep in wolf's clothing."

He was born in East Mississippi near the Alabama border in 1910. His father left to work in the Delta, and when he was ten his unstable mother sent him off to live with an uncle who proved exceptionally abusive, putting him to work in the fields. Wolf—so nicknamed by his grandfather at the age of five—would later say that his mother sent him away because his complexion was too dark. In any case, the pain of rejection was going to accompany him through life.

At thirteen he was whipped for the last time and took off, grabbing a train out of town, precisely as in his song "Smokestack Lightning": "Why don't you hear me crying? / Awooooo-hoooo, / Well fare you well, / I'll never see you no more. / Oh, don't you hear me crying?" He found his father, Dock Burnett, at the Young and Morrow Plantation near Ruleville, only three miles away from Dockery Plantation. Wolf had always sung and played harmonica, and in 1928, Dock had a good crop and bought Wolf a guitar. Naturally, he put himself at the feet of Dockery's master guitarist, Charlie Patton, who "showed me things on the guitar, because after we got through picking cotton at night, we'd

go hang around him." The first piece of music he learned was Charlie's "Pony Blues."

He also learned Lemon's "Match Box Blues" and even saw him play once in Greenville one memorable Saturday night. Wolf learned from the entire span of '30s blues recording stars: Sonny Boy II would teach him harmonica, and from his time with the Mississippi Sheiks he'd get the song "Sitting on Top of the World." His trademark howl came when he tried to yodel in imitation of Jimmie Rodgers, the "Singing Brakeman"; that, combined with a gravelly voice caused by childhood tonsillitis, made him "Howlin' Wolf." As he grew older, the voice became The Voice, an instrument, said a fellow musician named Ronnie Hawkins, "stronger than forty acres of crushed garlic, man! He didn't need a PA system."

Soon he'd be rambling around playing, with Robert Johnson on occasion, Son House and Willie Brown as well. After a brief turn in the army during the war that ended with an honorable discharge, he returned to the area just north of Robinsonville, where he farmed days and played nights. Run out of the fields by mechanical pickers, he landed in West Memphis, Arkansas, a wide-open town and the home of many clubs, part of a circuit that included the White Swan in Brinkley, the Hole in the Wall in Helena, and Baby Brother Gooch's Mona Lisa Club in South Memphis.

By now, Wolf had a band, the House Rockers. They got a spot on KWEM in West Memphis, and one day in 1951, a budding record producer named Sam Phillips got a tip to listen to them. Phillips had come up in radio in Memphis, engineering big bands at the Peabody Hotel there before he opened the Memphis Recording Service at 706 Union Avenue. He'd record local blues groups, then lease the results to independent labels like Modern and Chess. Soon he'd start his own label and call it Sun Records. Sam heard Wolf for the first time on KWEM. "This is for me," Phillips said. "This is where the soul of man never dies." He called Wolf and they recorded "Moanin' at Midnight," two

minutes, fifty-six seconds of pure anxiety, which he leased to Chess Records in September of that year.

"Wolf's best records," wrote the critic Greil Marcus, "came on like three-minute race riots. The drums, bass, piano and harp converged on the beat, hammering, shoving; for a moment they let the beat take the song, let you think you had the sides sorted out and the picture clear, and then the guitarist leaped in, heaved himself through the crowd like a tornado, and the crowd paid no attention and went right on fighting."

Around 1953, Wolf got in his band car, a twelve-passenger De Soto, and drove to Chicago. "The onliest one," he said, "drove out of the South like a gentleman." Hiring Hubert Sumlin as his guitarist, he took over Muddy's old slot at the Zanzibar and unleashed the scariest stage show in the blues, with Wolf and his seventy-foot microphone cord crawling, moaning, and dancing down the bar. The shows could be frightening; one night Wolf was crawling on the floor and a (former!) lover stuck him with a knife. He kept singing, but then headed for the door and the hospital. Another night Wolf started his song "Evil" and shots rang out. A guy at the front of the stage lurched against Sumlin, who kept pushing him away. "I'm pushing him, man, and every time I push him . . . he's dead, he's dead! This guy lighted him up, man. The first [dead] guy I ever seen . . ."

In a classy contrast, Wolf was quite businesslike offstage. He didn't mingle with the audience, didn't drink during the set, was frugal and never broke. He also deducted Social Security and unemployment charges from his employees' wages and righteously matched the deductions, which had to be unique in the history of the blues. Forty years later, Sumlin would be able to get by on his Social Security. On the personal level, Wolf was—also surely unique in blues history—a faithful husband.

"Smokestack Lightning" had the mood of an oncoming dark and terrible storm and was the perfect summing-up of Wolf's gigantic voice. It would peak at #11 in March 1956. It would be followed

with more great songs, mostly reworked older efforts, like "I Asked for Water," based on Tommy Johnson's "Cool Drink of Water Blues"; "The Natchez Burnin'"; the Sheiks' "Sitting on Top of the World"; "Killing Floor"; "Spoonful," based on Charlie Patton's "A Spoonful Blues"; "Back Door Man"; "Little Red Rooster," based on Patton's "Banty Rooster Blues"; and Willie Dixon's "Wang Dang Doodle" and "I Ain't Superstitious," a stop-time masterpiece.

As Muddy and Wolf burned up the airwaves, they made music that increasingly began to cross the racial divide. Forty years after the Austin High Gang, young white suburban Chicagoans began to listen to—and play—the blues.

MUDDY AND WOLF were not the only World War II–era musicians who were going to take the blues to a new place.

A little jittery as he waited to board his very first plane flight while touring with Benny Goodman in 1939, Lionel Hampton began whistling a tune. Benny asked him what it was, and he replied, "I don't know. We can call it 'Flying Home,' I guess." The Benny Goodman Quintet played it that night and recorded it soon after, but "Flying Home" became a major national hit when Hampton recorded it for Decca in May 1942. Big band vamps behind Hampton's rippling vibraphone dissolved into a sixteen-bar, two-notes-to-the-bar sax solo by Illinois Jacquet that sent audiences entirely over the rainbow. The honking R & B saxophones of the next twenty years began with Illinois.

The Alpha and Omega of the R & B transition was the career of a man named Louis Jordan. Born in Arkansas in 1908, Jordan alternated picking cotton with playing saxophone, joining his father on tour with F. G. Huntington's Mighty Minstrel Show, which included Mantan Moreland, from whom Jordan would borrow bits of stage shtick. Always achievement oriented, Louis rarely drank, didn't smoke, and studied pop music with great seriousness, particularly liking the shuffle rhythm of Paul Whiteman's star trumpeter

Henry Busse. Jordan caught on with Chick Webb as a vocalist and sax player, alternating with the woman vocalist, who happened to be named Ella Fitzgerald.

He grew ambitious and contemplated having his own band, which infuriated Chick, who fired him in May 1938, possibly because he tended to upstage Ella, who was a brilliant vocalist but had little stage presence. Louis never lacked for stage mannerisms, although some of them earned him the nickname within Chick's band of "Stepin Fetchit," even as his best laughs came from black audiences. His bent was confidently commercial and enthusiastically interracial. "My whole theory, my whole life," Jordan said, "has been: when you come out to hear me, I want to make you happy." He added, "I made just as much money off white people as I did off colored . . . my records were geared to the white as well as colored, and they came to hear me do my records."

His new band, the Tympany Five—the misspelling was intentional—opened at a club near the Savoy Ballroom in Harlem on August 4, 1938, and by the end of the year they were recording, at first for Decca with (yet again!) Mayo Williams. By 1940, his "A Chicken Ain't Nothing But a Bird" displayed the shuffle rhythm that would make him famous, a subtle adaptation of eight-to-the-bar boogie-woogie.

"What's the Use of Getting Sober (If You're Gonna Get Drunk Again)?" was recorded just before the August 1, 1942, recording ban, and it did well, crossing over to both black and white audiences, something only Louis Armstrong and Fats Waller had previously accomplished. In 1943, after Decca had signed with the union, "Is You Is or Is You Ain't (My Baby)?," written by the white Billy Austin, was another hit for them. By 1944, Louis Jordan would play back-to-back shows in Oakland, California, one night in front of forty-two hundred black people, and the next night in front of twenty-seven hundred white ones.

As the war wound down, yet another flavor of black music was emerging, one that reflected prosperity and urban freedom. It took

elements of blues, gospel, boogie, and swing, and used the eight- and sixteen-bar pop/gospel form. Previously, *Billboard* had lumped black and Southern "hillbilly" music together as Folk; then in October 1942 they separated the genres and created the "Harlem Hit Parade." Finally, on June 25, 1949, staff member Jerry Wexler would create a new listing: "Rhythm and Blues." The rural blues had tended to evoke hard times, and the Chicago blues would plumb the difficulties of adjusting to ghetto life. R & B was party dance music, pure and simple, and meant to be played loud.

R & B had many roots. One of them was Jimmie Lunceford's big band. Emphasizing a two-beat (backbeat) rhythm and a solid, thumping bass, the band was better in performance than on record, where they tended to back singers doing novelty songs. Another strand was the Kansas City blues shouting style of Jimmy Rushing and Big Joe Turner, which called for big chests and heavy vibrato. By 1942, the Midwestern territory bands were shifting from big bands to smaller groups that included electric guitar, saxophones, and vocalists like Turner, such as Wynonie Harris, who joined Lucky Millinder's outfit in April 1944.

The year saw the emergence of two other black artists with crossover potential. Lionel Hampton hired Ruth Jones, a veteran of the Chicago gospel group the Sallie Martin Singers, to sing pop. Changing her name to Dinah Washington, she had two hits that year in "Salty Papa Blues" and "Evil Gal Blues," redefining the concept of the blues queen. At the same time, Nat King Cole's "Straighten Up and Fly Right" would establish the sophisticated, world-weary blues sound that would influence lots of other musicians, most especially Charles Brown, and, soon, Ray Charles.

Recorded in January and out in March 1945, "Caldonia"—"What makes your big head so hard?"—was Louis Jordan's fifth straight #1 race song and the biggest yet. His shows, thought Aaron Izenhall, the trumpet player, had become like a Technicolor movie on stage, with wild colors, exaggerated movements, goofy and hilarious lyrics,

showmanship, costumes, screaming saxophone solos, and the blues, all jumped up with a shuffle. Some of the humor was of the minstrel variety—one song would be "Ain't Nobody Here but Us Chickens"—although some argued that it represented the rising black middle class mocking older rural traditions.

R & B reflected the World War II migration, as Texans and Middle Westerners like T-Bone Walker, Lowell Fulson, Cleanhead Vinson, Roy Milton, and Joe Liggins headed for California to record, Liggins hitting immediately at Modern in 1945 with "The Honeydripper," which would camp out at #1 for a large chunk of the year. The following year, on the other hand, was all Louis Jordan. He had five of the seven #1 R & B records that year, with "Choo Choo Ch'Boogie" on top for eighteen weeks. A light twelve-bar shuffle boogie blues by Vaughn Horton and Denver Darling, two white guys who were basically country-western writers, it was a humorous paean to postwar life and travel, and it was Jordan's first gold record, selling two million copies.

Even within R & B, the music was spinning off in multiple directions. The year 1946 saw the birth of the first and most influential of the a cappella street-corner singing groups, the Ravens. The first great electric guitar blues hit swept the nation the next year when Aaron Thibeaux "T-Bone" Walker put out "Stormy Monday."

Jackie Robinson's rookie year, 1947, saw another milestone not only in R & B but also in the black/white relationship over music with the founding of Atlantic Records by Ahmet Ertegun and Herb Abramson. Most of the independent record company owners probably thought of themselves as fans, but Ertegun really was one. A child of privilege as the son of a Turkish diplomat, he'd fallen in love with jazz on hearing Duke Ellington at the London Palladium in 1933 and become such a serious record collector that he and his brother were included in Charles Smith's 1934 "Collecting Hot" article in *Esquire*. His record company would reflect that spirit.

Ahmet and Herb began Atlantic as a jazz label, working with Erroll Garner among others, and they began at the bottom, pushing the desks in their office out of the way to turn the room into a recording studio in the evenings. Their first hit came in 1949–50, with their remake of Stick (brother of Brownie) McGhee's "Drinking Wine Spo-Dee-O-Dee." That success quickly changed Atlantic into an R & B record company, with Ruth Brown, LaVern Baker, Big Joe Turner, Ray Charles, Clyde McPhatter, and Ben E. King on their roster. Thanks to Tom Dowd, their superb chief engineer, their sound was the best in the business. And since they were actually paying royalties to their artists, said artists tended to stick around.

Many years later Ertegun said of his work, "I did a little bit to raise the dignity and recognition of the greatness of African American music." True. In so doing, he and his partners also helped to raise the hipness quotient of the white American youth who increasingly bought their records, unknowingly preparing for the white derivation of R & B, rock 'n' roll, which was to come.

The process first became noticeable in the use of the phrase *rock*, a synonym for sex that actually went back at least as far as Trixie Smith's 1922 "My Daddy Rocks Me (With One Steady Roll)." Duke Ellington put out "Rockin' in Rhythm" in 1931, but the first big hit with the word *rock* in the title was Wynonie Harris's "Good Rockin' Tonight," which was #1 by the summer of 1948. Soon there were lots of songs with *rock* in the title. By the early '50s, it was a flood.

The confluence of black and white over R & B was in part a side effect of the gathering momentum for civil rights that was the legacy of World War II. Black union membership went from 150,000 in 1935 to 1.25 million by the end of the war, and NAACP membership tripled in that period. Along with their white peers, hundreds of thousands of black men got an enormous boost in educational opportunity and the chance to buy their own home as a result of the postwar G.I. Bill of Rights.

In the summer of 1946, six black veterans were lynched in the South, and after President Truman called for an investigation, he got a report the next year, "To Secure These Rights," which was dangerously close to truthful, putting the phrase *civil rights* into common usage. That fall Truman became the first U.S. president to address an NAACP convention. In February 1948 he sent a message to Congress calling for an antilynching law, and on July 20, 1948, he signed an executive order desegregating the Armed Forces. The Supreme Court having struck down the white-only primary in 1944 in *Smith v. Allwright*, by 1948 more than six hundred thousand black people, mostly in the upper South, could vote. The number would double by 1952.

BY THE END of the decade and the beginning of the '50s, two more guys from Clarksdale would make music that would extend boundaries—both toward the future and deeply into the past. One was the amazing master of the entirely archaic one-chord drone, John Lee Hooker, who'd essentially get hits out of field hollers—"Boogie Chillen" in 1949, "I'm in the Mood" in 1951. The other was a piano-playing teenager named Ike Turner, who had a group with Willie Kizart on guitar and Jackie Brenston on vocals and saxophone called the Kings of Rhythm. In 1951 they went up to Sam Phillips's Memphis Recording Service studio on Union Avenue and recorded "Rocket '88." On their way, Willie's guitar amplifier fell and broke, adding a nasty fuzz to the sound. Always flexible, Sam said to give it a try anyway. Playing a bass figure, the guitar joined with R & B sax and piano to make a song that was a #1 R & B hit for seventeen weeks. More than one music historian has identified it as the first rock 'n' roll song.

In 1953, Louis Jordan ordered his bass player to go electric, which didn't prevent Decca from dropping him from the roster he'd been on since 1936. They replaced him with a white guy named Bill Haley. Haley had started as a hillbilly singer and singing cowboy disc jockey, and at one of his stations, his show was followed by an R & B

show called "Judge Rhythm's Court." Its theme song was "Rock the Joint," and it got into Haley's head. "It was strictly a Race record. I started to sing and hum the tune, and I started to use it in the show, and every time I would do it I would see this tremendous reaction. So I rewrote some of the lyrics, released the record, and it became a smash hit for us."

Now hep with a spit curl and dinner jacket, Haley formed a new band, Bill Haley and the Saddlemen, and they chose "Rocket 88" as their first tune to record. As Bill Haley and His Comets, they added Rudy Pompilli on saxophone and Franny Beecher, who'd once played with Benny Goodman, on guitar. A synthesis of blues, swing, and country-western was nearing critical mass. Their "Crazy, Man, Crazy" reached #15 on the pop charts in 1953 on a small label, which led to their being signed by Decca.

At Decca, their producer was Milt Gabler, who'd sing the group riffs from Louis Jordan's records. "Also I got the tenor sax player and the pianist to think along those lines, and I asked the whole group to project the way that Jordan's group had done." "We'd begin with Jordan's shuffle rhythm," Gabler told music publicist and historian Arnold Shaw. "You know, dotted eighth notes and sixteenths, and we'd build on it . . . They got a sound that had the drive of the Tympany Five and the color of country and western. Rockabilly was what it was called back then." On April 12, 1954, they recorded a tune by Max Freedman and Jimmy DeKnight (real name James Myers) called "Rock Around the Clock."

They also recorded a current hit by Big Joe Turner, one of Haley's prime models, who'd gone to New York with the boogie-woogie players after "Spirituals to Swing," recorded the up blues "Cherry Red" with Pete Johnson and Hot Lips Page in 1939, then edged into early R & B with "Rock Me, Mama." After some years of decline, Joe signed with Atlantic and worked with producer Jesse Stone, who'd created the bass line that was an essential part of Atlantic's signature

sound. As Charles Calhoun, Stone had also written a song called "Shake, Rattle and Roll."

Turner recorded the song, and when it was released in 1954 it was an instant hit. Haley's version was even bigger. Then "Rock Around the Clock," which had gone nowhere, appeared on the sound track of a new movie, out March 1955, called *Blackboard Jungle* (James Myers was the movie's music consultant), and suddenly *rock* was not only a verb but also a noun. Said Turner, "[Rock] wasn't but a different name for the same music I been singing all my life."

Except that now it was a national phenomenon. Just as with swing, a mostly white-performed African American music form was about to take hold of the imagination, feet, and lives of a generation of white youth.

19

Folk Roots and '50s Rock

CREATIVE WHITE SOUTHERNERS in the post–World War II era had a couple of obvious options in addressing the African American culture that surrounded them; they could ignore it, or they could integrate it into their own work. Those were the two paths of Thomas Lanier "Tennessee" Williams and the other Williams, Hank.

Consider Tennessee. On March 24, 1955, his play *Cat On a Hot Tin Roof* debuted at the Morosco Theatre on Broadway. Set in Clarksdale, Mississippi, it tells the tale of the Pollitt family, including Brick, his wife Maggie, and his father Big Daddy. Brownie McGhee and Sonny Terry were part of the cast that night, but merely as set dressing. Despite the fact that black people outnumbered white people three to one in Coahoma County, they have no role in *Cat* or Williams's life. His own sexuality was what Williams would address.

"I write out of love for the South," he once said. "[It] once had a way of life that I am just old enough to remember—a culture that had grace, elegance, an inbred culture, not a society based on money. I write out of regret for that." Williams was born just two months before Robert Johnson in 1911 and only a couple hundred miles away, but clearly in a different world, one of refinement, a fixed social order, and white supremacy. Tennessee would write about (white) manners,

particularly their sexual implications, leaving aside the broader social reality he was born to.

Hank Williams had a different approach. A sickly child who began boozing at the age of twelve, he took up as a teen with a black street musician named Tee Tot Payne, and the music that he'd make for the rest of his life would be nothing more than a white man's steel guitar–laced version of the blues and the evangelical religious music that was the common heritage of black and white alike. In the words of his song, his life was a "Lost Highway."

In 1947, he came to the attention of Nashville music *macher* Fred Rose and began to record, starting with the comical "Move It On Over," the religious "I Saw the Light," and "Lovesick Blues," which came out in May 1949 and stayed #1 for four months. That got him on the centerpiece of country music, the Grand Ole Opry, which was now a national show on 150 NBC stations with an audience of ten million. Though it was identified exclusively with white country music, the Opry's cast included DeFord Bailey, a black harmonica player. Somewhat later, Opry musicians Chet Atkins and Merle Travis would come to fame playing the Kentucky thumb style of guitar created by a black fiddle player named Arnold Shultz, who would also give the founder of bluegrass, Bill Monroe, his first paid gig as part of a band that included Bill's brother Charlie. Shultz's blues music would have an enduring influence on Bill Monroe. Ernest Tubb, whose "Walking the Floor Over You" brought honky-tonk music and the electric guitar to the Opry, had grown up listening to Ethel Waters and Bessie Smith. The lines were always thinner than first understood.

In this time, country music began to seep out of the South and into the mainstream. The decade's love affair with cowboy movies led to Gene Autry's "Back in the Saddle Again." Vaughn Monroe had been a big band leader, but "Mule Train," the theme song for his 1950 movie, *Singing Guns*, would be an enormous hit. The same year, Patti Page would cover an R & B recording by Erskine Hawkins called "Tennessee

Waltz," and the pop world began to cover country songs, most especially the part of the pop world that worked with Columbia producer Mitch Miller: Tony Bennett did Hank Williams's "Cold Cold Heart," Jo Stafford got his "Jambalaya," and Frankie Laine took Hank's "Hey Good Lookin'," among others.

These covers were patently just pop with country flavoring, something Nashville would lean toward for much of its history after Hank. A somewhat grittier and more soulful folk and country music came, oddly enough, from the Lower East Side of Manhattan. Moe Asch, the owner of Folkways Records, expressly saw himself as a man documenting folk cultures. The son of the great Yiddish writer Sholem Asch, he had arrived in the United States from Poland in 1914 at the age of nine. Growing up in Brooklyn, he became a ham radio operator, and when he went to Europe to study electronics, he found himself gripped by John Lomax's *Cowboy Songs and Other Frontier Ballads*. In 1948 he began Folkways, he said, to "describe the human race, the sound it makes, what it creates." Very much a part of the New Deal/socialist ethos, he embraced Lead Belly as a member of a fellow oppressed minority and soon began recording Huddie's entire extended musical family—Woody Guthrie, Pete Seeger, Cisco Houston, and more.

Seeger had returned from wartime service to start an organization called People's Songs, aiming to create a singing labor movement. But in the course of the war, a large part of the leadership of organized labor had joined the multinational corporate economy, and class songs were out of favor. The Left made a last-stand bid to support Henry Wallace in the election of 1948, and when Wallace finished fourth, behind Dixiecrat Strom Thurmond, the future was plain. Postwar reactionary politics would affect the folk music world quite as much as they did the broader society.

The enemies of the New Deal gathered. Truman tried to beat the Republican Party to the punch by creating a loyalty oath and a list of

subversive organizations, and the right ran wild with it, searching out divergent opinions in groups from Hollywood scriptwriters to school-teachers. Everyone who'd ever signed a petition or joined a committee, who had been a "premature antifascist" or just wasn't sufficiently flag-waving was vulnerable. While there was plenty of free-floating xeno-phobia, anti-Semitism, and anti-intellectualism around, what would be called McCarthyism was less a product of the American people as it was the collateral damage inflicted by the return to full power of the corporate world and its right-wing political allies.

The House Un-American Activities Committee (HUAC) subpoe-naed Leon Josephson, an attorney for the progressive International Labor Defense Fund, primarily because his brother Barney was the owner of Café Society. Soon Hearst columnists like Walter Winchell and Westbrook Pegler picked up on the investigation and began to run items about the club. The uptown branch closed in December 1947; downtown followed suit in 1949. People's Songs folded in March 1949. That year, Klan-led violence in Peekskill, New York, forced the postponement of a concert featuring Paul Robeson and Pete Seeger, and when the show went on ten days later, a mob attacked exiting concertgoers.

Pete kept singing, especially the song "If I Had a Hammer," which would be recorded by his new group, the Weavers. In May 1950, after a residency at the Village Vanguard, they recorded an Israeli soldier song, "Tzena, Tzena," backed by a cleaned-up (no morphine, no threatened murder) version of Lead Belly's "Goodnight, Irene," and it became a major hit, perhaps in part because Decca's house arranger, Gordon Jenkins, wrapped the songs in strings. That was the Weavers' high point; the full force of the early '50s American inquisition was about to land on them.

The next month, *Red Channels*, a pamphlet published by *Counterattack!*, a right-wing journal put out by three former FBI agents, listed a number of people in music and show business as having

communist associations: Pete Seeger, Alan Lomax, Leonard Bernstein, Orson Welles, Lena Horne, Aaron Copland, Dashiell Hammett, Lillian Hellman, Judy Holliday, Zero Mostel, Edward G. Robinson, Artie Shaw, and Gypsy Rose Lee among others. People reacted in various ways to HUAC pressure. Lomax left the country for England. Burl Ives named names. Josh White testified but did not name names. Although White publicly rejected the left folk world, the right still blacklisted him from lucrative TV jobs, and left publications like *Sing Out!* responded by essentially doing the same.

Thanks to the work of a paid government informant named Harvey Matusow—he would subsequently recant his testimony, though far too late to help—HUAC would destroy the Weavers. This wouldn't stop Pete Seeger. His love for singing had created an approach to folk music that would endure, even as repression stripped away the politics. His music, wrote the scholar Robert Cantwell, "preserved the ideality of the scholarly or recreational folk song as symbol of a shared American civilization and history, but which at the same time was a force for realizing personal identity in terms of that ideality in performance." In sum, folk music lost the ideology but retained its idealism and commitment to a populist America.

Pete had a mission, and that was to get America singing. He was not a musical purist, performing songs in his own style, and playing nonfolk songs like "Saint Louis Blues." Throughout the '50s, blacklisted from TV and other high-paying gigs, he put down a foundation for a future folk renaissance by creating a college circuit (and kindergartens and any other school that would have him). Swarthmore had an annual folk-singing weekend going back to the late 1930s and was joined as a folk music center by Antioch and Oberlin, Berkeley and Reed, the left axis of American colleges. Still pursued by HUAC, Seeger cited the First Amendment and refused to answer HUAC's questions in August 1955; on July 26, 1956, the House voted to indict him. His response was to write "Where Have All the Flowers Gone?" As

Stephen Spender put it, "Music is the most powerful of all the idealist drugs except religion." Pete kept on.

He had only a few visible allies in the early part of the decade. One was the Highlander Folk School, which researched and taught folk music within a framework of progressive politics. Established in 1932 in Tennessee, it was intimately involved with the Southern labor movement of the 1930s, and as the '50s passed it would become particularly effective in training civil rights activists.

Pete's other ally was a most peculiar record collection. Harry Smith was a pot-smoking bohemian with a taste for alchemy and the occult, a gay man who'd grown up in the Pacific Northwest before making field recordings of Native American music and experimental movies in San Francisco during the 1940s. He was a serious record collector, and when he moved to New York in the early '50s, he offered to sell his collection to Moe Asch, who declined but suggested that Harry cull the best of the songs and create an anthology, which Folkways would release in 1952.

The *Anthology of American Folk Music* was an epochal eighty-four-song, six-LP (33 rpm long-playing record) selection of music from the period 1927 to 1932, from the beginning of electrical recording to the Depression-era collapse of the record business. *The Anthology*'s organizing principles had a number of interesting aspects. There was no distinction between the races, and it was frequently impossible to identify the racial identities of the contributors. The package began with Child Ballads, then early nineteenth-century American songs ("Omie Wise," "Peg and Awl"), then later nineteenth-century songs like "John Henry" and "Stackolee." There were songs of great disasters, from the Titanic to the boll weevil, social music that supported dance and religion, and finally a selection of songs about freedom, like Mississippi John Hurt's "Spike Driver Blues."

One of the truly peculiar things about the *Anthology* was the packaging, which reflected Smith's alchemical interests. Harry was after a

far more ambitious result than simple antiquarianism—he was after human enlightenment. It was, wrote Robert Cantwell, "as if each selection were issued its own discographic birth certificate; a headline-like condensation of the song lyrics; and a paragraph of information and notes, followed by several lines of scholarly citations that refer to the discography and bibliography supplied at the end of the text . . . as if all its titles and information had been freshly telegraphed from that front where love, betrayal and murder, train wrecks, robberies, assassinations, chain gangs . . . brave homilies, and lonesome complaints of mountain and blues singers, wage continual war against the tyranny of abundance, safety, order, convenience, and comfort."

To this point, LPs were largely devoted to classical music, so the *Anthology* had a legitimizing effect on the genre. By reintroducing this lost music, Smith changed it from the commercially recorded popular music that it had been in the 1920s to folk music. By taking it from its original context and wrapping it in alchemy, he'd actually made the music postmodern even as it documented an older America than the sleek contemporary 1950s, in which the corporate managerial class had come to run a permanent war economy. The *Anthology* represented what critic Greil Marcus would call the "old weird America," "an occult, Gothic America of terror and deliverance inside the official America of anxiety and success."

Just as television was coming to dominate and homogenize American culture, here was a mother lode of material from the old weird America, selected by a man consciously seeking to subvert the current paradigm and open minds to new possibilities. At a time when historians proclaimed the consensus basis of the national history (and implicitly dismissed all those who weren't white, male, and prosperous), here was aural and experiential evidence of a diverse, thrashing America that had darkness and mystery. The *Anthology* was a time bomb, setting off explosions of inspiration in young musicians across the country, and it would have an effect beyond Smith's wildest hopes.

And it was not alone. Each of the various musics now thriving in America was connected in some way with the African American source and with the freedom impulse. Bop had produced self-conscious artists who refused to bow to conventional assumptions of what was entertaining. In freeing their music from the standard assumptions of show business, the boppers had taken an enormous risk—and their audience, at least as white as it was black, understood that and supported the implicit goal of liberation.

At this time early in the decade, the electric blues of Chicago had an almost exclusively black audience, but the music stood for a black autonomy that would be instantly grasped by the white acolytes who would locate it a few years later. R & B's celebration of good times delivered the same message of dancing sensuality as its predecessors ragtime and early jazz. The blues were implicit in much of postwar country music, so it was no great stretch for country to fuse with R & B to form rockabilly. And folk music formally presented a progressive message of peaceful racial coexistence that was merely a verbal manifestation of the vision articulated by those fusing racial streams that in the new decade would give the world rock 'n' roll. The stage was set for a remarkable transition.

ALONG WITH PROSPERITY and the shiny-new, the '50s brought other changes that would have long ripple effects. The great migration to the North through World War II had given black people at least some clout as they began to vote Democratic. In 1954, the Supreme Court handed down *Brown v. Board of Education of Topeka*, and the legal ground rules changed, although any realist knew that segregation wasn't going to end quickly. Tensions escalated in August 1955 after the body of fourteen-year-old Emmett Till, a black boy from Chicago visiting relatives in Money, Mississippi, was pulled from the Tallahatchie River, one eye gouged out and a seventy-pound cotton gin mill fan around his neck.

His body was returned to Chicago, where his mother insisted that the public funeral service include an open casket, inspiring a wave of revulsion at the mutilations and renewed outcries about the state of justice in Mississippi. At trial, the state's press and legal system closed ranks behind white supremacy, and the defendants were acquitted. Protected by the rule of double jeopardy, they smirked as they admitted their guilt to a journalist a few months later.

Black people began to move. Actually, Rosa Parks refused to move, and kept her seat on a Montgomery, Alabama, bus. On December 1, 1955, she was sitting in a middle row when white people boarded, so that she was supposed to move back, or stand. Ms. Parks was the secretary of the local NAACP branch and had trained in nonviolent civil disobedience at Highlander Folk School, and she wasn't putting up with any more bullshit. She remained seated and was arrested.

The president of the Montgomery NAACP, Pullman porter E. D. Nixon, saw an opportunity. He chose a charismatic, newly arrived young local minister, Martin Luther King Jr., to head their efforts, and together they began a boycott of public transit in Montgomery. For 381 days, no black person in Montgomery with a shred of self-esteem rode the bus. Late in 1956, a federal ruling, *Browder v. Gayle*, declared segregated buses unconstitutional. Earlier that year, there were riots at the University of Alabama protesting the presence of a black student named Autherine Lucy, and in the next few months, five deep-South states adopted pro-segregation measures.

The 1950s, observed C. Vann Woodward, resembled the era of Reconstruction in many ways. Both followed wars; people were tired of idealism and self-sacrifice and were determined to enjoy a self-indulgent materialism. A popular general was president, "celebrated for qualities other than moral enthusiasm." Of course, the South was much stronger than in the 1870s, not devastated by a war and *extremely* well represented in Congress. So when North Carolina senator Sam Ervin drafted a "Southern Manifesto" in March 1956

that promised to maintain Jim Crow segregation, getting support from 101 of the 128 members of Congress who represented the eleven original Confederate states, one might have surmised his cause would prevail.

When Governor Orval Faubus used the Arkansas National Guard to block the desegregation of Little Rock Central High School in 1957, he forced the previously silent Eisenhower to assert federal authority. Ike sent in the army, which would stay at Central the entire school year. Faubus would respond by closing Little Rock's high schools for the school year 1958–59, making him a hero to many Arkansans. Virginia closed schools rather than desegregate, and desegregation ground to a halt, with the bulk of the South convincing itself that the problem was all a result of outside agitators.

Black-white relations had signifiers other than the overt events of the civil rights movement. In its own way, music would muddle racial barriers perhaps even more effectively than campaigns did, and the authorities were not unaware of it. In 1955, the Juvenile Delinquency and Crime Commission of Houston, Texas, asked local radio stations to ban twenty songs, a list that included "Work With Me Annie" (Hank Ballard and the Midnighters), and "I Got a Woman" (Ray Charles), black R & B that was also stimulating an emerging rock 'n' roll that would seem honest and fresh, not least because some of the first great rock songs were written by the artists who performed them. Even more importantly, rock—as jazz and ragtime before it—excited the body and made kids want to dance, part of a long line of cultural evolution that had started in Africa, emerged in the black church, and now rang triumphant.

Rock 'n' roll, in fact, would be African American culture's ultimately most powerful gift to the white children of the '50s, '60s, and after, the third—after ragtime and jazz—of the cultural fusions that had spun off black creativity. Each of those gifts took the mainstream culture toward a greater tolerance and a greater sensuality. It

was powerful stuff indeed, and these influences have not stopped in their effects.

Bill Haley had kicked rock off with "Rock Around the Clock," but Elvis Presley made it an international phenomenon. Just as Haley had started out cowboy but listened to the blues, Sam Phillips of Memphis found in Elvis his own white kid who could sing like a black man. Sam mentioned him to another young man around the studio, a guitarist named Scotty Moore, who played boogie in the honky-tonks around Memphis with both jazz (Tal Farlow and Barney Kessel) and country (Merle Travis, Chet Atkins) influences.

Wearing white shoes and a pink suit, Elvis stopped by Scotty's house to talk about songs to record, and the two names Scotty recalled from the chat were Marty Robbins and Billy Eckstine. When they got to the studio on July 5, 1954, things didn't go so well, perhaps because Elvis was nervous. "He tried not to show it," said Phillips, "but he felt so *inferior*. He reminded me of a black man in that way, his insecurity was so *markedly* like that of a black person."

Which perhaps rang true when, having wasted some time, they took a stab at Arthur Crudup's "That's All Right," and pinned it perfectly to the grooves. Blues with a country beat, the fusion of black and white, had found its personification in Elvis. A lifelong member of the Pentecostal First Assembly of God who'd sung gospel from the age of two, he mixed church music with listening to Roy Acuff and Eddy Arnold at the Opry, Bill Broonzy, and Arthur "Big Boy" Crudup. Locally, he followed B. B. King, the Memphis blues guitar master, and spent considerable time with him.

Elvis yearned to live a larger life than that of a resident of the Lauderdale Courts public housing facility who drove a truck for the Crown Electric Company, and he'd get all the success that anybody could ever dream of and more as he recorded fourteen consecutive million sellers and became the King of Rock 'n' Roll. It was a success so overwhelming that he'd spend the rest of his life mostly trying to

hold on to his sanity. Meantime, he'd be managed by "Colonel" Tom Parker, who'd make sure Elvis would never grow, but would continue filling Parker's pockets until the day he died, and long after.

In the end, guitars were and would remain the heart of rock 'n' roll, and the first important rock guitarist was named Chuck Berry. In late April or early May 1955, Chuck approached Muddy Waters about recording, and Muddy sent him to Leonard Chess. On May 21, 1955, Berry, Johnnie Johnson on piano, Ebby Hardy on drums, and Chess house producer Willie Dixon on bass recorded thirty-five takes of a country-western song mixing hot rods and romance called "Ida Red," which owed something to a Charlie Poole and the North Carolina Ramblers tune called "Shooting Creek," but whose best-known version came from Bob Wills and the Texas Playboys.

As Johnson recalled it, Leonard didn't like the title and, after noticing a bottle of makeup, suggested it be called "Maybellene." Kingpin disc jockey Alan Freed heard it and flipped at the combination of country harmonies and blues rhythms, and after getting a piece of the royalties (along with Russ Fratto, Chess's landlord and part-owner of Midwest Record Pressing), helped make it, by July 1955, a #1 R & B song and a #5 pop song.

That November, *The Ed Sullivan Show*, America's national stage, would present fifteen minutes of rock with Chuck, Bo Diddley, and LaVern Baker. The next day, RCA would announce that they'd signed Elvis, and by February 1956 he was on the Dorsey Brothers' national TV show. In May, Chuck's insouciant wink at the classical world, "Roll Over Beethoven," charged up the charts. Presley's "Heartbreak Hotel" had been #1 for three weeks and would be the #1 record of 1956, reaching #1 on the Country-Western charts and #5 on the R & B charts, with two other Elvis songs, three Haley songs, two Little Richard songs, and two Fats Domino songs at the top.

Black and white were now mixing sufficiently to make a Klan member weep. Presley, the white Negro, was singing black Otis Blackwell's

"Don't Be Cruel," the B side of "(You Ain't Nothing But a) Hound Dog," written by two white guys with an enormous affinity for black culture named Mike Lieber and Jerry Stoller. First sung by Big Mama Thornton, "Hound Dog" went to #1 on the pop, rock, and R & B charts, which made Elvis the first white guy to top the R & B charts since Johnny Ray, five years before. Contrarily, Chuck Berry's driver's license identified him as Native American, and he used underexposed PR photos to suggest he was white, or perhaps Hawaiian.

By the mid-'50s, the singles market was the province of the young, with albums, first introduced in 1948 by Columbia, now directed at adults; *South Pacific* had been the best-selling album from 1949 to 1951.

Early rock 'n' roll's assault on the charts lasted only long enough to establish what Greil Marcus called "the crucial image of rock 'n' roll: the sexy, half-crazed fool standing on stage singing his guts out." Drafted, Elvis would enter the army in March 1958. On the heels of his big (and only) hit, "Blue Suede Shoes," Carl Perkins suffered a devastating car accident in March 1956 that would interrupt his career. Little Richard left rock 'n' roll for the Lord on October 12, 1957.

When the press learned in May 1958 of Jerry Lee Lewis's marriage to Myra Gale Brown, his thirteen-year-old cousin-once-removed, his future dimmed. Buddy Holly, Richie Valens, and J. P. "The Big Bopper" Richardson died in a plane crash in Clear Lake, Iowa, on February 3, 1959. And in December 1959, Chuck Berry was arrested under the Mann Act for consorting with Janice Escalante, a fourteen-year-old girl from Juarez, Mexico, whom he'd brought to his club near St. Louis to work as a hatcheck girl. A patently bigoted judge full of inflammatory questions ensured a guilty charge, and after two trials, Chuck spent a year and a half in prison. Rock seemed to have been a brilliant but very brief light in the sky.

20

The Beats and Folk Emerge and Jazz Ascends

IN THE MIDDLE of rock's ascendancy, and just as social critics were dithering over the sociosexual realities of young white people dancing to what was obviously black-derived music, another social bombshell disturbed the peace. On September 5, 1957, *The New York Times* reviewed Jack Kerouac's newly published *On the Road* and called its release an "historic occasion," comparing it to *The Sun Also Rises* as a generational document. "The most beautifully executed, the clearest and most important utterance yet made by the generation Kerouac himself named 'beat' . . . a major novel." The book's sales took off and would never stop.

On the Road and "Howl," the poem written by Kerouac's literary cohort Allen Ginsberg, had revived the transcendental impulse in America, the drive to celebrate the spiritual and reject the material. Their spiritual drive was largely inspired by what they'd taken from African American culture. The beat scene, like the blues, affirmed the divine in the individual ethical life, even if it manifested itself in ways that the mainstream culture would find utterly perplexing.

Kerouac's love affair with bop had never ended. He'd gone on to make jazz, and specifically the concept of improvisation, the basis for his entire art. As his friend John Holmes had written, a bop fan was "a different sort of person than a fan of swing or Dixie—with Bird you had to *dig* to know; your consciousness had to be at a different level of evolution . . . If a person dug Bop, we knew something about his sex life, his kick in literature and the arts, his attitudes toward joy, violence, Negroes, and the very processes of awareness." True, that.

After publishing a fairly conventional novel called *The Town and the City*, Kerouac had searched for a more highly evolved approach to writing, one in which nothing was hidden and the reader came into direct contact with the author. In October 1951 he saw Lee Konitz at Birdland. Swimming in chorus after chorus of "I Remember April," Kerouac wrote in his notebook, "Blow As Deep As You Want to Blow." Over the next two years he'd create his masterpiece, *Visions of Cody*, a brilliant if uneven collection of fragments. He wrote, "I dig jazz, a thousand things in America, even the rubbish in the weeds of an empty lot, I make notes about it, I know the secrets . . . and I dig *you* as we together dig the lostness and the fact that of course nothing's ever to be gained but death." Sitting in an attic in San Francisco in 1952, he listened to his favorite bop DJ, Pat Henry, on Oakland's KROW, and wrote that *Cody* was "like Bop, we're getting to it indirectly and too late, but completely from every angle except the angle we all don't know."

Later friends asked him to outline his methods, and he responded with a set of notes titled "Essentials of Spontaneous Prose," which included the line, "Procedure: Time being of the essence in the purity of speech, sketching language is undisturbed flow from the mind of personal secret idea-words, *blowing* (as per jazz musician) on subject of things."

He put all that and jazz too into *On the Road*, inspiring thousands of American kids to hit the road and seek a new America, reject the humdrum expectations of conventionality, and become one of

Kerouac's "mad ones, the ones who are mad to live, mad to talk, mad to be saved, desirous of everything at the same time, the ones who never yawn or say a commonplace thing, but burn, burn, burn like fabulous yellow roman candles exploding like spiders across the stars and in the middle you see the blue centerlight pop and everybody goes 'Awww!'"

Jazz undergirds much of *On the Road* as an ongoing sound track that links the characters and encapsulates the action. Jack and his friend Neal ("Sal Paradise" and "Dean Moriarity") listen to Dexter Gordon and Wardell Gray's frenzied "The Hunt" in North Carolina and go to see George Shearing at Birdland. They listen to "mad jazz records" on a New Orleans radio show with the DJ crooning, "Don't worry 'bout *nothing!*" as well as jump blues from Wynonie Harris and Lucky Millinder.

There's Slim Gaillard in a small San Francisco nightclub, some unknowns in another backstreet San Francisco joint, where "The behatted tenorman was blowing at the peak of a wonderfully satisfactory free idea, a rising and falling riff that went from 'EE-yah!' to a crazier 'Ee-de-lee-yah!'" In Chicago a young man he dubs "Prez" gets Kerouac started on a complete if brief history of jazz, from Basie and Bennie Moten to Monk and above all to Lester Young, "that gloomy, saintly goof in whom the history of jazz was wrapped; for when he held his horn high and horizontal he blew the greatest." Elsewhere, he sums up Lester on the stand as "eternity on his huge eyelids." It wasn't just *On the Road*; "Howl," the most important American poem of the late twentieth century, had been written to the sound of Young's "Lester Leaps In," which Ginsberg credited Kerouac for having gotten him to appreciate.

Kerouac lay himself open to charges of primitivism in spots, but he also understood the profound connection to the life force that is jazz, bringing to fruition a connection that began in Austin, Illinois, in the early 1920s. Racked by Depression, war, and Cold War, Americans so wanted peace and prosperity in the 1950s that they were willing

to sacrifice a great deal of freedom of thought and action to get them. Jazz and Kerouac and his Beat cohorts fanned the flames of cultural liberty, and a select segment of the young generation of the era paid very close attention.

Jazz was one path in the '50s, but there was another musical avenue toward liberation, an approach considerably less technically demanding than jazz, which by this time had become extraordinarily complex. Almost anyone could sing folk songs, and lots of people could strum a guitar. The folk revival of the late '50s and early '60s was an exquisite series of ironies. In Robert Cantwell's summing-up, it was when "a superannuated ideological minority found themselves celebrated as the leaders of a mass movement; when an esoteric and anti-commercial enthusiasm turned into a commercial bonanza, when an alienated, jazz-driven, literary bohemia turned to the simple songs of an old rural America, when a Manichean cold-war mythology created a huge pacifist counterculture more fundamentally threatening to the political establishment than a handful of ideologues had ever been, when state capitalism generated a massive antiestablishment reaction in which it found, ultimately, one of its richest new market constituencies."

The young people who turned to folk in the late 1950s were deeply affected by a Beat stance that shaded into existentialism and were certain only of great doubt as to the political verities of the day, a disdain for consumerism, and a faith that the folk tradition represented the very best in American culture. The folk renaissance was simply the contemporary manifestation of the freedom principle, more intellectual than the more sensual ragtime and jazz, but no less part of the black/white dialogue on civil rights. "So we all owe it to Rosa Parks," said Dave Van Ronk, one of the more perceptive minds in the Greenwich Village folk scene.

Folk became a national matter in the fall of 1958, when the Kingston Trio's "Tom Dooley" topped the charts before going on to sell four million copies. An Appalachian murder ballad that recounted

Tom Dula's murder of Laura Foster in Wilkes County, North Carolina, it was first recorded in the 1920s by a blind Tennessee fiddler named G. B. Grayson and then for Elektra in 1952 by a song collector and folklorist named Frank Warner. Warner had already come to New York and connected with Alan Lomax, who included "Tom Dooley" in his 1947 *Folk Song U.S.A.* By the late '40s and beyond, the song was a staple of the New York City folk scene.

The Kingston Trio was a clean-cut, commercially sharp child of Pete Seeger's quest to revitalize folk song in America. Born in San Francisco, founder Dave Guard had spent his teen years in Hawaii, where he became interested in Hawaiian ukulele music and then learned to play the guitar. While a student at Stanford from 1952 to 1956, he formed a calypso group that traded on the popularity of Harry Belafonte, and in 1957 he attended a Palo Alto concert of Seeger's and bought his banjo instruction book. A San Francisco music publicist named Frank Werber took on Guard and his group, and their simple, good-timey harmonies, collegiate good looks, and sharp striped shirts took them and "Tom Dooley" to the top.

They were the leading edge of a flood. Folk hadn't always been a strictly purist left-wing proposition; Henry Ford had used folk materials in the building of Greenfield Village for nativist purposes, and the first regional folk festivals were conservative venerations of Anglo-Saxon culture in the South, including Bascom Lamar Lunsford's festival in Asheville. Burl Ives and Richard Dyer-Bennett had developed what was known as the genteel folk tradition—although Ives had actually learned songs from his tobacco-chewing grandmother, he'd also had classical training at NYU.

There was also commercial folk, going back at least to the Weavers of the early '50s, whose success was then replicated a couple of years later by Harry Belafonte. A sexy entertainer but not a pop star, a morally serious man who would become deeply involved with the civil rights movement, Belafonte wasn't a folk purist but still looked for

songs at the Library of Congress. He'd begun singing professionally in the late 1940s with material that focused on jazz and standards but opened at the Village Vanguard as a folk musician, stylistically very much the heir of Josh White but without the political baggage. His first album, *Mark Twain*, was released in 1954 but in early 1956 climbed to #3. Then in February 1956 *Belafonte* went to #1, and four months later *Calypso* went to #1 for thirty-one weeks on the strength of "The Banana Boat Song (Day-O)," very possibly becoming the first million-selling album by a solo performer. Other folk songs crowded on to the pop charts, including Tennessee Ernie Ford's "16 Tons" in 1955 and Lonnie Donegan's "Rock Island Line" in 1956.

Along with the commercial-shading-to-pop folk singers came an enormous wave of folk purists, effectively created by the New Lost City Ramblers. Pete's younger half-brother Mike Seeger, John Cohen, and Tom Paley came together in New York City in 1958 aiming to replicate the old-time string band sound they'd heard on Harry Smith's *Anthology*. Naturally, they recorded for Folkways. Brilliant players, they brought to their largely college student audiences the notion that it was possible to reach out and truly embody a foreign culture.

It was necessary that they do so in New York, just as minstrelsy had begun there, just as Woody Guthrie had ended up there, just as the '40s folk scene orbited around Alan Lomax's New York–based "Back Where I Come From" radio show. Always the radiating center of the American media, New York had housed the folk music nexus of the country at least since 1945, when a printer named George Margolin had drawn a small audience in Washington Square Park on a Sunday summer afternoon by playing folk music. By the late 1950s, there would be dozens of players in a variety of genres in the park on Sundays. New York was also where, in March 1956, the Guthrie Children's Trust Fund concert at Pythian Hall would canonize the ailing Guthrie and begin, Pete Seeger thought, the folk revival. Many would say it was Pete himself who did that.

Hits create momentum, and a folk business structure began to evolve, with clubs like Chicago's Gate of Horn opening in 1956 and the Ash Grove in Los Angeles in 1958. By now, the Village Vanguard booked only jazz, but Greenwich Village was sprouting plenty of replacements, including Gerde's Folk City, the Bitter End, the Gaslight Café, and Café Wha?. On the national level, the reigning home of folk music became the Newport Folk Festival. Newport, Rhode Island, was home to tobacco heirs Louis and Elaine Lorillard, who had decided in 1954 that it would be nice to bring jazz to their town. The success of the first festival ensured repeats, and with folk in the air, an additional folk-oriented festival in 1959 seemed a natural.

The first two Newport Folk Festivals would be organized by promoter George Wein, who owned a jazz club in Boston called Storyville and booked the Jazz Festivals, with a board that included singers Theodore Bikel, Oscar Brand, and Pete Seeger, and the owner of the Gate of Horn, Albert Grossman. They featured the Kingston Trio, Theodore Bikel, Robert Pete Williams, Earl Scruggs, and gospel music, but the 1959 festival was completely taken over by the unannounced appearance of a Boston University dropout named Joan Baez. Baez took the ongoing questions of what is folk, exactly? what is authentic? can people outside a culture really play something well? and turned them inside out; her glorious voice made them irrelevant.

The California-raised daughter of a Scots mother and a Hispanic father, she was clearly no heir to the Appalachian culture, but when she sang the Child Ballad "Silver Dagger," no one could deny the quality, authenticity, and rightness of the pairing. She'd become one with the material she chose. Raised in the Quaker tradition, she'd arrived at BU in the fall of 1958 and soon met up with and studied Debbie Green, a folk-singing graduate of the Putney School, one of Pete Seeger's regular stops. Baez would learn more from Cambridge folkie Eric Von Schmidt, then introduce folk music to Cambridge's formerly jazz-oriented Club 47. The appearance at Newport changed her world

and ignited even greater interest in the Greenwich Village–Cambridge folk axis that already existed.

The inhabitants of that axis thought the two scenes were dramatically different. New York, with such old-guard institutions as *Sing Out!* and later *Broadside*, seemed more overtly political, although Baez would put her talents at the service of social change for her entire career. But in general and in both places, folk music was about personal transformation and personal authenticity. Having found in folk music a profound connection to the old weird America where death wasn't hidden away in a hospital and birth was a natural event, they used it and its ethos to empower themselves. It had pastoral and antiquarian elements, but in the end it pushed toward a dream, a vision of a culture that rejected racism and the consumer ethic, a culture that led toward freedom.

THAT SAME DREAM underlay the embrace of jazz by the by-now thoroughly integrated audiences of the '50s—in particular, in Greenwich Village. The movement of jazz to the Village and environs had begun as early as the 1930s, when Max Gordon's Village Vanguard presented jam sessions along with folk music, poetry, and comedians. But it reached critical mass in October 1955, when Miles Davis went into the Café Bohemia on Barrow Street with his first great quintet, featuring Sonny Rollins, Red Garland, Paul Chambers, and Philly Joe Jones. Now recovered from drug addiction, Miles was ready to make a major artistic statement, and the Café Bohemia was exactly the right place to do so. The poet Ted Joans lived across the street and had recently sheltered the troubled Charlie Parker, who'd made arrangements to work off his bar tab by playing at the Bohemia until death caught up with him on a kind friend's couch that March.

Born near the banks of the Mississippi in Alton, Illinois, Davis was a natural part of the river tradition of African American music. Raised in East St. Louis with memories of the 1917 riot all around

him, he would attend a school where two of the teachers claimed Nat Turner as an ancestor. His father was a successful dentist—"I came from people who were somebodies," Miles said—and a strong black man known as a "race man" to his peers. Miles grew up on two kinds of music. One was the black big band jazz on the radio show "Harlem Rhythms," and the other was what he'd hear outside churches when he visited his grandfather's Arkansas farm in the summer, music that would stay with him along with memories of dark Southern roads and the hooting of owls. It was a "blues, church, back-road funk kind of thing, that southern Midwestern, rural sound and rhythm."

He was playing the trumpet by the time he was twelve, developing a style that reflected influences from both the blues and the more European sound of Bix Beiderbecke. Graduating high school in 1944, he headed for Julliard, although his real education would come at Minton's and on Fifty-Second Street listening to Bird and Dizzy and the rest. Still, he took advantage of his opportunities, going to the library to check out scores by Stravinsky, Berg, and Prokofiev. "I just couldn't believe someone could be that close to freedom and not take advantage of it," Miles said. After a gig with Coleman Hawkins, in October 1945 Miles went to work for Bird—Dizzy had quit because of Bird's drug use—at the Three Deuces and then the Spotlite, both on Fifty-Second Street. It was an astonishing experience, although Davis would remark that you couldn't learn from Bird, only copy him. Listening to Bird was like "hearing music for the first time."

To that moment in jazz history, pretty much all trumpet players had sought to replicate Louis Armstrong's hot persona. But like Lester Young before him, Miles had gone to the other side, to what his biographer John Szwed described as "cool, green, quarter note lines, notes carefully chosen and spaced, delivered slightly off or behind the beat, and relaxed, as if Louis were playing in a different world of time." That cool space would be Miles's world for the next forty years. "It floods the tone," Miles said. "It has a softness in the approach and

concept," and it places the "emphasis on one note." Ali Akbar Khan, the great Indian sarod player, once said, "All music is in the under-standing of one note."

Working with Gil Evans and others, Miles would record *Birth of the Cool*, a nine-piece group playing orchestrated pieces. Cool jazz, a softer and more mainstream sound that would become associated with various white West Coast players, was often regarded by Africa-centric critics as a diversion from the true jazz path, although Miles noted that it did indeed come from black roots. "It came from Duke Ellington."

During Miles's Café Bohemia residency, Sonny Rollins would disappear for a while in an effort to clean up his drug dependence, and his place would be taken by John Coltrane ("Trane"), a man still tormented by his own drug problems, but a remarkable player nonetheless. Originally from North Carolina, Coltrane had moved to Philadelphia in 1943 after high school. The saxophone had been part of his life since his early teens, and Duke Ellington's Johnny Hodges was his first master.

Trane would be a journeyman for a number of years, playing as much rhythm and blues as anything else while working with King Kolax, Jimmy Smith, Big Maybelle, Eddie "Cleanhead" Vinson, Bull Moose Jackson, and Earl Bostic, as well as the more jazzy Johnny Hodges's small group and the Dizzy Gillespie big band. A good part of his technique—overblowing, biting on the reed for squeals, long solos verging on hysteria—came out of the R & B canon, which made for a perfect counterpoint to the muted, subdued Davis.

"And faster than I could have imagined," said Miles, "the music that we were playing together was just unbelievable . . . Man, the shit we were playing in a short time was scary, so scary that I used to pinch myself." In his memoirs, Miles quoted *New Yorker* critic Whitney Balliett, who wrote that Trane had a "dry, unplaned tone that sets Davis off, like a rough mounting for a fine stone." "After a while,"

said Miles, "he was a diamond himself, and I knew it, and everybody else who heard him knew it, too."

Which didn't stop Davis from punching Coltrane in the head because of his drug problems. Thelonious Monk happened to witness the incident, and was more than happy to scoop up a brilliant player.

LATE IN 1955, New York City demolished the Third Avenue El and artists began to drift into the area, the low-rent Bowery district of the city east of Greenwich Village. One of them, a pianist named Don Shoemaker, began to hold jam sessions in his loft at 1 Cooper Square, serving his guests beer from the Bowery Café, a working-class bar on the ground floor below him owned by Joe and Ignatze ("Iggy") Termini. The jam sessions moved into the bar, which became the Five Spot Café in 1956. The pianist Cecil Taylor had a well-received residency there in the fall of 1956, and people like Willem de Kooning, Franz Kline, Alfred Leslie, Larry Rivers, Jack Kerouac, and Allen Ginsberg (who lived around the corner) began to fill the small (110-capacity) joint.

On the Fourth of July 1957, a new group moved in for the long (six months) haul. One-third of the trinity that had transformed jazz in the '40s, Thelonious Monk had not been able to play a regular engagement in Manhattan for six years because of a drug bust in which he'd taken the fall for his friend Bud Powell. Now he was able to assume his rightful place. Backed by John Coltrane on tenor, Wilbur Ware on bass, and Shadow Wilson on drums, he was a revelation.

It was the consummate irony of the late 1950s that jazz flowered into full triumph amid the gray desolation of the era's American culture, recognized by black and white alike as the hippest, most creative artistic thing (along, perhaps, with abstract expressionism) around in the midst of the artistic stagnation of post-McCarthy America. America's greatest native art form had now become America's classical music.

At the Five Spot, culture mavens from Leonard Bernstein and Norman Mailer to LeRoi Jones and Robert Frank joined the painters and listened carefully. "The painters not only made the Five Spot grow from a Bowery bar to a jazz center," said one witness, David Amram, "but they created its atmosphere. They were genuinely interested in the music and they felt what we were doing was serious music."

Of the many who came to hear freedom being played, one was Monk's patron—actually, the patron of all New York jazz— the Baroness Kathleen Annie Pannonica "Nica" Rothschild de Koenigswarter. Nica had found the antidote to a repressed English Rothschild upbringing with jazz, and Monk's music had given her the strength to leave her diplomat's-wife life behind. In 1960, she told the journalist Nat Hentoff, "[Jazz is] everything that really matters, every- thing worth digging. It's a desire for freedom. And in all my life, I've never known any people who warmed me as much by their friendship as the jazz musicians I've come to know."

Nica's own art would be one of human sympathy, nurturing Monk and dozens of others. Jackson Pollock's art was painting, and he'd transformed American visual art with his abstract expressionism while listening to jazz, in his opinion the "only really creative thing happen- ing in this country."

HIS RESIDENCY WITH Monk at the Five Spot would change Coltrane profoundly. Though Monk had the reputation for being silent and removed, Coltrane experienced a different man. "Monk is exactly the opposite of Miles," said Coltrane. "He talks about music all the time . . . if, by chance, you ask him something, he'll spend hours if neces- sary to explain it to you." He added, "Working with Monk brought me close to a musical architect of the highest order. I felt I learned from him in every way—through the senses, theoretically, technically. I would talk to Monk about musical problems, and he would sit at the piano and show me the answers just by playing them. I could watch

him play and find out the things I wanted to know. Also, I could see a lot of things that I didn't know about at all."

In a metamorphosis of the highest order, Coltrane emerged from his season with Monk playing at a different, and truly brilliant, level. Simultaneously he also conquered his opiate addiction, and with that extra measure of personal freedom he put himself, said Miles, "on a mission." He returned to Miles's band in December 1957 at the end of Monk's Five Spot run as one of two saxophone players, joining Julian "Cannonball" Adderley, who'd come in a couple of months before. Adderley, said Miles, "had that blues thing, and I love me some blues."

Davis's wife, the dancer Frances Taylor, took him to see the Ballets Africains, and the sound and rhythm of the *mbira*, the thumb piano, captivated him. He wanted a freer music, one that was "more modal, more African or Eastern, and less Western," "And in the modal way I saw all kinds of possibilities." The group was ripe for it; the blues is a modal form in the first place, so Cannonball had no problem, and Coltrane could manage anything. In March 1959 the group went into Columbia's studios to record what would become one of the two most popular albums in the history of jazz, *Kind of Blue*.

Not the smallest element of its appeal is the thrown-together, utterly spontaneous nature of much of the album. There were no rehearsals, and the record was pretty much first takes. It was a modal masterpiece, plus another sound, one Davis remembered "from being back in Arkansas, when we were walking home from church and they were playing those bad gospels." The critic Gary Giddins called it "Zenlike," with "one-take meditations and heightened conscious-ness." The music floated, weightless, but was never background music; it demanded attention.

That November Miles would go into the studio with Gil Evans and an orchestra and record yet another superpopular masterpiece, *Sketches of Spain*. Another of his explorations outside conventional jazz, *Sketches* is African American only in the preacher-congregation

dialogue between his trumpet and the orchestra, but is otherwise largely European classical and based on Joaquin Rodrigo's *Concierto de Aranjuez*. A number of Africa-centric critics were appalled: "Miles fell into the same trap as many other African-American musicians, making European classical music a standard of justification for our music." Since Davis had gotten intrigued with Rodrigo's music out of curiosity about the Moorish and black history of southern Spain, this makes for an interesting argument. Simply put, Miles had gone far beyond what jazz had done to that point. So would Coltrane, although in a very different way.

Coltrane would leave the Quintet in 1960, having already declared independence from conventional bop changes with his solo album *Giant Steps*, recorded two weeks after *Kind of Blue*. His next stop showed itself when a song plugger brought him the sheet music to a tune from the 1959 Rodgers and Hammerstein Broadway musical *The Sound of Music*. Given that it was a waltz in 3/4 time, it hardly seemed a candidate for jazz immortality.

Trane's "My Favorite Things" would reintroduce the soprano saxophone to jazz and take a sentimental trifle into the realm of contemplative majesty. Its near-Eastern tones connected it to a kind of transnational, transcultural melancholy, "an enduring delight," wrote Gary Giddins, "almost erotic in its opulence, emotionally generous, technically flawless." Joining *Kind of Blue* and *Sketches of Spain*, the album *My Favorite Things* would make jazz an essential element in the required knowledge of anyone pretending to have a reasonable comprehension of American culture.

Then Coltrane did something even more challenging. Along with Ornette Coleman, he took jazz beyond all the pop elements it had been founded on for sixty years into realms of abstract pure sound almost unconnected to melody or rhythm. A powerfully spiritual man, he turned to the African roots of jazz and then turned himself and his music inside out. In the summer of 1964 he would deliver

another improvisational masterpiece, *A Love Supreme*, which began with the simple four-note blues riff that followed the syllables of the title—"a-love-su-preme"—and then traversed the universe.

In so doing, Coltrane effectively resolved the blues/gospel dichotomy of the entire century, for he took simple minor-key blues riffs, mixed them with African polyrhythms and modal jazz tempos, free jazz, and gospel release to make spiritual music of the highest order. "If you do not have a very good understanding of the blues," said one of Coltrane's greatest musical descendants, Branford Marsalis, "you cannot play these pieces. And I don't mean the twelve-bar blues, I mean the representation of what the blues is, all of this stuff that goes into growing up and living in a black neighborhood."

A Love Supreme represented an enormous step toward an art of liberation, a difficult genre far away from all that was familiar and easy, yet one aimed at the human soul and spirit. Unlike the rock and folk music of this era, it was challenging and not at all for everyone, but it was great art in any case.

It was a long way from Buddy Bolden, and not so very far away at all.

The Blues Revival

ECONOMICALLY SPEAKING, '50s rock 'n' roll largely flattened the world of the blues, but as the '60s began, many of the blues-men found a new market in white college youth. This brought changes. Enamored of a rooted folk music tradition, most of the kids thought the blues meant a man and an acoustic guitar. A shrewd man like Willie Dixon could see this coming and repackage his blues as folk music, forming a duo with the pianist Memphis Slim (John Len Peter Chatman) and recording for Folkways, particularly a live album at the Village Gate with Pete Seeger in 1960.

This turnover in audience could have bizarre effects. Muddy Waters played a triumphant closing set at the 1960 Newport Folk Festival, a performance that would dramatically widen his audience. When Chess made an album from it, the cover showed him holding an acoustic guitar rather than the electric one he'd actually played. The same thing would happen in 1962, when Vogue released Howlin' Wolf's *The Rockin' Chair Album* with a cover featuring an acoustic guitar leaning against a rocking chair, neither of which had anything to do with the sizzling electric classics on the record.

Such manipulations have spurred a considerable reexamination of the blues revival in recent years that seeks to determine how much

white expectations changed the music. "Instead, by our interpre-
tive acts," wrote one historian, "we constructed the very thing we
thought we had found." Folk purism that prized "great age, obscu-
rity, correct tutelage, the agrarian milieu," wrote Charles Keil, could
be "a semi-liberal variant of the patronizing 'white man's burden'
tradition." Appreciating the art of a marginalized people on its own
terms is of course anyone's right; romanticizing this life to create the
mythical uninhibited, free-child-of-nature black man is not intellectu-
ally defensible.

Revisionist critic Marybeth Hamilton poses very reasonable ques-
tions: Who defined what was "authentic" blues? Who selected the
musicians and songs that would, in the 1960s, appear on rereleases?
What was the basic mind-set of the decision makers? She makes a per-
suasive case that a considerable part of the mind-set was created by
an almost entirely unknown man named James McKune, whom she
describes as a subeditor at *The New York Times* and a loner, "a wiz-
ard, a prophet, a lunatic."

Details of his life are quite sketchy, but it's reasonably certain that
McKune began collecting African American blues in the early 1940s.
His taste rapidly had him seeking the more obscure Delta players like
Tommy Johnson rather than the more successful Leroy Carrs of the
era, until one day he unearthed Charlie Patton's Paramount 13110,
"Some These Days I'll Be Gone," heard it, and was exalted.

To Hamilton, it was at that moment in McKune's room in the
Brooklyn YMCA "that the Delta Blues was born." He entered the col-
lecting network that Frederic Ramsey and friends had begun in the
1930s and began to run ads seeking certain titles in *Record Changer*, a
magazine that would codify the record-collecting process by teaching
beginners a lingo and basic information like label names, numbers, and
a code with which to grade the quality of used records. McKune swiftly
earned a reputation for acumen and then acquired followers. After a
while they began to meet at each other's homes to share information

and company. In time they nicknamed themselves the Blues Mafia, and the group would include such eventually recognized authorities as Stephen Calt, Lawrence Cohn, Nick Perls, Pete Whelan, and Sam Charters.

McKune was their mentor. He was a man, said Cohn, listening to Charlie Patton "before any of us even knew who Brownie McGhee was." He taught them where to look, like "the furniture stores under the subway tracks in Queens where Charles Edward Smith unearthed boxes of untouched OKehs and Vocalions." His lessons imparted, McKune would fall prey to raging alcoholism, dying in a Lower East Side welfare hotel in 1971.

But in the course of the 1950s, McKune and his collector friends, wrote Hamilton, "set up record labels, issued LP anthologies, and wrote liner notes, articles, and books of blues history that framed the blues as we now know it." Certainly McKune's orientation toward the Delta blues as the most powerful of all the varieties of blues was influential, although Hamilton's rhetorical conceit of having him "invent" the blues hardly seems justified.

It is impossible to say what conclusions someone with no prior knowledge would draw after sitting down to listen to all the blues available, which is why cultural history will always be slipperier than those lovely hard sciences where you can replicate your experiments. I'm willing to wager, however, that a significant portion of our mythical tabula rasa blues-listeners would cite Charlie Patton as being exceptionally ear-catching and powerful.

Interestingly, Harry Smith independently developed an aesthetic fairly similar to McKune's. Though he chose only one Patton piece and no Robert Johnson in the original package (he did select "Last Fair Deal Gone Down," which appeared in a version Revenant Records released in 2000), Smith largely chose songs and musicians that were not modern, not slick, and not nationally commercially successful—Blind Willie Johnson, Mississippi John Hurt, Furry Lewis, and

Cannon's Jug Stompers—to go with the three Blind Lemon Jefferson sides he included in the *Anthology*.

The blues revival first flourished in England, helped along by the folk music program on BBC hosted by the exiled Alan Lomax and an ongoing association of blues with traditional (*trad* to the English, *Dixieland* to Americans) jazz. In 1955 banjo player Anthony James "Lonnie" (the name taken to honor Lonnie Johnson) Donegan recorded a single of Lead Belly's "Rock Island Line" backed only by bass and washboard; for reasons known only to the Infinite, it swept England and became a hit, then crossed the Atlantic and did the same.

This began what in England would be called the skiffle craze, *skiffle* being a 1920s Chicago term for rent party. The music was a variation on jug bands, played on improvised instruments like jug, kazoo, and tea chest (standup) bass. Because it was fun and the instruments were cheap, thousands of skiffle groups popped up all over England, including a group in Liverpool called the Quarrymen, led by a promising lad named John Lennon. All over England young protomusicians were introducing themselves to African American music and learning to play it.

Donegan's bandleader Chris Barber would go on to help American blues players like Big Bill Broonzy, Sonny Terry and Brownie McGhee, and Muddy Waters and Otis Spann find work in England, bringing the latter two over in October 1958. Since the audience expected acoustic music, Muddy's electric guitar confused them at first, but Muddy got a little quieter and the ten-date tour became a roaring success, thoroughly revitalizing Muddy, who would retain an interest in white fans afterward.

Other members of Barber's band would make waves, including pianist Alexis Korner and harmonica player Cyril Davies, who formed a duo and established the London Blues and Barrelhouse Club in 1955 before creating Blues Incorporated in 1961. Blues Incorporated was an electric blues/R & B group with a free-floating membership that

included Charlie Watts, Jack Bruce, Ginger Baker, Long John Baldry, and a younger subset of occasional players with names like Mick Jagger, Keith Richards, Brian Jones, John Mayall, Rod Stewart, and Jimmy Page. In short, a sizeable chunk of British '60s rock royalty started by working with Korner.

SAM CHARTERS'S 1959 publication of *The Country Blues* was a major event in the evolution of the blues audience. Charters had fallen in love with the blues in his teens upon hearing Bessie Smith and in 1950 had moved to New Orleans at least in part to study the blues as a precursor to jazz. He spent much of the decade carrying out field recording for Moe Asch, finding the great Bahamian singer Joseph Spence among others. His book centered generally on the most popular bluesmen—he'd listened to some rarities with Blues Mafia members, but was not persuaded by their aesthetic, and so he selected subjects based on sales figures, focusing on Lemon, Lonnie Johnson, Leroy Carr, and Bill Broonzy, and sensibly including Muddy Waters.

His inclusion of Robert Johnson, whom he describes as dark, possessed, and clearly attractive, would trouble revisionists like Elijah Wald, who grumbled that Charters's "title maintained the central myth of the Hammond and Lomax approaches." Charters would later make clear that he was operating with a certain bias, conducting what he called "my own private revolution" against American racism. He worked consciously to make the legends of the bluesmen romantic, to attract young white Americans to an appreciation of black culture, to make it "glamorous" to go south.

The very idea of consulting sales figures appalled James McKune, who would write a stinging commentary on the book for a British collectors' magazine, *VJM Palaver*, which essentially argued that Charters's subjects were popular, but not great. McKune assumed a priori that the masses—black, white, it mattered not to him—could not

discriminate between the two. In the wake of McKune's letter to *VJM*, one of his protégés, Pete Whelan, would start up the Origin Jazz Library (blues being to Whelan the origins of jazz), a record label designed to reissue blues based on a very different set of criteria from Charters's, emphasizing roughness, raw intensity of emotion, and primitive song forms. The first release was a collection of Charlie Patton and the second spoofed Charters's title with its own: *Really! The Country Blues.* Origin was a very small—the first pressing for the second release was only five hundred and took two years to sell out—but rather influential label; scholars like John Fahey, Robert Palmer, Lawrence Levine, and Greil Marcus would all cite Origin as a fundamental source.

It began to occur to fans that not all the original recording blues musicians were necessarily dead. In 1964 Phil Spiro was a DJ at MIT who learned that Son House was alive. He gathered up long-time Blues Mafia member Nick Perls and blues photographer and future manager Dick Waterman, leaped into a VW, and headed for Mississippi. Eventually they learned that Son had moved to Rochester, New York, and drove straight there. On the same day that they found Son in Rochester, John Fahey and two others found Skip James in Tunica. Tom Hoskins would soon locate Mississippi John Hurt near Avalon, the town he'd sung about in "Avalon Blues."

Many of the "rediscovered" would return to the performing stage, some after years of not playing, which raised further questions. None of the performers objected to a late-in-life payday, of course, but at least one, Skip James, would feel a fair amount of contempt for an audience that would applaud what he knew was a third-rate performance. It was easy for critics to ridicule naïve young white people listening to—the older and more decrepit, the better—bluesmen who were far removed from when the blues were a fresh and creative thing. The mockery implied that one should appreciate an art only if it's indigenous to one's own time and culture, which is preposterous. The art of a bygone day is no less valid for being an orphan.

Perhaps more ominously, wrote one of these blues fans, Peter Guralnick, "We also consciously or unconsciously tried to shape the music that they played on stage [by asking for specific songs or instruments]. The same statement could be made for the guys running Paramount during the thirties, but at least their motive was simple profit, which motive the artist shared. Our motivation was a strange combination of ego, scholasticism, and power." It became uglier still when the researchers fell out and fought with each other. Some of them were clearly exploiting their situation, and overall, observed Spiro, only Dick Waterman and Chris Strachwitz of Arhoolie Records saw the rediscovered bluesmen as real breathing humans.

But listening to the blues was not the only white response. As the '50s shaded into the next decade, the still-vital electric blues tradition in Chicago began to attract a few gifted young white Chicago musicians to haunt the black clubs, listen to the masters, and eventually learn to play the real thing. The best known and most gifted was Michael Bloomfield, born in 1943 to a wealthy Jewish family on the North Side. Once he heard the blues, he was gone. He picked up a guitar and soon had a reputation as anyone's equal, playing in the black South Side blues clubs with Sleepy John Estes, Yank Rachell, and Little Brother Montgomery.

In time he met Paul Butterfield, a young white kid raised in the mixed Hyde Park neighborhood who'd graduated from the prestigious University of Chicago Laboratory School as a superb flautist and a potential track star until he fell in with a fellow named Nick Gravenites; by the late '50s they were haunting the South Side clubs listening to Muddy, Wolf, Little Walter, and Otis Rush, and Butterfield swapped his flute for a harmonica. Butterfield stayed semiconventional long enough to get into the University of Chicago, but then he met fellow student Elvin Bishop, a National Merit Scholar and physics major. Soon Bishop decided to major in the blues, and music replaced books.

In 1963 Butterfield and Bishop were offered a gig at the North Side folk club Big John's, which enabled them to lure Jerome Arnold (bass) and Sam Lay (drums) from Wolf's touring band. Bloomfield started coming around, and the Butterfield Blues Band was born. They'd learned their blues lessons well—in terms of suffering and damage, sometimes far too well. But the kinship was unchanged, and the bond between black music and young Americans flourished as never before.

APPRECIATION FOR THE blues was sufficient in Europe to bring German promoters Horst Lippmann and Fritz Rau to Chicago in 1962 and set up an office in Willie Dixon's home to book the "American Folk Blues Festival (A.F.B.F.)." Muddy, Sonny & Brownie, T-Bone Walker, John Lee Hooker, and Memphis Slim were the first wave, and over the course of the decade, Sonny Boy Williamson, Howlin' Wolf, Big Joe Williams, Otis Rush, and Buddy Guy would join the procession.

Giorgio Gomelsky, a jazz and blues fan and club owner, would be the festival's representative in England, so his friends among the new blues-oriented English bands like the Rolling Stones and the Yardbirds would get front-row seats to the shows. A gathering at Gomelsky's home in 1964 would lead to three very large black men—Howlin' Wolf, Sonny Boy Williamson, and Willie Dixon—sitting on the sofa with coffee and Johnny Walker, with Jimmy Page, Eric Clapton, and several other future British guitar gods literally at their feet. Sonny Boy would dismiss the young men in front of him with the classic put-down, "They're awful. They want to play the blues so bad, and they play it so *bad* . . ." As usual, Dixon was a little sharper. While in England he was taping songs and giving them to the bands to consider for recording.

Moments like that would lead the revisionist Elijah Wald to write that Robert Johnson was "a creation of the Rolling Stones," as these skinny white boys fell in love with the blues. Indeed, the real nexus of current blues revisionism is located in the ongoing argument over the

career of poor Bob, and the conundrum of why a man who sold so few records to black people could be such an object of fascination to white people thirty years later in the 1960s, and remain so some fifty years further on. This debate encapsulates every issue raised in this study, from minstrelsy to the present: Where does an interest in the culture of the Other cross from interest to exploitation, from admiration to a demeaning worship, from curiosity to the worship of the exotic, implicitly another form of domination?

THE MOST POTENT event in the history of the blues revival was in fact Columbia's 1961 release of *King of the Delta Blues Singers* and its ensuing reception. For one thing, the phrase *Delta blues* almost immediately replaced *country blues*.

In essence, the response of the first critics to write about Johnson in the early '60s—Greil Marcus, Robert Palmer, Peter Guralnick—was so extremely enthusiastic that there has been an inevitable reaction. This even goes back to the very first coverage of Johnson, to John Hammond in the '30s and Rudi Blesh in the '40s. The circumstances of Johnson's life—dying young, being mysterious because of the limited amount of information available, rumors of the supernatural—are so juicy that it drives those not engaged by the quality of his songwriting and performing completely nuts.

He is a ghost, seemingly condemned to wander through the corridors of the American culture as critics quarrel over his fate. It wasn't until fifty years after his death that a verifiable picture of him went into circulation. Thanks to the sloppy record keeping of black lives in the South, conflicts among his school records, the census, his marriage license, and death certificate make even his date of birth a point of contention. He had three fathers—his birth father, a first stepfather in Dodds/Spencer, and a second stepfather, Dusty Willis. He claimed at least two last names. He lived in a world treacherous enough to rob him of his young wife and baby and have her family blame him and

his music for it. Finally, the location of his burial spot was a point of
contention for many years, although more recently it seems to have
been settled. Now *there*'s a good start on a legend. He is a mythic
figure, "part of the European religion of art," wrote Wald, "not any
African American spiritual tradition . . . [the] archetype of the sensi-
tive artist cut down in his prime." Certainly the brevity of his career
feeds the legend, as when Peter Guralnick linked him with Keats and
James Dean.

How that legend evolved is worth study. John Hammond had
received review copies of Johnson's first releases and wrote enthusi-
astically about them in *New Masses*, describing him as "the greatest
negro blues singer who has cropped up in recent years," making Lead
Belly "sound like an accomplished poseur." A brief mention a couple
of months later had Johnson as "a worker in a Robinsville [*sic*] planta-
tion." Hammond did not lose interest after Johnson's death and shared
recordings with other members of his jazz-collecting world, including
Alan Lomax, who would include Johnson titles on his *List of American
Folk Songs on Commercial Records*.

As people will, authors tended to see their own interests in Johnson.
Thus Charles Edward Smith and Frederic Ramsey's 1942 *Jazz Record
Book* celebrated the protest and work song elements in the music;
these left-wing early jazz collectors saw Johnson and his peers as folk
musicians rather than entertainers, since they saw blues as the precur-
sor to the more sophisticated work of jazz. That Johnson sang things
other than the blues did not seem important to them.

In 1946, Rudi Blesh would publish *Shining Trumpets* and be the
first to associate the supernatural with Johnson. In a consideration of
"Hell Hound," he notes that it expresses "uncanny and weird feelings,"
that his voice "sounds possessed like that of a man cast in a spell."
Then he waxes poetic: "The high, sighing guitar notes vanish suddenly
into silence as if swept away by a cold, autumn wind. Plangent, iron
chords intermittently walk, like heavy footsteps . . . [The images] are

full of evil, surcharged with the terror of one alone among the moving, unseen shapes of the night." And so forth . . . Sam Charters was also fascinated with Robert's "attraction" to the demonic and psychoanalyzes him based on the two supposedly demonic songs, "Hell Hound" and "Me and the Devil Blues."

The 1961 release of *King of the Delta Blues Singers* would also shape a portrait of Johnson that leaned heavily on the dramatic. Produced by the jazz archivist Frank Driggs for John Hammond's "Thesaurus of Classic Jazz" series, it suggested both by packaging and selection—it did not include the modern and danceable "Dust My Broom" and "Sweet Home Chicago," and the version of "Cross Road Blues" he chose is much less romantic than the alternate take—that Johnson was a lone, tormented, ghostly figure.

Grounded in the idea that Johnson was an unreflective and unsophisticated folk artist and not a professional—after all, Willie Dixon wrote a ton of mojo lyrics, and no one speculates on his relationship with Satan—Driggs and Blesh were both guilty of making the assumption that the lyrics are autobiographical. Certainly the intelligent lyricist, as with all writers, writes what he or she knows best, but this assumes a fairly complete lack of imagination, and that's clearly an error.

Most of Johnson's songs are about wandering and love, both lost and gained. Only two of Johnson's songs appear to be seriously devoted to the subject of the supernatural, and not so very clearly, at that. It's been suggested that "Hell Hound" is about being pursued by a cop or a woman, and in any case it's more atmospheric and evocative than specific, except for the single line "Hellhound on my trail." "Me and the Devil Blues" does not celebrate evil but communicates guilt, sadness, and resignation over sins related to his love life. While it is true that there are African magical associations with a crossroads, there is no reference to anything magical in "Cross Roads"—it's about hitchhiking.

Greil Marcus's *Mystery Train* (1975) has been rightly celebrated as a significant benchmark in the history of rock criticism, not least for

his great facility in mixing a broad range of cultural references into his considerations. His evaluation of Satan in Johnson's work has to do with his understanding of black Christianity, with the idea that the blues singers are "the real Puritans," who feared the devil "because they knew him best." This Manichean approach to black life is at the very least arguable; what makes Marcus the target of the revisionists is his extreme enthusiasm over the music, that it "changed the way the world looked."

Johnson suited perfectly the '60s counterculture's need for heroes who rebelled against conventions, lived lives of unfettered freedom while expressing themselves artistically, and pursued pleasure while evading any commitment to one partner—Johnny Shines: "Did Robert really love? Yes like a hobo loves a train . . . off one and on the other . . ."—all to compensate for being deprived of full citizenship. Pete Welding's liner notes on the 1970 release of the remainder of Johnson's work portray an "apocalyptic" man possessed by "dark foreboding, and almost total disenchantment with the human condition," a black Orpheus beset by evil in his wanderings.

One of the best rock critic/historians ever, Peter Guralnick did not do his best work when he wrote of Johnson, "Doomed, haunted, dead at an early age . . . a brief flickering of tormented genius. Not one of his songs fails to bear out the romantic association," in his *Feel Like Going Home* (1975). A bit overstated, that.

The specific and very reasonable charge by the revisionists is that a considerable portion of Johnson's appeal lies in the supernatural, in the notion that he sold his soul to the devil in return for transcendent powers of performance. The meme began with a 1966 *DownBeat* piece by Pete Welding that quotes Son House as suggesting that, having gone away and returned a far better player, the gap in time was so brief that there must be some supernatural explanation. Son didn't make a big deal of it, and neither should we. It's far more likely that Johnson was gone longer than Son recalled. It's also true that when Julius Lester

later interviewed Son in 1965 Son didn't mention the idea, and when Dick Waterman asked him about it, he dismissed the notion.

Once started, the idea acquired a life of its own—after all, there's a reason the Faust legend has endured for so very long. Paganini supposedly made the same bargain. In *Mystery Train*, Marcus temporized, using the phrase "let us say." By 1982, Peter Guralnick would add Tommy Johnson's brother LeDell's story of Tommy selling his soul, and then write that "Son House was convinced" about Robert's soul—which is a considerable overreading of the original remark. In *Deep Blues* the same year, Robert Palmer would write of Johnson's "unabashed identification with the leader of the world's dark forces, the ultimate Other," and repeat the soul-selling story, although his source was the musicologist and Johnson expert Mack McCormick, who claimed unspecified sources who were relatives of Johnson's.

In 1979 and again in 1991, musician and University of Maryland professor Barry Lee Pearson interviewed Honeyboy Edwards, Robert Shines, and Robert Junior Lockwood about Johnson and elicited no mention of devils. In 1996, Honeyboy would tell the writer Paul Trynka a full crossroads story, and in his autobiography, published the following year, he slid sideways. "It may be Robert could have sold himself to the devil. In the way he was, the way he played and the way he acted, he could have felt that he sold his soul." The sequence could be offered as an object lesson to beginning researchers about the influence of repetition on witnesses.

Of course, the cultural event that put the myth in concrete came from—where else?—Hollywood, in a 1986 coming-of-age film called *Crossroads*. It's not a good movie, but its reduction of all Johnson's talent into the Dr. Faustus legend makes it dubious indeed. Anything that contributes to the *Rolling Stone Encyclopedia* (1995) entry that states flatly that Robert Johnson learned to play from the devil is not a contribution to a better world.

As fate would have it, Johnson's death also inspired confusion, argument, and mystery. Honeyboy told Pete Welding in the 1960s that it was clearly caused by poison, but over the years, his memories of the event grew suspiciously more and more detailed.

The same is true of Sonny Boy Williamson II, who claimed to have been at Johnson's last performance, and very possibly was. But over time, Sonny Boy would come to be holding Robert as he died . . . probably not. Various people at various times also claimed he was stabbed. (Stephen LaVere relates that there was indeed a Robert Johnson who was stabbed, but not the musician. This Robert Johnson is the one buried in Quito.)

Story inflation is not restricted to Johnson's peers. In his memoir *The Land Where the Blues Began* (1993), Alan Lomax recounts a touching scene of being told by Robert's mother, Julia (except that he calls her Mary), that her son had given her his guitar while denouncing it as the devil's instrument, although this story was not in his original research notes, and he's recalling it fifty-one years later.

Patty Johnson, a Clarksdale health care professional, blues producer, and consultant, offers a less romantic view. Her friend Willie Coffee had been Johnson's boyhood pal, and Willie had heard Johnson died of pneumonia. Leaving aside the question of causes, the symptoms people described included great pain and dementia. Multiple organ failure, as a consequence of syphilis (as the local plantation owner speculated) or even pneumonia, would cover those symptoms. The terminal shutdown of liver and kidneys is extremely painful, and as the body becomes septic, dementia is quite common. Sepsis is actually a form of poisoning, but from within. It's all speculation, of course, and always will be.

With all these inflated claims and general confusion, it's no wonder that revisionists have cropped up to cast some refreshingly chilly buckets of cold, skeptical water on the subject. Unfortunately, they tend, from my view, to overinflate their responses. "The idea of something

called the Delta blues," wrote Marybeth Hamilton, "dates from the late twentieth century . . . discovered—or, if you like, invented—by white men and women" who were in search of an "uncorrupted black singer, untainted by the city."

Elijah Wald admires Johnson's music, but one would conclude from reading his *Escaping the Delta* that because Johnson did not sell many records, he's not really a significant part of the history of the blues, which is a popular black art form, and that the later white interest in the '60s and after in some fashion corrupts his legacy. If one only looks at the popular, one has to somehow imagine that Mamie Smith invented the blues in a New York City recording studio.

The truth is that Robert Johnson wrested a superb art out of the blues tradition, an art that has appealed to generations of both black and white listeners, an art that is an essential element of the ongoing progression that is the freedom principle in operation. Forget the context, the mysteries, and the lies; those twenty-nine masters represent artistic truth.

THE BLUES REVIVAL brings us to the early 1960s, as an entire generation's interest in cultural freedom quickened and grew. The baby boomers had been born into an extraordinary stasis. Their parents had grown up in the most devastating depression in world history, producing a deep longing for economic security. That generation then took part in an enormous war that was won because of an extraordinary fusion of technology and a social/corporate technocratic organization that defeated a terrifying enemy—and also dramatically recast American society and social values so that those who didn't participate in large-scale organizations were in a distinct minority.

In addition to the worship of technology, postwar America further altered the social landscape with the brilliantly successful entitlement programs known as the G.I. Bill, which lifted an enormous number of veterans, black and white, up a social class (from working to middle)

with education benefits and the ability to borrow money to fulfill the American dream and own their own home. All these factors encouraged them to focus on material goals.

Finally, the Cold War generated a postwar backlash against the values of the New Deal that not only lionized American business but also fed a witch hunt against any deviation from the social norm. In short, when Americans watched such television shows as, say, *Father Knows Best*, they believed that they were watching reality—that America had no black people, that all sins were minor and grist for laughter, that abuse or incest or alcoholism was rare and didn't require being mentioned, that this was the best of all possible worlds—so long as one did not make significant waves.

All these strands of music reveal that this is not so. And those cultural strands were all going to combine in the stirrings and dreams of freedom of a good part of an entire generation, and in the art of one genius composer. All of it would challenge that stasis in remarkable ways.

III

THE MAN WHO BROUGHT
IT ALL BACK HOME

22

Bob Zimmerman Becomes
Bob Dylan

THE CREATION OF African American music revolved to a considerable degree around the Mississippi River, mostly between St. Louis and New Orleans. The river begins at Minnesota's Lake Itasca as a creek about fifty feet wide, with some strategically placed stepping-stones that allow you to cross it easily.

Some 2,352 miles south, it empties into the Gulf of Mexico. Six cubic feet of water, about one bathtub full, leaves the lake every second (cfs). At the Gulf, the rate is somewhere around half a million cfs. It will take a drop of water ninety days to make the journey. Standing on those stepping-stones brings to mind some lines from T. S. Eliot's "Little Gidding" in the *Four Quartets*:

> We shall not cease from exploration
> And the end of all our exploring
> Will be to arrive where we started
> And know the place for the first time . . .
> At the source of the longest river . . .

THE RIVER IS pure and clean here, although that won't last. Minnesota is the essence of the Midwest, perceived from the late nineteenth century on as the repository of rural/agricultural "Arcadian" virtue just as the East Coast became conclusively urbanized and polyglot, "the land of purity and the pure," wrote a Minnesota historian, "a moral beacon for the nation."

Northern Minnesota, the source of the Mississippi, is a cold, austere place, which made it a comfortable destination for turn-of-the-century emigrants from Scandinavia and Russia. Near here at the river's origins one of black music's most notable heirs began his life.

Robert Allen Zimmerman, a descendant of Lithuanian Jewish immigrants, was born in Duluth on May 24, 1941. He and his family—father Abe, mother Beattie, and younger brother David—soon moved to a mining town further north called Hibbing, Beattie's hometown, where Abe joined his brothers in a business called Micka (pronounced *Mike-a*) Electric. Prospering, in 1952 they moved into their own home at 2425 Seventh Avenue, a three-floor, nine-room "Mediterranean Moderne" house in a new development.

Hibbing is part of the Mesabi Iron Range, "The Range" for short, an eighty-mile crescent of red earth across northern Minnesota that has been the preeminent American source of iron for more than a century. The entire upper Midwest was effectively deforested after the Civil War, and the next step for American business was to mine the denuded land. In 1892, a road builder from Duluth named Frank Hibbing remarked, "I believe there is iron under me, my bones feel rusty and chilly." Smart bones. Below him was some of the richest iron ore in the world, ore so good that an open pit sufficed to remove it. So began what would become the Hull-Rust-Mahoning Mine, among the biggest and dirtiest man-made holes in the world, a lunar landscape that would extend for miles and look like nothing so much as a red, bleeding wound on the planet's skin.

In the twentieth century, the miners would dig up 1.4 billion tons
of dirt, which yielded 500 million tons of iron ore. As Bob grew up
in the 1940s, one railcar load left the mine every twenty seconds, one
10,000-ton boatload's worth every hour, day and night, for eight
months of the year. When the good iron ore petered out, they switched
to the less pure taconite, and now in the new millennium the trucks are
thirty feet tall and haul a 275-ton load.

Hibbing flourished and by 1950 had a population of seventeen
thousand, largely immigrants from Italy and Eastern Europe who'd
come to work in the mines. A six-block downtown strip on Howard
Street included the posh Androy Hotel, two department stores—
Feldman's (Beattie worked there) and Herberger's—and four clothing
stores, including Stone's, owned by Beattie's parents. There were four
movie theaters, all owned by Bob's grandfather Ben Edelstein, includ-
ing the Lybba, named for Bob's grandmother, on First Avenue.

Winter was the single great fact of Hibbing, and it was what Bob
would always remember. It was transcendently cold, so cold that it
was silent, as though the very sound waves had frozen. "Nothing
moved," he said later. "Eight months of that . . . You can have some
amazing hallucinogenic experiences doing nothing but looking out
your window." Winter brought him dreams and visions, and long
before he understood it, he'd acquired a sensitivity to his environment
far beyond the average child. He would be solitary and contemplative
from the start. As he grew up he also came to realize that Hibbing's
source of existence, the mine, was a deep affront to nature, to the earth
itself. Realizing that made him separate from all the rest of Hibbing,
which took pride in the mine.

One of the other great realities of Hibbing was its isolation. No one
passed through Hibbing on the way to somewhere else; it was and is
the end of its own road. It was an unusually egalitarian town in appear-
ance. The mine owners lived far away, and almost everyone lived in a

single-family dwelling. This did not exempt it from being small-town provincial, conservative, and philistine in values. Later he'd describe it as a "vacuum." It was not a place for dreamers.

Another thing that separated him early on from most of the rest of Hibbing was his birth religion. The clearest comment on Bob's ambivalence about this has been his lifelong tendency to dismiss the whole subject, telling one reporter, "I've never felt Jewish. I don't really consider myself Jewish or non-Jewish. I don't have much of a Jewish background." Which is *extremely* hard to accept.

Minnesota's state capital was notoriously anti-Semitic, and in Hibbing, Abe was denied membership in the Mesabi Country Club. Bob's family was deeply involved with Jewish life—Abe was president of the B'nai B'rith, Beattie of Hadassah. Though it did not have a rabbi in residence, Hibbing had a synagogue, Agudath Achim, and Bob was part of its Chanukah program at the age of seven. He was bar mitzvahed at thirteen, and in later summers he would go to the Jewish Camp Herzl in Wisconsin.

More than one of his friends would speak of his sensitivity on the subject. "The kids used to tease Bob, sometimes," said Larry Furlong. "They would call him Bobby Zennerman because it was so difficult to pronounce Zimmerman. He didn't like that." Some years later, in high school, his first great love, Echo, would ask him if he was Jewish. Bob wouldn't reply, and his friend John would warn her that it was a touchy area. Jewishness, too, pushed him back into his private dreams.

So he did what was natural for a dreamer. By the time he was eight or nine he was writing, "poems, rhythms, you know, about the flowers and my mother and stuff like that."

He had a materially comfortable childhood. He had his own room, which every child prizes. The family had a record player, and they even had one of the first TVs in Hibbing, but it was the big mahogany radio that brought him his first hero. Listening to it one Saturday night in 1951 or 1952, he heard a mournful, keening voice coming from

Nashville on the Grand Ole Opry, and soon learned that the man's name was Hank Williams.

Years later, he'd write that Hank would be his "voice an' tell my tale / An help me fight my phantom brawl." The music itself moved him, especially "Cold Cold Heart," and it didn't hurt that Hank sang of railroads and rattling wheels, just like the long trains that came in and out of Hibbing, connecting it to the rest of the world. Music reached in and affected him powerfully, more than any other thing in his life. Hank would die on New Year's Day 1953, only twenty-nine years old, and that would be a blow, but there were other singers. One early favorite was Johnny Ray, who had what Bob would later call a "strange incantation in his voice . . . like he'd been voodooed."

Then came Bob's salvation. After diddling with other instruments, around 1954 or 1955 Bob worked on his father's delivery truck long enough to buy a Sears Silvertone guitar. He went to Crippa's Music Store and bought Nick Manoloff's *Spanish Guitar Method*, and though he didn't learn to read music, he began to absorb what the guitar could do. Here was one more thing to take him away from Hibbing and into a world of his own. "And once I had the guitar," he said later, "it was never a problem. Nothing else was ever a problem."

Things got even better when he heard Elvis Presley. "When I first heard Elvis's voice I just knew that I wasn't going to work for anybody and nobody was gonna be my boss. Hearing him for the first time was like busting out of jail."

In the fall of 1955 he moved up to high school, only four blocks down Seventh Ave. from home. The mines had built Hibbing High School in 1920 at the extravagant cost of $3.9 million, and it had four stories, two gyms, a swimming pool, an eighteen-hundred-seat auditorium with a pipe organ, a positively luxurious library, and a strong resemblance to a castle, complete with turrets. In a sign of the times, the imposing entrance, which started with twenty steps up to the main corridor of the school, was also adorned with signs for fallout shelters.

What coincided with high school impressed him even more. *Blackboard Jungle* had opened that March, and Bob was hopping around to "Rock Around the Clock" along with almost every other teenager around. When he got a chance to see the movie the next year, he'd tell his friend LeRoy Hoikkala, "This is really great! This is exactly what we've been trying to tell people about ourselves." He may have looked like a nice Jewish boy on the outside, but inside, he was changing.

Two months into high school, in November 1955, he heard his second major idol on Duluth's WDSM. That month, one of the wiggiest stars in American musical history, Richard Wayne "Little Richard" Penniman, put "Tutti Frutti" on the national charts. Bob loved it. "Everything. The sound of his voice, the intensity of it. The register that he sang in, his high-speed delivery. And the songs were simple and easy to learn." Bob was now officially a teenager. He listened to the radio, spent lots of time hanging out at Crippa's Music Store, "and I slambanged around on the guitar, and played piano, and learned songs from a world which didn't exist around me."

Little Richard described himself from childhood as being something of a freak. One leg and arm were each shorter than the other, and he had an enormous head and, from his earliest memory, a wholehearted desire to be a girl and play with girls. He reacted to being different by being loud and seeking attention, and early on realized that performing on stage was his natural outlet. He began with a gospel group called the Tiny Tots, then a family gospel band. At fourteen he hit the road with Dr. Hudson's Medicine Show, and before long he was part of a minstrel vaudeville show called Sugarfoot Sam from Alabam'.

Early in 1955, Richard sent a tape to Specialty Records, which made its way to producer Robert "Bumps" Blackwell, who'd already worked with Ray Charles. Specialty's boss Art Rupe had told Blackwell to find another voice that could combine gospel and the blues, and now Blackwell had it. They decided to record Richard at Cosimo Matassa's

J & M Studios in New Orleans with Fats Domino's session guys, most notably Earl Palmer on drums.

When they sat down to record, the first morning's work was a waste; Richard was inhibited, his material seemed flat, and nothing worked. At a lunch break next door at the Dew Drop Inn, he began playing piano to show the saxophone player, Lee Allen, his style—and out came his song "Tutti Frutti," which contained lots of words that they couldn't record. Bumps called in Dorothy LaBostrie to tone them down—Richard had to be coaxed to sing the dirty ones in front of her—and with Richard on the piano, they pushed through three takes in fifteen minutes and had it.

Richard merged the fire of gospel with New Orleans R & B, injecting abandoned evangelical ecstasy into rock 'n' roll with a pounding piano and wailing vocal delivery. He was truly possessed by the spirit, even if it was more Dionysus than Jesus. The freedom principle was alive and stalking America's pop charts. Hits like "Long Tall Sally" and "Lucille" followed, before he succumbed to exhaustion in late 1957 and announced what would become an oft-broken retirement to preach the gospel. In Hibbing, Bob, feeling the fire, pounded on the Gulbrandsen spinet piano Abe had installed in the basement.

The year 1955 was a good fall for those seeking the rebellious in American culture. In October, James Dean's *Rebel Without a Cause* swept through American teen lives, opening just four days after Dean's death in a car crash. Bob would see it repeatedly and come to identify profoundly with Jim Stark, Dean's restless, isolated, good-hearted, vulnerable, and inarticulate character. When Jim's father tells him that he'll see things differently in ten years, Jim replies with a line Bob would frequently quote: "Ten years? I want an answer now. I *need* one." Before long, Bob had adopted Dean's leather jacket and jeans, his slouch and mumble. James Dean would be one of the fundamental talismans of his life.

Bob was still conventional enough to be a member of the Gutter Boys, a team that won the school bowling tournament his freshman

year, but he was drifting away from conventionality. He and his best
friend, John Bucklen, would eventually invent a mind game called
Glissendorf—"Say a word. Wrong word. I won." They called their
classmates "bongs"—that is, the conventional types, versus their own
Otherness—and in Bob's bedroom they began lip-synching/miming to
records, especially Gene Vincent.

As high school passed, rock 'n' roll and poetry were all that
made sense to him, and inevitably, his conventional, hard-working,
Depression-era father began to fret. Since Bob was always drawing,
Abe "tried to push architecture. I figured at least he could make a living
. . . I said: 'Please go to school and make yourself a living. These poems
aren't going to make you a living.'" Bob soon developed the complete
"bad attitude" teen package, neglecting his schoolwork and not show-
ing up at the store to work. Abe reacted predictably: "We've given you
a good home. We buy you the best of everything. What more do you
want? I never had it so soft when I was your age . . ."

Abe had a point. For his sixteenth birthday Bob would get a convert-
ible; later there'd be a Harley-Davidson motorcycle. To be rewarded
for such extravagant generosity with a sullen mumble and a nervous
twitch in his son's leg (which would last for twenty years) drove Abe
crazy. When Bob came home late one night after seeing James Dean in
Giant, father and son got into a squabble that ended with Abe ripping
down the pictures of Dean that decorated the basement walls.

It got worse. Abe's role at what was now Zimmerman Furniture
and Electric was bookkeeper, which meant that he had to deal with
credit and repossessions. The mid-'50s in Hibbing found the mines
in the middle of the transition from iron ore to taconite, and it was
hard times, so there were plenty of miners with payment problems.
"I used to make him go out to the poor sections," Mr. Zimmerman
said, "knowing he couldn't collect any money from those people. I
just wanted to show him another side of life. He'd come back and say,
'Dad, these people haven't got any money.' And I'd say, 'Some of those

people out there make as much money as I do, Bobby. They just don't know how to manage it.'" This kind of patronizing Babbitry was guaranteed to trouble a sensitive boy like Bob. Benny Orlando, the service manager, recalled going out at least once with Bob on a repossession when the customer was outraged, blaming Abe—and Abe's religion—for his troubles. Bob got "real quiet after that. He didn't talk to anyone for a long time."

Music continued to be his refuge. His first band was the Jokers, an a cappella doo-wop effort with two buddies from Camp Herzl. He was more serious about the Shadow Blasters, which gave him a chance to mold things. Chuck Nara on drums, Bill Marinac on bass, Larry Fabbro on guitar, John Shepard on trumpet were the players, but Chuck and Larry were into jazz, and Marinac played bass in a Yugoslavian folk-dance group; they didn't know rock 'n' roll the way Bob already did. By the time they played a show, Fabbro said, "We were strictly Bob's back-up band." They debuted on April 5, 1957, at the student council variety show, the band in pink shirts, dark glasses, and pompadours, with Bob standing at the piano screaming out Little Richard's "Jenny Jenny" and "True Fine Mama." It was loud and disorganized, and Bob didn't care that some of the audience was laughing at him. He already had an inner certainty about what he was about.

Soon he had support. Echo Star Helstrom was a warm, sensitive, and extremely attractive blond classmate who didn't fit in with the kind of people his folks wanted him around. She wore what Hibbing thought were outrageously tight jeans and lots of makeup and was considered a hot thing and a "greaser chick." They met one day in September 1957 at the beginning of junior year in front of the L & B Café on Howard Street, after Bob and John Bucklen had been playing music upstairs in the Moose Lodge. Going into the L & B, he told her that he was forming a band. To show she knew her stuff, she asked him if he knew the song "Maybellene." He certainly had, as Echo recalled later. He raved about "Chuck Berry, Fats Domino, Little

Richard, Jimmy Reed—Bob thought he was fabulous, the best!—and everybody who was popular those days in other parts of the country, but who might as well have not ever existed as far as most of Hibbing was concerned."

He went on about how great music was and how much he wanted to play, she said, "all with his eyes sort of rolled back in his head, in a whole different *world* until" he stopped, leaned across the table, his eyes big, and whispered, "You . . . you don't mean that . . . *you* listen to Gatemouth Page out of Little Rock?" Echo replied yes of course, do you think you're the only one? It made for a deep bond.

Knowing about Gatemouth in polka-schmaltz Hibbing was a lifeline that connected you with a far-away world of music and black people and the South and all the things that were at the other end of Highway 61, at the southern end of their own river.

Early in the 1950s, radio station KWKH in Shreveport, Louisiana (and rebroadcast on KTHS in Little Rock), a fifty-thousand-watt monster audible after dark across a good deal of the country, took on a new DJ, Frank "Gatemouth" Page, the "Mouth of the South." By 1956, his show was called "No Name Jive," after a song recorded by Gene Krupa. Gatemouth was cool, reciting street poetry and playing the best blues and R & B music of the day—Muddy Waters, John Lee Hooker, Howlin' Wolf, Jimmy Reed, Magic Sam, Chuck Berry, and more. Bob would stay up until two and three in the morning listening to the songs, trying to figure out how to play them. Fortunately, the show's major advertiser was Stan's Record Shop, which had an enormous mail-order business, selling singles for $1.89, or three for $3.49. One of Stan's best customers would soon become young Bob Zimmerman.

This connection was fundamental to his life and brought him an understanding of his own country, of Highway 61 and the river it flanked. The highway passed just a few miles south of Hibbing, and it connected him to the magic he heard night after night. Many years later Bob would write, "I always felt like I'd started on it, always had been

on it and could go anywhere from it, even down into the deep Delta country. It was the same road, full of the same contradictions, the same one-horse towns, the same spiritual ancestors. The Mississippi River, the bloodstream of the blues, also starts up from my neck of the woods. I was never too far away from any of it. It was my place in the universe, always felt like it was in my blood."

It was just as well that Beattie and Abe had no idea of how deep into this music he was falling and how very far from their world it was taking him. They were sufficiently riled about his male friends, and would never have approved of Echo, who wasn't Jewish and was from the wrong side of the tracks. But Bob was always up for secrets, which suited his personality and also made sense in Hibbing, where, as Echo observed, "if you were different they would pick you to pieces." So he kept their relationship a secret from his folks, once concealing Echo in a closet when grandma Florence came home unexpectedly.

Echo's family was not prosperous and lived in a shanty three miles southwest of town. Fortunately, Mrs. Helstrom was a kind, nurturing woman, and had a huge collection of country-western 78s that included Jimmie Rodgers and Hank Snow, which made Bob extremely happy. Echo wanted to be a movie star, and Bob could at least help her get into the local theaters. She "brought out the poet in me," said Bob, and it was a classic young romance.

He was easing out of his parents' world but not fully separated. He looked like a greaser but was still fairly "sheltered," said his friend LeRoy Hoikkala, who really was a greaser. Years later, Bob would tell a reporter, "I see things that other people don't see. I feel things that other people don't feel. It's terrible. They laugh. I felt like that my whole life . . . All I did was write and sing, paint little pictures on paper, dissolve myself into situations where I was invisible."

Except, of course, when he was on stage. LeRoy was the drummer and Monte Edwardson the lead guitarist for a trio they called the Golden Chords, which rehearsed in Bob's garage and basement and

mostly played Sunday afternoons at "Collier's BBQ" (officially named Van Feldt's), on Fourth Avenue and Nineteenth Street. Although they'd started out with country tunes like Johnny and Jack's "I'll Be Home," they were soon mostly doing things from No Name Jive— Little Richard and other R & B songs. It was not the music most of Hibbing was listening to. As a result, Echo would enjoy the rehearsals at Collier's, but when they played at the big auditorium at Hibbing High, it was harder. "Nobody liked their music much, least of all Bob's voice. I used to get so upset, for days ahead of time, when I knew he was going to sing in public . . . [people would] laugh and hoot at Bob, and I'd just sit there embarrassed, almost crying," she said.

The Golden Chords reached their high point—and certainly one of the peaks of Echo's embarrassment—at the Jacket Jamboree on February 6, 1958, which was the coronation of the homecoming queen. The Chords were the loudest thing anyone at HHS had ever heard, and according to Principal Kenneth Pederson, "He and the others were carrying on in a terrible way, right on the stage, and it got out of hand. I couldn't tolerate it." Pederson cut off the microphone but Bob kept going, so Pederson had the curtain closed. Bob's English teacher, B. J. Rolfson, remembered the day as the occasion when Bob, channeling his inner Little Richard, broke off the pedal on the school piano. Having a somewhat different grasp of the meaning of rock 'n' roll, Bob smirked through all of the next day's English class.

Echo would reach the absolute peak of sensitivity at one of the school assembly shows. She'd shut her eyes and stuffed her fingers in her ears to not hear the laughing, but a friend pulled her hands away and screamed, "Listen." "At first I couldn't hear anything but the band. Bob *always* had the amplifiers too high . . . they were doing a Ray Charles boogie, *really* loud . . . He was *howling* over and over again, 'I gotta girl and her name is Echo!' making up verses as he went along. I guess that was the first song I'd ever heard him sing that wasn't written by somebody else. And it was about me! People laughed at Bob

that night like always, but I didn't even care." He was proud when they met outside school afterward. "Didja like it? Didja like it?"

Around this time the Chords entered a talent contest—very possibly the Valentine's Day 1958 Winter Frolic Talent Contest sponsored by the Chamber of Commerce at the Memorial Building Little Theater. For once they were a hit with the teenage audience. As LeRoy recalled it, they only got second: "They couldn't give us the trophy because we played rock 'n' roll and that would have been like an endorsement of the music." Shortly after, LeRoy and Monte joined up with some guys who were more commercial and became the Rockets, and that would gnaw hard at Bob for years. In his memoirs, he'd comment that "the guys who took my bands away had family connections to someone up the ladder in the chamber of commerce or that world . . . It went to the very root of things, gave unfair advantage to some and left others squeezed out."

To be sure, Echo thought he lived in his own world, a more interesting and dramatic one than Hibbing. The night of their Junior Prom, May 2, 1958, Bob was miserable, since he couldn't dance and was uncomfortable in his suit and tie. At length they escaped, jumping into his car and heading for Virginia, a town twenty-five miles up the Range, which housed something remarkable. James "Jim Dandy" Reese was a black man with an extraordinary record collection who'd somehow landed in Virginia on radio station WHLB. Bob and his friends Bucklen, Leroy, and Echo would visit with Reese a number of times to share music and a feeling that they weren't in Hibbing any more. Big Bill Broonzy, Son House, Bukka White, Lester Young, Charlie Parker, and Coleman Hawkins were only some of the people that Reese introduced them to, and they were deep lessons for Bob. "I remember Jim telling Bob," Bucklen said, "that rock music was nice superficially, but that jazz had a much deeper meaning to it."

Any connection to the outside world was attractive to Bob. A hack Borscht Belt comedian appeared at the Moose Lodge, and Bob lingered

on the sidewalk, waiting to talk with him about showbiz and life on the road. Years later he would relate how the occasional carnie folk who passed through Hibbing drew his rapt attention. "The Bearded Lady, the half-man, half-woman, the deformed and the bent. . . I got close to some of those people. I learned about dignity from them. Freedom too. Civil rights, human rights. How to stay within yourself."

He knew his life would not be in Hibbing, and he also knew by now that in that wider world he wouldn't be Bob Zimmerman, either. Sometime in the spring or summer of 1958, he told Echo that he'd found a new name for himself in a book of poetry he'd been reading. The new name was going to be Bob Dylan.

Senior year kicked off with a bang. Bob had a band with a cousin in Duluth, the Satin Tones, and he was rocketing down Highway 61 as often as possible, escaping Hibbing for Duluth and Minneapolis. There were other girls there, too—faithfulness would never be one of his virtues—and Echo wasn't stupid. One Monday morning in the school hallway, she returned his ID bracelet. "Shhh," he said. "Not *here*!"

He didn't have a band in Hibbing that year, but the one-time "Elston Gunn and the Rock Boppers" played the Jacket Jamboree in January 1959, with Bob backed by Bucklen on guitar, Bill Marinac on bass, and three young women singing doo-wop.

He was an audience member, not a performer, at the most important concert of his senior year. On January 31, 1959, Buddy Holly, Link Wray, Ritchie Valens, and the Big Bopper performed at the Duluth Armory, and Bob was in the third row. He was convinced Buddy had looked at him, and he would cherish the moment, especially because just three days later, on February 2, Holly would play the Surf Ballroom in Mason City, Iowa, with the next night's show almost four hundred miles away. Their tour bus was unheated and Buddy, Valens, and the Bopper grabbed a chance to fly in a small plane. At 1:00 a.m. it took off and immediately crashed, killing everyone. It was no surprise that Bob would hold on to his memory of Holly in Duluth.

High school finally ended on June 5, 1959, and he probably felt as though he'd escaped from Devil's Island. Inevitably, he had to endure a graduation party thrown by his parents. He didn't want to go but stayed and charmed the family friends until midnight before going out and walking around boring old Hibbing for a couple of hours.

Buried in this ritual celebration was a musical grenade that would blow up his world. An uncle gave him a stack of Lead Belly 78s for a graduation present, and when he listened to them the next day, he called Bucklen and said, "I've discovered something great."

HAVING PROMISED HIS parents that he'd give college a try, he went down to Minneapolis shortly before classes began at the University of Minnesota in the fall of 1959. Since his cousin Chucky was president of the Sigma Alpha Mu ("Sammy") house, he started out living there. Sammy material he was not. The "fraternity brothers thought he was strange because of the way he looked and acted," recalled a fellow pledge and old friend from Camp Herzl, Richard Rocklin. "He always had the same silly smile on his face that invited the others to pick on him—which they did." Perhaps they were also annoyed by his transparently false claims of having played with Buddy Holly and Little Richard.

Just three years before, the Western World's Official Master of Culture, T. S. Eliot, had lectured on "The Frontiers of Criticism" at UM, but that was not the part of the university where Bob would study. The university lay on the east bank of the Mississippi opposite downtown Minneapolis. To the north lay Dinkytown, the Beat annex to campus, a low-budget Bohemian home to Melvin McCosh's very good radical bookstore, a brand-new coffeehouse named the Ten O'Clock Scholar, the Varsity Cinema, and some cheap apartments. It was full of bright minds that liked being close—but not too close—to a university as they found themselves growing increasingly doubtful about mainstream American thought, politics, and culture.

In Minneapolis and pretty much across America, the folk music scene and the Beat scene had fused; in the late 1950s, almost all the dissenters could see the common ground. Certainly Bob had already opted out of the standard society that was represented by Abe's repossessions, and he naturally gravitated to what he called the "beat scene, the Bohemian, BeBop crowd, it was all pretty much connected . . ." There were painters, and musicians, and there were poets. After Hibbing, Bob said, in Dinkytown "every day was like Sunday."

Later, Bob would write that he'd come to college looking for "what I read about in *On the Road*," but before he absorbed his Beat influences, he found a follow-up to the Lead Belly songs that had impressed him so much in June. He'd gone into a record store and spotted *Odetta Sings Ballads and Blues*. Hearing this powerful voice—she'd had operatic training from the age of thirteen but had chosen musical theater and then folk as more practical for her—accompanied only by an acoustic guitar completely dazzled him. "Santy Anno," "Jack o'Diamonds," and "Alabama Bound" were all traditional songs and they brought him to a new place. He'd come to realize that contemporary rock 'n' roll wasn't enough for him.

In folk, he would realize and write much later, he could find "outlaw women, super thugs, demon lovers and gospel truths . . . Folk music was a reality of a more brilliant dimension. It exceeded all human understanding, and if it called out to you, you could disappear and be sucked into it. I felt right at home in this mythical realm made up not with individuals so much as archetypes, vividly drawn archetypes of humanity, metaphysical in shape . . ." Folk songs were "filled with more despair, more sadness, more triumph, more faith in the supernatural, much deeper feelings . . ." "Right then and there, I went out and traded my electric guitar and amplifier for an acoustical guitar, a flat-top Gibson."

Deadly serious, he began to study the folk repertoire. A member of his scene would recall that he "was the purest of the pure. He had to get

the oldest record and, if possible, the Library of Congress record[ing]."
He had an extremely facile and retentive ear, and he could learn songs
in one or two plays in a booth at the record store.

He also latched on to whoever could teach him, and the first
of those teachers was "Spider" John Koerner, Minneapolis's best
player. From John he learned "John Hardy" and the Child Ballad
"Golden Vanity." He also studied ragtime, material from the New
Lost City Ramblers, sea shanties from Folkways, and more. Koerner
was a serious blues player, as were many others in the Minneapolis
scene, and from him Bob soon learned about Arhoolie Records and
then explored Blind Lemon Jefferson, Charlie Patton, and Tommy
Johnson. As with Odetta, Bob studied America's folk music, black
and white, making no distinctions. It was as though Cecil Sharp
had never existed. In the years to come he'd make a broad range of
American music his own. Though he'd be labeled as part of the folk
scene, his approach showed a great deal more affinity for the blues
tradition, in which each player adapts something and adds a bit of his
own approach, rather than the archival folk version, which places so
much store on an unchanging tradition.

Late in 1959 or early in 1960, he approached David Lee, the owner
of the Ten O'Clock Scholar, introduced himself as Bob Dylan, and
asked if he could play. He did some Belafonte, some Carter Family
songs, "St. James Infirmary," and "Golden Vanity." Lee didn't think
he was all that good.

Dylan had never been too reliable about attending classes—later
he'd joke that "I also failed out of communication class for callin' up
every day and sayin' I couldn't come"—and had long since moved out
of the Sammy house and was living irregularly, crashing with friends
like Koerner and Harry Weber on Seventh Street for a bit, then in a
room above Gray's Drugs at Fourth Street and Fourteenth Avenue that
was just half a block from the Scholar. At Christmas he visited Hibbing
and told Bucklen about folk music from a hip, philosophic perspective.

January brought a new decade, and the people of Dinkytown sensed the '60s as a fresh beginning. After a decade in which public intellectuals had assumed a freedom from ideology, America was now moving into a time in which the very idea of objectivity would be dismissed, with all perspectives seen as a function of context—race, gender, class. Politics and the personal coalesced; authenticity was everything.

Two events early that year signaled the political side of the change—thought would digest and catch up to action somewhat later. One was the visit of the House Un-American Activities Committee (HUAC) to San Francisco's City Hall in May 1960. The committee that had once terrified the film industry, the army, and other institutions now confronted the students of the University of California at Berkeley, and the students weren't having it. They organized and began a petition to abolish HUAC. By the second day of the hearings, the issue had become access to the hearing room, because passes were given only to HUAC supporters. A scrum broke out, and students in line sat down on the giant staircase in the rotunda of City Hall. The police ordered firefighters to use hoses to sweep them off the steps. Wet and angry, they wouldn't move. Astonishingly, HUAC suddenly seemed revealed as the bully it was. On the last day of hearings, around two thousand people picketed City Hall, including hundreds of longshoremen with work hooks in their pockets, and the city's overwhelming response was derision toward HUAC. The fear was gone.

The other event began a great deal more modestly but had even greater implications. On February 1, 1960, four Greensboro A & T freshmen—Franklin McCain, David Richmond, Joseph McNeil, and Ezell Blair Jr.—sat down at the segregated lunch counter of their local Woolworth's and ignited a firestorm. Within four days, the four protestors became eighty-five, with sympathetic sit-ins in Durham and Raleigh. The Greensboro Four were not trained in civil disobedience tactics, but they had silence and patience and fortitude on their side, and the power of being right.

Ironically, the real nexus of this movement-to-be was in Nashville, where for some time a man named Jim Lawson had been training students in nonviolent thinking and protest. They read Thoreau and Lao Tzu and Niebuhr, studied at the Highlander Folk School, and decided that they could redeem the South by accepting the abuse they knew would come, so long as they endured with an open and loving heart. On February 13, 1960, 124 students marched to downtown Nashville and began sitting-in at downtown lunch counters. Five days later, it was 200; two days after that, it was 340. They sang as they were arrested and as they were marched to their cells, and they filled the jail. Refusing bail, they so confused the city fathers that finally they were simply turned loose. A potent moral energy had been set free.

As he entered this new decade, Bob was developing fast. He was alternating weekend sets with Koerner now, and even acquiring fans. One of the first was Gretel Hoffman, and another was Bonnie Jean Beecher, a beautiful (she'd later be a Playboy bunny) young theater major from Edina who was worldly enough to go to Goody's Record Store on visits to New York City and buy Harry Smith *Anthology* musicians like Rabbit Brown. Bob was attracted to both as well as others that spring, and both would break his heart, Gretel by marrying the local Beat personality Dave Whitaker on May 8. Bob continued hanging out with the newlyweds, mostly because Dave had things to teach him, like morning glory seeds, and a passionate "Live Life!" philosophy. They got high on pot, listened to the blues, read Allen Ginsberg, stayed up for two or three days on Benzedrine, and generally stretched the margins.

Whitaker was part of the Beat scene, and that literature would move Bob as no other. Around this time, Dylan later told Ginsberg, someone handed him a copy of Jack Kerouac's jazz-influenced *Mexico City Blues*. "It blew my mind," he said. Friends didn't remember him reading all that much in this period, but his friend Tony Glover would recall lending him a copy of William Burroughs's *Naked Lunch*—the

original French Olympia Press edition, ordered by mail. Bob kept it for a couple of weeks and returned it. The Beat scene was moving him in a direction of cultural politics that transcended—or at least evaded—the old left/right political categories of power politics. It wasn't liberal/conservative that divided this generation from their elders as much as the difference between what would come to be called a "freak" versus a "straight." *Naked Lunch* was distinctly not straight.

In that spirit, Bob started the summer of 1960 by hitching to Denver, where he landed a job playing piano in a honky-tonk called the Gilded Garter in a tourist trap of a town west of the city called Central City. It was a lousy gig and he didn't last long, but the trip paid off when he got to meet fellow singers Judy Collins and Jesse Fuller. Fuller was from Oakland, California, a one-man band who played guitar, a fotdella (a foot-operated bass instrument), and a harmonica in a rack. By the time Bob was back in Minneapolis, he had one of those harmonica racks. His harmonica playing was not casual or affected but rather grounded him securely in the blues music that was a substantial part of his repertoire, linking him to Rice Miller and Little Walter and other musical models.

His repertoire was eclectic. In May, a fan of his at the Scholar by the name of Karen Wallace had recorded him playing a number of songs—the "St. Paul Tape"—and they covered a wide span, ranging from "Gotta Travel On," a recent country hit for Billy Wayne Grammer, the traditional folk song "The Roving Gambler," the old English murder ballad "Two Sisters," Ewan MacColl's modern song "Go Down, You Murderers," the spiritual "Sinner Man," the '20s blues tune "Nobody Knows You (When You're Down and Out)," a cowboy song called "Doney Gal," and Jimmie Rodgers's "Muleskinner Blues (Blue Yodel #8)." Most unusually in the folk world, he'd even written a couple of songs, including "Blackjack Blues." The list also included four songs by Woodrow Wilson Guthrie—"Pastures of Plenty," "This Land Is Your Land," "Great Historical Bum," and "Columbus Stockade Blues."

A dancer named Flo Castner had asked him if he'd heard Woody
Guthrie and took him to her brother's house to listen to a Guthrie
record. Bob was stunned, unsure if he was high or sober: "It was like
the record player itself had just picked me up and flung me across
the room . . . That day I listened all afternoon to Guthrie as if in a
trance and I felt like I had discovered some essence of self-command
. . . So this is the game.'" Later, probably in the fall of 1960 after
he got back to Minneapolis, he and Dave Whitaker sat listening to
Dust Bowl Ballads, and Dave began talking about Woody's autobi-
ography, *Bound for Glory.* Soon after, he located a copy for Bob. It
would change Dylan's life. Later, he'd write of Guthrie, "He was like
a guide."

Bound for Glory describes a life as anguished and heartbreaking as
any folk song and begins as Woody jumps onto a freight train headed
out of Bob's birthplace, Duluth, climbing into a boxcar crammed with
seventy men all coated in cement dust, a grim scene which immediately
breaks into a huge brawl. "Messed up. Mixed-up, screwed-up people.
A crazy boxcar on a wild track . . ." Guthrie's childhood was a "fistic
sweatshop. And with low pay." He wandered across Depression-era
America and found a deep faith in the music he played and the people
he met, especially the man who saved him from dying from exposure
by sharing a blanket. Woody never did see his face, and in years to
come he'd wonder, as he saw men passing by, if *he* was the guy who'd
saved him.

Though his persona was that of an uneducated hick, Woody was
always hungry to learn, and educated himself in the public library.
Music was his only ambition, and it led him to years of working in live
radio, first in Pampa, Texas, where his family had settled, and then in
Los Angeles. One day there, he introduced a harmonica piece by the
name "Run Nigger Run." He got a letter from a young black man that
shook him to the core, and after apologizing on the air, he never used
the word again. It raised his consciousness about politics in general,

and he began to explore the lives of his fellow expatriate Okies in the
Hoovervilles of the Central Valley. When he discovered that many of
the dispossessed were not victims of windstorms or mechanization but
of bankers assembling cattle ranches, he grew even more radicalized.

Politically, Woody developed a rough left-wing populism that
was particularly strong in its antiracism. The music of Blind Lemon
Jefferson would become his vocal model, and he'd listen hundreds of
times over to a handful of Lemon's records, as well as study Huddie
Ledbetter in person. During the war he was the only white man in a
quartet with Sonny Terry, Brownie McGhee, and Huddie himself.

Woody's audience was made up of societal outcasts, people on the
fringe, and Dylan could certainly empathize with that. At nineteen,
Dylan needed a role model. "The folk and blues tunes had already
given me my proper concept of culture," he wrote many years later,
"and now with Guthrie's songs my heart and mind had been sent into
another cosmological place of that culture entirely." In the image of
Guthrie, the hobo minstrel, he found himself. "Woody turned me on
romantically . . . I could tell he was very lonesome, very alone, and
very lost out in his time. That's why I dug him. Like a suicidal case or
something. It was like an adolescent thing—when you need somebody
to latch on to, you reach out and latch on to them." Latch on he did.

He completely patterned himself on Guthrie. "He became very
good at singing just like Woody," said his friend Harvey Abrams. "He
would sit and listen to a record, then repeat it. It was phenomenal. Even
his speech patterns began to change. That Oklahoma twang, which
became much more extreme after he left here, came into his voice. That
incredibly harsh gravel sound in his voice became more a part of him
. . . He *was* the people he identified with, especially Guthrie . . . We
really felt that Bob's real self was coming out from underneath."

There was more than just Guthrie, of course. Not least of Bob's
discoveries at this time was Harry Smith's *Anthology*—"It's all poetry,
every single one of those songs," he'd say later. But as 1960 came to

a close, his thoughts were mostly on Woody, now an invalid hospitalized at Greystone Park Psychiatric Hospital in New Jersey due to his Huntington's Chorea, the same neurodegenerative disease that had destroyed Guthrie's mother.

After visiting Hibbing to tell his folks that he was headed for New York, Bob planned to spend Christmas in Minneapolis with his girlfriend, Bonnie Beecher. But her parents said no, and he realized it was time to go. Standing on the side of the road in a Minnesota snowstorm, he stuck his thumb out and surrendered to the gods of hitchhiking.

Some time in January 1961, dozing in the backseat of a Chevy Impala, he pulled into Manhattan.

23

Dylan in New York

NATURALLY, DYLAN WENT straight to Greenwich Village. The Village had been receptive to folk music at least since the Almanac Singers had lived on West Tenth Street, and it was a genuine community. It wasn't about money, he'd write a couple of years later. "Instead a bein drawn for money you were drawn / for other people."

Soon Bob hooked up with a blues player named Mark Spoelstra, and they worked at the Café Wha? as a duo in the afternoons. Before long he was playing other basket houses (so-called because the only pay came when someone passed a basket around the audience), often three or four in a day, working from noon to 2:00 or 3:00 a.m. He began to develop a hip, funny stage act that went along with the songs. He also played anywhere else that would let him unpack his guitar, especially at parties and at Israel "Izzy" Young's Folklore Center.

He had a voice—not a conventional voice, not the sweet voice of Minneapolis, but what one of his biographers called "a tonsilly scranch, a dry, throaty tenor, 'with all the husk and bark left on the notes.'" He also had a persona as a baby Woody Guthrie, and he was *always* in character. His closest friends weren't sure if he was playing Woody or being himself—ultimately, he was always inscrutable—until after a while, it was clear that he'd become what he imagined.

The bluesman Big Joe Williams would say of Dylan, "Bobby didn't change, he just growed." Quite so. Small, baby-faced, and charming yet ravenously ambitious, he was no innocent, but full of what Raymond Chandler called "the hard core of selfishness which is necessary to exploit talent to the full." He grew famous for spinning fantasy tales about his past that weren't entirely lies but what Andrew Loog Oldham meant when he wrote, "It wasn't an act, even if it was."

He was also at heart a moralist, very much part of the world of the songs he sang, "hard-lipped folk songs with fire and brimstone servings," as he wrote later. "They weren't friendly or ripe with mellowness . . . They were my preceptor and guide into some altered consciousness of reality, some different republic, some liberated republic." They were "weird," Dylan said later, "full of legend, myth, Bible and ghosts."

A song like "Barbara Allen" poses fundamental questions: Why are people cruel, why is life so hard? The answer is that it's a mystery— and, Dylan added elsewhere, "Mystery is a fact, a traditional fact." The magic's in the mystery; the mystery *is* magic. And the mystery is spiritual. Folk songs, black and white, were what he would later call his "lexicon and my prayer book. All my beliefs come out of those old songs . . . I believe in Hank Williams singing 'I Saw the Light.'"

To top it off, Bob played the folk songs with what he called a "rock 'n' roll attitude. That is what made me different and allowed me to cut through all the mess and be heard." Rock 'n' roll, the white derivative of the black musical ethos, would always be an essential part of his oeuvre.

As soon as he could, he went off to find Woody, going first to his home in Brooklyn, where he charmed Woody's thirteen-year-old son, Arlo. Arlo sent him to Bob and Sidsel Gleason's fourth-floor walkup in East Orange, New Jersey. The Gleasons were loving fans whose home had become a Woody Guthrie salon. On Sundays, they would bring Woody from the hospital, and his wife and son Marjorie and Arlo,

Alan Lomax, Woody's former manager Harold Leventhal, Pete Seeger, and Cisco Houston when around, perhaps some of the younger Village players, would all gather to eat, talk, and sing.

Healing the body politic and wringing wisdom from a social commitment were the more subtle aspects of the salon, and Bob soaked it all up. He also had the privilege and joy of having his idol validate what he was doing. "The boy's got it! He sure as hell's got it!" By now, Woody was so terribly ill that some questioned how much he could actually relate, but most witnesses were clear that a strong bond grew between the boy and the man. Dylan began to visit Woody at Greystone, bringing him Raleigh cigarettes and playing "Tom Joad" as the other patients passed by—the shufflers, the man who licked his lips, the poor fellow chased by spiders.

Humility would never be Dylan's strongest virtue, but Woody's suffering taught him "that men are men / shatterin' even himself / as an idol . . . for he just carried a book of Man / an' gave it t' me t' read awhile / an' from it I learned my greatest lesson." In mid-February he came back to the Village from one of the sessions at the Gleasons' and wrote his first really good song, "Song to Woody," an honest and moving tribute from a protégé who accepts a link and does so without ego.

He spent a great deal of time now with Hugh Romney, the Beat poet much influenced by Lenny Bruce who was the MC and entertainment director at the Gaslight. "Dig yuhself," Hugh kept saying, but he also introduced Bob to the work of Lord Buckley, whose "Black Cross" would become part of Bob's repertoire.

The Gaslight was a dark, tiny, crowded basement room below the Kettle of Fish Bar where a musician had to learn to avoid hitting one's head on the pipes above the stage. It had once been a coal cellar, and it was still the filthy home of rats and cockroaches. It had begun by featuring poetry—Allen Ginsberg had read there—but switched to folk music when the tides of commerce had so dictated. The coolest part of the Gaslight was the Room, a closet backstage, where the players

gathered. Since they could do only three songs each, this meant there was plenty of traffic, and while waiting to go on they played penny poker. It was another classroom for Dylan.

Actually, all New York had things to teach him, and he was alert to the possibilities. On Sundays he'd go to the old Madison Square Garden on Fiftieth Street for gospel shows, seeing the Soul Stirrers and the Mighty Clouds of Joy. Then the Clancy Brothers exposed him to another kind of folk music. Paddy and Tom Clancy were actually Broadway actors who started doing Midnight Special shows at the Cherry Lane Theatre to raise money for a production they wanted to put on. Their brother Liam and friend Tommy Makem joined them in New York in the mid-'50s, and they recorded an album of Irish rebel songs, *The Rising of the Moon*. They slowly became singers more than actors, and on March 12, 1961, they appeared on *The Ed Sullivan Show* and were such a hit that John Hammond signed them to Columbia. Dylan thought Liam was the best ballad singer he'd ever heard. They shared a common joy in escaping repressive small towns and a taste for drink and good company at the White Horse Tavern, where Dylan's education proceeded.

There was the Commons, a basement club on the west side of MacDougal Street near Minetta Lane, later known as the Fat Black Pussycat. Around the corner on Bleecker Street was the Bitter End, a more legitimate club with a bigger stage and a real backstage. There was Izzy Young's Folklore Center, packed with records and books in front, instruments on the walls, Izzy on the phone saying "schmuck" a lot, and musicians in the back teaching each other songs.

And there was Washington Square on Sunday, "a world of music," Dylan wrote. "There could be fifteen jug bands, five bluegrass bands, and an old crummy string band, twenty Irish confederate groups, a Southern mountain band, folksingers of all kinds and colors singing John Henry work songs . . . drummers of all nations and nationalities. Poets who would rant and rave from the statues."

There was also Gerde's Folk City at 11 West Fourth Street. Izzy Young had tried to run it but it had reverted to the bar owner, Mike Porco. It had a tiny stage—bluegrass players had to choreograph getting to the microphone to sing—and didn't look like much, but it was going to be a very important place to Dylan. In mid-March 1961 it featured Lonnie Johnson, and Bob saw him whenever possible, crediting him with influencing the way Bob would play "Corinna, Corinna." Big Joe Turner was there too—Bob was conscious that he was an heir to these men, and he was paying attention while he could.

And not just to folk musicians. Dylan would spend a significant amount of time listening to jazz, from Cecil Taylor, with whom he once played, to Red Garland and Don Byas. Bird had been gone six years, but lots of people who'd known him were around, and it seemed, Dylan said, "like he had transmitted some secret essence of life to them." As the poet Ted Joans had written on the wall for all to see, "Bird Lives." Thelonious Monk was at the Blue Note, and Dylan would recall dropping in on him once and introducing himself as playing folk music up the street. "We all play folk music," said Monk. Folk clubs and jazz joints sat side by side, and the Beat tradition brought jazz and poetry together onstage. "I was close up to that for a while," Bob would recall.

On April 11, Dylan began his first regular paid gig in New York at Gerde's, opening for John Lee Hooker, who was advertised as a "country blues singer," having recently released *The Folk Blues of John Lee Hooker*. Bob got $90 a week, which was satisfying, and he loved Hooker, going to his hotel with wine and a guitar and talking until late. "What he was doing was blues," said Hooker, "but it was folk-blues. He loved my style and that's why he got with me and we would hang out together all the time." He performed well, and the Gleasons, Tom Paxton, *New York Times* folk critic Robert Shelton, the Clancy Brothers, and Dave Van Ronk all showed up to hear him, bespeaking an impressive status after just three months in town.

Van Ronk was an important part of Dylan's life at this point. His wife, Terry Thal, was Bob's first manager of sorts, although her efforts to get him a record deal were not fruitful. Moe Asch at Folkways wasn't interested. Manny Solomon at Vanguard said no.

More significantly, Van Ronk was by far the premiere blues singer among the Village folkies, and he taught Dylan songs like "The House of the Rising Sun," "Poor Lazarus," and Blind Lemon Jefferson's "See That My Grave Is Kept Clean." Van Ronk was five years older than Dylan and sang, Bob thought, "like a soldier of fortune and sounded like he'd paid the price." The Gaslight was his fiefdom, and he made Bob welcome, "brought me into the fold" there.

Van Ronk had come to folk through Duke Ellington and the stride pianists and then become a "moldy fig" New Orleans–style banjo player. He became a close friend of Clarence Williams, who'd once produced Bessie Smith and was now retired to the Harlem Thrift Shop, which was more of a hangout than a store, playing duets there with friends like Willie "The Lion" Smith. It was no wonder that Van Ronk introduced Dylan to the Vanguard, the Village Gate, and the Blue Note, the jazz clubs that shared the Village with the folkies.

Dylan went out of town to New Haven on May 6 to play the Indian Neck Folk Festival, a small gathering put on by some Yale students. There he encountered players from the Cambridge folk scene, including a young artist and singer from Ohio named Bob Neuwirth. They clicked over a common love for Hank Williams, Woody Guthrie, and Jimmie Rodgers and bonded fast. Neuwirth would take him up to Cambridge, and although it would never be a central part of his life, a couple of people there would have their effect on him.

The Cambridge scene centered on Club 47, a coffeehouse at 47 Mt. Auburn Street in Harvard Square. The owners had thought to make it a jazz place when they opened in 1958, but Joan Baez soon changed their minds. There was also the Café Yana and the Golden Vanity near Boston University, the Turk's Head on Charles Street and

the Salamander on Huntington. It was a much more relaxed place than New York, of course. "You could be loose in Cambridge and not have your head kicked in," reflected Neuwirth.

The music was fairly eclectic. Inspired by the New Lost City Ramblers, the Charles River Valley Boys—Bob Siggins, Clay Jackson, Ethan Signer, Eric Sackheim—played bluegrass. Eric Von Schmidt was an aspiring illustrator who'd heard Lead Belly and fallen in love with music. Ten years older than most of the folkies, he played a wide range of blues and country music, and his apartment became a regular gathering place for the scene. Neuwirth would bring Dylan to visit Von Schmidt, and in between the red wine and games of croquet—Dylan was the worst player Eric had ever seen, he said—he introduced Dylan to a blues song called "Baby Let Me Follow You Down."

As the summer of 1961 passed, Bob got a week's gig opening for Van Ronk at the Gaslight and met comedian Bill Cosby's manager, Roy Silver, who signed him to a management contract. He also spent time watching foreign movies, particularly Truffaut's *Shoot the Piano Player*, about a talented piano player who lived for music and women. "Everything about the movie I identified with," he said. More importantly, on July 29 he went to Riverside Church, where a new radio station, WRVR, was celebrating its debut with an all-day folk music program. The show featured Van Ronk, Tom Paxton, the Reverend Gary Davis, Ramblin' Jack Elliott, newly returned from five years in Europe, and Victoria Spivey.

One of the audience members at WRVR was a seventeen-year-old folk fan named Suze Rotolo. The child of left-wingers, she'd been raised on the Woody/Pete/Lead Belly canon, listening to Oscar Brand's Folksong Festival radio show with her sister Carla, she said, "while still in our cribs" (the show debuted in 1946 when she was just two and, amazingly, was still running actively in 2010). She'd attended the socialist Camp Kinderland as a child and at fifteen took part in a 1958 anti-segregation March on Washington organized by CORE (the Congress

of Racial Equality). Her father's death that year had left her vulnerable, as had a car accident in 1961 that damaged an eye. She was intellectual, cultured, passionate, pretty, politically sophisticated, a little naïve, and at loose ends emotionally. Bob took one look and was smitten.

Later he'd write, "Meeting her was like stepping into the tales of 1,001 Arabian nights." It would not be a tranquil relationship. Dylan was secretive and complex, and as Suze put it, "neither one of us had any skin growing over our nerve endings." But when it worked, their romance was a thing of beauty. Suze opened up New York even more for him, and together they devoured the cultural buffet that was the city. Afternoons they went to MOMA (Museum of Modern Art) to see Picasso's "Guernica." Her favorite artist—and soon Bob's—was the young multimedia artist Red Grooms, whom Bob would later dub the "Uncle Dave Macon of the art world." Evenings they went to see Off Broadway productions like the Living Theater's *The Connection*. Suze's sister Carla worked for Alan Lomax, and between her and the Gleasons, Bob would have access to all the folk music he could imagine. Having read the Beat poets in Minneapolis—Ginsberg, Corso, Ferlinghetti, and Kerouac—he now joined with Suze in digging into the French poets Rimbaud, Verlaine, and above all Villon, a rowdy fifteenth-century brawler who delighted Bob.

Suze connected Dylan to something even more profound. Her day job was at CORE, and in 1961 it was action central for the burgeoning civil rights movement in America. CORE had been at the heart of the Montgomery bus boycott and had grown enormously in the wake of the Greensboro lunch counter sit-in in early 1960 and the subsequent actions in Nashville. These early activists were spiritual warriors who acted on love and would not respond to the violence directed at them. "They were to be teachers," wrote their biographer, David Halberstam, "as well as demonstrators."

Something special took place in Nashville in 1960, and the events would affect the national civil rights movement for years to come.

After months of sit-ins and hundreds of arrests at the department stores in Nashville, white resistance escalated. A bomb went off at the home of black attorney Z. Alexander Looby in April 1960. Thousands gathered and marched silently downtown to meet the mayor at the courthouse steps.

As they waited for him to arrive, Guy Carawan, a folk singer from the Highlander Folk School, led them in a song. The song had once been a Baptist hymn, "I'll Overcome Someday." It had been modified by Pete Seeger and passed to Carawan. It was called "We Shall Overcome," and it became the activists' anthem. Singing had always been at the center of black culture, and now it became a pivotal part of the movement. The mayor arrived and was challenged by Diane Nash, one of the student leaders. At some length, she forced him to agree to oppose segregation. Victory!—and it came with a song.

The weekend before the bombing, black students from across the South had gathered at a conference in Raleigh, North Carolina, and formed the Student Nonviolent Coordinating Committee, SNCC (pronounced *Snick*). Early the next year, CORE ran an ad in the SNCC monthly seeking volunteers to test the recent (December 1960) decision by the U.S. Supreme Court, *Boynton v. Virginia*, which banned segregation in public transportation. On May 4, 1961, the Freedom Riders set off from Washington, D.C., aiming to arrive in New Orleans on May 17, the seventh anniversary of *Brown v. Board of Education*. It was a very brave act, for they had no allies; President Kennedy was cool and uncommitted—he presided over a Democratic Party full of very senior, very racist Southern senators—and the FBI was commonly assumed to be sympathetic to the white South.

Although there were beatings at certain stops, there was little major violence until May 14, when the Klan attacked and firebombed one of the two Birmingham-bound buses in Anniston, Alabama. No one died, but only because the head of the Alabama State Police, Floyd Mann, was an honest cop. He'd planted an undercover officer named

Eli Cowling on the bus, and Cowling's gun dissuaded the Klan from finishing off the passengers who stumbled away from the burning bus. When the second bus arrived in Birmingham that day, all hell broke loose as a Klan-led mob beat media members and Freedom Riders alike (law enforcement in Birmingham was controlled by city police).

Birmingham's leading civil rights activist, the Reverend Fred Shuttlesworth, drove to Anniston and collected the Riders, and everyone gathered at his home. The head of CORE, James Farmer, was convinced that continuing the rides was going to kill people, and he threw in the towel. The Nashville/SNCC students, as represented by Freedom Rider John Lewis, saw it differently. The federal government could not ignore the unfolding events—it was only a month after the debacle at the Bay of Pigs in Cuba and the president was about to meet with Soviet premier Nikita Khrushchev; he needed to show that he was in control. President Kennedy had his attorney general, brother Bobby, send his assistant, John Seigenthaler, to Birmingham. Seigenthaler told Diane Nash, running the situation from Nashville, "You're going to get your people killed." She replied, "Then others will follow them."

On May 20, the bus arrived in Montgomery, where the Klan was waiting, having been promised a fifteen-minute open season by Birmingham Police Chief Eugene "Bull" Connor. By now the American media was out in force, and the station was thronged with TV and photographers. The Klan attacked the Riders, but also the photographers and press in general. Women swung heavy purses and little children clawed with their fingernails at the faces of Riders who'd been knocked to the ground. "It was madness," wrote John Lewis. "It was unbelievable . . . Everywhere this crowd was screaming and reaching out and hitting and spitting. It was awful. They were like animals."

John Seigenthaler's skull was broken. Lewis would have been killed but for the presence of Floyd Mann, who fired a gun into the air, which started breaking things up. Violence makes great TV, and scenes of the

attack went around the country—and the world. Eventually, the federal government would intercede for real, and after failing to convince the students to stop, the bus would move out of Montgomery escorted by a convoy of National Guard soldiers, helicopters, and Border Patrol aircraft. When the Riders reached Mississippi and all got arrested and sent to Parchman Farm, hundreds more followed in their wake and filled up the jail cells in Jackson.

The most dramatic events in black-white relations since the Civil War would send out reverberations for decades. For Dylan, falling in love with a young woman who was at CORE headquarters was going to affect him to the depths of his being.

ALTHOUGH HE'D ALREADY written several songs, Dylan began pursuing the idea more seriously that summer. In his memoirs, he would recall seeing the brilliant multi-instrumentalist Mike Seeger of the New Lost City Ramblers at Alan Lomax's loft on Third Street playing songs "as good as it was possible to play them." He was taken aback. "I would have to start believing in possibilities that I wouldn't have allowed before, that I had been closing my creativity down to a very narrow, controllable scale." So he'd have to write his own songs, ones that "Mike didn't know."

This of course violated the orthodox folksinger-as-curator model. One obvious alternative to the curator mode was the entertainment side of folk, which smoothed down ragged edges to appeal to mass audiences, and Bob had no interest in that. To this point, only Woody and Lead Belly, who were excused for political reasons, had been allowed to create their own songs. But their model suited Bob just fine, and he gave considerable thought to the process. One thing he realized was that the very speed of his mind would work against him. "I did everything fast. Thought fast, ate fast, talked fast, and walked fast . . . [I] needed to slow my mind down if I was going to be a composer with anything to say."

In response, he went to the New York Public Library and began to read newspapers from the Civil War era. With thoughts of the contemporary civil rights movement fresh in his mind, he read about riots, religious revivals, and reform movements, becoming a mystical historian of the collision between the factory-bell-time North and the agrarian-sun-time South. "Back there, America was put on the cross," he'd write of this period in his memoirs, "died and was resurrected. There was nothing synthetic about it. The godawful truth of that would be the all-encompassing template behind everything that I would write."

What he first wrote was a talking blues, a relatively simple model that put spoken, usually humorous lyrics over a three-chord progression, a form Woody had used to great effect.

Sometime in June, Noel Stookey showed Bob a clipping from the June 19, 1961, *Herald Tribune* titled "Panic Stops a 'Holiday Cruise.'" Almost three thousand people had gathered at the 134th Street Pier for the Le Douze Club's Father's Day excursion. There was a problem with counterfeit tickets, the boat was quite late, and the waiting crowd lost all patience. When the boat finally arrived there was a surge across the gangplank and a dozen people were trampled. Eventually, the *Hudson Belle*'s captain canceled the trip. It was perfect for Dylan, who drolly recast it into "Talking Bear Mountain Picnic," with a Guthrie-esque suggestion that the promoters who'd oversold the event should be sent up to Bear Mountain . . . for a picnic. It wouldn't be his last talking blues and would serve as a useful training model in songwriting.

There were other songs at this time, and not all talking blues, although the Guthrie influence was unmistakable. "Hard Times in New York Town" and "Man on the Street" were clearly the work of a beginner.

Around Labor Day, Suze's mother, Mary, sublet the penthouse at One Sheridan Square, which came with a side bedroom with separate entrance for Suze. Bob was staying with Mikki Isaacson, the folk scene's den mother, who had an apartment in the building. His

relationship with Suze flourished, even when she saw his draft card and realized he'd given her a "false" name. She responded by nicknaming him RAZ, for his initials. Their lives moved in a circuit that included the Kettle of Fish, the Cedar Tavern on University Place, the used bookstores on Fourth Avenue, Sam Wo's in Chinatown, Zito's Bakery on Bleecker Street, poker nights at Dave Van Ronk and Terry Thal's apartment on Waverly Place, and radio hostess Cynthia Gooding's apartment, which had some of the best parties in the Village.

For Dylan, the big news was a chance to record—as a sideman. That August, he had revisited Cambridge and met singer Carolyn Hester and her husband, Richard Fariña, at Club 47. Fariña, a charming and ambitious fabulist of Irish/Cuban descent, began telling Bob about Carolyn's upcoming album, to be recorded that fall with producer John Hammond, and Bob was definitely interested. Carolyn was looking for material, specifically a blues, and Bob quickly offered to teach her "Come Back Baby."

In mid-September he went to rehearse with Hester and her backup musicians, the well-known New York session guitar player Bruce Langhorne, and bassist Bill Lee, who normally backed Odetta (and fathered filmmaker Spike). As John Hammond looked on, Bob went over "Come Back Baby" with Hester. Hammond approved of the song, inquiring if Bob wrote songs.

Twelve days after the rehearsal, Bob was about to begin a two-week run at Gerde's opening for the Greenbriar Boys, and he boldly decided to put in a call to Robert Shelton, the *New York Times* folk critic, a regular at both the Gaslight backstage poker game and the White Horse Tavern. Shelton also happened to be infatuated with Carolyn Hester, so they had plenty to talk about.

Shelton showed up on opening night and interviewed Bob in the kitchen—Bob's most creative bit of mythology was that he'd learned to play slide guitar from a guy named Wigglefoot in Gallup, New Mexico—before listening to a set that had him raving that Dylan was

"bursting at the seams with talent." Dylan's basic set was already a superb mix of blues like "House of the Rising Sun" and Josh White's "Dink's Song," shaggy-dog stories to fill time while he tuned, and "Song to Woody." Shelton loved the comic "Talkin' New York" and the joke on international folksingers, "Talkin' Hava Negeilah Blues," and said Dylan's "music-making has the mark of originality and inspiration, all the more noteworthy for his youth." He noted that Dylan was "vague about his antecedents and birthplaces, but it matters less where he has been than where he is going, and that would seem to be straight up."

The piece, "Bob Dylan: A Distinctive Folk-Song Stylist/20-Year-Old Singer is Bright New Face at Gerde's Club," ran on September 29, which happened to be the day of Carolyn Hester's recording session—and John Hammond never missed reading *The Times*. Bob played harmonica on "Come Back Baby," "Swing and Turn Jubilee," and "I'll Fly Away," and after the session, prior to even hearing him sing, Hammond offered him a contract. That's Dylan's version.

As Hammond told the story, he invited Dylan to visit the Columbia studio after the rehearsal, heard Bob play "Talkin' New York," and responded, "Bobby, I don't know what Columbia is going to say about this, but I think you're absolutely wonderful and I'm going to sign you." In any case, just eight months after arriving in New York, Dylan was set to sign at the leading record company with the most famous record producer in the country, the man who'd recorded Bessie Smith, shaped Count Basie's career, "discovered" Billie Holiday, Charlie Christian, and many more, a moral exemplar and civil rights pioneer. Currently he was producing Pete Seeger. This was far more than getting a record deal; this was entering the music business at the very highest possible level. Ecstasy.

It wasn't big news just yet; the big buzz in American music that month was a dance fad at a mafia-run gay dive on Forty-Fifth Street called the Peppermint Lounge. The Twist hit, and on October 19, *The*

New York Times would describe in "Habitués of Meyer Davis Land Dance the Twist" how Nöel Coward, Greta Garbo, and Tennessee Williams had all visited the Peppermint Lounge.

Columbia was somewhat above dance fads, being run by Goddard Lieberson, the stage manager for Hammond's "Spirituals to Swing" concert and a veteran of the classical and Broadway musical worlds. Hammond's direct boss was Dave Kapralik, who would recall that Hammond seemed even more impressed by Dylan's persona than his music: "The gist of it was that we had to sign Dylan immediately because he was going to be important—not just musically, but intellectually and politically, as well. Not a *recording* artist, but a recording *artist*. He seemed more excited about the kind of message Dylan conveyed and what he represented than about his music, which was so unusual." Kapralik respected Hammond's ears and said go ahead.

On October 25 Dylan signed his contract, a fairly crummy new artist deal that gave him a 2 percent royalty rate and five yearly options, with no guarantees to Bob at all. He told Hammond he was an orphan, so John let him sign the contract at age twenty. As record producers will, John gave him a couple of prerelease albums in plain white sleeves as a present. One was the Delmore Brothers with Wayne Raney. The other was Robert Johnson's *King of the Delta Blues Singers*, which would be released the next month.

In his memoirs, Dylan would relate the moment he put the record on as one of the high points of his life. It would be advisable to approach any literal acceptance of this with a certain reserve, since at least two points in his story of that day are not possible. He speaks of Hammond showing him the cover art and says that Johnson's fierce eyes "already had me possessed." But the perspective of the cover looked down on an archetypal blues singer, and there are no eyes in it at all. Bob writes that he'd never heard of Johnson, which was very possibly true; the best information on Johnson at the time was Sam Charters's *The Country Blues*, and Bob might have missed it. Dylan went immediately

to Van Ronk's apartment to share this treasure and wrote that Dave hadn't heard of Johnson either, and that's most unlikely. Dave was not only a proficient blues scholar, but he also played in a band with Sam Charters.

That said, I find Dylan's response to the music completely believable. "From the first note the vibrations from the loudspeaker made my hair stand up. The stabbing sounds from the guitar could almost break a window. When Johnson started singing, he seemed like a guy who could have sprung from the head of Zeus in full armor. I immediately differentiated between him and anyone else I had ever heard. The songs weren't customary blues songs. They were perfected pieces . . . fires of mankind blasting off the surface of this spinning piece of plastic."

He began to play "Ramblin' on My Mind" and "Kindhearted Woman Blues" in his live sets and also started to copy Johnson's lyrics out to study their patterns, thinking of how serious Johnson seemed to be. Years later, the critic Gene Santoro would write, "Dylan was always the grown-up at the party in the 1960s, disdaining airy talk of love and change. He was the closest thing to a real bluesman born of that time." Santoro is talking about a certain hard-edged wisdom often seen as paranoia in Dylan, but the comparison also fits Dylan's early approach to songwriting, which was clearly part of the black songster tradition, in which fragments of different songs were swapped around in new versions.

What all this points to is that the young man who recorded eighteen songs on November 20 and 22 in two three-hour sessions, thirteen of which became the album *Bob Dylan*, was not the relatively limited Woody Guthrie acolyte-folkie that he has typically been characterized as. At minimum, he was at least as influenced by black music as white. The concept of freedom that had traveled through black music since the 1740s was as central to what he was doing as it was to Robert Johnson before him—or any member of the Austin High Gang.

It was no average folkie who would end his debut album with Lemon's "See That My Grave Is Kept Clean" and have three of those thirteen songs be about death ("In My Time of Dyin'," "Fixin' to Die"). And what his searing harp riffs and utterly serious voice did to Eric Von Schmidt's "Baby Let Me Follow You Down" (which is to say that Dylan got it from Von Schmidt, who'd heard it performed by Blind Boy Fuller) was not the work of a twenty-year-old youngster but of someone who'd integrated something far older, far deeper into his skinny boy's body and life.

He'd prepared seriously for the session by studying Carla Rotolo's record collection. Much of the material was new to him, with only four of the songs on the record appearing in his September Gaslight set.

He was new enough to the recording process to frustrate Hammond, who grumbled that he "popped every p, hissed every s, and habitually wandered off mic. Even more frustrating, he refused to learn from his mistakes. It occurred to me at the time that I'd never worked with anyone so undisciplined before." Yet someone so undisciplined delivered five of the songs on the album in single takes. "Song to Woody" took two takes. On the second day, after hitting his stride on the keeper fourth take of "See That My Grave Is Kept Clean," he delivered consecutive keeper single takes of three songs, then capped the day with a completely demonic version of the traditional (Child Ballad #243) "The House Carpenter," which he'd never been known to play before—and which was omitted from the album. That Bob, such a kidder.

There's some hard traveling in *Bob Dylan*, but little sex or booze. And it's the death songs that work best. Josh White's "In My Time of Dyin'" is simply superb, with first-class Delta slide blues picking and a vocal that is the real thing, authentic as it could possibly be. It's the only time Dylan's known to have ever performed the song. "Man of Constant Sorrow" is just as good, heartfelt, and sincere, and how a twenty-year-old youth could sing it is a wonder. His version of "House

of the Rising Sun" is superb, but the arrangement was so entirely lifted from Van Ronk that it ruptured their relationship. Ambition is not always pretty.

Perhaps that greed was redeemed by "Song to Woody." He'd written it on Valentine's Day in the Mills Bar on Bleecker Street after a visit with his hero, and it is a genuinely humble song of gratitude, modest in what he attributes to Woody ("not many men" have done what he's done), and then includes Woody's pals Cisco, Sonny (Terry), and Lead Belly to spread the glory. He's quite subtle. At first, the very long hold he puts on "paupers" in the first verse seems off, until you realize that it keeps the last line from going singsongy and pat. The concealed quotation from "Pastures of Plenty"—"That come with the dust and are gone with the wind"—is delightful. And his quiet ending—that the last thing he'd want to claim is that he's hitting some hard traveling too—elegantly links him to the tradition without pretense or posturing.

24

The Movement and Changes

S UZE HAD TURNED eighteen on November 20, and together they
moved in to a top-floor walkup apartment at 161 West Fourth
Street, just off Sixth Avenue. Cozy and full of sunlight, it was hot in
the summer, cold in the winter, smelled of tomato sauce from the pizza
joint next door, and cost either $60 or $80 a month, but it was theirs.
Bob was madly in love, and with that came a possessiveness that was
already frightening Suze. She wrote a friend that December, "I don't
want to get sucked under by Bob Dylan and his fame. I really don't.
It sort of scares me. I'm glad and all, but I just have a funny feeling
about it . . . I can see [egomania] happening to Bobby, and I've tried
to tell him in so many ways but it's really useless, it really is. Each day
it gets harder."

However much Suze thought she was being overwhelmed by
Dylan's personality, her effect on him was considerable. Just as they
settled in together, he was becoming consumed with songwriting to an
entirely new degree, and for the next year and more those songs would
center on issues of social justice, on the very topics that she grappled
with in her daily life at CORE. He did not write them from a preor-
dained vision of a harmonious world, and he had no party, cause, or
agenda. Just like Thoreau, just like Twain, he wrote from rage, from

a burning anger at the way the nation had failed of its promise. As the
Quaker phrase had it, he wrote "to speak truth to power."

One of the myths about Dylan at this time was that he seized on
social justice topics as a careerist stepping-stone, a claim that Van Ronk
dismissed out of hand. "He was no opportunist. He really believed it
all . . . but he didn't really understand it." His writing model was
Woody, who'd written political songs, among other kinds. In that,
Woody's model was akin to the blues singer, who at least since Charlie
Patton had sought to put a personal touch on songs, even if they were
assembled from a lyric stockpile. Van Ronk, a craftsman, linked Dylan
to his mentor in his occasional sloppiness, as well. A great line could be
followed by a weak one; "He always seemed to think it was easier to
write a new song than to fix an old one." Years later, Dylan would tell
an interviewer that most of the early songs were first drafts.

He had no fixed model for song structure, although in a conversa-
tion about songwriting much later he'd say, "It's important to always
turn things around in some fashion." In the early days, he'd take his
melodies from hymns or the blues. He used quatrains for perhaps half of
his songs, and three-line blues structures for perhaps a quarter. At first,
his lyrics were modeled on other songs, but very quickly it was just him.

The speed of his evolution as a songwriter was quite remarkable.
Dylan had thrown out a number of songs he'd written in the summer
of 1961. A friend fished them from the wastebasket and now research-
ers can see them. They were derivative training exercises, and he'd
been quite correct to toss them. Within the first few months of 1962
he'd write an anthem. And what hardly anyone could have anticipated
was that the political material would gradually unleash his creativity
so that he'd be able to write anything.

Hammond arranged a publishing deal for him with Lou Levy at
Duchess Music. It brought a welcome advance (depending on the
source, it was either $100, $500, or $1,000) and inspiration—there
was talk about a songbook when he had enough material.

On February 1, 1962, Izzy Young's journals noted a new Bob Dylan song, "Ballad of Emmett Till," written specifically for a CORE benefit scheduled for February 23. Adapted from a Len Chandler song, it was fairly literal, a murder ballad as well as a protest song. A few days later, Dylan watched "A Volcano Called White," a public television documentary about a murderer who'd pleaded to be institutionalized but was released because of jail overcrowding. Within days Dylan had written "The Ballad of Donald White," with a melody taken from Bonnie Dobson's version of "The Ballad of Peter Amberley," which he'd heard her play at Gerde's that week. Soon he'd add the mocking "Talkin' John Birch Paranoid Blues," the antijingoist "John Brown," and "Let Me Die in My Footsteps" ("I Will Not Go Down Under the Ground") to a growing pile. While there was an ease and comfort to having a premade plot, what he was doing was anything but simply transferring newspaper stories into lyrics.

He wrote wherever he was, sometimes spending an entire day at a corner table in a coffeehouse transcribing whatever came to mind. "He was always working on something—*always*," said Suze. "Or listening." "Let Me Die in My Footsteps" came from seeing the construction of a bomb shelter. There seemed so many other possibilities in life to the young man. "If nothing else," he told an interviewer, "they could look at the sky, and walk around and live a little bit, instead of doing this immoral thing." Tender and wise, it gently urges the listener toward life and away from the inevitability-of-war mentality that had been so pervasive in the America of his adolescence and after. It also contained what appears to be his first original melody.

Conveniently, he had an outlet available to him, one far more immediate and accessible than the recording studio or even gigs, which he wasn't doing very many of anyway. Several times a week, Bob would join Robert Shelton and Gil Turner, the MC at Gerde's, in a visit to the White Horse Tavern, scene of Dylan Thomas's last days. One night, Turner told Dylan about a magazine in the planning stages, *Broadside*,

which was to focus on topical songwriting and would be run by Agnes "Sis" Cunningham, a labor-movement friend of Woody's and a member of the Almanac Singers, and her husband, Gordon Friesen.

Shortly after, Bob turned up at *Broadside* HQ, Sis and Gordon's apartment on Ninety-Eighth Street, and his "Talkin' John Birch" would be part of the first issue. Dylan's impressive new work would be a regular feature of *Broadside* and he'd be listed as a contributing editor; it was very possibly the only organization he'd ever be a regular part of.

With a cover photo that showed cheeks still round with puppy fat, *Bob Dylan* was released on March 19, 1962. Clearly it had been delayed, and Hammond had needed to go to God—Goddard Lieberson—to get it out. Though the *Village Voice* heralded it as an "explosive country-blues debut," it generated little response, and by the end of the year it had sold a mere five thousand units. The phrase *Hammond's Folly* was bruited about Columbia, and Dave Kapralik wanted to drop Dylan. Hammond replied, "You'll drop him over my dead body," and between Hammond's and labelmate Johnny Cash's strong support, Dylan went into the recording of his second album still on the roster.

At the same time he also got to record as a sideman with his special heroes Victoria Spivey and Big Joe Williams. Spivey had been a part of the original blues women generation, recording "Black Snake Blues" in 1926, although it was Lemon who would have the hit. She'd recorded strange songs like "Dope Head Blues" and plenty of double-entendre material like "Furniture Man" with Clarence Williams and Lonnie Johnson. Dylan had met her the previous fall when she played Gerde's with Lonnie Johnson.

After spending years in church and away from the music business, Spivey joined with a fan named Leonard Kunstadt in the late '50s and began the Victoria Spivey Recorded Legacy of the Blues record label, which put out her old work and material by Johnson, Little Brother

Montgomery, Peter "Memphis Slim" Chatman, Roosevelt Sykes, and Big Joe Williams. *Three Kings and a Queen* would unite Spivey, Sykes, Johnson, and Williams with Dylan blowing harp on "Sitting on Top of the World."

The elder musicians were clearly fond of their protégé. "Bobby, you know, had no color denomination to him at all," said Spivey. "Everybody was people, not color." Williams was even more fulsome. He'd played three weeks at Gerde's that February 1962, and Dylan was there every night. Among his tall tales of a childhood jumping boxcars, Dylan had claimed that Big Joe had taught him the blues, which Van Ronk had filed under "exceedingly unlikely." Then he and Dylan had walked into Gerde's on Joe's first night, and Joe looked up and said, "Hey, Bobby! I haven't seen you since that boxcar down to Mexico!" Van Ronk mused, "I will always wonder whether Bobby somehow got to Joe and set the whole thing up, but it certainly blew us away."

The Village gang would be even more blown away by Dylan's next song. Sitting in a café across from the Gaslight, he started with the melody of "No More Auction Block," the spiritual that the Fisk Singers had called "Many Thousands Gone," which he'd probably gotten from the *Odetta at Carnegie Hall* album (1960). He was singing the song in his set at this time, and a recording of it later that year in the fall of '62 at the Gaslight was tremendous, haunting and fierce and tragic, someone transcending ninety years with complete empathy.

His mind turned on the phrase *your silence betrays you*, and he began working with the line from *Ezekiel* (12:1–2), "They have eyes to see and see not; ears to hear, and hear not." What came out seemed quite simple, overt, and very specifically of its time, the early phase of the civil rights movement.

Dylan finished the song, he said, in ten minutes. Excited and needing an immediate response, he ran across the street to the Gaslight and grabbed Gil Turner, who was gigging there. Dylan taught him the

song, and on April 16, 1962, Turner became the first person to sing
"Blowin' In The Wind." Dylan stood in a corner of the club and heard
thunderous applause and in the coming weeks watched as the song
was published in the May *Broadside* and then in the June *Sing Out!*,
becoming an anthem. Considering it much later, he thought it was a
"lucky classic song" but "one dimensional."

At first it struck many as too obvious—Van Ronk would think it
"incredibly dumb"—with a chorus line that was abstract and vague
(what do *you* hear in the wind?). Others, like Peter Yarrow, felt that it
was the openness of the song, the refusal to supply answers, that made
it poetry and invited people to supply their own answers. Certainly it
captured a zeitgeist, a moment when people believed, could feel things
in the wind.

The reaction was intense and bothersome, because it confined
him to the label "protest singer." It also anointed him as The One
in the Village folk scene, generating professional jealousy in others
and an occasionally justifiable suspicion in Dylan of people's motives
toward him. He wanted to be a star, but being put on a pedestal made
him uncomfortable. One night around that time there was a pass-
the-guitar-around party at Mikki Isaacson's, and Mark Spoelstra,
Dylan's first friend in the Village, played a song he'd written. Dylan
followed it up with the brand-new "Blowin' In The Wind," and peo-
ple began to cry. Spoelstra blurted out that his songs simply weren't
as good, and Mikki suggested to Bob that he help Mark—which was
embarrassing to both of them. He had no more peers, and that was a
lonely and troubling place.

He was about to get even more deeply lonely. Suze's mother, Mary,
didn't like or trust Dylan, whom she called "The Twerp," and con-
vinced Suze that a period of studying art in Italy would be just the
thing. Suze went along with Mom, and early in June 1962 she sailed
away. Bob was devastated. He thought of her as "The true fortuneteller
of my soul," and his pain would naturally spill into his songwriting.

He'd begun recording what would become *The Freewheelin' Bob Dylan* in April, mixing his own material like "John Birch," "Emmett Till," and "Let Me Die in My Footsteps" with blues like Robert Johnson's "Milkcow's Calf Blues" and Big Joe Williams's "Baby Please Don't Go." The blues had outlasted the Guthrie material in his repertoire. Much of his original material was fragmenting from song to song, lyrics migrating, said the critic Paul Williams, "recombining and reforming like molecules of DNA."

When he resumed recording on July 9, his thoughts were on Suze. By the time he was finished that month, he would have versions of two dozen songs available to him, of which only five would make the album. One was the keeper version of "Blowin' In The Wind." After that, the session was dominated by blues-based love songs. "Honey, Just Allow Me One More Chance" adapted the chorus from the 1927 recording by Henry "Ragtime Texas" Thomas, a tune with deep roots in nineteenth-century African American pop music (Henry was born in 1874 and was fairly venerable by the time he recorded). "Bob Dylan's Blues" talks about his gal in the middle of a funny, self-deprecating mix of the Lone Ranger and bank robbers. "Down the Highway" was a straight blues, original but completely authentic, wherein his baby takes his heart, packs it into a suitcase, and takes it away to Italy.

He wrote plaintively funny letters to Suze—"the dogs are waiting to go out, the thiefs [*sic*] are waiting for an old lady—little kids are waiting for school— . . . Everybody is waiting for cooler weather— and I am just waiting for you"—and spent much of the summer of '62 at the Waverly Theatre watching movies like *A Face in the Crowd*, which featured Andy Griffith as "Lonesome Rhodes," an amoral country singer. In Suze's absence over the rest of the year he spent an increasingly significant amount of time with SNCC activists like James Forman, Cordell Reagon, and in particular Bernice Johnson, who were visiting the North, mostly to raise money and awareness for the struggle going on down South.

After the Freedom Rides, the focus of the civil rights movement had moved in the fall of 1961 to Albany, Georgia. Albany wasn't a great triumph for the movement, but singing would become ever more central to what went on there. Bernice Johnson was a student at Albany State College, secretary of the local junior chapter of the NAACP, and a singer. "Ordinarily," she said, "you go to church and you sing but sometimes the congregation takes the roof off the building. *Every* mass meeting was like that. So the mass meetings had a level of music that we could recognize from other times in our lives . . . The music actually was group statement." The traditional songs and prayers of black people were now used in a practical way as part of the struggle, and it was powerful.

In the fall, Pete Seeger came to Albany thinking he'd lead some singing, as he usually did. Ironically, his versions had different keys, tunes, and words, and it didn't go well musically—these people needed no help in the singing department. But he'd witnessed a genuine singing movement, and he was deeply impressed. He encouraged Bernice to start a SNCC singing group like the Almanac Singers, and so were born the SNCC Freedom Singers, led by Bernice and her soon-to-be-husband, Cordell Reagon. Pete's wife, Toshi, would book their first tour, and Bernice became part of the Seeger family. Bernice would say of Dylan, "Some whites moved with us out of some special sort of love of blacks, while others were just loaded with guilt. Dylan wasn't the same . . . I've always just regarded Bob as a friend. He's never been a star to me, just a friend."

Toward the end of summer, Bob took care of some practical details in his professional life. On August 9 he went to court and legally changed his name to Bob Dylan. Later in the month he signed a management contract with Albert Grossman, a relationship that would have a major impact on his career over the next several years. Among other things, Grossman kept Dylan away from stupid TV shows and the kind of silly promotional ideas that record companies so often

generate. By his own example, he taught Dylan, as one biographer put it, "the virtues of acquired mystique."

Unfortunately, Grossman's mystique arose from a paranoid and manipulative manner that would encourage Dylan to distance himself from his peers. That would be consonant with Dylan's fundamentally secretive nature, but not necessarily healthy. Musically, Grossman had no apparent impact. Promotionally, he would be brilliant, selling Dylan's music by using the talents of Peter, Paul, and Mary, the group he'd created in 1961. The fact that Grossman's contract gouged Dylan and was not entirely legal (Grossman was not licensed to be a manager in New York State) was at least partly because Dylan himself never did read the contract and would learn many ugly details only some years later.

In a left-wing folkie world that valued spirit over finance, Grossman was a barracuda surrounded by dinner. He'd gone to college in economics and worked as a management aide at a public housing complex in Chicago before he was, wrote Dylan biographer Bob Spitz, "summarily dismissed for 'gross irregularities.'" From there he opened the Gate of Horn folk club and then became involved with the development of the Newport Folk Festival. In 1961 he'd assembled Paul Stookey, Peter Yarrow, and Mary Travers into a folk supergroup. Their career would soar from their eponymous first album, which included hits like "Lemon Tree" and Pete Seeger's "If I Had a Hammer" and "Where Have All the Flowers Gone?"

Grossman was anti–John Hammond, at least in part because Dylan's contract was not overly generous, and in the course of the fall he'd get his client a new contract with a higher royalty rate—and, eventually, the replacement of Hammond with a new producer, Tom Wilson, a young black man who was a Harvard graduate and who'd already recorded Sun Ra and Cecil Taylor.

Around Labor Day, Suze wrote to tell Dylan that she was going to stay in Italy indefinitely, igniting an anger that he would express with a

new song, "Don't Think Twice, It's All Right." His next song was not nearly so directly personal and would be extraordinary in conception, execution, and impact.

"A Hard Rain's A-Gonna Fall" started with the classic English ballad (Child #12) "Lord Randall," in which the singer poses a series of questions to the Lord, whose answers gradually reveal that he has been murdered. This antiphonal structure was relatively rare for Dylan. "Blowin' In The Wind" asked questions, but the asker gives the answers. In "Hard Rain," we gradually learn that the questioner is Mother Earth herself, and the answer communicates a vision of hell on earth. The hard rain is not something so literal as the trace elements of nuclear testing that the evening's drizzle brought down, but an overall sociopolitical rain of poison—of lies, of the corruption of language in advertising and the false promises of politicians.

Dylan's vision was soaring now to levels of sophistication and ambition no one before had considered using for popular song. This first combination of symbolism and the traditional folk song was unique. He sat writing in Hugh Romney's apartment above the Gaslight on Hugh's Remington typewriter, pinning an enigmatic stream of images of evil to the page—a deserted highway of diamonds, branches dripping with blood, broken-tongued talkers, children with guns and swords. He hears the song of a crying clown and meets a man wounded by hatred. When asked what he'll do now, he promises to go to the depths and stand against it, to "know my song well before I start singin'."

It's structurally odd, with no end rhymes at all; internal rhymes and alliteration carry the rhythm. The replies to the questions increase in length, so that the first reply is five lines and the last twelve—things build up until the listener is simply steamrolled. Each line, he said, was potentially the beginning of another song; "when I wrote it I thought I wouldn't have enough time alive to write all those songs so I put all I could into this one."

Eventually, he went downstairs to the Gaslight to play it. It was a warm September night, and Van Ronk had to leave the club after the song, even though Dylan wasn't finished with his set. Van Ronk couldn't speak. "I remember being confused and fascinated that night because, on one hand, the song itself excited me, and on the other, I was acutely aware that it represented the beginning of an artistic revolution."

A month later, almost as if to prove Dylan a prophet, the world lurched close to nuclear disaster in the Cuban Missile Crisis. That same month, Joseph Heller's antiwar masterpiece *Catch-22* was published in paperback. Sales, quite modest in the original release, took off, never to slow. If ever a book spoke to a moment, this was it. Dylan would write to Suze that he'd spent the worst night of the missile crisis sitting in the Café Figaro "waiting for the world to end." He wasn't angry anymore; in fact, he wrote the exquisitely tender song of longing, "Tomorrow Is a Long Time," for her.

Meantime, Bob was engaged by another national crisis. It was nine years after *Brown v. Board of Education*, and just 13,000 of the 2.8 million black students in the United States were in integrated schools. Tokenism and evasion ruled the day. That September, James Meredith, under an order from Supreme Court Justice Hugo Black, tried to register at the University of Mississippi. Governor Ross Barnett personally blocked the door.

On October 1, 1962, 320 federal marshals moved onto the campus and put Meredith in a dormitory. The result was insurrection. The marshals came under serious assault not only from students but also from armed mobs let onto campus by the state police who were supposedly keeping order. An all-night battle ensued, pitching marshals augmented by federalized Mississippi National Guard and later regular army troops against rocks, bottles, clubs, Molotov cocktails, and firearms. Eventually, 3,000 regular troops would patrol the campus. Two died and 375 were injured, including 166 marshals, 29 of whom had gunshot wounds.

Dylan responded with "Oxford Town," which he told interviewer
Studs Terkel, "Well, yeah, it deals with the Meredith case, but then
again it doesn't." He never names Meredith, and the song is ultimately
an indictment of liberal hand-wringing, ending with the classic "some-
body better investigate soon." It is subtle and understated and, in that
way, perfect.

In November 1962 Dylan went to Sis Cunningham's and recorded
eight songs, including three little-known civil rights originals, "Walkin'
Down the Line," "Train A-Travelin'," and "Paths of Victory." Then
on December 6 he went to Columbia and in three hours recorded three
songs, all first takes, which would be on the album: "Hard Rain," a
rewrite of Lead Belly's "We Shall Be Free" called "I Shall Be Free," and
"Oxford Town."

Soon after the Columbia session, he took off for England. Grossman
was traveling with his client Odetta on her first European tour and had
invited Bob as well. As an enticement, he'd found Bob a small part on
a BBC television show being shot in London. Bob mostly saw it as a
chance to see Suze in Italy and would only find out she'd left for home
when he called on his arrival in Europe.

The stay in London was not altogether smooth. The BBC had put
him up at the posh Mayfair Hotel, and the atmosphere—and sheer num-
ber of people expecting tips—unnerved him. When he began working on
the TV show—he had the role of a young anarchist in *The Madhouse on
Castle Street*—he rather appropriately wanted to rewrite his lines, news
the director did not greet with enthusiasm. In the end, they would use
Bob only to record "Blowin' In The Wind" behind the credits. Finally,
he was firmly snubbed by the resident gurus Ewan MacColl and Peggy
Seeger at the in-group Singer's Club when he performed his new and
very long "Hollis Brown" and ran over the five-minute limit.

Things improved when he met the English folk musician Martin
Carthy and began learning new songs, English tunes in the original and
not their American variations. Carthy taught him "Scarborough Fair,"

and the melody became in Dylan's hands two different songs in the next few weeks, "Girl from the North Country" and "Boots of Spanish Leather." Carthy also taught him "Lord Franklin," which became the melody of "Bob Dylan's Dream."

Carthy's friend Bob Davenport taught Dylan another song, "Nottamun Town." Ironically, the song had originated in England but had traveled to Kentucky and died out in Britain. Jean Ritchie, the great-great-granddaughter of the man who'd brought it to America, had returned it to England when she'd used a Fulbright scholarship to visit the mother country and research her family's songs. Since it was thought to be an old mummer's song with magical properties, perhaps that rebirth wasn't surprising.

Even traveling, Dylan was acutely aware of the social order, and "Nottamun Town" quickly became his absolute epic of rage, "Masters of War." The masters were everything he loathed, the people who "build to destroy" and played with his world "Like it's your little toy." It was that remote-control, detached manipulation that maddened him. The masters work the triggers "For the others to fire" and then sit back and watch while the death count mounts. And young Bob wishes death upon them, promising to watch their bodies be lowered into the grave, just to make sure they're dead.

Not subtle, the song, and not near what he'd come to do. But something very interesting happened about "Masters of War." Some months later, Allen Ginsberg, the Beat poet and author of "Howl," was at a party in Northern California and a friend played him the song. (At other times, Ginsberg said the song that moved him so was "Hard Rain.") He was flabbergasted. "It seemed to me that the torch had been passed, from Kerouac or from the beat genius on to another generation completely . . . and he'd taken it and made something completely original out of it, and that life was in good hands. I remember bursting into tears."

The torch had indeed been passed. Spiritual freedom in the arts was the focus, and it was doing very well indeed.

LATE IN 1962 Eric Von Schmidt, his marriage over and his life a shambles, departed Cambridge for London to lick his wounds. He found Richard Fariña there, about to go through a Mexican divorce with Carolyn Hester so that he could secretly marry Joan Baez's seventeen-year-old sister Mimi, whom he'd met that summer in Paris. Dylan joined them and sang his new "Don't Think Twice," which resonated with all three men, each ensnared in the coils of love. A party began and continued, they blearily recalled, for a couple of weeks. "Dylan really was amazing back then," said Von Schmidt. "He kept changing sizes. He changed shape from day to day. On Tuesday he'd be big and husky; on Wednesday he'd be this frail little wisp of a thing; on Friday he'd be some other size and shape. The trickiest part was that he was always wearing the same clothes."

Dylan soon moved on to Italy, looking for and not finding Suze—the Cuban Missile Crisis had made her homesick, and she'd sailed home in December. Their letters and plans had crossed mid-Atlantic, and they wouldn't see each other until well into January. Suze returned to find that Bob had not suffered in silence; it seemed to her that the Village had cast her as Barbara Allen to Bob's Sweet William.

In Italy, he kept working on a number of songs, including the tenderly romantic "Girl from the North Country." Legions of writers have wondered whether this was meant for Echo or Bonnie Beecher, and I'd suggest both, with a large measure of missing Suze thrown in. He also finished "It Ain't Me Babe" and "Boots of Spanish Leather."

One month after Dylan left London, on February 22, 1963, "Please Please Me" reached #1 on the English charts, and the Beatles, to that point unknown outside of Liverpool and Hamburg, were on their way. They'd meet Dylan in the next year.

Returning to New York, Bob and Suze had a sweet reunion. She was more confident in herself, and he was somewhat more open. They settled back into their lives and went to MOMA for "The Art of Assemblage," saw the Living Theater's *The Brig* and the film *Pull*

My Daisy, which was narrated by Jack Kerouac and featured the Beat poets Allen Ginsberg, Peter Orlovsky, and Gregory Corso.

In March, Columbia's publicist Billy James and the photographer Don Hunstein came to Bob and Suze's apartment and swept them up to shoot the new album's cover outside on the street. In a clear triumph of style over comfort, Bob carefully selected a suede jacket even though the day was extremely cold. Nothing was planned, and out of the spontaneity came the iconic cover of *Freewheelin'*, the two of them as glowingly alive as only young lovers can be.

That month, folk came to national television with the debut of *Hootenanny*. Six of the year's top twenty-five albums would be folk music—three by Joan Baez, two by Peter, Paul, and Mary, and one from the Kingston Trio. Though the Court of Appeals had dismissed Pete Seeger's contempt case with Congress on a faulty indictment in May 1962, he was still blacklisted by national television and *Hootenanny* wouldn't book him, stirring a boycott from people like Dylan and Baez. Instead, the TV show offered more pop-oriented acts like the Chad Mitchell Trio and the New Christy Minstrels, with a sprinkling of classics like Mother Maybelle Carter and Doc Watson.

As the blacklist showed, some things in America hadn't changed very much. That January, the new governor of Alabama, George Wallace, had said in his inaugural address, "Let us rise to the call of freedom-loving blood that is in us and send our answer to the tyranny that clanks its chains upon the South . . . segregation today . . . segregation tomorrow . . . segregation forever."

Birmingham (often called "Bombingham" in reference to the dynamite bombs that targeted civil rights activists) was still, said John Lewis, "the most segregated city in the South." In April, Martin Luther King and the local Reverend Fred Shuttlesworth, with the Freedom Singers helping, began sixty-five consecutive nightly mass meetings. Public Safety Commissioner Bull Connor, who'd already closed parks and playgrounds to avoid integrating them, arrested 150

on the first day of sit-ins. But Bull was a tough opponent and the sit-ins seemed stuck.

James Bevel, one of the Nashville group, convinced King that something extra was needed. Bevel had been training high school kids in nonviolence, and King agreed to let them march. Ten thousand children marched, and on the first day five hundred or more were arrested, so many they had to be confined at the fairgrounds. Embarrassed by the sheer numbers, Bull decided not to arrest anyone on the second day, May 3. Instead, he turned fire hoses and police dogs on the children, and the television cameras caught it all. The federal government got involved, and eventually Wallace stood symbolically in the schoolroom door to prevent black people from attending the University of Alabama. Then he stepped aside. On the same day, President Kennedy announced a civil rights bill. That night, June 12, 1963, Medgar Evers, the head of the NAACP in Mississippi, was assassinated by a sniper, part of a triple murder planned by the Klan (the other two attempts were unsuccessful). In response, Reverend King announced a march, a march for freedom and dignity, a march on Washington, D.C.

In New York, Dylan had performed his first really big-time show on April 12 at Town Hall. Bob gave the audience "Hollis Brown," "Masters of War," and a scintillating "Tomorrow Is a Long Time," a peace offering to Suze because they'd had a bad fight that afternoon. Two new songs were also highlights. The first was "Who Killed Davey Moore," about the boxer who'd died just a few weeks before. Deftly adapting "Who Killed Cock Robin?," Dylan ran through a list of denials from the referee to the manager to the gambler to the fan, attacking not boxing but the human capacity for avoiding responsibility. It was a finger-pointing song, as the phrase had it, but Dylan made sure that the finger pointed at everybody.

The second new song was yet another product of Bob's stay in England, the tune by Dominic Behan called "The Patriot Game." "With God On Our Side" was a masterpiece of culture criticism stuffed

into six minutes and eighteen seconds. Standing squarely in Thoreau's shoes, Dylan took up the notion of American singularity and virtue and shook it until it crumbled. The cavalry charges, the Indians die, the Civil War consumes a generation, there's a First World War whose rationale for fighting is never clear, a Second World War after which we forgive those who killed six million (now they, too, have God on their side), our allies the Russians are now our enemies, the planet holds weapons of universal death that we actually consider using, and a concluding sane thought: If God's really on our side, "He'll stop the next war."

Late in April Bob went into the studio for his final *Freewheelin'* session, this time with Tom Wilson. Given Hammond's reputation as a passive producer who sat in the corner silently reading newspapers, the switch meant little. That Hammond made sure Columbia kept him under contract would have more lasting consequences, both for Columbia's bottom line and Hammond's reputation for acumen. The last session included "North Country," "Bob Dylan's Dream," and "Talkin' World War III Blues."

On May 12, Bob went uptown to *The Ed Sullivan Show*, planning to play "Talkin' John Birch Paranoid Blues." He'd auditioned it for Sullivan earlier in the week and there hadn't been any objections. However, during dress rehearsal, the network censor determined that it would be libelous and couldn't be played. The producer told Bob, and Bob calmly turned down his chance to join Al Hirt, Irving Berlin, Teresa Brewer, Topo Gigio, and Myron Cohen. "If I can't sing this song, I prefer not to sing." Times had changed; the coverage in *The New York Times*, the *Village Voice*, *Time*, and *Playboy* all cheered his stance.

Columbia also had libel lawyers. They, too, were concerned about "John Birch." Then something very curious happened. A few hundred copies of the original version of *Freewheelin'*, which included "John Birch," seemingly left Columbia—but only a very few. According

to Columbia's attorney, Clive Davis, the "problem began with Ed Sullivan," but his memory seems to be wrong, since there was a meeting of Dylan, John Hammond, and Davis—Grossman isn't mentioned as having been there, which is itself exceedingly odd. It was probably in early April, since some time that month Hammond was replaced as producer by Tom Wilson and would hardly have gone to such a meeting afterward.

Clive Davis was in a fix. He was a liberal who'd volunteered for Adlai Stevenson and admired Dylan, but he had to explain libel law, and Dylan responded, "What *is* this? What do you *mean* I can't come out with this song? You can't edit or censor me." Squirming, Clive attempted to explain that it was not a political but a legal situation, but Dylan wasn't buying. "It's all bullshit," he said, and bolted from the room.

All of which suggests that the meeting preceded the final *Freewheelin'* session on April 24 and gave Dylan a chance to recast the album on his own terms. The esteemed critic Paul Williams theorized that "Talkin' World War III Blues" was very possibly a spontaneously improvised substitute laid down for that very purpose. In any case, "John Birch," "Rocks and Gravel," "Rambling Gambling Willie," and "Let Me Die in My Footsteps" were replaced by "Girl from the North Country," "Masters of War," "Talkin' World War III Blues," and "Bob Dylan's Dream." Anticensorship stalwart that I am, I find it inarguable that at least one of the reasons for the substitutions was that the new material was incomparably stronger.

Released on May 27, 1963, three days after his twenty-second birthday, *Freewheelin'* was a truly great album that included an anthem in "Blowin' In The Wind"; epic sociopolitical rants in "Masters of War," "Hard Rain," and "Oxford Town;" one of the best love songs ever, "Girl from the North Country"; one of the best hostile love songs ever, "Don't Think Twice"; political satire in "Talkin' World War III Blues"; a superb blues in "Down the Highway"; and some excellent comedy in "I Shall Be Free." All but two of the songs were originals.

As part of the prepromotion for the album, Dylan played at the Monterey Folk Festival on May 18. Rather than return to New York, he lingered in the area. Dylan had met Joan Baez in April, when he'd played two nights at the Café Yana in Boston. He'd sung "With God On Our Side" to her, and she was seriously impressed. After the Monterey show, he went to her place in nearby Carmel.

In his memoir, Dylan would say of Baez that "She had the fire and I felt I had the same kind of fire." They were twins, really, both blessed with unsurpassable talent, both capable of being extremely cold and condescending, with blood-drawing edges to their wicked senses of humor. Riding on a once-in-a-generation voice and great personal beauty, Baez had walked onstage at Newport in 1959 and been a star when she stepped back on the ground. Her first album, out in late 1960 without promotion except for review copies, would spend 140 weeks on the charts and earn her more than $1 million. In November 1962 she'd been on the cover of *Time*—"Sibyl with Guitar"—and was queen of the world she lived in.

Dylan was the man who'd written songs that she knew were the product of genius, and she wanted to be next to that genius. She bought him a jacket and some cufflinks and wrote later, "He was a Sunday child, fidgeting . . . and I was Mom. But I was also sister mystic and fellow outlaw, queen to his jack, and a twin underground star." Dylan would write that her exquisite voice was rather too much for him, that he understood only ugly sounds, "crackin shakin breakin sounds." Then he listened. While in Carmel he wrote another impossibly good song, which Joan wisely grabbed for herself, "Love Is Just a Four-Letter Word." Having received such a gift, Baez reciprocated, inviting Dylan to join her in future performances, or as she wrote later, "dragging my little vagabond out onto the stage."

He returned to New York in June. Not only was *Freewheelin'* out, but also Peter, Paul and Mary had released their version of "Blowin' In The Wind" on June 18, 1963, and sold three hundred thousand

copies in the *first week*. It was only a month after the fire hoses and police dogs had been trained on the children of Birmingham. The song was classic, and in the next year, more than sixty cover versions were recorded by people like Duke Ellington, Marlene Dietrich, Trini Lopez, and Lena Horne.

The album was remarkable. After *Freewheelin'*, Suze would notice, people would approach Bob at parties with reverence, wanting to share the stories of their lives and "then wait for him to speak." They wanted enlightenment; "He wanted to make music, not address a congregation." He definitely didn't want to get questions like the one he'd get a few months later from the *Village Voice*, asking him if he had "any important philosophy for the world." "Are you kidding? The world don't need me. Christ, I'm only five feet ten. The world could get along fine without me. Don'tcha know, everybody dies."

One of the songs in *Freewheelin'*, "Bob Dylan's Dream," concerned Bob and his earliest friends. It's world-weary and nostalgic, longing for a time when their company was all he wanted, when hearts were young and times were simple and innocent. Most would assume that it's Bob looking back at John Bucklen and Echo and Hibbing. I wonder if Bob was already feeling what would become quite clear after *Freewheelin'* had set the pattern, that his art was taking him away from most human relationships, and that "Dream" concerned the Village in 1963 as much as his youth.

It was around this time that Bob started visiting Albert Grossman's country place in Woodstock, about one hundred miles north of Manhattan. Peter Yarrow had family there and was another Woodstock regular. In 1902, various people associated with John Ruskin and the arts and crafts movement relocated to Woodstock, and it had remained an arts community, the summer home of the Art Students League, and a refuge for freedom-seeking spirits ever after, welcoming Clarence Darrow, Thorstein Veblen, Maria Ouspenskaya, Rabindranath Tagore, and Thomas Mann among others.

At some point in May or June, Dylan got a call from Theodore Bikel urging him to visit Greenwood, Mississippi, in support of the civil rights movement there. The call must have set off a fascinating chain of images for Bob. Greenwood was where his hero Robert Johnson had died. Parchman Farm and all the other place names of the Delta blues that he'd studied were just down the road. It was now ground zero for the civil rights movement that Dylan was so deeply grounded in.

Some would come to question his commitment to that cause, but that summer Dylan would actually stage a debate with his friend Paul Nelson of the Minneapolis folk magazine *Little Sandy Review* concerning the relative importance of folk music and the movement. The *Review* had annoyed Bob by faulting *Freewheelin'* for its orientation toward protest songs over "pure" folk, so during a July visit to Minneapolis he challenged Nelson, arguing that social issues "were more important than music." Nelson admitted that Dylan "outargued me a hundred to one. He was really a brilliant talker then."

Bikel was calling because the movement had bogged down in Mississippi. Home of the White Citizen's Councils (WCC), which had emerged in the aftermath of the show trial of Emmett Till's murderers (which had taken place just forty miles up the road from Greenwood), it was a state led by Senator James O. Eastland of Doddsville, Sunflower County (thirty miles northwest of Greenwood), a planter and heir to the Delta plantation mentality. The WCC were actually financed by public money from the state legislature and provided the extralegal muscle that seconded the legislature's active opposition to voter registration.

Between the fall of 1961 and the spring of 1963, twenty thousand men, women, and children had been arrested for civil rights–related incidents in the South. Later in 1963, another fifteen thousand were arrested. The epicenter was Birmingham, but Greenwood was a primary flash point. It was perhaps the scariest place in the South.

Robert Moses of SNCC had been organizing in Greenwood for a year by now, and one of his best local recruits was a sharecropper named Fannie Lou Hamer, who'd found out the previous year at the age of forty-five that she was entitled to vote. A woman of profound faith, she'd gone to the courthouse singing "This Little Light of Mine," and when she was subsequently evicted from the plantation for this action she felt set free to join the movement. She was witty—called a communist, she'd dryly replied that she knew as much about communism "as a horse do about Christmas"—and she was tough. Savagely beaten after an arrest, she said, "Sometimes it seems like to tell the truth today is to run the risk of being killed. But if I fall, I'll fall five feet four inches forward in the fight for freedom."

Moses had been joined in Greenwood by a Chicago journalist named Jim Forman, and between regular arrests on flimsy pretexts and the constant threat of murderous violence, their progress was slow. A little outside support was more than welcome. Bikel told Dylan, "It looks different and feels different when you're in the midst of it." Grossman would tell Bikel, "He can't afford to. The fare's too high," and Bikel wrote out a check. Early in July, Dylan and Bikel and Pete Seeger flew to Atlanta and then to Jackson, where activists picked them up and drove them to Greenwood.

After all the songs, from Charlie Patton to Robert Johnson to Muddy and Wolf, Dylan might well have thought that he had a sense of the Delta. The first actual sight of "white" and "colored" drinking fountains and toilets must have been a shock. He spent much of his two or three days there scribbling notes on bits of paper when he wasn't speaking with the SNCC workers—Forman, Bernice Johnson Reagon, and Julian Bond among others. Dylan and Forman bonded quickly, and Dylan learned some sobering truths. President Kennedy was not protecting voter registration efforts, the game was getting deeper and scarier, and the SNCC activists were going to follow their path all the

way down. Bikel described Dylan as "humble," apologizing for not being able to offer more. The Delta had taken him aback.

After sleeping one night in the loft of a church, he was driven to Silas Magee's farm, two miles outside Greenwood, for the show. It had been scheduled for 10:00 a.m. on July 6, but it was so hot that they waited until dusk. Perhaps three hundred local black people attended, along with a film crew and a sprinkling of robed Klan members. Standing in front of a truck that a few sharecroppers were using for a seat, Dylan chose to debut his newest song, composed in the three weeks since Medgar Evers's murder in June, "Only a Pawn In Their Game." "The Greenwood people didn't know that Pete, Theo, and Bobby were well known," said Bernice. "They were just happy to be getting support. But they really liked Dylan down there in the cotton country."

The song was superb, a doctoral dissertation on the manipulation of racism and class interests condensed into five verses of poetry: "And the Negro's name / Is used it is plain / For the politician's gain." That name was *nigger*, and it ruled the South. It was the height of irony that Evers's killer, Byron De La Beckwith, would turn out not to be one of the pawns but a wealthy man, but that took nothing away from the song. It took resolve to sing of hiding beneath the white hood while looking out at Klan members, to have one's songs come so vividly to life. It was a powerful day for Dylan, and he was going to be thinking about Greenwood and the people he'd met there for a long time. Joined by Bikel, Seeger, and the Freedom Singers, he finished the show with "Blowin' In The Wind" and "We Shall Overcome."

25

An Existential Troubadour

DYLAN'S NEXT GIG was a big one. The Newport Folk Festival had lapsed in 1961 and 1962, because the first two years, 1959 and 1960, had not done well; too many stars, not enough tradition. There had also been crowd-control problems at the 1960 jazz event. George Wein revived the Folk Festival in 1963 (July 26 to 28) as a nonprofit, with proceeds going to the Highlander Folk School and the purchase of guitars for Skip James and John Hurt, among others. All performers were to receive $50 a day plus food and lodging. The emphasis would be on education as much as entertainment, with lots of workshops.

It was an extraordinary event, not least because it juxtaposed a populist music gathering with the most fabulous mansions that the American super-rich had ever managed to build. The fog that blew in off the water wreathed the grounds in gray and, combined with the ghosts onstage—musicians everyone thought had died long ago, like Mississippi John Hurt and Dock Boggs—made for a spectral atmosphere.

The '63 festival was consciously linked to the civil rights movement and included photo exhibits from Greenwood's voter registration efforts. Saturday night, Joan Baez, James Forman, and the Freedom Singers led a march through Newport that ended in Truro Park, where

Forman urged the audience to attend the march on Washington sched-
uled for a month later.

Dylan was booked for Friday night, and after a set that included
"Talkin' World War III Blues," "God On Our Side," "John Birch,"
and "Hard Rain," he was joined by Peter, Paul, and Mary, Pete Seeger,
Theodore Bikel, Joan Baez, and the Freedom Singers to close with
"Blowin' In The Wind" and "We Shall Overcome." Bob played sev-
eral times in the weekend, including a workshop with Pete Seeger, and
joined Joan Baez on her Sunday night festival-closing set. Baez per-
formed a number of Dylan tunes, introducing "Don't Think Twice"
with the remark, "This is a song about a love affair that has lasted too
long"—Suze went pale and left—before bringing Dylan out to close
the show with a simply fantastic duet on "With God On Our Side."

Though Dylan had been justifiably annoyed when Ronnie Gilbert
of the Weavers had introduced him with the patronizing remark, "And
here he is . . . take him, you know him, he's yours," the festival, on
top of *Freewheelin'*, made it clear that he was now a star. Building on
that, he performed with Baez on several East Coast shows in the next
month, most notably at Forest Hills Tennis Stadium in New York. The
real event for both of them, however, took place on August 28.

The March on Washington had evolved considerably by that day.
What had originally focused on jobs and then shifted to civil rights had
largely been co-opted by federal officials. It was, wrote John Lewis,
who was there to speak for SNCC, "a march *in*, not *on*, Washington."
Still, the size and broad makeup of the march made it one of the more
important public demonstrations in American history. The eloquence
that so memorably ended the day was really only icing.

Singing on the steps of the Lincoln Memorial under the marble gaze
of Father Abraham in front of a quarter million people made for an
impressive moment. Joan Baez kicked it off with "We Shall Overcome"
and Odetta's "Oh Freedom." Odetta followed with "I'm on My Way."
Peter, Paul, and Mary sang Pete Seeger's "If I Had a Hammer," then

closed with "Blowin' In The Wind" joined by the other singers. Dylan did "Only a Pawn"—*The New York Times* found it "lugubrious"— and then with Baez debuted "When The Ship Comes In," which he'd written earlier in the month. With Baez and Len Chandler, he concluded with "Keep Your Eyes on the Prize." The iconic civil rights veteran Marian Anderson sang "He's Got the Whole World in His Hands." Reverend King's favorite, Mahalia Jackson, delivered "How I Got Over" and "I've Been 'Buked and I've Been Scorned."

For Dylan, one of the prime events of the day would be John Lewis's speech. The SNCC people were his people, and his friend Jim Forman had written a line for Lewis that read, "We will march through the South, through the heart of Dixie, the way Sherman did. We shall pursue our own 'scorched earth' policy and burn Jim Crow to the ground, nonviolently. We shall crack the South into a thousand pieces and put them back together in the image of a democracy." There was more—dismissing the president's civil rights bill as "too little and too late," asking "which side is the federal government on?," a reference to political leaders as cheap—and under pressure from A. Philips Randolph, Lewis cut those lines. But his ending was not shy and made for the second-best speech of the day. "We must say, 'Wake up, America. *Wake up!!!*' For we cannot stop, and we *will* not be patient."

Reverend King followed, and his prepared speech seemed to drag a little, and Mahalia Jackson said, "Tell 'em about the dream, Martin!" and he reached down into his African roots and black preacher soul and improvised a closing chorus that is among the greatest moments in American oratory. By the end of the day, the federal government had joined the civil rights movement.

The next day, *The New York Times* included an item titled "Farmer Sentenced in Barmaid's Death," which reported that a Maryland tobacco farmer named William Zantzinger had been given a six-month sentence (deferred until after the harvest) and a $625 fine for

manslaughter and assault in connection with the death of a barmaid named Hattie Carroll. Exceedingly drunk at a charity event, he had whacked Carroll several times with a toy cane, cursing her and calling her "nigger," because he didn't get the drink he'd ordered fast enough. A short time later, Carroll began to show the symptoms of what would prove to be a brain hemorrhage and died a few hours later that day.

Someone gave Dylan the clipping, and he went to work with a small notebook in a luncheonette on Seventh Avenue. The melody was adapted from the Scottish ballad "Mary Hamilton" and the set structure of the piece from Bertolt Brecht's "Pirate Jenny" in *The Threepenny Opera*, which he'd seen that spring at the Sheridan Square Playhouse. Dylan would be "totally influenced" by the song, although he'd stay away from the ideology.

Dylan biographer Clinton Heylin would belabor his subject for misrepresenting Zantzinger (called "Zanzinger" in the song), and for the life of me I don't really know why. Hattie Carroll's enlarged heart and hardened arteries contributed to why she died, but as the court found, Zantzinger's verbal abuse and physical assault clearly triggered her death. The real point of the song was not so much Zantzinger's actions as the protection he enjoyed as a wealthy white man in contrast to what society offered a poor black barmaid. Dylan certainly takes some poetic license—he describes the cane sailing through the air, which it didn't literally do—but it seems well within bounds.

The distinguished scholar Christopher Ricks would analyze the song at length and call it "perfect," observing details of Dylan's technique, for instance the repetitions of the word *table* as Hattie cleans; the rhyming is enslaved—as is Hattie. *Lonesome* is part of the title (and not the lyrics) simply for cadence. After ending each verse by saying that it isn't the time for tears, he ends the song by saying that *now* it's appropriate, but what he says is "Now's the time"—the difference between "now is" and "now's" is considerable. He never mentions Hattie's race. All in all, it's a masterpiece of subtlety, all

the more remarkable, I would suggest, because it was written in the shadow of a terrible, gut-wrenching disaster, the death of four young girls—Cynthia Wesley, Carole Robertson, Addie Mae Collins, Denise McNair—in the bombing of Birmingham's Sixteenth Street Baptist Church on September 15, 1963.

Dylan finished the song at Joan Baez's place in Carmel, where he'd gone after Suze had moved out of their apartment. Gossip from others and Dylan's lies had finished her. While in Carmel, Dylan spent time hanging out with the newly married Richard Fariña and Joan's sister Mimi and working on another song, "Lay Down Your Weary Tune," which expressed his increasing ambivalence about performing.

He returned to New York and in the course of the next couple of months would record what would be called *The Times They Are A-Changin'*. All the great songs of social criticism of the past year, including "Hollis Brown," "God On Our Side," "Only a Pawn," and "Hattie Carroll," made it extraordinary. The title song, he later said, "was definitely a song with a purpose . . . I wanted to write a big song, some kind of theme song, ya know, with short concise verses that piled up on each other in a hypnotic way." Perhaps because of that, it's a trifle self-conscious, with Dylan a little too aware of what he's doing.

Or maybe it's slightly overboard because it is a song of prophecy. Digging deep into the Bible, which had come to him most strongly, I suspect, through black gospel songs, he begins with Noah's floods, the wheel (of fate) in spin, a doorway, storms, and roads. He closes with a line half-quoted from the book of Mark 10:31, "But many [that are] first shall be last; and the last first." The song is so fundamental that it endures to this day, as relevant as ever it was in the so-called revolutionary '60s.

Stardom was going to take Dylan some getting used to, and since his main advisor, Albert Grossman, was strongly inclined toward paranoia and suspicion, it was unsurprising that Dylan had concluded that he needed protection. Dubbed the "Mindguard," his entourage included

Victor Maymudes, who had worked for Albert in Chicago and was qualified by virtue of being a match for Dylan in chess, pool, and Go. The other Mindguards were Albert Maher and Geno Foreman, whom Dylan had met in the Cambridge folkie scene. Geno actually had a rather ferocious-looking shillelagh, but it was his personality that was compelling. Baez wrote that he was the same age as all of them "but seemed to have lived several lifetimes. He was a hustler and a schemer and a dreamer, the original fuckup, but such a stylish one that he was impossible not to admire . . . He played the guitar and piano, both with natural brilliance. Geno ate yogurt, wheat germ, and vitamin C and was hooked on heroin."

Whatever needs the Mindguard served, subsequent events were going to generate even more negative expectations in Dylan's life and make them seem even more necessary. His big show of the fall was on October 26, 1963, at Carnegie Hall, which went quite well but was overwhelmed by other events. As it approached, *Newsweek* decided to run an article on Dylan. Unfortunately, one of Grossman's blind spots was the value of the press—and of a good publicist. Dylan got no intelligent advice on how to handle things and, after jacking the reporter around, finally met with her.

As it became clear that she'd researched his upbringing, Dylan grew enraged, and the interview descended into a serious argument. In consequence, what the magazine ran on November 4, "I Am My Words," was a merciless hit piece, outing all his tall tales about his childhood. When he denied having a relationship with his parents, she revealed that those same parents were sitting in a New York hotel, because Bob had flown them in for the Carnegie Hall concert. Worse still, the article repeated a flagrantly false rumor that suggested someone else had written "Blowin' In The Wind."

When you depend on secrecy, being embarrassed is more than just a little hard to take. Dylan was already beginning to feel the strain of success, and this blow hurt. It was soon followed by national tragedy.

John Kennedy's murder on November 22 exploded the notion of American singularity with a vengeance. Assassinations were for third-rate countries, banana republics, or little Asian places where democracy wasn't really understood; the idea that it could happen here was devastating. The death of Oswald and the enduring belief in a conspiracy all ate away at the faith in America that had once seemed so stable.

Dylan had been opening his shows that fall with "The Times They Are A-Changin'," and he had a show to do soon after Kennedy's death. He didn't want to use the song, thinking "they'll throw rocks at me," but instead the audience applauded. "And I couldn't understand why they were clapping or why I wrote that song, even. I couldn't understand anything. For me, it was just insane."

It was in that state of mind and in the shadow of the assassination that he went to the Emergency Civil Liberties Committee's Bill of Rights Dinner on December 13 to accept their Tom Paine Award. The previous year's recipient had been The Right Honourable The Earl Russell, O.M. (Order of Merit), F.R.S. (Fellow of the Royal Society), Bertrand Russell. Dylan looked out over the Princess Ballroom of the Americana Hotel at the black-tie-and-jewels crowd and could think only of the nonviolent warriors in overalls in Greenwood, of who belonged in a hotel ballroom with the penguins and how he most definitely did not.

He calmed his nerves with drinks and more drinks and got thoroughly plastered. When it came time to speak, he tried to tell the truth, that there was violence in everyone and humanity even in an assassin, and *why are you so satisfied? You think that by organizing like this you are above all this chaos, able to tell everyone how to think and feel? Not me, babe.* What became obvious that night was that causes and rational solutions made no further sense to him. "There's no black and white, left and right to me anymore, there's only up and down and down is very close to the ground. And I'm trying to go up without thinking of anything trivial such as politics."

So he took flight. He flew into an isolated, at times anti-intellectual existentialism, and along with it he embraced arrogance and elitism and a contempt that left him at times telling people, *You fools, you don't see the horror. Only I see the horror.* For years he would play mind games with the press and, abetted by the Mindguard, with the people around him. What he needed was compassion, both for himself and others, but that was a lesson he hadn't learned yet.

Six months later he talked about the "Tom Paine Award" audience to Nat Hentoff. "The only thing is, they're trying to put morals and great deeds on their chains, but basically they don't want to jeopardize their positions. They got their jobs to keep. There's nothing there for me . . . The only thing I'm sorry about is that I guess I hurt the collection at the dinner . . . Well, I offered to pay them whatever it was they figured they'd lost because of the way I talked. I told them I didn't care how much it was. I hate debts, especially moral debts. They're worse than money debts."

It would have spoken very well for him if he'd honored that offer, but when Clark Foreman, the Chairman of the Emergency Committee (and Geno's father), dunned Grossman, he was offered a benefit concert, which was set and then cancelled. Rescheduling it was shined on, and the debt was never paid.

Near the end of the year Dylan wrote an open letter to *Broadside* that included,

Away away be gone all you demons
An' just let me be me
Human me
Ruthless me
Wild me
Gentle me
All kinds of me

The Times They Are A-Changin' was released on January 13, 1964. It was fierce and angry and made him even more a spokesman for youth. His stance wasn't political but moral—"I was more a cow-puncher than a Pied Piper," he'd write later—but the title song so invited a generational interpretation that it was no surprise when it got one. "Hollis Brown" was more what he was up to, a folk ballad about rural poverty, Dreiser-like in its doom, truly and magnificently dark and awful. "North Country Blues" was another song in that general range. "God On Our Side," "Only a Pawn," and "Hattie Carroll," each a masterpiece, joined them.

"When the Ship Comes In" pointed to the future. Triggered by a snub from a hotel clerk, it's apocalyptic and biblical, sounding like a gospel song and full of Old Testament fury and Revelations. It was a critic's wet dream, with the ego making the journey and the ship as salvation. It made sense to sing at the March on Washington both in its gospel flavor and its social awareness, however mystical, but it also shows him going within.

A number of interesting songs didn't make it into the album, the best of which was "Seven Curses," which was based on Judy Collins's "Anathea" and the Child Ballad #95, "The Maid Freed from the Gallows." It was another social justice song, this time about a young woman who sacrificed her virtue to an evil judge to save her father from hanging . . . and was twice burned. "Percy's Song" also treats a cruel judge and is also based on a traditional ballad, "The Two Sisters" (Child #10).

The album ends most unconventionally, with Dylan doing a not-terrific job of singing his rewrite of an Irish drinking song, "Restless Farewell." Based on "The Parting Glass" and originally called "Bob Dylan's Restless Epitaph," it strikes a slightly self-pitying tone as he apologizes to all the women he might have hurt—Suze leaps to mind—and ends with a verse that some interpret as a response to the *Newsweek* fiasco, "the dust of rumors," which is the reverse of an

apology, but a promise to "remain as I am / And bid farewell and not give a damn."

It's in his liner notes, "11 Outlined Epitaphs," that Dylan makes quite clear what's on his mind. At the beginning he asks, "who t'picket? / who t'fight?" At the heart of it, he poses the question that John Lewis had asked the nation at the March on Washington, asking his friend Jim Forman, "Jim, Jim / where is our party / where is the party that's one / where all members're held equal / an'vow t'infiltrate that thought / among the people it hopes t'serve . . ."

He was confronting something that had begun in Greenwood that July. Quite simply, he had lost faith in anything resembling collective action. As his fame grew that year and he became appointed a representative rather than a singer, he was even more appalled. As Baez said, "The Left opened a door to him, but he just saw more little boxes behind the door, factions that wanted something else from him. It all came out as 'Our Spokesman.'"

Three years later, Dylan would tell Nat Hentoff that it was "Not pointless to dedicate yourself to peace and racial equality, but rather, it's pointless to dedicate yourself to the *cause*; that's *really* pointless. That's very unknowing. To say 'cause of peace' is just like saying 'hunk of butter.' I mean, how can you listen to anybody who wants you to believe he's dedicated to the hunk and not to the butter."

However mystifying the last remark is, it's exactly what Dylan was thinking—and feeling. At least one member of the movement understood him perfectly. "When he simply drifted away from the movement, it was the whites in SNCC who were resentful," said Bernice Johnson Reagon. "The blacks in SNCC didn't think that, or say that. We only heard the phrase 'sellout' from the whites, not the blacks. I've always just regarded Bob as a friend. He's never been a star to me, just a friend."

Late in 1963 Bob met Allen Ginsberg, and the encounter would push him artistically. Ginsberg was working on the poems that would be published as *Planet News*, and he had things to teach. One of

them was about breath—Allen encouraged Bob to loosen his, to let his poetic lines stretch as the material warranted. The other was to encourage a higher poetics, what Ginsberg called "magic politics," "a kind of poetry and theater sublime enough to change the national will and open up consciousness in the populace."

That required changes in the shape of the art, as well as a content that led to liberation. Just at this time Susan Sontag would chastise Edward Albee and Tennessee Williams in *Partisan Review* for the way they handled sex, feeling that they used it only to shock rather than address it on a deeper level. She concluded, "The only real shocks in art are those that pertain to form." I think it unlikely that Bob read *Partisan Review*, but this was precisely what he was going to do.

In the aftermath of John Kennedy's assassination, he'd written lines in free verse about cathedral bells:

strikin for the gentle
strikin for the kind
strikin for the crippled ones
an strikin for the blind.

He'd soon use these in a different context, but they document his growth as a writer at this time, as he embraced ever more deeply the Beat literary tradition that he'd inherited as a reader and now catalyzed in his deepening friendship with Ginsberg. He was also heading into an artistic territory then tilled by the black-humor novelists—Nabokov (*Lolita*), Heller (*Catch-22*), Pynchon (*V*), and Kurt Vonnegut (*Mother Night*). The novels combine insanity, the irrational, and the arbitrary with a sense of dread and fatality. History is absurd, but also deathly. Instead of the academic values of "irony, ambiguity, and paradox," what critic Morris Dickstein termed the "Holy Trinity of the well-made poem," we have fantasy and vision. Ironically, Dylan would also

embrace that trinity, although his irony was more hand grenade than the soupçon of wit that college poets would use. His road was going to get very dark indeed.

Early in 1964 Dylan took off on a car trip, sitting in the backseat with a typewriter working on a couple of songs that would be very much part of the Beat absurdist/surrealist direction, and chanting as he typed, "The birds are chained to the sky. No one's free." He had shows to do on the West Coast and decided to travel slowly and do a bit of poking around on the way. He was accompanied by three companions—his road manager Victor Maymudes, his friend Paul Clayton, and Pete Karman, a friendly journalist.

They stopped to visit Carl Sandburg at his home in North Carolina, a nonevent; Sandburg was cordial but obviously had no clue who Dylan was and after a few minutes excused himself to go back to work. After a concert at Emory on February 8, Bob spent a day hanging out with Bernice and Cordell Reagon before stopping in Meridian, Mississippi, the birthplace of Jimmie Rodgers, and then set off for New Orleans.

Drugs and the radio were the central artifacts of their journey. Pot, pills, and liquor made it a very drugged trip, and being stoned was of the essence. What they heard on the car radio was musical history in the making. The #1 song in America was the Beatles' "I Want to Hold Your Hand." "She Loves You" would be #1 the next month, and "Please Please Me" and "I Saw Her Standing There" were newly released and on their way. In April, the top five songs on the *Billboard* charts were all Beatles tunes. They had arrived in New York on February 7 and played *The Ed Sullivan Show* on February 9, and America was recovering from the devastation of John Kennedy's death with a happy, African American–derived music craze, Beatlemania. To Dylan, "Their chords were outrageous, just outrageous, and their harmonies made it all valid . . . I knew they were pointing the direction of where the music had to go."

Dylan was listening to the car radio, but mostly he was working on a song, a brilliant, extravagant exercise in wordplay that would be

called "Chimes Of Freedom." Partaking of Rimbaud's derangement of the senses, the song submits human affairs to the apocalyptic power of nature in a giant storm. Combining sight and sound in a perfect display of synesthesia, the lightning bolts create the sound of chimes. It's a storm of freedom, and it illuminates a wide range of possible consequences, both joyful and terrifying.

Perhaps reflecting Ginsberg's influence—or Whitman's—it catalogs those with whom Dylan sympathizes—his friends in SNCC, whose "strength is not to fight," for refugees and underdog soldiers, "the luckless, the abandoned an' forsaked," for outcasts, the gentle, "the mistreated, mateless mother," and "for every hung-up person in the whole wide universe." It is the very essence of compassion.

They reached New Orleans at Mardi Gras time, and Dylan created another song jewel from the experience. Mad Mardi Gras visions, a pinch of Fellini's *La Strada*, the phrase *jingle jangle* from Lord Buckley, and perhaps his friend Bruce Langhorne's big Turkish tambourine all went into the song "Mr. Tambourine Man."

Many assumed it was about drugs, since it uses a phrase—"take me on a trip"—that actually came to have a drug reference somewhat later. But thinking it's about drugs is more than a little reductionist. (In fact, Dylan would first take LSD some months later in Woodstock with Maymudes and producer Paul Rothchild.) "Mr. Tambourine Man" is about transcendence, about escaping the wheel of suffering, about waking up and being free. Who is the tambourine man? First, he's the source of the rhythm, but he's the source of the music itself, of inspiration, of salvation. He's the muse (has there ever been a male muse?). It's a prayer of sorts, an invocation to the muse to cast his spell, which the singer vows to submit to. As Christopher Ricks points out, the irony is that Dylan talks of being weary, but the song itself pulses with energy, for it is about sound itself, and how to hear the muse.

They made it to Berkeley, where he'd debut "Chimes of Freedom" and sing "God On Our Side" and "Blowin' In The Wind" with Joan

Baez. Lawrence Ferlinghetti, the publisher of City Lights Books and of *Howl*, was a special guest at the show, since Bob was considering publishing something with him. It wouldn't work out, as Dylan made clear in a letter a few months later: "I do got things of songs an stories for you, my hangup is tho that I know there will be more. I want t send the more more then I want t send the got. yes I guess that's it." The show itself was brilliant, reported the eminent Bay Area critic Ralph Gleason, who hadn't appreciated Dylan's performance the previous year at Monterey but certainly understood now.

Back in New York, Bob had a final series of scenes with Suze, including an enormous fight with Carla, who was trying to stick up for her sister. "We talked a lot," wrote Suze, "but told little . . . All those people, the constant crowding—I had the sensation of being in a herd of cattle and being prodded to move, move along with the hustling herd . . . Quite a herd goes with fame." One night on East Seventh Street she told him that she had to go, that her life was at stake: "With a resigned sadness, he gestured toward me with his hand. It wasn't an offer to take it. I saw it as an acceptance of the inevitable, and I echoed the gesture."

IN MAY 1964 Dylan went to England for his first tour there and experienced his own brand of Beatlemania, with screaming crowds at the stage door that both frightened him and perhaps also really turned him on. Grossman and Bob's friend Anthea Joseph of the Troubadour had to drag him back inside when Bob went out to the car and disappeared "under this wave of humanity who were sort of grabbing at his clothes and his hair," she recalled. "That happened to pop stars . . . but not singer-songwriters."

He was on top of the entertainment world. As he got to England, one of the hit songs was an electric version of his "House of the Rising Sun" done by a new group called the Animals. His London show at Royal Festival Hall was a triumph. At intermission, he received a telegram from John Lennon expressing regrets that they couldn't be there

because they were filming a movie, which would be called *A Hard Day's Night*.

Bob also saw an old friend in London, and it became clear how much success was twisting his life. John Bucklen had gotten out of Hibbing and was now in the air force, and it was a pleasure to see him. But when Bob decided to take a woman up to his room at the Mayfair and John said let's forget about it, Bob turned on him. Dylan would apologize for his behavior the next time he saw John, which would be twenty-five years later, the incident still vivid in his mind.

After England he took time off in Paris and then Greece. It was definitely a working vacation, because while in Greece he wrote or at least finished much of the material that would be on the next album, including "All I Really Want To Do," "Spanish Harlem Incident," "To Ramona," "I Shall Be Free No. 10," "Ballad In Plain D," "It Ain't Me, Babe," "Mama, You Been On My Mind," "Denise," and "Black Crow Blues," working on Mayfair Hotel notepaper. Songs were spilling out of his head in an extraordinary profusion, and they were going in a number of directions. The obvious point was that they weren't overtly political.

On June 9, 1964, he went into the studio to record the album and told Nat Hentoff, there for a *New Yorker* profile, "There aren't any finger-pointin' songs in here. Those records I've made, I'll stand behind them, but some of them was jumping into the scene to be heard and a lot of it was because I didn't see anybody else doing that kind of thing . . . I don't want to write for people anymore. You know—be a spokesman . . . From now on, I want to write from inside me, and to do that I'm going to have to get back to writing like I used to when I was ten—having everything come out naturally."

With an audience that included Hentoff, Ramblin' Jack Elliot, and *New York Post* writer Al Aronowitz, Dylan started recording at 7:30 p.m. and by 1:30 a.m. was done. It was a fabulous night's work, even if "Chimes of Freedom" took seven takes.

Love is indeed the primary subject, but there's lots more going on as well. "Spanish Harlem Incident" is a love song to a "Gypsy," but the implications of asking the hot-blooded gypsy to "come an' make my / Pale face fit into place, ah please! . . . So I can tell if I'm really real" are strongly primitivist and not something he'd usually write.

Among love songs ranging from the modest ("All I Want To Do") to the seemingly humble ("It Ain't Me Babe"—though in the end, he says the lady asks too much; it's her fault), to the mean-spirited ("Ballad In Plain D," an attack on Carla and Mary Rotolo), to the anguished ("I Don't Believe You"), he throws in a piano boogie ("Black Crow Blues") and a piece of surreal whimsy ("Motorpsycho Nightmare"). Two songs seemingly speak to his loss of faith in the movement.

A mix of Wordsworth and Blake, a seeking after poems of innocence, "My Back Pages" is his overt apologia for leaving the movement, with everything explained with his classic paradoxical throwaway, "I was so much older then, I'm younger than that now." But he gets to the heart of the matter when he acknowledges "Fearing not that I'd become my enemy / In the instant that I preach / My existence led by confusion boats / Mutiny from stern to bow . . ." When you start believing you have the right to tell people how to think, you'd better be damn careful.

Psychobiography through song lyrics is a risky business, but perceiving "To Ramona" as at least partly a song for Bernice Johnson Reagon and the movement seems not entirely unreasonable. When Dylan sings to Ramona that she has "Nothing to win and nothing to lose," that "Everything passes, / Everything changes, / Just do what you think you should do," it probably resembled something he was telling himself. He'd once believed, but not anymore. Any investment in society seemed pointless to him, and life was made up only of individuals.

He told his biographer Anthony Scaduto, "I stopped thinking in terms of society. I'm not really part of any society, like their society. You see, nobody in power has to worry about anybody from the outside . . . not gonna make a dent . . . so why be a part of it by even

trying to criticize it? That's a waste of time." The real message in the song is in the tune, which is a gentle and lovely waltz. That, I would argue, genuinely expresses his feelings for Bernice and his other movement friends. And "Chimes of Freedom," while not overtly political, is absolutely consonant with the spirit of the movement.

There's one particularly odd thing about this album. Years later Dylan would say that he "begged and pleaded" with his producer, Tom Wilson, not to use the title *Another Side of Bob Dylan*, that it played into the hands of critics who called Dylan's dropping of movement songs a sellout, that it "seemed a negation of the past which in no way was true." The idea that the guy who walked off *The Ed Sullivan Show* rather than be forced to compromise would then accept a title he didn't want doesn't jibe. Why Dylan would duck responsibility even twenty years later is a bit perplexing.

Twelve days after he recorded the album, on June 21, Freedom Summer activists James Chaney, Andrew Goodman, and Michael Schwerner were arrested by police in Philadelphia, Mississippi, released, and then disappeared. When he recruited Northern whites for the summer's project, Robert Moses had told them, "Don't come to Mississippi this summer to save the Negro. Only come if you understand, really understand, that his freedom and yours are one." Chaney was from Meridian, and he understood. Goodman and Schwerner were from New York, and they understood too. In the course of the summer, there were a total of six movement deaths, one thousand arrests, thirty buildings bombed, and thirty-five black churches burned in Mississippi. Sixteen hundred black people were registered. Sixteen thousand were turned away. The Northern press covered it all, often in as much danger as the activists, especially the TV camera crews, whose equipment made them so obvious.

On July 2, Congress passed a civil rights bill banning Jim Crow in all public places and that night President Lyndon Johnson signed it. The Freedom Summer workers in their overalls and white T-shirts

(a uniform to link them with local people) were listening to Curtis Mayfield and the Impressions and their new song, "Keep on Pushing." They had to, because they were about to be betrayed.

At summer's end, the Democratic Party held its convention and chose to seat the regulars, the people who supported Stennis and Eastland, rather than the integrated alternative, the Mississippi Freedom Democratic Party. "That was the turning point for the country, for the civil rights movement and certainly for SNCC," wrote John Lewis. "People began turning on each other. The movement started turning on itself."

In addition to turning on itself, the movement also began to spread out—to California, for example. Freedom Summer veterans set up tables soliciting funds for the movement in the "free speech" strip of Sproul Plaza on the edge of the University of California at Berkeley campus. The existing rules actually limited such activity to school Democratic and Republican clubs, and on September 14 a dean announced that the rules would be enforced. On October 1, police arrested a former graduate student named Jack Weinberg, who was sitting at the CORE table and refused to show ID. Once Weinberg was put in the police car, as many as three thousand students surrounded it, and it did not move for the next thirty-two hours; instead, it became a speaker's podium for one of the most remarkable and educational public discussions the campus had ever seen. Eventually, charges against Weinberg were dropped.

The right to free speech was only the most obvious issue at hand; at root, the Free Speech Movement was a protest against a mega-university that treated education as a product and students as consumers. Their resistance was part of seeking to be authentic, just like the activists who'd gone to Mississippi. Further negotiations having failed, in December several thousand students would occupy Sproul Hall, the administration building, and graduate student and Mississippi Freedom Summer volunteer Mario Savio would echo Thoreau: "There's a time

when the operation of the machine becomes so odious—makes you so sick at heart—that you can't take part. You can't even passively take part. And you've got to put your bodies upon the gears . . . And you've got to indicate to the people who run it, to the people who own it, that unless you're free, the machine will be prevented from working at all." Eight hundred students were arrested that night, but in the end, they won their free speech rights. The spirit of activism continued to spread.

At SNCC, donations dried up, with Northern liberals no longer comfortable with the harder-edged anger that had erupted after the summer's treachery. The other black organizations offered no support. All this took place in the shadow of August 4, when the bodies of Chaney, Goodman, and Schwerner had been found. On December 4 the FBI would arrest twenty-one persons, including Neshoba County Sheriff Lawrence Rainey and his chief deputy Cecil Price, for interfering with the trio's civil rights; three years later seven of them, not including Rainey, would be convicted. On December 10, 1964, Reverend Martin Luther King Jr. accepted the Nobel Peace Prize in the name of the movement, specifically citing the children of Birmingham and the young people of Philadelphia, Mississippi, among others.

THAT SUMMER, DYLAN was omnipresent in the 1964 Newport Folk Festival (July 23 to 26), taking part in a song workshop on Friday afternoon and helping Baez close her set Friday night before closing the festival on Sunday night. The epic sets of 1964 were performed by Muddy Waters and Johnny Cash, who'd earlier defended Bob in a letter to *Broadside*—"SHUT UP! . . . AND LET HIM SING!"—and who followed his own Friday performance, which included the song "Don't Think Twice," by spending the night playing music with Bob and Baez in her room.

Another Side would be released on August 8, to desultory sales. Dylan defended it to Ralph Gleason in a letter—"The songs are insanely honest, not meanin t twist any heads an written only for the

reason that I myself me alone wanted and needed t write them. I've conceded the fact there is no understanding of anything. at best, just winks of the eye and that is all i'm looking for now i guess."

After his debate with Paul Nelson the previous year, when Dylan had argued that social activism trumped folk songs, he had played a new tune of his, "Eternal Circle." It was an odd footnote to the debate, because the highly self-conscious song is about a singer who sees a pretty woman in the audience but can't talk to her until he's finished his song, by which time she's gone. The eternal circle is that there will always be another song, because that's the singer's job, it's what he's here to do.

That would be the right attitude to take, because in the fall he would be twice attacked in *Broadside*, first by Ewan MacColl, who dismissed his songs as "tenth-rate drivel." Editor Irwin Silber followed up with an Open Letter that said "the paraphernalia of fame" was "getting in your way." Bob stayed on the job and on Halloween played New York's Philharmonic (later Avery Fisher) Hall. It was a truly brilliant performance, opening with "Times Changing" and working his way through "John Birch," "Hard Rain," "Hattie Carroll," "God On Our Side," and "Tambourine Man" among others. There were two new songs that night that he'd written that summer, and they were special, utterly unlike anything anyone had ever written before in America.

It was utterly appropriate that Allen Ginsberg was in the audience that evening, because this new material partook at least as much of the Beat literary tradition as it resembled anything one would call folk material. In fact, it was high poetry.

"Gates Of Eden" descends into the grotesque and the absurd, fights its way through paradox and enigma, and declares human freedom as the ultimate value. It's the same issue he'd been writing about all along, but in a surreal and dreamlike context. It's a generalized protest against everything false. (What are you rebelling against? Marlon Brando in *The Wild One*: "Whaddya got?")

Mostly, "Gates" is about what's outside Eden, a dystopian world where the truth only twists, clouds have four legs, candles glow black, lampposts stand with folded arms, and ships have tattooed sails. It's a corrupt world of consumerism, where "Relationships of ownership" control and paupers covet the possessions of other paupers—Henry David Thoreau would understand this perfectly—and it is inhabited by a cowboy angel, a motorcycle black Madonna, a gray flannel dwarf, and monks who make false promises. By contrast, inside the Gates, the singer's lover comes and shares her dreams, not stopping to analyze meaning but only to share truth and bridge the gap between people.

Later, the critic Tim Riley would remark that Dylan's goal was not to be understood, but to be felt. The language of "Gates" is frequently puzzling, and meant to be; the feelings it induces are all the more genuine for the fact that they will vary from listener to listener.

"Its Alright Ma (I'm Only Bleeding)" is an existential masterpiece celebrating the pursuit of authenticity. Driven by a pulsating guitar riff, the song outlines a dark shadow world where sun and moon are eclipsed and trying is dismissed as pointless, yet the entire point is that "he not busy being born / is busy dying" (which of course includes Dylan himself). The powerful make the weak crawl, preachers and teachers promote falseness, and the result is $100 plate dinners. Society sells toy guns and flesh-colored Christs with advertising signs that trick you into thinking that you'll be okay if you just buy . . . something, anything. As the scholar Sean Wilentz pointed out, this is precisely a description of the Moloch in Ginsberg's "Howl." The tradition was clear.

People obey authority that they do not respect, loathe their lives, turn art, the very flowers they cultivate, into just another investment, and are so twisted that when they see someone striving to rise, they most often would rather just pull them down into their hole. At the root, money doesn't talk—it's obscene, and what's supposed to be obscene is a joke (how can naked flesh be obscene?).

And Dylan knows only that he and everyone listening have to resist, kick off the bonds, push back and say, what else ya got? And so what? Death will come, but for now, it's life "and life only."

Home Again to Rock 'n' Roll

A WASH IN SONGS just six months after his previous album, Dylan returned to the studio on January 13, 1965. Though the sessions would appear revolutionary after the fact, it's clear in hindsight that at least initially he was largely feeling his way. In the first session, he recorded acoustic versions of "Subterranean Homesick Blues," "If You Gotta Go, Go Now," "On The Road Again," "Bob Dylan's 115th Dream," "California (a.k.a. Outlaw Blues)." "I'll Keep It With Mine," "Farewell, Angelina," and a fantastic "Love Minus Zero, No Limit."

The next day they brought in a backup band, with Bobby Gregg on drums, William Lee on bass, and Paul Griffin on piano, and recorded an even better "Love Minus Zero," "Subterranean," "Outlaw," "She Belongs to Me," and "115th Dream." After dinner, Dylan went back to work, now with John Hammond Jr. and John Sebastian on guitar and bass, recording six songs, none of which were ever used.

On top of this experimentation, he recorded "Gates Of Eden" and "It's Alright Ma (I'm Only Bleeding)" solo in single takes. They even got "Maggie's Farm" and "It's All Over Now, Baby Blue" down in single takes, which is remarkable considering that there were no rehearsals. According to Kenny Rankin, a guitarist who passed through the sessions, there wasn't even a count off—Dylan would start strumming

and everyone else would jump in. Somehow, it worked—the album was recorded in three days.

Bringing It All Back Home—a reference, one assumes, to his return to his rock 'n' roll roots—was a perfect transition from folk to rock, with a blend of raucous band tunes and dazzling solo acoustic material. It was America's first great response to the British (musical) invasion. Released on March 22, it was instantly popular and his first million seller, with a bigger reaction than anything he'd done other than "Blowin' In The Wind."

Bringing It All Back Home is a distillation, a fruition, of the three streams of this study: the white reaction to African American music that is rock 'n' roll, the correlational pursuit of freedom that almost all the songs touch on, and the fabulous verbal application of that freedom that the Beat literary revolution (itself to a considerable extent a response to African American culture) had engendered.

The album opens with a clamorous "Subterranean Homesick Blues," the sound of anarchy put on vinyl, guitars jangling, drums whacking, and harp soaring, with Dylan's sardonic voice reciting lyrics that give the American dream a hotfoot. It's a Marxist (both Karl and Groucho) analysis of alienation, actually. Society says behave, and Bob's not buying. It's a musical declaration of independence with the flavor of Chuck Berry's "Too Much Monkey Business," skip rope rhymes, and a pattern derived from Woody and Pete's "Taking It Easy."

Paradox and contrariness were the essential elements of everything Dylan was doing in general and as they related to women in particular, and "She Belongs To Me" is no exception. It's exquisitely beautiful, with a lead by Bruce Langhorne stitching itself around Dylan's strums and vocals. At the same time, as the critic Paul Williams points out, the lyrics paint the subject as a man-eater. At least some of the time "She" is the muse, and Dylan's relationship with her is ambivalent. He resents her wholeness and her beauty and how she never stumbles; he's

unworthy and loathes himself for his dependence and craving, down on his knees peeking through a keyhole at her. That's the muse for you.

He returns to social analysis with "Maggie's Farm," the band rocking and bouncing as he declares his freedom from meaningless, wasted labor. It's Thoreau in different dress, but just as witty and funny. As Robert Shelton wrote, "the laughter is satanic."

And back to love. "Love Minus Zero, No Limit," the "no limit" as in poker, because love's a game. It is a very nearly perfect distillation of balance and paradox that is as close to the quiet of Zen as Dylan ever came. Perhaps that's because the previous year, he had fallen in love with a most exceptional woman, Sara Lownds.

By now, things have loosened up enough that "Bob Dylan's 115th Dream" begins with Dylan completely cracking up into a wonderful laugh. He gets off a screaming chortle that is swallowed up by a rocking riff and then Bob's singing about riding on a *Mayflower* captained by Captain Arab ("Ahab the Arab" was a 1962 hit song) that arrives in America, where Arab starts writing deeds and buying land with beads. It's a perfect rendering of a dream. Dylan flips a coin to decide on returning to the ship or going to the jail where Arab and the crew are incarcerated; it comes up tails, which of course rhymes with *sails*, and back to the dock he goes. As he's leaving, he sees three ships led by Columbus coming in . . . and wishes them good luck. Dada in 6'33" of vinyl.

Side two begins with "Mr. Tambourine Man," succeeded by "Gates Of Eden" and "It's Alright Ma (I'm Only Bleeding)." It ends, naturally enough, with a good-bye—to something, to whatever you want: "It's All Over Now, Baby Blue." He had carried the song in his mind for a long time before writing it, and as he wrote he recalled a Gene Vincent song he'd sung in high school, "Baby Blue." It's a farewell and an invitation to begin again, a song so filled with gerunds that it's all activity, the need to be moving on. He was most definitely moving.

Among the significant things about *Bringing It All Back Home* is its cover. Though *Freewheelin*'s cover had been iconic, it was a simple

photograph. This cover was planned, stylized, and detailed, announcing sophistication and sexiness and anything but proletarian folk simplicity. Shot in Albert Grossman's living room with a fish-eye lens for the proper surrealistic feel, the cover centers on an elegantly dressed Dylan—he's wearing the fine cufflinks given him by Joan Baez—staring into the camera with Sally Grossman impossibly soigné in red on a chaise lounge behind him. Sally's kitten peers out from between his hands. Images sufficient to make a semiotics professor drool are scattered around—a fallout shelter sign, a harmonica, a copy of *Time* with LBJ on the cover, albums by Robert Johnson, Ravi Shankar, the Impressions, Lord Buckley, Lotte Lenya, and even his own *Another Side*. A magazine with an advertisement for *Jean Harlow's Life Story* by Louella Parsons rests on Dylan's knee. A glass collage Dylan had made for his Woodstock friend Bernard Paturel called "The Clown" sits on the mantel behind them.

The liner notes reference Sleepy John Estes, Jayne Mansfield, Humphrey Bogart, and Mortimer Snerd in the first sentence, which is pretty much all you need to know ("i accept chaos. I am not sure whether it accepts me"), except for a prescient reference to Vietnam; twenty days before the album was released, the United States began Operation Rolling Thunder, the sustained aerial bombardment of North Vietnam that would deliver more bombs than in all of World War II.

Dylan had action even when he wasn't present. Five days after he finished recording the album, the Byrds—actually, Roger McGuinn, David Crosby, and Gene Clark on vocals backed by "The Wrecking Crew" of studio musicians led by Hal Blaine—recorded "Mr. Tambourine Man." Released in April, it would be #1 by June. When he heard it, Dylan was delighted, telling McGuinn, "Wow man, you can dance to that."

IN THE WEEKS just before *Bringing It All Back Home* was released, America's attention turned south once again. Martin Luther King Jr.

had asked LBJ for a voting rights bill the previous fall, and the president had said it was too soon to go back to Congress. At the end of the meeting, he said, "Now, Dr. King, you go out there and make it possible for me to do the right thing." Soon after, King told friends, "We'll write [a voting rights bill] for them. And we'll do it in Selma."

Selma, Alabama, was the epitome of the small-town South. Run by a refugee from a Faulkner novel named Judge James Hare, with Sheriff Jim Clark as overseer to Hare's plantation owner, the town was locked into a war with the idea of black people voting. After a young man named Jimmie Lee Jackson was killed during one of the demonstrations, Reverend James Bevel, one of the original Nashville activists, went to Jimmie's family, the poorest of the poor. Bevel asked Jackson's grandfather if they should continue. Certainly. Then Bevel asked him if he'd be willing to march. "Oh yes, Reverend Bevel, I'll walk with you." Later that night Bevel suggested to King that they walk from Selma to the capital, Montgomery.

On Sunday, March 7, six hundred local people set out to walk. Most were old. The movement had set them free of their fears, and they weren't going to wait any longer. To get from Selma to Montgomery, you take Highway 8 south out of downtown Selma across the Alabama River on the Edmund Pettus Bridge. Led by John Lewis of SNCC and Hosea Williams of the SCLC, they got to the bridge and were stopped by state police and Jim Clark's deputized posse, which was basically any white male in Selma who could find a club. Clark ordered them to disperse. They knelt to pray and the troopers and posse charged, nightsticks flailing, tear gas exploding. A crowd of white onlookers cheered enthusiastically and then turned on the media as the troopers and posse pursued the marchers the mile back to their starting point.

There were fifteen solid minutes of footage of the beatings on ABC-TV that night. "This was a face-off in the most vivid terms," wrote John Lewis, "between a dignified, composed, completely

nonviolent multitude of silent protesters and the truly malevolent force
of a heavily armed, hateful battalion of troopers. The sight of them
rolling over us like human tanks was something that had never been
seen before."

Demonstrations across the country protested the brutality. Sixty
members of Congress sent a telegram to Johnson asking for an imme-
diate voting rights bill. On March 9, Martin Luther King led clergy-
men from all over the country to the bridge but then turned back in
deference to a restraining order. That night a Unitarian minister from
Boston, James Reeb, was beaten to death in front of a segregationist
hangout in Selma, the Silver Moon Café.

On March 11, a Southern-born president went on nationwide
television and said, "I speak tonight for the dignity of man and the
destiny of democracy," and announced a voting rights bill. "Because
it is not just Negroes, but really it is all of us who must overcome the
crippling legacy of bigotry and injustice. And we *shall* overcome."
The marchers left Selma on March 21, taking five days to get to
Montgomery, and by their arrival in the capital they were twenty-five
thousand strong—along with two thousand regular U.S. Army troops,
nineteen hundred federalized Alabama National Guardsmen, and lots
of FBI and Federal Marshals.

Five months later, on August 6, the Voting Rights Act was signed. It
worked; by 1969, 66 percent of the eligible black voters of Mississippi
were registered, with comparable numbers across the South. Five days
after the act was signed, on August 11, the black ghetto of Los Angeles,
Watts, went up in riotous flames. Johnson felt betrayed. His focus had
already turned to Vietnam; the previous month he'd announced he was
sending one hundred thousand troops there. By the next year, Stokely
Carmichael would replace John Lewis in a coup at SNCC, and later
in the year whites would be expelled from the organization. Burnout
and black separatism—and in a weird way, success—had ended the
momentum of the civil rights movement.

DYLAN SPENT LATE February to March 24 on tour with Joan Baez at East Coast colleges. Later he would tell Robert Shelton, "I rode on Joan, man. You know? I'm not proud of it." It would get even more twisted. Late in April, Dylan, along with Mindguard Bob Neuwirth and Uber Mindguard Albert Grossman and guest Joan Baez, set off to tour England. To that point, the recent musical flow had all been England to America, but the tide was turning. In March, the seven thousand tickets for the May 10 Royal Albert Hall show sold out in two hours on the strength of headlines like the January 9 *Melody Maker*: "BEATLES SAY—DYLAN SHOWS THE WAY."

Grossman had suggested filming the tour. D. A. Pennebaker had a well-earned reputation as a pioneer in cinema verité—one of his important early documentary projects had covered the efforts to desegregate the University of Alabama, when George Wallace literally as well as symbolically blocked the schoolhouse door—and agreed to meet with Dylan and Neuwirth. By now, Dylan and Neuwirth were a tag team comic act that used wit to mask serious abuse and hostility. Neuwirth scared Bob's college friend Bonnie Beecher so much that she'd hide behind Dylan if Neuwirth was there. One of the other courtiers, *New York Post* reporter Al Aronowitz, was candid about what it was like to be around Dylan: "To be the constant target of digs from Bob was the price each of us paid for hanging out with him. He was, after all, some kind of messiah to each of us and so each one of us in his inner circle willingly paid the price. Bob liked to feel big by making his hangers-on feel small."

Dylan and Neuwirth ran Pennebaker through their mill and he passed. He felt that they had "the same sense about what they were up to as we did about what we were up to, which was a kind of conspiracy. We felt as if we were out conning the world in some kind of guerilla action and bringing back stuff that nobody recognized as valuable and making it valuable." Cameras in hand, Pennebaker and his assistant Howard Alk, with Howard's wife, Jones, on sound, would trail Dylan from their late-April departure until June.

What they witnessed and documented was complex. There was brilliant music on stage, there were extravagant and not infrequently ugly displays of temperament offstage, especially in relation to various women, and there was the looming and magisterial presence of Grossman. Surrounding it all was a media firestorm.

"The Times They Are A-Changin'," his first English single, entered their charts at the beginning of April. Two weeks later, *Freewheelin'* hit #1 on the British charts, where it had been in residence for the past year. As he arrived, "Times Changing" entered the Top 10, as did *Another Side*. The tabloids couldn't miss it. Dylan had been winging it for years with constant changes manifested by a stunning sensitivity, and now he was going to do it in front of cameras and surrounded by the truly remarkable phenomenon of an all-out British tabloid press scrum. Sanity in such an atmosphere is impossible.

Their arrival at Heathrow was Beatles-esque, with a crush of fans and the press barking like hounds. On his way from the plane to a press gathering, Dylan found a large light bulb in a trash bin and carried it along. When asked what his message was, he responded, "Keep a good head and always carry a light bulb." A woman reporter asked if he cared about people, and the Dylan sparring match went into action. "We all have different definitions of all those words—like caring, and people . . ." Laurie Henshaw of *Disc and Music Echo* asked why he was hostile. "Because you're hostile to me. You're using me. I'm an object to you. I went through this before . . ." Oddly enough, she loved his response, and published it as "MR. SEND UP."

In Pennebaker's view, "He conducted the session in such a way that the reporters could actually hear how stupid their questions sounded as they asked them and it stripped them of their composure. No one had ever done that to them before, and the atmosphere in that room was incredible. Everyone left feeling like they'd been completely off-balance."

With a song list that included most of his best work, from "Times" to "Eden" to "It's Alright Ma" to "Love Minus Zero," "Tambourine

Man," and "Hattie Carroll," his shows were spectacular, and the English responded with reverent silence. People were simply stunned— at least until after the show, when the exercise of getting out of the theater and into the car included girls hurling themselves at vehicles.

Back at the Savoy, London's first and still preeminent luxury hotel, a circus was in full swing, and Pennebaker's camera caught it all. Joan Baez singing "Percy's Song," Dylan at the typewriter, leg twitching, with Grossman in the corner reading a letter. In another corner, Marianne Faithfull sat silent. "We all sat on the floor of Bob's room talking, drinking, and playing guitars," Faithfull said later, "while Bob pretended none of this was happening. He would walk in and out of the room, sit down and type, talk on the phone, he would even answer incredibly stupid questions, but only if he felt like pulling that particular thing into focus. Otherwise we might as well have been invisible . . . They were all so hip, so devastatingly hip. They were all so fucking high. Every five minutes or so someone would go into the bathroom and come out speaking in tongues."

Dylan's biographer Clinton Heylin theorized that Dylan and Neuwirth were snorting methamphetamine, which seems likely. Certainly he was maintaining the killing pace of his past several years with the aid of some sort of stimulant, and drug abuse–induced exhaustion explained some of his temper. The cameras captured the extraordinary scene of Dylan attempting to seduce Faithfull, who was not particularly interested. His response was to grab up some of his typed material and begin shredding it, shrieking at her, "Satisfied?" before storming out only to return and eject her from the suite.

Shortly after, he took up with an extremely voluptuous sixteen-year-old English flavor-of-the-moment pop singer named Dana Gillespie. And then there was Baez, who kept hanging on, waiting to be asked to join him onstage, an invitation that never came. "It was not love that made me such a nuisance," she later wrote. "It was desperation. For the first time in my short but monumentally successful

career someone had stolen all my thunder from under my nose." She sought comfort from Neuwirth, who told her that Dylan didn't "know what's happening anymore, can't you see? He's just out there spinnin' and he wants to do it by himself."

Baez was also about to confront another secret in Bob's life. In the middle of the tour he took a break in Portugal, where his future wife Sara joined him. Returning to London, he was sick in bed at the hotel from a bout of food poisoning and Joan came to visit. Sara answered the door, and Baez began to figure things out. It could have been even more complicated; shortly before the tour, Grossman had called Suze Rotolo and told her he could arrange to have her go on the tour. Wisely, she declined the invitation.

The Beatles stopped by. The Stones came to visit. Allen Ginsberg, who'd just been crowned King of the May in Czechoslovakia before being deported, showed up with various friends. Grossman threw cocktail parties and sparred obnoxiously with hotel clerks over noise complaints. Derroll Adams, an old playing partner of Rambling Jack Elliott's, brought a hipster delegation, and a drunk member of the group threw a glass into the street, which led to Dylan screaming at him and the drunk replying, "I'm a small cat . . . I'm nothing."

It was his conversation with *Time* magazine's Judson Manning that left the lasting impression. Compared to his abysmal treatment of one student reporter, Dylan was actually rather direct with Manning, critiquing *Time* and its policy of separating reporting from writing.

"It's gonna happen fast, and you're not gonna get it all . . . I've never been in *Time* magazine, yet this hall is filled twice . . . I don't need *Time* magazine . . . there's no ideas in *Time* magazine, there's just facts." His condescension was almost magnificent, if it hadn't been so petty. "I know more about what you do . . . than you'll ever know about me, ever." The argument concluded, "I'm saying that you're going to die . . . so am I. I mean we're just gonna be gone. The world's going to go on without us. ("Right," said Manning.) All right now,

you do your job in the face of that and how seriously you take yourself, you decide for yourself. ("Right.") Okay, now I'll decide for myself."

It's as good a statement of existential life, of a world of no god, no evolution toward perfection, no necessary meaning, as there is. It's actually a statement of the blues life, of black life. This was where all those blues lyrics had carried him; Dylan's hellhound was fame, and it was most definitely on his trail.

The final concerts at Royal Albert Hall were remarkable, and a couple of jokes in "Talkin' World War III Blues" were revealing. At one point, he remarks, "I looked in a closet and saw Donovan," which naturally drew a big laugh. Then he came to the point where he paraphrased Lincoln's "you can fool all the people some of the time," which he usually followed by saying, "Abraham Lincoln said that." On this night, he said, "T.S. Eliot said that." Eliot had been the poet of the twentieth century, and he'd died on January 5, just before Dylan had gone into the studio to record *Bringing It All Back Home*. It was almost as though there had been a transmission of something, some inspiration. Certainly Eliot was on Dylan's mind, and he'd be part of his lyrics soon.

Pennebaker's film would be brilliant, defining the mid-'60s and the art form of cinema verité. The opening sequence, in which Dylan held up placards with the lyrics of "Subterranean Homesick Blues" as the song played, had been his own idea. He'd brought it up at their first meeting at the Cedar Tavern. He wanted, Pennebaker said, "a takeoff of what the Beatles had to do when they had to play the playback, which was demeaning. They accepted it because they were told you had to do this to sell records . . . Dylan wanted to put a little needle into that, by doing it as a gag."

FOR DYLAN, THE tour had been, to appropriate a phrase from "Gates Of Eden," a "crashing but meaningless blow." "After I finished the English tour," he told journalist Jules Siegel, "I quit because it was

too easy . . . There was nothing happening for me. Every concert was the same: first half, second half, two encores and run out . . . I'd get standing ovations and it didn't mean anything. The first time I felt no shame. But then I was just following myself after that. It was down to a pattern." A year later he told Nat Hentoff, "I was playing a lot of songs I didn't want to play . . . It's very tiring having other people tell you how much they dig you if you yourself don't dig you."

Exhausted and drug-worn, he came home, collected Sara, and went to Woodstock, to a cabin owned by Peter Yarrow's mother. Starting with the rhythm of "La Bamba" in his ears, he began writing what he would later call a "piece of vomit" that went on for six or ten or twenty pages (accounts vary), and fairly soon all thoughts of quitting music were gone. "It suddenly came to me that this is what I should do . . . I want to write songs."

The piece was "all about my steady hatred directed at some point that was honest. In the end it wasn't hatred. Revenge, that's a better word." Working primarily with the self-loathing of the truly burned-out, certain phrases started working in his mind. One was *rolling stone*, from the Leon Payne song sung by Hank Williams, "Lost Highway," a song he'd played with Baez and Neuwirth at the Savoy. Muddy Waters's "Catfish Blues," which also had the phrase, entered into it. The Rolling Stones, whose arrogance he shared and whose visual style—Brian Jones in particular—he was in the process of adopting, were part of it too.

"I had never thought of it as a song, until one day I was at the piano, and on the paper it was singing. 'How does it feel?' in a slow motion pace, in the utmost of slow motion. It was like swimming in lava . . . I wrote it. I didn't fail. It was straight."

Straight, indeed. Pride goeth before the fall (the original line, in Proverbs 16:18, is "Pride goeth before destruction, and an haughty spirit before a fall"), and hubris is an easy target. The song kicks off like a fairy tale, "Once upon a time," and then ferociously depicts a "Miss Lonely" who's dressed "so fine" as she mocks all those who

warn her of her pride, an arrogant miss who went to the best schools and won't compromise with what Dylan calls the "mystery tramp."

Things get weirder; the circus is in town. Jugglers and clowns caper around our spoiled princess, one of the pretty people. She lacks compassion, she lacks soul, and now she has "no direction home," she's just a rolling stone.

In the end, the song is a demand for honesty, for total honesty *this instant*, what Greil Marcus would call a "very *strange*" "spontaneous revolution." And in that honesty, in that destruction of boundaries, there would be no more secrets, no hindrances, no fear; we would all be free. Some time later, Dylan quoted Henry Miller to a reporter on the role of the artist: "to inoculate the world with disillusionment."

The song written, he began to think about who should record it with him. Two years before he'd been playing in Chicago and met the young blues guitarist Michael Bloomfield. Bloomfield hadn't liked Dylan's first album and had come down to blow him away but found himself enchanted. "He couldn't really sing, y'know," said Bloomfield, "but he could get it over . . . better than any guy I've met."

Dylan invited Bloomfield to Woodstock and went down to the bus station to pick him up. After teaching him the new song and some others, Dylan gave him a surprise. "I figure he wanted blues," Bloomfield said, "string-bending, because that's what I do. He said, 'Hey man, I don't want any of that B. B. King stuff.' So I really fell apart. What the heck does he want? We messed around with the song." Eventually, Bloomfield played something Dylan liked. Michael continued, "It was very weird, he was playing in weird keys which he always does, all on the black keys of the piano."

On June 15, Dylan went into Columbia's Studio A on Seventh Avenue with Bobby Gregg on drums, Russ Savakus on bass, Frank Owens on piano, Paul Griffin on organ, and Bloomfield on guitar. "It was just like a jam session, it really was," thought Bloomfield. Not a terribly productive day.

There were different players on the second day, June 16. Although
he's uncredited, Joe Macho was apparently the bass player, not
Savakus. Bruce Langhorne was around. Al Kooper, who'd just writ-
ten a #1 hit for Gary Lewis & the Playboys ("This Diamond Ring"),
had dropped by to watch at the invitation of producer Tom Wilson.
He'd brought his guitar along but sensibly put it away when he heard
Bloomfield warming up. Then Wilson moved Paul Griffin from organ
to piano, and even though Kooper couldn't play organ, he went to
Wilson and said he had a part.

"He just sort of scoffed at me," Kooper said. "'Ah, man, you're
not an organ player. You're a guitar player.' Then [Wilson] got called
to the phone. And my reasoning said, 'He didn't say *no*, so I went out
there.'" Wilson saw Kooper and said, "*Heyyyy*—what're *you* doin'
out there?' I just start laughing—and he goes, 'Awright, awright, here
we go, this is take something . . .'"

Their first take was not at all bad, but it needed work on the cho-
rus. Wilson didn't like Kooper's organ part, but Dylan said to turn it
up. Kooper couldn't hear himself, because his speaker was on the other
side of the room and covered with blankets. He was dubious about
Wilson, feeling that no one was entirely in charge. On instinct, "In the
verses, I waited an eighth note before I hit the chord. The band would
play the chord and I would play after that." Somehow, it all worked.

Gregg's drums and Langhorne's tambourine locked down
the rhythm, Kooper's organ spread a carpet for them to dance on,
Bloomfield's guitar stung and snarled, Dylan's rhythm guitar and the
bass locked hands the way God planned it, and Dylan sang, in the
words of Greil Marcus, like "Jonathan Edwards's *Sinners in the Hands
of an Angry God*." Their fourth take was superb.

Dylan was unsatisfied, and they went through eleven more
attempts, with three complete takes. Finally, they listened to the play-
back and realized that the fourth take was perfect. Kooper couldn't
play organ, but he had delivered the missing piece to the creation of

"Like A Rolling Stone," arguably the greatest rock 'n' roll song ever recorded. In Dylan's own captivating phrase, they had achieved "that thin, that wild mercury sound." In a word, it was magical.

That night, Dylan took an acetate copy of the song to Grossman's place in Gramercy Park. Neuwirth called their friend, the producer Paul Rothchild, and told him to come over. He came and saw Dylan and Neuwirth sitting and grinning, playing the acetate over and over. "I knew the song was a smash," Rothchild said. "And yet I was consumed with envy because it was the best thing I'd heard any of our crowd do and knew it was going to turn the tables on our nice, comfortable lives."

There was a catch. At six minutes, it was extraordinarily long, and while the A & R and Promo departments at Columbia loved it, Sales and Marketing did not, suggesting it be cut in half. Dylan declined. There would otherwise have been a fight, but the higher-ups at Columbia were then consumed and distracted by their move from their old headquarters at 799 Seventh Avenue to "Black Rock," CBS headquarters on Sixth Avenue. Consequently, it was dumped without internal protest into "unassigned release" purgatory.

As they moved, the new-releases coordinator at Columbia, Shaun Considine, found a demo pressing of "Rolling Stone" and took it home. That Sunday, he went to the hottest disco in town, Arthur. Among its investors were comedian and film director Mike Nichols, Broadway legend Stephen Sondheim, Leonard Bernstein—and also Considine. He gave the pressing to a DJ to play.

"Around 11 p.m., after a break, he put it on," wrote Considine. "The effect was seismic. People jumped to their feet and took to the floor, dancing the entire six minutes. Those who were seated stopped talking and began to listen. 'Who is it?' the DJ yelled at one point, running toward me. 'Bob Dylan!' I shouted back. The name spread through the room, which only encouraged the skeptics to insist that it be played again. Sometime past midnight, as the grooves on the temporary dub began to wear out, the needle began to skip."

A DJ at WABC and the program director at WMCA, two impor-
tant stations, were at Arthur's that night, and on Monday morning
they called Columbia and demanded copies. Meetings were held. God
(Lieberson), who'd recently gone backstage to see Dylan in London,
where Joan Baez accused him of allowing Columbia to "exploit and
commercialize Bobby," became involved. Shortly thereafter, the release
memo was cut, and on July 15 the record was shipped, hitting radio
nationally by July 24. It would reach #2.

A young man named Bruce Springsteen heard the song on
WMCA and thought that the explosive snare shot that opened the
song "sounded like somebody's kicked open the door to your mind."
There were two other reactions. The last-ditch folkies cried "sellout,"
although a six-minute song with dark imagery hardly seemed a com-
mercial move. In fact, Dylan had created the first truly serious rock 'n'
roll song. Freedom had found an entirely new level.

The other reaction was a clumsy literalism, asking the question,
who was "Miss Lonely"? The most common guesses were Baez and
Edie Sedgwick, who'd been a brief player in the Dylan circus the previ-
ous fall, but Dylan and the song were certainly more subtle than that.
By making the protagonist a woman, Bob had executed a nice cape
pass to distract all the analysts.

Some years later, Dylan told Robert Shelton that some time in
1967, "I discovered something. I discovered that when I used words
like 'he' and 'it' and 'they' and putting down all sorts of people, I was
really talking about no one but me . . . You see, I didn't know that
when I was writing those earlier songs."

After all, his mother's maiden name was Stone—if you want to
be literal.

"Like A Rolling Stone" centered Dylan squarely on the middle of
the emerging rock 'n' roll, what the cultural historian Morris Dickstein
would call "the organized religion of the sixties—the nexus not only
of music and language but also of dance, sex and dope, which all came

together into a single ritual of self-expression and spiritual tripping"—
the manifestation and fulfillment of the freedom principle that had
existed since Thoreau. With the song all over the radio, Dylan was the
man of the hour as he went off to the Newport Folk Festival (July 23
to 25) with Victor Maymudes and Al Kooper.

He played "All I Really Want To Do" solo at the Saturday after-
noon workshop, but the crowd overwhelmed the venue. He'd out-
grown the festival.

The first tremors of the earthquake to come started with the
Butterfield Blues Band, a late addition to the festival lineup at the sug-
gestion of Peter Yarrow, a member of the festival board. (Other board
members included Pete Seeger, Alan Lomax, Theodore Bikel, Jean
Ritchie, and Ralph Rinzler.) Production manager Joe Boyd, who'd
been working for producer George Wein on the American Folk Blues
Festival tours in Europe, agreed that it would be possible to accom-
modate the electric-based Butterfield band and invited the band's pro-
ducer, Paul Rothchild, to mix the sound.

Alan Lomax introduced them. Lomax didn't dig their setup. "Used
to be a time when a farmer would take a box, glue an axe handle to
it . . . Now here we've got these guys, and they need all of this fancy
hardware to play the blues. Today you've heard some of the great-
est blues musicians in the world playing their simple music on simple
instruments. Let's find out if these guys can play at all."

Their show at the Saturday afternoon blues workshop was packed.
Rothchild had gotten them on a 99-cent Elektra compilation "folk
sampler" album, which usually sold twenty to sixty thousand units
but that year had sold two hundred fifty thousand. As a result, 5,000
attended the workshop, not the usual 250. Although there were some
noise complaints, the set was a triumph.

What took place at the side of the stage was something else. Albert
Grossman was either already the band's manager or about to be, and
he didn't like Lomax's tone. "What kind of a fucking introduction

was that?" Lomax: "For fucking assholes!" Grossman: "Never, *never* do that to a performer. I don't care if it's my act or not. Never treat an artist that way." Lomax: "Oh yeah, who's gonna make me do that?" Straight out of a schoolyard, two large middle-aged white guys were tussling on the floor, performers watching agape until they were separated.

That night, Lomax convened a board meeting—they were oddly unable to find Grossman's client Peter Yarrow for the session—and demanded that Grossman be banned from the festival. Wein pointed out that this would mean the loss of Peter, Paul, and Mary, Dylan, and Buffy Ste. Marie, and the demand was ignored.

Saturday night featured the Jim Kweskin Jug Band; youth was being served. Sunday afternoon was highlighted by a spectacular set from Dick and Mimi Fariña. It began to rain, and Mimi was sure that everyone would leave to seek shelter, but instead they began to dance joyously, and her big-time debut was a glorious one.

Meantime, Dylan spent the afternoon rehearsing with Bloomfield, Kooper, and the Butterfield rhythm section of Sam Lay and Jerome Arnold. It's never been clear if Dylan had planned this in advance. Kooper said they met up at the festival, and Eric Von Schmidt would say that Dylan heard Butterfield on Saturday and decided then. In any case, the rehearsal was rough, as Lay and Arnold were strictly bluesmen and had a hard time figuring out Dylan's music. Of course, Dylan had chosen them at least in part for their blues background; if he was going to play with other musicians, he wanted to be comfortable himself, and blues was quite as much part of his background as anything else, no matter what he'd recently created.

Sunday night, Pete Seeger began the evening by playing a recording of a newborn's first cry. The Butterfield Blues Band, their afternoon set rained out, played for half an hour. They were followed by the Moving Star Hall Singers, from the Georgia/South Carolina Sea Islands, a much more conventional folk festival act.

Wearing a snappy polka-dot shirt that was a far cry from denim, Dylan came onstage with his band and slammed into "Maggie's Farm." It was not all that loud by later standards, but as Joe Boyd put it, "in 1965 it was probably the loudest thing anyone in the audience had ever heard." Dylan's Minneapolis player friend Tony Glover thought the sound was lopsided and unclear, and that Rothchild was in over his head as a live mixer. A buzz of shock and excitement ran through the crowd. When the song finished, there was a roar that contained many sounds. "Certainly boos were included, but they weren't in a majority," said Boyd.

Boyd got a message to go backstage, where Lomax, Seeger, and Bikel were furious. They ordered him to turn the sound down, and he replied that he had no direct communication to the soundboard and it would take a while. Lomax harrumphed, "You go out there right now and you tell them that the sound has got to be turned down. That's an order from the board." Racing through the crowd, Boyd thought, was like "being in the eye of a hurricane . . . some were cheering, some booing, some arguing, some grinning like madmen." Grossman, Yarrow, and Rothchild stood behind the soundboard, "grinning like cats." Boyd passed Lomax's message on, and Yarrow replied, "Tell Alan the board is adequately represented at the sound controls and the board member here thinks the sound level is just right. And tell him . . ."—and raised his middle finger.

It was an appropriate gesture for the moment. "Like A Rolling Stone" surged out over the audience, and the reverberations are still being felt. The moment compared with Stravinsky's debut of *Le Sacre du Printemps* in 1913, where a modernist intellectual brought primitivism into the classics. With all his irony, paradox, and complexity, Dylan was a postmodern anti-intellectual intellectual tapping into some of rock's very nonintellectual and primitive features, like volume and sensory overload. Apropos Susan Sontag's diktat of the year before, this was a new form, indeed.

Seeger and Lomax saw rock 'n' roll as commercial music that would despoil the pure, noncommercial community that the Newport Folk Festival represented to them. They were wrong about Dylan's music, which would encompass folk, not discard it, but they were right about the record industry, which would use Dylan's ascent into rock to package coolness and dissent, make billions for themselves, and ultimately encourage passivity and consumption. At Newport on July 25, all that Seeger and Lomax knew was that great change had come and they didn't like it.

"It Takes a Lot to Laugh" (at that point called "Phantom Engineer") followed, and it was followed by cries of "*moooooore*" as well as boos, but they'd rehearsed only three songs, so that was that. Dylan went backstage to get his acoustic guitar but couldn't find it, with Yarrow now onstage saying, "Want to hear more? Bob's gone to get his *acoustic* guitar, if you want to hear more." Eventually, Dylan borrowed one from Johnny Cash and returned to play "Tambourine Man" and then, in an almost-but-not-quite-too-pat gesture, ended his set with "It's All Over Now, Baby Blue." Two sets later came Ronnie Gilbert of the Weavers, who'd introduced Bob so dismissively two years before. One of her songs that night was "Masters of War."

As Dylan left the stage he passed Pete Seeger, who was crying. At least for a brief while, Pete would withdraw from the folk world, resigning from the board of the festival, his column in *Sing Out!*, and the Woody Guthrie Children's Trust Fund. He'd call the Newport music "some of the most destructive music this side of hell." A year later, he recorded with the Blues Project. He would also tell a biographer that his real objection at Newport was that the lyrics were inaudible.

At the postshow party that night, Dylan sat in his old Cambridge friend Betsy Siggins's lap looking, Bikel thought, "visibly shaken." Maria Muldaur asked him to dance, and he replied, "I would, but my hands are on fire."

It wasn't just his hands. His brain was on fire with creativity, had been for the past three years and more, and he was moving like a man who felt he had little time. Four days after Newport he returned to the studio to continue recording, now with Bob Johnston, who had replaced Tom Wilson as producer. Ten years older than Dylan, Johnston had written songs for Gene Autry, Roy Rogers, Eddy Arnold, and Elvis Presley movies and produced Patti Page in Nashville for Columbia.

They began with "Phantom Engineer," still very fast, and then did a few takes of "Tombstone Blues" before going to lunch. "Tombstone" was an interesting study in contrasts. Though it had a conventional rock verse/chorus structure and a storming up-tempo groove, its lyric content, which ranges through Belle Starr, Jack the Ripper (who's "head of the chamber of commerce"), the hysterical bride, John the Baptist, the Commander in Chief, Gypsy Davey, Cecil B. DeMille, Ma Rainey, and Beethoven, is beyond anything rock had ever imagined.

During the lunch break, Dylan went to the piano and worked on "Phantom Engineer" and slowed it down, and in the afternoon they got the keeper track, which made "It Takes a Lot to Laugh, It Takes a Train to Cry" an elegant love song wrapped in a bluesy shuffle, with a fragment of the lyrics adapted from Charlie Patton's "Poor Me": "Don't the moon look pretty shinin' down through the tree."

"Positively 4th Street" was next, a song brilliant in its bitterness, but it wouldn't make the album and would be released only in a greatest hits package that fall. Given that there's a Fourth Street in both Dinkytown and Greenwich Village, literalists tend to have a field day with it, although one might speculate that much of the emotion comes from what had just happened at Newport.

Dylan was in the grip of an artistic revolution, one that would alter the American musical landscape, and he wasn't always able to be gracious about it. A few months later, his friend Al Aronowitz brought the Brill Building superstar songwriters Gerry Goffin and Carole King

backstage after a concert to say hello. Blown away by the show, which had ended with "Positively 4th Street" and "Like A Rolling Stone," Goffin gasped, "You have reason to be proud." "I do?" sneered Dylan. The couple went home, broke some of their old demos, and promised each other to "grow up." The residents didn't know it yet, but the Brill Building, the latter-day home of Tin Pan Alley, was about to go up in metaphorical flames. In the future, it would be de rigueur to write your own songs.

Even the Beats, his artistic mentors, would lionize him. Later that year he would perform in Berkeley, where he was the cynosure of all the City Lights poets, who clustered around him as goo-goo-eyed as college coeds. The front row of one of Dylan's Berkeley shows one night held Joan Baez, Ken Kesey, Allen Ginsberg, Michael McClure, Gary Snyder, and Lawrence Ferlinghetti, who was shaken by the concert, Ralph Gleason thought, puzzled at how this young man had seized the muse and held her in thrall.

On Sunday after the concerts, Dylan went to City Lights to pose for pictures with the poets, and afterward everyone crossed the alley to Vesuvio's. The poets ordered drinks, and Dylan ordered tea—and the poets changed their orders. That is not a healthy place to be. Bob had Sara, whom he would marry that fall when he had a couple of days off, but even that would have only a limited impact. He was engulfed in a maelstrom of unimaginable and ultimately unsustainable creativity that came with an ever-steepening toll on his capacity to be a healthy human being, which appeared to include massive abuse of stimulants balanced by an increasing use of something to permit some form of calm. He never slept.

Dylan and company returned to the studio on July 30 and resumed recording the album that would come to be named *Highway 61 Revisited*, with Bob's friend Tony Glover watching. Glover felt that no one was in charge, but what he missed was that Dylan was essentially trying to inject improvisation into the recording process. At

times he was writing songs and recording them simultaneously, and his approach at any given session was to take a number of tries and see what stuck. This bothered Russ Savakus, for instance, who bailed after the thirtieth, to be replaced, at Kooper's suggestion, by Harvey Brooks. Dylan rarely spoke but would kick off songs by tapping his toe. Johnston thought of Dylan as a prophet and removed all the clocks in the studio to improve focus. Mostly, he made sure that tape was rolling. In truth, Bob didn't really need any help.

After a weekend in Woodstock where Dylan and Kooper made up chord charts for the musicians, they returned to the studio on the evening of Monday, August 2, with Sam Lay on drums and resumed work.

"Just Like Tom Thumb's Blues" explored a land like William Burroughs's Interzone, a place where anything is possible, and the old verities no longer obtain. In "Thumb," Interzone is located in the border territory near Juarez, where the singer is sick, the whores are delicate and sad, and everyone else seems to be an authority figure, a cop, or a ghost. Rimbaud's poem "My Bohemian Life (Fantasy)" references Tom Thumb, which is interesting, as is the very peculiar rhyme scheme, where the early verses rhyme only on even lines, but in the last verse both even and odd lines rhyme.

"Queen Jane Approximately" is one of Bob's mystical invocations to the muse.

Literalists of course link "Ballad of A Thin Man," one of the rare times Dylan recorded a song playing the piano, to Dylan's exchange with Judson Manning, although there was a reporter named Jones who swore he was the one. Of course it's not one person but an attitude that Bob's singing about, a point of view that gets its information only secondhand, from books or newspapers or other people, but not from visceral experience. Mr. Jones is the sort of person who wants his life predigested and safe, and this song is his dream, or rather his nightmare, along with midgets, geeks, and so forth. It's also a treasure trove for those looking for gay elements in Dylan's life, with all manners of

elements Freud would love: bone, throat, a sword swallower who clicks his high heels. "Thin Man" is a line in the sand between the hip and the square. It's neither kind nor compassionate, but that's Dylan in 1965.

The album closed with eleven and a half minutes of madness, "Desolation Row." It begins with the comment "they're selling post-cards of the hanging," which has a weird literal link to Dylan; in 1920, three black men had been lynched in his birthplace of Duluth, and in the aftermath people indeed sold postcards of the hanging. Dylan's sources for the images he uses are manifold. He would say that it is a minstrel song inspired by his childhood visits to carnivals, seen through lessons learned from T. S. Eliot and the Beats.

In fact, the song is at least in part an homage to Jack Kerouac's *Desolation Angels*, which had been published that March. Not only is it the apparent source of the title, but as the historian Sean Wilentz points out, there are also explicit fragmentary quotations or near quo-tations from Kerouac's work in the lyrics, describing the surrealist poet Philip Lamantia as the "perfect image of a priest," and elsewhere referring to people who "sin by lifelessness." Later in the year, when asked for the location of "Desolation Row," Dylan responded at a press conference, "Oh, that's somewhere in Mexico"—which was the location of much of Kerouac's novel. That Charlie McCoy's elegant acoustic accompaniment would be an exquisite Tex-Mex borderland near waltz is simply perfect.

The circus is in town, but this is no child's delight. This is a Fellini type of circus, where the clowns are assassins and the tight-rope walker—well, he's tied to the blind commissioner's hand, with the commissioner's other hand down his pants. It is a world built of debris, and no one is free here, especially Dylan. "Desolation Row" is both the last home of the authentic and also hell, the junkyard of all American culture. It is where you can see the truth, what William Burroughs called the "*naked* lunch, a frozen moment when everyone sees what is on the end of every fork."

Fictional characters—Cinderella, Romeo, Cain and Abel, the hunch-back of Notre Dame, Ophelia, Dr. Filth—mix with Einstein, Ezra Pound, and T. S. Eliot, and they're all swept up by the agents who strap heart attack machines across your shoulders. There's a preference for popular culture against the elite—calypso singers laugh at Pound and Eliot (the mermaids in this verse can be found in his "The Love Song of J. Alfred Prufrock")—and later that month Dylan would expound to Nora Ephron and Susan Edmiston on the idea of having great paintings in places where people hang out—men's rooms, dime stores, gas stations.

In the end, it's apocalyptic and confusing, a mystery in the highest sense, partaking of the eternal and definitely important. And because it's important, we search it for clues, like paranoids trying to prove conspiracies, looking for meaning just as Dylan is.

Having recorded it with a band on August 2, he decided to make it acoustic and rerecorded it on the fourth with McCoy, a Nashville studio cat and friend of Johnston's who happened to be in New York. Columbia would release the album on August 30, 1965, complete with liner notes by Dylan that feature the Cream Judge, the Clown, savage Rose & Fixable, Tom Dooley, a plainclothes cop from Fourth Street, and the WIPE-OUT Gang, which owns the Insanity Factory. The music, he says, "though meaningless as it is—has something to do with the beautiful strangers . . . the beautiful strangers, Vivaldi's green jacket & the holy slow train."

The album's title song was special in many ways. Dylan had reached down into his own musical as well as personal genealogy to compose a paean to freedom, a galloping rock tune that starts with a blast on a police whistle that Dylan found (Kooper said it was his; Tony Glover thought Sam Lay brought it), put in his harmonica rack, and blew very, very hard as they began. It knits together parts of his life as disparate as his father, Gatemouth Page, and all the music coming up the river that had so inspired him in Hibbing. It brings his life to that moment full circle.

Highway 61 is of course a real place and the primal link for Dylan between his young self and the music that he came to inhabit (and vice versa); it passes through Hannibal, Missouri, which makes it Mark Twain's Highway 61 too. But the song begins with Genesis 22, where God ordered Abraham to kill his own son. One can only imagine what Abe Zimmerman thought of the song, but it's hard to miss. Ironically, at the time Dylan was recording his tribute to the blues highway, the United States was completing the Interstate Highway System, and even Highway 61 was starting to show off sections with four lanes.

After we dispense with the literal, Dylan's 61 turns out to be a place where anything is possible, but much of the freedom is out of a nightmare. Highway 61 is where you can find a promoter to start the next world war and sell telephones that don't ring. Mississippi Fred McDowell and Sunnyland Slim (Albert Luandrew) had written Highway 61 songs, but this was something altogether different, yet also consonant with their blues.

It was a great song that would endure in his repertoire.

The same week he finished recording *Highway 61 Revisited*, Congress would pass the Voting Rights Act, on August 6, in the highwater mark of the civil rights movement, a century after the end of the Civil War, just a bit longer than that since Emancipation.

Which is a good place to conclude this odyssey through American culture. Dylan represented a great flowering of the influence of the African American quest for freedom on the arts, both in his genuine commitment to the civil rights movement and his use of black influences in his music, and certainly those influences would continue to affect him.

He'd go on making music for a lifetime and in the process become the embodiment, as Sean Wilentz particularly and brilliantly noted, of the true American "whiteface" minstrel. He'd grasp, touch, and manifest the entire tradition of minstrel creation and songster adaptation covered in this book, from Daniel Emmett to Henry "Ragtime Texas"

Thomas, from Charlie Patton and Jimmie Rodgers to Blind Willie McTell and beyond. His work became a form of musical alchemy, a literal nexus of musical transformation transcending time and space.

But their transmission and that tradition are substantially revealed in these first six albums, and going on is unnecessary. The picture is full.

Its priorities controlled by the disaster in Vietnam, the federal government would lose focus on civil rights issues. Riven by burnout and Black Nationalism, the civil rights movement itself would scatter. Though it would have an impact in many arenas, it would never regain the moral force and clarity of the movement in earlier times. Dylan would still affect it, sometimes in the oddest of ways: Picture Huey Newton and Bobby Seale in October 1966, writing their manifesto for the Black Panther Party, "What We Want/What We Believe," to the sound of "Ballad of A Thin Man."

Paradoxically, as Bob led rock 'n' roll into new heights of artistic sophistication, rock in general was moving away from black music, so that the divide that had once seemed closed was now ever widening. In the years to come, there would be only a few black acts at the epochal rock festivals of Monterey and Woodstock. Bob Dylan wasn't writing dance music, which was the central response to the soul and R & B of the '60s.

Dylan would hole up in Woodstock and be a family man before rock 'n' roll lured him out once more, and after all the changes, he would end up living his life on the road, just like his great heroes— Woody Guthrie, Jack Kerouac, and the bluesmen he revered.

His music and the tradition of black and white reconciliation/ affirmation/inspiration it represented would, along with many other proximate influences, trigger an extraordinary assessment of American culture—the era of great questioning known as the '60s. Though many of the positive consequences of that great challenge dissipated themselves in indulgence and greed, the impulse toward

liberation that emerged in that era endures in a dozen causes—the environmental movement, the feminist movement, the pursuit of rights for all those who do not live in conventional sexual roles—and far, far more. That history is still being written. The tradition that began with Thoreau that seeks to realize the extraordinary promise of America is still with us. Even in a time of remarkable ignorance and abuse of power, hope remains.

Let W. E. B. Du Bois have the last words:

"If somewhere in this whirl and chaos of things there dwells Eternal Good, pitiful yet masterful, then anon in His good time America shall rend the Veil and the prisoned shall go free. Free, free as the sunshine trickling down the morning into these high windows of mine, free as yonder fresh young voices welling up to me from the caverns of brick and mortar below—swelling with song, indistinct with life, tremulous treble and darkening bass."

Notes

1: America and Henry Thoreau

"The pastoral ideal": Marx, *Machine*, 3. "late medieval", Shi, 8. Mather: Shi, 21. Slavery: David Davis, passim. "land, family...reckless speculation": Robertson-Lorant, 12. Franklin: Gordon Woods, *The Americanization of Benjamin Franklin*. Unitarian joke: Hyde 169. "in miracle": RWE Works I:335, Shi 126. Anti-Slavery in Concord: Petrulionis, passim. "The degredation": as quoted in Petrulionis, 65. "There will never," "I have never," "a sort of," "Action from principle": Thoreau, *Civil*, 145. 140, 132-133, Ibid. Anthony Burns: Petrulionis 99, Davis 265. "In spite of your": from "Massachusetts in Mourning," sermon of 6/4/54 - http://higginson.unl.edu/writings/twh.wri.18540604.html. "My thoughts are," "natural habitat," "The law will never," Thoreau, *Slavery in Massachusetts*, 185, Ibid., 186. "proceeded to violate": Woodward, *Burden*, 45. "I never did": as quoted, Ibid., 53. "I did not send": Emerson's Eulogy. "craven hearted," "Which way have," "by descent," "a transcendentalist," "peculiar doctrine," "a man has," "had the courage," Thoreau, *A Plea*, 266. 266, 262, 271, 276, 276, 262.

2: A Child of the River and the South

The River: Ambrose and Brinkley, 8. "The whole tree": *Walden*, 216. "a bedridden," "a faithful and," *Autobiography ("AB,")* 7, 9. "impressive pauses": Fishkin, *Twain and Race*, 133. "mild domestic," "brutal plantation," *AB*, 39. "wantonly canter": Dempsey 11. John Clemens, the students, and Henry: Dempsey, 50, 54. "taught us that," "the wise and the good": *AB* 9, 39. Bennett: Dempsey, 60. Sam and slaves: Dempsey 87, *AB* 31. "a much baser," "and carried": as quoted, Fishkin, *Lighting Out*, 23. "straitened means": as quoted, Dempsey, 114. Charley: Fishkin, *Lighting Out*, 20. "not quite a nation": Woodward Introduction to Cash, Xlviii. Cotton statistics: Walton, 34. "One of the effects," "knock hell," "ultimate incarnation": Cash, 32, 43, 43. Education and literacy: Wyatt-Brown, 193–194. "not even disapproved," "white man's honor": Ibid., 293, 16. "atheists, socialists": as quoted, Cash, 80.

3. Antebellum Black Music and White Minstrelsy

"Got one mind": Levine, Xiii. "the singing of birds": as quoted, Levine, 19. "the most original": Du Bois, 141. "The benches are pushed": Allen, Warren, and Garrison, *Slave Songs of the United States*, 1867, xiii–xiv, as quoted in Floyd, 37. "The ante-bellum Negro": Paul Radin, as quoted in Levine, 33. "The spirituals are": Levine, 33. "came to regard": Abrahams, Xvii. Whites and black dancing: Ibid., 137. "new institution," "burst upon," "Lips were thickened," "an extravagant": *AB*, 77–78. "account of the," "Every day": *AB*, 80.

Minstrelsy, general: Lott, Toll, Giddins, *Visions* 15. "To be or": Lott, 45–46. Rice: Lott, 19. Virginia Minstrels: Lott, 52. Name: Toll, 30. UTC on stage: Toll, 213. "Life among": Toll, 94. "if I had known": Letter from Col. T. Allston Brown to T. C. De Leon. Published in De Leon, *Belles, Beaux, and Brains* and quoted in Nathan 275. Nathan, Hans. *Dan Emmett and the Rise of Early Negro Minstrelsy*. Norman: University of Oklahoma Press, 1962. Early bohemians: Lott 51. "the filthy scum": as quoted, Lott, 15. Sexual undercurrent: Lott 121. "two left legs": as quoted, Abrahams, 148.

4. Mark Twain Grows

"I reckon I": 8/24/53 to Jane Clemens, as quoted, Powers, 64. Pilot: Powers, 75. "What do you," "Well to-to," "What is the," "He might as": *Life*, 40, 49. "the face of the water,": *AB*, 58. "I had failed": *AB*, 60. Civil War and Death: Davis, 300; Faust, passim. "You've sullied": Wyatt-Brown, 56. "crusade of the New England," "In a time" "thus Negro suffrage": Du Bois, 31, 33, 40.

"It is nothing," "Ah! So.," "The only one": *Innocents Abroad*, 182. "better than any of us": as quoted, Paul Kaplan. "Ah, well! Too": as quoted, Powers, 274–275. Children at Quarry Farm: Fishkin, *Lighting*, 91. "no more trouble," "Aunt Rachel," "Oh, no, Misto C—": "A True Story": *Atlantic*, November, 1874. "Sociable Jimmy": Fishkin, *Was Huck Black?*, passim. "Wide-eyed, observant," "The most artless," Ibid., 14, 15. "for half a generation": as quoted, Chadwick-Joshua, 22. "these gentlemen and ladies": as quoted, Fishkin, *Was Huck Black?*, 150.

"amounted to the appropriation": Cantwell, 34. "They must know": as quoted, Levine, 141. Early studies of black song: Cantwell, 32–33. Fisk Singers: see Andrew Ward, passim. "a sweet, coherent": A. Ward, 115 "denatured": Levine, 166. "gradually transformed": Blesh, 12. "a kind of genteel": Cantwell in Anderson, 140. "Their 'John Brown's Body'": as quoted, A. Ward, 225. "Then rose and swelled": as quoted, A. Ward, 407. SC to Joe Twitchell, 8/22/97, in MT's *Letters*, ed. Paine, 2:645-646. "The Union fought," "remarkably modest": Woodward, *Burden*, 84, 100. Colfax: Lemann, passim. Sheridan: Lemann, 11. White Line: Lemann, 128. "Banditti": Lemann 94. "Lost cause": Borritt, 184. "Darwin, Huxley": Cash, 139. "rage born of fear": Kemp, 89.

5. Huckleberry Finn

"was Ignorant, unwashed": *AB*, 88–89. "I have always preached": Ibid., 358. "it is the deep": as quoted, Fishkin, *Lighting*, 79. "not purified": Kaplan, 73. "Mostly a true": *Huck*, 233. "at his own free": *Tom Sawyer (TS)*, 58. "they said he was": *Huck*, 260. Not "Nigger Jim": Fishkin, *Lighting*, 49. "where a sound": Unpublished notebook at UC Berkeley. 28a (I), typescript, p. 35 (1895), MT Papers, Bancroft Library, UCB. "I said I wouldn't," "Yes; en I's," "Chickens know," "most ruined": *Huck*, 276, 280, 282, 239. "Writing at a time": Ralph Ellison, "Change the Joke." Minstrel language: Cameron Nickels, passim. "it doan'," "Take it all," *Huck*, 299 "A harem's a," "my heart wuz," "It was fifteen," "looking like a black": *Huck*, 311, 319, 320, 328. "The South has not": *Life*, 258. "Every day that": as quoted, Turner, 67. "dream that the years," "might as well bully": *Life*, 162. "Why, it's like": MT to WDH, as quoted, Perry, p. 111. "This summer it is no more": Ibid. "Other places do seem," "Hain't we got," "But, Huck," "and I do believe:" *Huck*, 350, 410, 385–86, 387. "the Wagnerian aria": Powers, 475. "The more I studied," "All right, then," "It was awful," "Good gracious," "was a boy," "there ain't no," "I wish there," "It don't make," "just that particular," "planned beautiful": *Huck*, 445, 447, 447, 454, 467, 471, 473, 476–77, 480, 508. "All modern American": Ernest Hemingway, *The Green Hills of Africa*. "failure of nerve": Marx, *Pilot*, 14. "without it": as quoted, Fishkin, *Lighting*, 198.

"but I do not feel": as quoted, Ibid., 101. "any system": as quoted, Ibid., 23. "But I reckon": *Huck*, 526. "If Mr. Clemens": as quoted, Perry, 148. "The committee of the Public": Ibid. "a truly stupendous": as quoted, Powers, 494. "masterpiece": T.S. Eliot, Introduction to *Adventures of Huckleberry Finn*, London, Cresset, 1950. "one of the world's great": Lionel Trilling, Introduction to *Adventures of Huckleberry Finn*, New York: Rinehart, 1948. "He wrote as though" Arthur Miller in an interview, cited in *Nom de Plume: A (Secret) History of Pseudonyms* by Carmela Ciuraru. New York: Harper, 2011. "a rebellious, democratic": Marx, *Pilot*, 15.

Abolitionist image: Kathleen Maclay, Media Relations "New 'Huckleberry Finn' by UC Berkeley's Mark Twain Project" http://berkeley.edu/news/media/releases/2001/06/11_hfinn.html. "PERSONS attempting to": *Huck*, Preface. "The glances embarrassed": as quoted, unpublished essay, "A Family Sketch," 1906. Fishkin, 124.

6. Black Minstrelsy and the Rise of Ragtime

Polk Miller: Brooks, 218. "it has been my aim": Ibid. See also Nickels, passim. Black Patti, Charles Hicks, minstrel troupes: Abbott and Seroff, 62, Wondrich, 35, Toll, 134. "close cousins": Palmer, 25. Cakewalk: Abbott and Seroff, 162; Blesh, 98. "The Laughing Song": Brooks, 67. Williams and Walker: Brooks, 106, 113. "Funniest man I": as quoted, Giddins, *Visions*, 14. "Nobody": Brooks, 113. "I am now satisfied": as quoted, Abbott and Seroff, 273.

World's Fair: Ambrose & Brinkley, 177. "It is never right": Joplin note on "Leola," 1904, as quoted in Berlin, 152. Ragtime and Chicago: Blesh, Berlin, Waldo, Abbott and Seroff, 293. "Little Egypt": Abbott and Seroff, 285. Theodore Thomas: Curtis, 49. "from the formless": as quoted, Levine, 20. Turner: Curtis, 58.

Rags: Abbott and Seroff, 443. "Ragtime is *syncopation*": as quoted, Waldo, vii. Ernest Hogan: Abbott and Seroff, 445. "Kansas City girls": Ibid., 448. Joplin Bio: Berlin, Curtis. Sedalia: Curtis, 87. Joplin's first songs: Berlin, 26. "Real ragtime on the piano": as quoted, Blesh, 226–27. Early rags: Blesh, 89. "working *from* a folk": as quoted, Waldo, 201. Stark, Maple Leaf Rag: Waldo, 32, Berlin 72, Curtis 90–93. Later Joplin: Blesh, 69–72, 53.

Institutions: Leonard, *White*, 17–18. "the language of the soul": as quoted, Leonard, *Myth*, 8. "A person inoculated": as quoted, Ibid., 11. "Can it be said": Walter Winston Kenilworth, "Demoralizing Rag Time Music," *Musical Courier*, 5/28/13, 22–23. "It perpetuates and embodies": as quoted, Lopes, 25. "Libertine men and scarlet": "Ya Got Trouble," *The Music Man*, Meredith Willson.

7. Race in America from the 1890s to the 1920s

Indian rope trick: Wiseman, R., & Lamont, P. (1996). "Unravelling the Indian Rope-Trick." *Nature*, 383, 212–13). Jim Crow: Woodward, *Strange*, passim. "the eyes of a tolerably": as quoted, Woodward, *Strange*, 36. Baseball: Thorn, p. 207. "The South's adoption": Woodward, *Strange*, 69. "in all things purely": as quoted in Du Bois, *Souls*, 43. "Voting is necessary," "There is no true": Ibid., 51, 22. "in the same room": Ibid., 98. "A white deacon": Levine, 311–12. "common historic grievance": Woodward,

Strange, 13. Dunning: see Lemann, *Redemption*. Racial science: see "Who's White?"—review of *The History of White People*, Nell Irvin Painter, Norton 2010 by Linda Gordon, NYTBR, 3/28/10. Von Herder, Child, Sharp: see Filene, passim. "tasteless": Filene, 15. Black music: Levine, 195. "Denial, dilution": Levine, 270. Odum: Filene, 31, Hamilton, 43, 46. "the lighter, happier," "shout for": as quoted, Hamilton, 61, 66. "I ought never": as quoted, Cott, 199. "Gimme eggs": Brooks, 241. "I'm Jack Johnson": Miles Davis, *Jack Johnson*, Columbia Records, managed by Kobalt Music.

 Birth of a Nation at White House: Lemann, 189–90. "multiple cameras": Barnes, 69. "The real big purpose": as quoted, Barry, 141. Lynching: Cash, 299. Migration figures: Marable, 9–10. Chicago: Teachout, 63. Train ride: Lemann, 43. Oliver and complexion: Peretti, 59. "Lord, Bessie Smith": as quoted, Ibid., 64. East St. Louis: Barnes, passim. "like nothing so much": Ibid., 151. Protest march: Barnes, 199. Klan: Barry.

8. The Primal Blues, Its First Populizer, Its First Star

"A lean, loose-jointed": Handy, 74. "Poor Boy": Calt-Wardlow, *Smithsonian Classic Blues II* liner notes. Gus Cannon: Palmer, 46. "hymns of the most," "weird in interval," "They had me": as quoted, Gordon, 15. "I'm so tired": as quoted, Palmer, 24. "Ma" Rainey: Wald, 11. Morton: *Mr. Jelly Roll*. Memphis: F. Davis, *History*, passim. "Sportin' class o'": as quoted, Oakley, 130. "I'd rather see you": as quoted, Handy, 11. "picking out a tune," "an odd new vogue," "low folk form," "with cane rows," "unpleasant," "rounders and their," "rain of silver," "a simple slow-drag," "That night": Handy, 142, 58, 76, 76, 77, 77, 77. "had become a common": Handy, 99. Reels: F. Davis, *History*, p. 6. Sentimentality: Calt Wardlow, 105. Rags to blues: Giddins, *Visions*, 29. Blues songs: Brooks, 415. "I aimed to use": Handy, 121. "I hate to see": "Saint Louis Blues." "plagal chords": as quoted, Friedwald, 50. Recording of "Saint Louis Blues": Brooks, 424. "folklorist familiar": Friedwald, 40.

 "To say that the artists": Wald, *Escaping*, 7. "fast-paced and worldly" Hamilton, 234. "sang and played": Palmer, 61. Patton: Calt-Wardlow, 114. "reveals that nothing": Ibid., 57. The Delta: Palmer, 8, Cobb, 3. Sharecropping: Cobb, 54–55, 71. Levees: Lomax, *Land*, 212. New South: Cobb, 100; Cash, 173. "That's Honey": Edwards, 47. "a two-phrase tune"; Lomax, *Land*, 89. "These poor people": Twain, *Life*, 176–77. Thomas: Oakley, 61. "The blues is kinda": as quoted, Calt and Wardlow, 94. "Ain't no kind of blues": as quoted, Waterman, 32.

 Patton description: Calt and Wardlow, 13. Dockery: Ibid., 74–75. "hated work," "He was just a loafer": as quoted, Calt and Wardlow, 110. Mentors: Calt and Wardlow, 46, 97, 104. "Charlie Patton was a clowning": Sam Chatmon to BBC, quoted in Oakley, 49. " "and it *blew* just like my baby getting on board," "where the Southern cross the Dog," "Some people say the Green River blues ain't bad / Then it must-a not been the Green River blues I had": "Green River Blues," Charlie Patton, EMI Music, Sony/ATV Music Publishing. "break up his own": as quoted, Hadley. "I've seen him playin'," "Right there in the middle": as quoted, Calt and Wardlow, 129, 29.

9. The Birth of Jazz, in New Orleans and New York City

Slave market: Walter Johnson, *Soul by Soul, Life Inside the Antebellum Slave Market*. Cambridge: Harvard U. Press 1999. Population, Congo Square: Sublette, 113, 117, 120. "The head rests": as quoted, Ventura. Creoles and Uptowners: Brothers, 186. Parades: Brothers, 212. "Yeah Pops": Armstrong, *Own*, 4. Funeral: Brothers, 84–86, 214. See also Turner. "Even police horse": as quoted, Stearns, 62. Buddy's Band: Marquis, 76. "Calling the Children": Ibid., 62. "where the rough people": Foster, 15. "Some of the Creole": as quoted, Lomax, *Mr. Jelly Roll*, 120. Population: Peretti, 25. Jazz Grammar: see Marcus Roberts in Howard Reich, "The Rise of Jazz Piano." "He claimed—he": Armstrong, *Own*, 24. "He just talked": Foster, 111.

 Black Storyville: Brothers, 150. "dozens of New": Barker, *Buddy*, 100. "real primitive," "yard and": Barker in Shapiro & Hentoff, 51. "the ratty": as quoted, Barker, 28. "So ratty music": Barker, 28. Repertoire: see Luc Sante, "I thought I Heard Buddy Bolden Say," in Wilentz and Marcus. "I Thought I Heard": Marquis, 3. "The blues?": as quoted in Lomax, *Mr. Jelly Roll*, 109. Elements of jazz: see Gushee, 4. "if he forgot": Marquis, 100. "multi-themed compositions": Reich and Gaines, 39. "first true composer": Lomax, *Mr. Jelly Roll*, 85. "Jelly Roll Blues": Reich and Gaines, 45. "If I wanted to make": as quoted, Lomax, *Mr. Jelly Roll*, 105–6.

 "New York is a dream": as quoted, Peretti, 47. Joplin: Berlin, Curtis. Clef Club, Dance Fad: Brooks. Twentieth-century expansion of entertainment: see McFarland. Castles: Wondrich 183; Wald, *Beatles*, 41; Brooks. Tin Pan Alley: Albertson, 293. Berlin bio: Sheed. "The synergy": Giddins, *Visions*, 37. "*chasse beaux*": Alan P. Merriam, Fradley H. Garner, "Jazz-The Word," in O'Meally, 16. "They used jasmine": Bushell, 13. "jazz ball because": "jazz ball" because," "Seals Return from the Spa to Tackle the Famous White Sox," *SF Bulletin*, March 6, 1913. From "The Jazz Story for Non Irish Speakers," Dan Cassidy—http://www.edu-cyberpg.com/pdf/jazz.pdf. Also Bill Swank, "Did Neologic Baseball Pitcher Invent 'Jazz'?" *Downbeat*, August, 2007. Hickman: Stoddard, 195.

 "Trade name": as quoted, Gordon Seagrove, "Blues Is Jazz and Jazz Is Blues," *Chicago Tribune*, 7/11/15, E8. Origins of ODJB: Brunn, 30. "Livery Stable Blues": http://www.redhotjazz.com/jazz1917. html. "Those are numbers": Bechet, 114. LaRocca's claim: Peretti, 80. "They had no white": as quoted,

Blesh, *Trumpets*, 206. Twain and "A Club": McFarland, 123. Greenwich Village: McFarland. Golden Swan: Ibid., 179. "You are elected," "A revolutionary": Ibid. "Jazz music was": as quoted, Brunn, 172.

10. Louis

Armstrong Bio: Brothers. Church: Ibid.: 33, 45. "After *blowing*": Armstrong, *Own*, 12. "wouldn't learn notes": as quoted, Lomax, *Mr. Jelly Roll*, 114. "He stuck real close," "see the whole thing": Bechet, 79, 81. Armstrong on the coal wagon: Teachout, 39. Bechet hires Armstrong: Bechet, 92–93. Armstrong and Oliver: "Joe Oliver Is Still King," *Own*, 37–39. "Everything I did": as quoted, Brothers, 116. "the prettiest and": Armstrong, *Own*, 124. Streckfus line: Kenney. "danced their": Ibid., 4. "going to the conservatory": Singleton in Shapiro and Hentoff, 76. "We's got it": as quoted, Kenney, 48. Armstrong at Lincoln Gardens: Armstrong, *Satchmo*; Giddins, *Satchmo*, 216.

Chicago clubs: Smith, 127. "The one thing": Ibid., 129. Original Creole Band: Gushee. Nonrecording: Baquet in Barker, *Buddy*, 136. Johnny Dodds: Giddins, *Visions*, 79. "As an improviser": as quoted, Teachout, 75. "I'd say they regarded": Bushell, 25. "Everything he had on": as quoted, Teachout, 65. "The first number went down": Armstrong, *Own*, 50. "sense of infinite": as quoted, DeVeaux, 82. "Well, I tell you": as quoted, Teachout, 103. Oliver skimming: Teachout, 77. Henderson: DeVeaux, 73. "Oh, I thought": Giddins, *Visions*, 93. "There were thousands": as quoted, DeVeaux, 73. "his lines grew more": Santoro, 51–52. Dickerson repertoire: Teachout, 99. "it was like we": as quoted, DeVeaux, 77. Scat singing: Teachout, 94. "Louis was wild," "Only the coda," "When it first": as quoted, Ibid., 112, 115, 115. "absolute refusal": as quoted, Shapiro and Hentoff, 105. "always have a": Armstrong, *Own*, 160. "sexy, stylish": Giddins, *Visions*, 87–88. "His goal was": Brothers, 7.

11. The Blues Women

Bradford and Smith and OKeh: Bradford, 115, 117. "Every blues ever": Barker, *Life*, 158. Jazz Hounds: Smith, 104. "our folks wants": Bradford, 126. "shouter": Bushell, 21. Early blues recording: Wald, *Escaping*, 17, 20. TOBA: Harrison, 24. Rainey bio: Harrison, Albertson, 11, Stewart-Baxter, 38, 42. "I talked to a fellow": Sterling Brown, "When Ma Rainey Comes to Town," *The Collected Poems of Sterling A. Brown*, edited by Sterling A. Brown. Reprinted by Permission of the Estate of Sterling Brown. Ethel Waters: Giddins, *Riding*, 4. Bessie Smith bio: Albertson. Contract: Ibid., 37. "love, sex," "slapstick hokum": Ibid., 62. "sadness . . . not softened": as quoted, Carl Van Vechten, *Vanity Fair*, August, 1925, 86.

"church deal," "She could bring": as quoted, Shapiro and Hentoff, 240, 243. "The thing about": as quoted, Albertson, 55. "only amusing," "fastidious circus," "midtown branch," "only music of value": as quoted, Kellner, 65, 65, 162, 192. "The Blues are," "most important contribution": Van Vechten, "Langston Hughes," *Vanity Fair*, September, 1925. "voyeur," "decadent," "abominably": as quoted, Anderson, 101. "Van Vechten has been": as quoted, Kellner, 195. Talent scout: Anderson, 100. "Her face was beautiful": as quoted, Albertson 118–19. "This was no actress": as quoted, Shapiro and Hentoff, 245. Death: Albertson, 256–57.

12. White People and Jazz and Its Flowering in New York

"Why . . . why isn't," "Something as unutterably": as quoted, Shapiro & Hentoff, 141–42. "Jazz originally," "The weird chant": as quoted, Lopes, 51. True believers: Leonard, *Myth*, 19. "a shrine": as quoted, Ibid., 148, 149. "It said what": as quoted, Levine, 295. "Great improvisers": as quoted, Leonard, *Myth*, 74. "modern syncopation," "savage": as quoted, Lopes, 59. "Not that I mean": as quoted, Early, 174. "remove the stigma," as quoted, Leonard, *White*, 79. Bio: Delong; Stearns, 165. "often more than": as quoted in Gerald Early, "Pulp & Circumstance," in O'Meally, 410. "defined the arranging," "rear-guard holding": Wald, *Beatles*, 4, 10. Aeolian Hall Concert: Stearns, 166–67; Lopes, 70; Early, 169; Anderson, 234; Delong. "crude jazz": as quoted, Brunn, 186. "gorgeous piece of impudence": as quoted, *Jazzmen*, 305. "syncopated classical": as quoted, Peretti, 189. "I know as much": as quoted, Delong, 68.

"The Negro had": Jones, *Black*, 149. Roppolo bio: Jack Weber, as quoted in Shapiro and Hentoff, 58–59. "We did our best": as quoted, Shapiro and Hentoff, 123. Learning "Farewell Blues": Stearns, 174. Blue Friars: Jimmy McPartland, in Shapiro and Hentoff, 118–21. "different kind of mob," "Jazz supplied": Ibid., 118. "all the bluenoses": Mezzrow, 109. "first and greatest": Rexroth, *Green Mask*, 163. "I see you": as quoted, Sudhalter, *Lost*, 190. "Mostly white fellows": as quoted, Shapiro and Hentoff, 115. "It was hypnosis," "The tone," "stiff with education": Condon, 107, 111–12. Studying Noone: Joe Marsala, in Shapiro and Hentoff, 127. "She had timing": Condon, 123. "no other identifiable": Peretti, 88. "all hit me": Mezzrow, 14. "He plays just": as quoted, Mezzrow, 108. "Every word that," "His whole manner": Mezzrow, 111–12, 146. "We didn't take": as quoted, Sudhalter, *Lost*, 194. "They got too," the rebel in us," "A creative": Mezzrow, 342, 127, 125.

"came out sounding": Condon, 85. "I had never heard": Mezzrow, 80. "His main interest": as quoted, Shapiro and Hentoff, 161. Bix Bio: Sudhalter, *Bix*. "the great time": Page 21, Hoagy Carmichael (and Stephen Longstreet), in *Sometimes I Wonder*. New York: Farrar Straus and Giroux, 1965. "didn't care nothin'": as quoted, Hentoff and Shapiro, 183. "The colored and the white": Foster, 136. "We tried

to see": as quoted, Shapiro & Hentoff, 159. "It's impossible": as quoted, Ibid., 158. Exotic Harlem: Leonard, *White*, 70; Smith, 141. "For Locke": as quoted, Anderson, 165. "sublimation, Western": Anderson, 54. "you have been": as quoted, Kellner, 223. "urban folk": as quoted, Anderson, 9. "squeezing all of": as quoted, Ibid., 172. Hughes heritage: Anderson, 178. "as fine as any": as quoted, Ibid., 181. "There wasn't an eastern": Bushell, 19. "I was on Bach": as quoted, Blesh, 203. Hearing Jelly: Reich and Gaines, 41. Charleston: Smith, 97. Smith Bio: Smith, 11, 12. "The weather down there," "The bands proved": Smith, 199, 124. Race records: Kirkeby, 67. The Stroll and Mezz: see Mezzrow. Wexler and Mezz: Greenfield, 26. Fats Bio: Kirkeby. Bechet and Duke: Bechet, 135; Ellington, 47. Ellington as composer: Wynton Marsalis in O'Meally, 151. "primarily in the playing": as quoted, Anderson, 225. "hard-drinking and combative": Peretti, 118. fifteen hundred pieces: Giddins, *Vision*, 106. "Mood Indigo": Ellington, 78–79.

13. The Flood, and the Blues That Followed

The Flood: Barry. Volume: Barry, 16. The levee breaks: Barry, 194–206. Will Percy: Barry, 326–335. "Lord the whole round country": "High Water Everywhere," EMI Music Publishing, Sony/ATV Music Publishing. Paramount: Charters, *Country*, 50–55; Widen, 104–5. Blind Lemon Jefferson: Uzzel. "The only place": as quoted, Uzzel, 21. "We like for women": as quoted, Uzzel, 25. "My whole family": as quoted, Uzzel, 26. Recording: Uzzel, 32, Charters, *Country*, passim. "take sympathy": as quoted, Oakley, 115. "See That My Grave": Charters, *The Bluesmen*, 176.

"Mmmm, black snake": "Black Snake Moan," Blind Lemon Jefferson. Universal Music Publishing. "When a woman": Levine, 262. "White folks on the sofa": Levine, 279. Gospel: Levine, 175. "No, when I was," "No . . . I was": as quoted, O'Neal, 39. Light Crust Doughboys: McLean, 77–78. Repertoire: McLean, 77–78, C. Townsend, passim. "greatest thing": C. Townsend, 40. Jimmie Rodgers: See Porterfield. Bluebird sound: Wald, 39–40; Broonzy, passim. Jug Bands: Charters, *Country*, 108–9. "a lonesome sound": as quoted, Calt and Wardlow, 14. Speir: Wardlow, 135, 139. "kinda forward," "He had a regular ol'": as quoted, Calt and Wardlow, 17. "was the only singer," "the only dance blues": Calt and Wardlow, 184. On "Pony Blues": Palmer, 64. Son House: Calt and Wardlow, 210. "Do it a long": as quoted, Calt and Wardlow, 216–18. Throat: Ibid., 226. Death: Palmer, 88.

14. Swing

Financial information: Oakley, 145. Stranded: Charters, *Country*, 166. Sweet bands: Lopes, 99. "nothing but New Orleans": as quoted, Daniels, 155. Reader's polls: Lopes, 127. Radio: Wald, *Beatles*, 92; Leonard, *White*, 103, 92. "the unhip public": as quoted, Peretti, 131. BBC: Stearns, 197. Goodman: Giddins, *Visions*, 154. "If we're": http://www.tuxjunction.net/bennygoodman.htm#The%20 Palomar%20Triumph. Dance band business: DeVeaux, 127. Carnegie Hall: Early, O'Meally, 424; Anderson, 231. "effected the transformation": Early, 199. "reflected the nation's": Giddins, *Visions*, 153. Red Wing Hotel story: Basie, 7–8. "just followed," "I hadn't ever really": Ibid. "For every three": as quoted, Shapiro and Hentoff, 34. "I was not alone": as quoted, Ibid., 206.

Young Bio: Daniels. "Trumbauer always told": as quoted, Sudhalter, 238. "I knew they": as quoted, Daniels, 124. "I have my own": Basie, 170. "hand-clapping elation": Giddins, *Visions*, 171, 174. Collectors: Ramsey and Smith, *Jazzmen*, 289. United Hot Clubs: Louis Armstrong, *Swing That Music*, 1936. Ramsey and Smith and Russell: *Jazzmen*, 289; Hamilton, 157–60, 171. Finding Jelly Roll: Hamilton, 161. "That is, where heritage": as quoted, Ibid., 181. "both sides have": *Jazzmen*, 105. Oliver's death: Leonard, *Myth*, 120.

15. Robert Johnson

"the personification": Guralnick, *Searching*, 2. "Investigators have hidden": Wald, *Escaping*, 106. Bio: Palmer 112, Calt and Wardlow, Wald, *Escaping*, 109. "Such another racket," "BLOO," "This your rest": as quoted, Wald, *Escaping*, 109–10. "And play, that boy": as quoted, Lomax, *Land*, 16. "He wasn't gonna": Townsend, 69. "Robert could ride," He couldn't punch": Shines to Guralnick, as quoted, Wald, *Escaping*, 112, 114–15. "Robert I hear," "We never had," "Now I had": Shines to Pete Welding, as quoted, Wald, *Escaping*, 114. "I liked his finger style": Townsend, 68. Turnaround: David "Honeyboy" Edwards in Hadley. "He'd be sitting there": Johnny Shines in the video *The Search for Robert Johnson*. "Now you take": as quoted, Guralnick, *Searching*, 20. "People were crowdin'": as quoted, Gordon, 31.

Johnson records: Wardlow, 199. "unquestionable masterpiece": Wald, *Escaping*, 142. "I said I flashed your lights" "Terraplane Blues," Music Publishing Company of America. "Now we played": "Phonograph Blues": Music Publishing Company of America. "I'm lonesome": as quoted, Guralnick, 36. Second session: Guralnick. "I got stones in my": "Stones in My Passway," Music Publishing Company of America. "Blues falling down": "Hellhound On My Trail," Music Publishing Company of America. Cops: Wardlow, 198. "I used to run around": as quoted, Hadley. "We would be justified": as quoted, Cobb, 147. Death certificate: Wardlow, 89. Burial place: "Steve Cheseborough, Gayle Dean Wardlow—Chasin' That Devil Music," Reuters, 8/15/01.

16. "Spirituals to Swing" and After

"amid finger-popping": Barker, 134, 139. "She inherited": Hammond, 14. Bio: see also Prial. Trip
to London: de Lerma, 44; Prial, 18. "Despite the influence": Hammond, 68. "has thrived in," "the
most important": "The Music Nobody Knows," 3. Bessie Smith's death: Prial, 118; Hammond, 122,
123. "I don't believe," "died last week": "The Music Nobody Knows," 4. "who farmed in Arkansas,"
"heavy make-up": Hammond, 206, 231. Show: "Spirituals to Swing" CD Box Set, Vanguard Records.
Hammond and "Strange Fruit": Prial, 130. Lead Belly: Wolfe and Yarnell, passim; Cray, 192; Hamilton.

Lomax: Filene 32; see also Nolan Porterfield, *Last Cavalier: The Life and Times of John A. Lomax,
1867–1948.* Urbana, U. of Ill. Press 1996. "Home on the Range": Filene, 242. "Irene": Wolfe and
Yarnell, 56; Abbott and Seroff, 48. "The songs would make," "the hospitality of the Prison": as quoted,
Hamilton, 103, 128. Presenting Lead Belly: Filene. "We are disturbed": as quoted, Hamilton, 119.
"Leadbelly is a nigger": as quoted, Filene, 59. Knife: Wolfe and Yarnell, 173. *Negro Folk Songs:* Wolfe
and Yarnell, 195. Left circles: Ibid., 211. "one of the most amazing": as quoted, Hamilton, 132. Camp
Unity: Wolfe and Yarnell, 210. "Grapes of Wrath Evening": Wolfe and Yarnell, 216.

Seeger: Dunaway. "with ideas," "than with intimacy": Wilkinson, 8, 10. Almanacs: Dunaway;
Cantwell, 133. Josh White: Wald, *Josh White.* Guthrie: Cray; Cantwell, 133. "pastoral and mythical":
Ibid., 137. Almanac House: Cray, 212.

17. Bop and the Music of the '40s

"I'd play the original": as quoted, DeVeaux, 190. "by using the higher": Parker, as quoted in John
Wilson and Michael Levin, "No Bop Roots in Jazz: Parker," *DownBeat,* September 9, 1949, p. 12.
"wasn't dizzy at all": Barker, 164. "strange paintings depicting": as quoted, Shapiro and Hentoff, 338.
"a benefactor since": as quoted, Ibid., 339. Monk: De Wilde, 15. "zombie music": as quoted, Shapiro
and Hentoff, 311. "I wanted to play": as quoted, DeVeaux, 222. "At Minton's Monk": Barker, 171.
"So on afternoons": as quoted, Shapiro and Hentoff, 337. "convert our style": as quoted, Ibid., 222.
"Just play the tune": as quoted, DeVeaux, 174. "I think I was": Gillespie, *To Be,* 177. "His phrasing":
as quoted, Shapiro and Hentoff, 80. "Bird could play": as quoted, Gitler, 63. "They're not particular":
as quoted, DeVeaux, 347. "We called ourselves": as quoted, Shapiro and Hentoff, 350. "Harmonically,
bebop": Giddins, *Riding,* 215.

"We were playing a real fast": as quoted, DeVeaux, 218. "a combination of the Midwestern,"
"another way of saying": as quoted, Lott. "Double V," in O'Meally, 460. Harlem riot: Lott, DeVeaux,
288. "We just figured": as quoted, DeVeaux, 167. Quiet: Szwed, 34. Fifty-Second Street: Smith, 203–
205; Szwed, 37. Kerouac: see my *Desolate Angel.* "most of today's swing": Jack Kerouac and Albert
Avakian, "Real Solid Drop Beat Riffs, *Horace Mann Record,* March 23, 1940, p. 4. "Count Basie's
swing": Kerouac, "Count Basie's Band Best in Land," *Horace Mann Record,* 2/16/40. Kerouac and
Young: Edie Parker, speaking at 1982 Naropa Kerouac conference. Moldy Figs: Bernard Gendron,
"'Moldy Figs' and Modernists: Jazz at War 1942–1946," in Gabbard, Krin, Ed., 32; Anderson, 220.
"To me as far": as quoted in Gendron, 35. "fetishizing technique": Ibid., 49.

18. Muddy Waters and Louis Jordan Change the Blues

Lomax and Work: Hamilton, 150. "the musical habits": Ibid., 151. Mechanical cotton picker: Lemann,
3, 5. Muddy and Lomax, including dialogue: Gordon, Xii, Xiv, Xv. Muddy bio: Gordon, passim. "I
belongs": Ibid., 94. "They were trying": as quoted, Filene, 96. "I said I wasn't": Dixon, 54. "My job was
to": Ibid., 83. "Man, this song": Ibid., 84.

"the soul of conventional": Segrest and Hoffman, 33. "Stop your train": "Smokestack Lightning,"
BMG/Chrysalis/Hal Leonard Corporation. "showed me things": as quoted, Shaw, 302; Guralnick, *Lost,*
283; Segrest and Hoffman, 18. "stronger than forty": as quoted, Ibid., 78. "This is for me": as quoted,
Ibid., 87. "Wolfe's best records": as quoted, Ibid., 101. "the onliest one": as quoted, Ibid., 107. "I'm
pushing him": as quoted, Ibid., 124. Wolf offstage: Ibid., 178–79.

"I don't know": as quoted, Shaw. Jordan Bio: Chilton, *Good,* 32. Jordan and Ella: Bushell, 103.
"Stepin Fetchit": Chilton, *Good,* 51–52. "My whole theory," "I made just": as quoted, Shaw, 72, 67–68.
Recording history: Chilton, *Good,* passim. Lucky Millinder: Shaw, 59. Izenhall: op. cit., 126. Ahmet
Ertegun and Atlantic Records: Greenfield, passim. "I did a little bit": as quoted, Greenfield, 351, from A.
J. Bardach, "Interrogating Ahmet Ertegun," February 25, 2005, *Slate.com.*

Use of "rock": Tosches, 6. WWII and civil rights: Marable, 13–14. Truman: Woodward, *Strange,*
141. "Rocket 88": Palmer, 223. "It was strictly": Swenson, 37. "Also I got the tenor": as quoted,
Chilton, *Good,* 194–95. "We'd begin with Jordan's": as quoted, Shaw, 64. Jesse Stone: Tosches, 15.
"(Rock) wasn't but a different": as quoted, Tosches, 25.

"I write out of love": as quoted, Spoto, 139. GOO: Hemphill. Atkins, Monroe, Tubb: Guralnick,
Lost. "He tried not": as quoted, Guralnick, *Lost,* 332. "to describe the human": as quoted, Cantwell,
82. Pete Seeger, the Weavers, and HUAC: Dunaway. *Red Channels:* Wald, *Josh,* 179. "preserved the
ideality": Cantwell, 146. Folk circuit: Dunaway, 197; Cantwell, 273. "Music is the most": as quoted,

Dunaway, 189. Harry Smith: Cantwell, 200–2. "as if each selection": Cantwell, 197–98. "old weird America," "an occult, Gothic": Marcus, *Bob Dylan*, 280.

19. Folk Roots and '50s Rock

Civil rights: see Woodward, *Strange*. "celebrated for qualities": Ibid., 165. Manifesto: Marable 41. Berry: see Pegg. Recording: Ibid., 40. "Maybellene": Pegg, 110. Song hits: Pegg, 58. "Hound Dog": Wald, *Beatles*, 190. Berry and race: Pegg, 69, 85. "South Pacific": Wald, *Beatles*, 196. "the crucial image": Marcus, *Train*, 143. Berry trials: Pegg, 123.

20. The Beats and Folk Emerge and Jazz Ascends

"historic occasion," "the most beautifully": as quoted, McNally, 240. "a different sort of person": Holmes, *Nothing More to Declare*, 105. "Blow As Deep": McNally, 140. "I dig jazz," "like Bop, we're": Kerouac, *Visions*, 40, 296. "Procedure: Time being": Jack Kerouac, "Essentials of Spontaneous Prose," *Evergreen Review*, Summer 1958. "mad ones," "mad jazz," "Don't worry," "The behatted," "that gloomy, saintly," "eternity on": Kerouac, *Road*, 9, 116, 116, 162, 197–98, 205. Ginsberg and Lester Young: Ginsberg, *Composed On the Tongue*, edited by Donald Allen. Bolinas, California: Grey Fox Press, 1980, 43.

"superannuated ideological": Cantwell, 18. "So we all owe": as quoted, Marqusee, *Redemption*, 42. "Tom Dooley": Cantwell, 2–3. Burl Ives: John Rockwell, "The Foggy Foggy Dew," Wilentz and Marcus. Belafonte: Cantwell, 276. Washington Square: Cantwell, 287. Newport Folk Festival: Cantwell, 295; Bruce Jackson, "The Folksong Revival," Rosenberg. Baez Bio: Baez.

Jazz to Village: Ted Panken, "When Giants Walked the Village," *DownBeat*, June 2005. "I came from," "blues, church, back-road": Davis and Troupe, 19, 29. Bix influence: Szwed, 21. "I just couldn't believe": Davis and Troupe, 61. "like hearing music": as quoted, Szwed, 62. "cool, green, quarter": Szwed, 52. "It floods": Davis and Troupe, 99. "All music is": as quoted, Watts, 450. "It came from Duke": Davis and Troupe, 119.

Coltrane bio: Thomas. Technique: Palmer, 13. "And faster than": Davis and Troupe, 196. "dry, unplaned tone": as quoted, Ibid., 196. "After a while": Ibid. Five Spot: Kastin, Amram. "The painters not only": Amram, 263. "[Jazz is] everything": as quoted, Kastin, 66. "the only really creative": Lee Krasner, as quoted, Friedman, 88. "Monk is exactly": as quoted, Kahn, 29. "Working with Monk": as quoted, Don. DeMichael, "Coltrane on Coltrane," *DownBeat*, September 29, 1960. "on a mission," "had that blues," "more modal, more African," "And in the modal," "from being back": Davis and Troupe, 224, 193, 220, 225, 234. "Zenlike," "one-take meditations": Giddins, *Visions*, 349. "Miles fell": Cole, 153. "an enduring delight", Giddins, *Visions*, 483. "If you do not have": as quoted, Kahn, 13.

21. The Blues Revival

Muddy's guitar: Filene, 124. *Rockin' Chair Album*: Segrest and Hoffman, 191. "Instead, by our": Titon, 223. "great age, obscurity": Keil, 38. "a wizard, a prophet," "that the Delta Blues," "before any of us," "the furniture stores," "set up record": Hamilton, 210, 209, 212, 220, 210. Korner: Wald, *Beatles*, 238–39. Muddy in England: Filene, 119; Gordon, 158–62. Charters: Charters, *Country*, Introduction; Hamilton, 226. "title maintained": Wald, *Escaping*, 241. McKune's response: Hamilton, 228. Origin Jazz Library: Hamilton, 231. Finding Son House: von Schmidt and Rooney, 193; Hamilton, 194. Skip James: Calt, *I'd Rather*. "We also consciously": Guralnick, *Lost*, 197. Rediscoverers: Phil Spiro in von Schmidt and Rooney, 198.

A.F.B.F.: Filene, 122; Segrest and Hoffman, 215; Dixon, 135. "They're awful": Levon Helm, as quoted in Palmer, 263. "a creation of the Rolling," "part of the European: Wald, *Escaping*, 220, 263. "the greatest negro": Hammond as quoted, de Lerma, 59; *New Masses*, March 3, 1937; Pearson, 18. "a worker": *New Masses*, June 8, 1937; Pearson, 20. "uncanny and weird," "sounds possessed," "The high, sighing": Blesh, *Shining*, 121–22. "the real Puritans," "changed the way": Marcus, *Train*, 22, 31. "Did Robert really": as quoted, Pearson, 106. "Doomed, haunted, dead": as quoted, Pearson, 36.

Son and supernatural: Pearson, 30, 90. "Son House was convinced": as quoted, Wardlow, 200. "unabashed identification": Palmer, 18, 113. "It may be Robert": Edwards, 105. Honeyboy and Johnson death: Pearson, 16. "The idea of something": Hamilton, 11–12.

22. Bob Zimmerman Becomes Bob Dylan

"We shall not cease from exploration": "Little Gidding," *Four Quartets*, 208. Midwest virtue: Shortridge, passim. "the land of purity," "a moral beacon," Amato and Amato, Graubard. Zimmerman family: Sounes 13, Engel 13. "I believe there is iron": as quoted, Engel, 13. Mine figures: Shelton, 26. "Nothing moved": as quoted, Rosenbaum. BD on mines: Shelton 16; Engel 129. "vacuum": Shelton, 25. "I've never felt Jewish": as quoted, Rosenbaum. Country Club: Shelton, 37. Chanukah: Engel, 63. "The kids used to tease": as quoted, Heylin, 9. "poems, rhythms": as quoted, Martin Bronstein, CBC, 2/20/66. Hearing Hank Williams: Sounes, 22; "voice and tell my tale": Dylan, Liner Notes to *Joan*

Baez in Concert. "strange incantation": BD in Scorsese. Sears guitar: Rosenbaum. "And once I had": as quoted, Loder. "When I first heard": as quoted, Sounes, 27.

"This is really great": as quoted, Spitz, 42. Little Richard; Santelli; Heylin, 14. "Everything. the sound": BD, Santelli, 8–9. "and I slambanged": BD, Santelli, 9. Little Richard bio: White. "Ten years": as quoted, Sounes, 27. Glissendorf: Sounes, 30. Bongs: Shelton, 45. "tried to push," "We've given you": as quoted, Shelton, 42, 23. Car, motorcycle: Sounes, 30. "I used to make him": as quoted, Siegel. "real quiet after": as quoted, Spitz, 61. "We were strictly": as quoted, Spitz, 39. Shadow Blasters: Sounes, 29; Engel, 152.

Echo: Spitz, 58. "Chuck Berry, Fats," "all with his eyes": as quoted, Thompson, 67. Gatemouth Page: see Wes Smith, *The Pied Pipers of Rock and Roll*, Longstreet Press, 1989. Also Scorsese, Sounes, 23; Loder, Heylin, 24. Stan's Record shop: Spitz, 35–36. "I always felt like": BD, *Chronicles*, 240–41. "If you were different": as quoted, Scaduto, 11. Echo's family: Shelton, 48. "brought out the poet": BD, Scorsese. Romance: Sounes, 34. "sheltered": as quoted, Scaduto, 14. "I see things": as quoted, Siegel. "Nobody liked their music": as quoted, Thompson, 70. Golden Chords: Shelton 41, Spitz 49–50, 53; http://www.b-dylan.com/pages/samples/leroyhoikkala.html.

"He and the others": as quoted, Sounes, 35. Smirking: Engel 79, Thompson 38. "Listen," "At first I couldn't": as quoted, Thompson, 71. "They couldn't give": as quoted, Spitz, 67. Losing LeRoy and Monte: Heylin, 21. "the guys who took": BD, *Chronicles*, 43. Jim Dandy: Engel, 178. "I remember Jim": as quoted, Spitz, 48. Comedian: Spitz, 11. "the Bearded Lady . . .": Dylan on BobDylan.com (in connection with 2009 release of *Together Through Life*), as quoted, Wilentz, 169. New name: Scaduto, 33; Sounes, 38; Spitz, 68. "Shhh": as quoted, Thompson, 75. Graduation: Shelton, 55. Lead Belly: Sounes, 40. "I've discovered": as quoted, Ibid., 56.

"fraternity brothers thought": as quoted, Spitz, 73. False claims: Ibid. Eliot at UM: Ackroyd, 317. "beat scene, the Bohemian": as quoted, Crowe. "every day was like": as quoted, Shelton, 70. "what I read about": BD, *Chronicles*, 235. Odetta: Rosenbaum. "outlaw women, super": BD, *Chronicles*, 236. "filled with more despair": as quoted, Crowe, 26. "Right then and there": as quoted Rosenbaum. "was the purest": as quoted, Heylin, 39. Koerner: Crowe. Blind Lemon Jefferson, Patton: BD, *Chronicles*, 239. Debut at Scholar: Spitz, 84. "I also failed": BD, "My Life in a Stolen Moment" (poem for a concert program). Christmas 1959: Spitz, 82, 83.

HUAC: http://www.fsm-a.org/stacks/AP_files/APHUAC60.html. Greensboro: Woodward, Strange, 169. Nashville: Halberstam; Lewis, 94–102. Gretel Hoffman: Spitz, 91. Bonnie Beecher: Sounes, 46–47. Dave Whitaker: Spitz, 94; Sounes, 55; Heylin, 43. "It blew my": Wilentz, 49. Glover and *Naked Lunch*: Ibid. Denver: Sounes, 60, 61; Heylin, 45; Spitz, 102. "Blackjack Blues": Heylin, 41. "It was like the record": BD, *Chronicles*, 244. "He was like a guide": BD, "Tribute to Woody Guthrie" program notes. "Messedup. Mixed-up," "fistic sweatshop": Guthrie, 25, 111. Guthrie Bio: Cray, 109, 134. "The folk and blues tunes": BD, *Chronicles*, 248. "Woody turned me on": as quoted, Hajdu, 70–71. "He became very": as quoted, Shelton, 75. "It's all poetry": as quoted, Sounes, 59. Madison: Sounes, 68–70.

23. Dylan in New York

"Instead a bein": BD, Peter Paul and Mary *In the Wind* album liner notes. Fred Neil, Spoelstra: Spitz, 123, 126–27. "a tonsilly scranch": Ibid., 123. "Bobby didn't change": as quoted, Shelton, 127. "the hard core of selfishness": Raymond Chandler to Hamish Hamilton, June 23, 1950, *Selected Letters of Raymond Chandler*, 220. Frank MacShane, Editor. New York: Columbia University Press, 1981. "It wasn't an act": Andrew Loog Oldham, *Stoned*, New York: St. Martin's Press, 150. "hard-lipped folk," "They weren't friendly": BD, *Chronicles*, 6, 34–35. "weird," "full of legend": as quoted by David Marsh, Wilentz and Marcus. "Mystery is a fact": as quoted, Hentoff, *Playboy*, 130. "lexicon and my prayer": as quoted, Gates. "rock 'n' roll attitude": as quoted, Crowe, 10.

Gleason salon: Sounes, 77. "The boy's got it!": as quoted, Spitz, 139. "That men are men": BD, "11 Outlined Epitaphs." Romney: Shelton, 91. Gaslight: Spitz, 133; van Ronk, 146, Wilentz, 58. Gospel: BD to Cott. Liam Clancy: BD to Derek Bailey, July 8, 1984. Folklore Center: von Schmidt and Rooney, 129. "a world of music": as quoted, Rosenbaum. Gerde's: Rotolo, 16. "like he had transmitted," "We all play folk music,": as quoted, BD, *Chronicles*, 94. "I was close up": Cohen, *Spin*, 1985.

"What he was doing": as quoted, Sounes, 91. Van Ronk songs: Shelton, 100. "like a soldier" "brought me into": BD *Chronicles*, 15, 262. Van Ronk bio: Van Ronk. Jazz Clubs: BD, *Chronicles*, 262. Indian Neck, Cambridge: von Schmidt and Rooney. "You could be loose": as quoted, Ibid., 65. Ron Silver: Sounes, 94. "Everything about the movie": as quoted, Sounes, 97.

"while still in our cribs": Rotolo, 45. Rotolo bio: Ibid. "Meeting her was like": BD, *Chronicles*, 265. "neither one of us": Rotolo, 10. "Uncle Dave Macon": BD, *Chronicles*, 269. Villon: BD to Cohen. "They were to be teachers": Halberstam, 79. "We Shall Overcome": Filene; Halberstam, 231; Lewis, 82. Freedom Rides: Halberstam, Lewis. "You're going to get": as quoted, Halberstam, 286. "It was madness": Lewis, 156. "as good as it was possible," "I would have," "I did everything" "Back there, America": BD, *Chronicles*, 70, 71, 84, 86. Bear Mountain: Shelton, Harvey, 102. RAZ: Rotolo, 103. Hester: Hajdu. Shelton and Hester: Hajdu, 36–37, Spitz, 164. "bursting at the seams," "music-making

has the mark," "vague about his antecedents": Robert Shelton, "Bob Dylan: A Distinctive Folk-Song Stylist/20-Year-Old Singer is Bright New Face at Gerde's Club," *New York Times*, September 29, 1961. Hester session: Shelton, 113. "Bobby, I don't know": Hammond, 351. Signing with Hammond: Heylin, 77; BD, *Chronicles*, 221; Hammond, 351; Prial, 221. "The gist of it": as quoted, Spitz, 170. "already had me," "From the first note": BD, *Chronicles*, 281, 282. Playing Johnson: Heylin, 99. "Dylan was always": Santoro, 168. Preparation for recording: Shelton, 133; Spitz, 173. "popped every p": as quoted, Heylin, 83.

24. The Movement and Changes

West Fourth Street apartment: Rotolo. "I don't want to get": as quoted, Spitz, 187. "He was no opportunist": as quoted, Scaduto, 142. "He always seemed": Van Ronk, 204. First drafts: Hilburn. "It's important to always": as quoted, Hilburn. Early songwriting: Harvey; Heylin. Publishing: Sounes, 109–10; Colin Escott, liner notes for *The Witmark Demos, 1962–1964*. Broadside: Harvey; Scaduto; Shelton, 139; Heylin, 90. "He was always": as quoted, Spitz, 185. "If nothing else": Dylan to Hentoff, 1964. "explosive country-blues": *Village Voice*, April 19, 1962. "You'll drop him over": Hammond, 352. Spivey bio: Harrison. "Bobby, you know": as quoted, Sounes, 112. "Hey Bobby! I," "I will always": as quoted, Van Ronk, 163, 163. "your silence betrays": Scaduto, 139. "lucky classic," "one dimensional,": as quoted, Shelton, 60.

"incredibly dumb": as quoted, Spitz, 193. Yarrow's take: Sounes, 135. Spoelstra songwriting: Spitz, 190. "The true fortuneteller": BD, "11 Outlined Epitaphs." "recombining and reforming": Paul Williams, 50. Recording *Freewheelin'*: Heylin; Shelton. "the dogs are waiting": as quoted, Rotolo, 178. "Ordinarily you go to": as quoted, Cluster, 19. Seeger in Albany: Dunaway, 222. Freedom Singers: Cluster, 18. "Some whites moved": Shelton, 150. Name change: Sounes. "the virtues of acquired": Heylin, 98. Grossman contract: Sounes, 117; Heylin, 95. Dwarf Music: Sounes, 198. "summarily dismissed": Spitz, 179. Tom Wilson: Marcus, *Stone*, 104. "Hard Rain": Ricks, 342, Sounes 122; Harvey, 2–6. "know my song well": "A Hard Rain's A-Gonna Fall," Special Rider Music. "when I wrote it": BD to Hentoff, 1963. "I remember being confused": as quoted, Spitz, 205. "waiting for the world": as quoted, Rotolo, 19. Oxford: Woodward, *Strange*, 175. "Well, yeah, it deals": as quoted, Ricks, 247. "somebody better investigate": "Oxford Town," Special Rider Music. Three civil rights songs: Heylin, 113–14.

Snubbed by MacColl: Shelton, 253. Martin Carthy: Sounes, 128. "Nottamun Town": Harvey, 70. "build to destroy," "Like it's your little toy," "For the others to fire": "Masters of War," Special Rider Music. "Hard Rain" and Ginsberg: Scorsese. "It seemed to me that the torch": http://webcache.google-usercontent.com/search?q=cache:wI0lSfoe0kkJ:www.oceanstar.com/patti/bio/ginsint.htm+bob+dylan+desire+liner+notes+bolinas+ginsberg&cd=7&hl=en&ct=clnk&gl=us.

"Dylan really was amazing": von Schmidt and Rooney, 116. Reunion with Suze: Rotolo, 199. Photo shoot: Rotolo. Folk albums: Wald, *Beatles*, 226. Seeger: Dunaway, 210. "Let us rise": http://www.archives.state.al.us/govs_list/inauguralspeech.html. "the most segregated": Lewis, 195. Birmingham: Woodward, *Strange*; Lewis. "He'll stop the next": "With God On Our Side," Special Rider Music. Ed Sullivan: Spitz, 215. "If I can't sing": Ibid. "problem began," "What *is* this?" "It's all bullshit": Clive Davis, 56. Meeting Baez: Heylin, 119; Hadju, 147. "She had the fire": BD, *Chronicles*, 256. "He was a Sunday": Baez, *Voice*, 85. "crackin shakin": BD, liner notes, *Joan Baez in Concert, Part 2*. "dragging my little vagabond": Baez, *Voice*, 91. "Blowin" covers: Shelton, 164. "then wait for him": Rotolo, 274. "any important philosophy": BD to Santelli, 35. Woodstock: Hadju, 178; Shelton 165, 381; Rotolo, 227; Sounes, 139. Bikel: Sounes, 133. "were more important," "outargued me": as quoted, Heylin, 123. White Citizens: Cobb, 228. Arrests: Marable, 116. Fannie Lou Hamer: Marqusee, *Chimes*, 74. "as a horse," "Sometimes it seems": as quoted, Cobb, 244, 243. "it looks different," "He can't afford": as quoted, Sounes, 133. "humble": as quoted, Shelton, 179. "The Greenwood people": as quoted, Ibid. "And the Negro's name": "Only A Pawn in their Game," Special Rider Music.

25. An Existential Troubadour

Newport Folk Festival: Bruce Jackson, "Folksong Revival," Rosenberg, 77. "This is a song about a love affair": Hajdu, 103. "And here he is": as quoted, BD, *Chronicles*, 115. "a march *in*": Lewis, 215. "We will march through," "too little," "which side is the federal," "We must say": Lewis, 219–21. "Tell 'em about": Clarence Jones, "On Martin Luther King Day, remembering the first draft of 'I Have a Dream" *Washington Post*, January 17, 2011. "Hattie Carroll": BD to Crowe; Ricks, 221–33; Heylin, 125, Marqusee, *Chimes*. "perfect": Ricks, 233. "was definitely a song": BD to Crowe. Mindguard: Sounes, 146. "but seemed to have lived": Baez, *Voice*, 56. "they'll throw rocks," "And I couldn't understand": as quoted, Scaduto, 160. Bertrand Russell: Spitz, 240. "There's no black and white": as quoted, Heylin, 137. "The only thing is": as quoted, Shelton, 204. "Away away be gone": BD to *Broadside*. "I was more a cowpuncher": BD to Crowe, 31. Ego and salvation: Ricks. "the dust of rumors," "remain as I am":"Restless Farewell," Special Rider Music. "who t'picket," "Jim, Jim/where": "11 Outlined Epitaphs." "The Left opened a door": as quoted, Shelton, 192. "Not pointless to dedicate": BD to Hentoff, 1966. "When he simply": as quoted, Shelton, 150. "magic politics," "a kind of poetry": as

quoted, Dickstein, 22. "The only real shocks": as quoted, Ibid., 101. "*strikin for the gentle*": as quoted, Wilentz, 69.

"irony, ambiguity," "Holy Trinity": Dickstein, 15. "The birds are chained": as quoted, Spitz, 256. The trip: Shelton, 241. "Their chords were outrageous": as quoted, Scaduto, 203–4. "whose strength is not to fight," "the luckless, the abandoned," "the mistreated," "for every hung-up": "Chimes of Freedom," Special Rider Music. "Mr. Tambourine Man": BD to Crowe; Sounes, 147; Shelton. "take me on a trip": "Mr. Tambourine Man," Special Rider Music. LSD: Spitz, 273–74. "I do got things": as quoted, Heylin, 140. "We talked a lot," "With a resigned sadness": Rotolo, 272, 277. "under this wave": as quoted, Heylin, 155. Bucklen story: Ricks, 155, 157. "There aren't any": as quoted, Heylin, 160. "come an' make my": "Spanish Harlem Incident," Special Rider Music. "I was so much older," "Fearing not that": "My Back Pages," Special Rider Music. "Nothing to win," "Everything passes": "To Ramona,"Special Rider Music. "I stopped thinking": Scaduto, 205. "begged and pleaded," "seemed a negation": BD to Crowe.

"Don't come to Mississippi": as quoted, Lewis, 256. Movement: Lewis, 274; Woodward, Strange, 164. "That was the turning point": Lewis, 292. Free speech movement: Rossman. "There comes a point": www.youtube.com/watch?v=tcx9BJRadfw. Johnny Cash: Shelton, 261. "The songs are insanely": as quoted, Heylin, 164. "tenth-rate drivel": as quoted, Shelton 313. "the paraphernalia": Ibid. "Relationships of ownership": "Gates Of Eden," Special Rider Music. "he not busy being": "It's Alright Ma (I'm Only Bleeding)," Special Rider Music.

26. Home Again to Rock 'n' Roll

Recording: Heylin, 175–76; Sounes, 167–68. "the laughter is": Shelton, 272. "Love Minus Zero": Ricks, 289–98. "I accept chaos": Liner Notes, *Bringing It All Back Home.* "Wow man, you can": as quoted, Heylin, 179. "Now, Dr. King," "We'll write [a voting rights bill]" as quoted, Halberstam, 482. "Oh yes Reverend": Ibid., 484. Edmund Pettus Bridge: Lewis, 341. "This was a face-off": Ibid., 344–45. "Because it is not just Negroes": as quoted, Halberstam, 516. Voting statistics: Marable, 79. "I rode on Joan": as quoted, Hajdu, 247. "BEATLES SAY": Shelton, 288.

"To be the constant target": as quoted, Heylin, 181. "the same sense about": as quoted, Spitz, 280. British record charts: Heylin, 186. "Keep a good head," "We all have different," "Because you're hostile": *Dont Look Back*; Shelton, 291. Henshaw: Heylin 187. "He conducted the session": as quoted, Spitz, 285. "We all sat on the floor": as quoted, Heylin, 188. Dana Gillespie: Sounes, 173. "It was not love": Baez, *Voice*, 96. "know what's happening": as quoted, Baez, *Voice*, 96. "I'm a small cat": *Dont Look Back.* "It's gonna happen fast": Ibid. "I looked in a closet," "T. S. Eliot": Ibid. "a takeoff": as quoted, Heylin, 185. "a crashing but meaningless": "Gates Of Eden," Special Rider Music. "After I finished the English": as quoted, Siegel. "I was playing a lot": BD to Hentoff, 1966.

"La Bamba": BD to Crowe. "piece of vomit": as quoted, Nigel Williamson. "all about my steady," "I had never thought": as quoted, Scaduto, 244–45 (from Siegel). "Once upon a time . . . so fine . . . mystery tramp . . . no direction home." "Like A Rolling Stone," Special Rider Music. "very *strange*": Marcus, *Stone*, 8. "to inoculate": BD to Rosenbaum. "He couldn't really": as quoted, Heylin, 119. "I figure he wanted": as quoted, Nigel Williamson. "It was very weird," "It was just like": as quoted, Heylin, 203, 204. "He just sort of scoffed": as quoted, Marcus, *Stone*, 111. "In the verses": as quoted, Ibid, 115–16. "Jonathan Edwards' *Sinners*": Ibid., 117. "that thin, that wild": Dylan to Ron Rosenbaum, 1978. "I knew the song": as quoted, Heylin, 205. "Around 11 p.m.": Considine. "exploit and commercialize": as quoted, Considine.

"sounded like somebody's": as quoted, Heylin, 205. "I discovered something": Shelton. "the organized religion": Dickstein, 186. Venue overwhelmed: Sounes, 180. Newport: Boyd, 94. Lomax introduction: as quoted, von Schmidt and Rooney, 253. Butterfield show: Spitz, 301. "What kind of a fucking": as quoted, von Schmidt and Rooney, 258. Board meeting: Boyd, 99. "in 1965 it was," "Certainly boos were": Boyd, 103, 103. Glover: Manchester Trade Union Hall 1966 liner notes. "You go out there," "being in the eye," "grinning like cats, "Tell Alan the board": Boyd, 104–5. "Want to hear more": as quoted, von Schmidt and Rooney, 262. Ronnie Gilbert: Ibid, 261. "some of the most destructive": Filene, 215; Dunaway, 249. "visibly shaken": as quoted, Sounes, 183. "I would, but": as quoted, von Schmidt and Rooney, 265.

"head of the Chamber": "Tombstone Blues," Special Rider Music. Recording: Heylin, 218; Sounes, 185. "You have reason to be": as quoted in Joel Selvin, unpublished manuscript. Vesuvio's: Larry Keenan, in Sounes, 197. Rhyme scheme: Ricks, 43. *Desolation Angels* and "Desolation Row": Wilentz, 81–82. "Oh, that's someplace": Wilentz 82, from KQED press conference 12/3/65. "*naked* lunch": William Burroughs introduction to *Naked Lunch*, New York: Grove Press, 1959. Clues: Dickstein, 124 "though meaningless": Liner Notes, *Highway 61 Revisited*, Special Rider Music. Minstrel/Alchemist: Wilentz, 12, 335. "If somewhere in this": Du Bois, 190.

Bibliography

Abbott, Lynn, and Doug Seroff. *Out of Sight: The Rise of African American Popular Music, 1889–1895.* Jackson: University of Mississippi Press, 2002. ("A & S")

Abrahams, Roger D. *Singing the Master: The Emergence of African American Culture in the Plantation South.* New York: Penguin Books, 1992.

Ackroyd, Peter. *T. S. Eliot: A Life.* New York: Simon and Schuster, 1984.

Albertson, Chris. *Bessie.* New Haven: Yale University Press, 2003.

Ambrose, Stephen E., and Douglas G. Brinkley. *The Mississippi/and the Making of a Nation.* Washington, D.C.: National Geographic, 2003.

Amram, David. *Vibrations.* New York: Macmillan Co., 1968.

Anderson, Paul Allen. *Deep River: Music and Memory in Harlem Renaissance Thought.* Durham & London: Duke University Press, 2001.

Appel, Alfred Jr. *Jazz Modernism.* New York: Alfred A. Knopf, 2002.

Armstrong, Louis, edited by Thomas Brothers. *Louis Armstrong, in His Own Words.* New York: Oxford University Press, 1999. ("LA-OW")

———. *Satchmo: My Life in New Orleans.* New York: A Da Capo Paperback. 1986. ("LA-S")

Baez, Joan. *And a Voice to Sing With.* New York: Summit Books, 1987.

Baker, Chet. *as though i had wings.* New York: St. Martin's Griffin, 1997.

Bane, Michael. *Willie.* New York: A Dell/James A. Bryans Book, 1984.

Barker, Danny. *A Life In Jazz.* New York: Oxford University Press, 1986

———. Edited by Alyn Shipton. *Buddy Bolden and the Last Days of Storyville.* London and New York: Cassell, 1998.

Barnes, Harper. *Never Been a Time: The 1917 Race Riot That Sparked the Civil Rights Movement.* New York: Walker & Company, 2008.

Barry, John M. *Rising Tide: The Great Mississippi Flood of 1927 and How It Changed America.* New York: Simon & Schuster, 1997.

Basie, Count, as told to Albert Murray. *Good Morning Blues.* New York: Da Capo Press, 1995.

Bechet, Sidney. *Treat It Gentle.* New York: Da Capo Press, 2002.

Benfey, Christopher. "Emily Dickinson's Secret Lives," *New York Review of Books,* January 17, 2002.

Berlin, Edward. *King of Ragtime: Scott Joplin and His Era.* New York: Oxford University Press, 1994.

Blesh, Rudi. *Shining Trumpets: A History of Jazz.* New York: Da Capo Press, 1980.

Blesh, Rudi, and Harriet Janis. *They All Played Ragtime.* New York: Oak Publications, 1966.

Boritt, Gabor. *The Gettysburg Gospel.* New York: Simon and Schuster, 2006.

Boyd, Joe. *White Bicycles.* London: Serpent's Tail, 2006.

Bradford, Perry. *Born With The Blues.* New York: Oak Publications, 1965.

Bragg, Rick. "Driving the Blues Trail, In Search of a Lost Muse." *New York Times* online, April 19, 2002

Branch, Taylor. *Parting the Waters: America in the King Years 1954–63.* New York: Simon and Schuster Paperbacks, 1988.

Brinkley, Doug. *Bob Dylan's America.* (Interview). Rolling Stone, May 14, 2009, 42.

Brooks, Tim. *Lost Sounds: Blacks and the Birth of the Recording Industry, 1890–1919.* Urbana and Chicago: University of Illinois Press, 2005.

Broonzy, Bill. *Big Bill Blues.* New York: Oak Publications, 1964.

Brothers, Thomas. *Louis Armstrong's New Orleans.* New York: W. W. Norton & Co., 2006.

Brunn, H. O. *The Story of the Original Dixieland Jazz Band*. New York: Da Capo Press, 1977.

Buell, Lawrence. *The Environmental Imagination: Thoreau, Nature Writing, and the Formation of American Culture*. Cambridge: The Belknap Press of Harvard University Press, 1995.

Buerkle, Jack V., and Danny Barker. *Bourbon Street Black: The New Orleans Black Jazzman*. New York: Oxford University Press, 1973.

Bushell, Garvin, as told to Mark Tucker. *Jazz From the Beginning*. New York: Da Capo Press, 1998.

Calt, Stephen. *I'd Rather Be the Devil*. Chicago: Chicago Review Press, 2008.

Calt, Stephen, and Gayle Wardlow. *King of the Delta Blues: The Life and Music of Charlie Patton*. Newton, NJ: Rock Chapel Press, 1988.

Cantwell, Robert. *When We Were Good: The Folk Revival*. Cambridge: Harvard University Press, 1996.

Cash, Johnny, and Patrick Carr. *Cash*. New York: Harper Paperbacks, 1997.

Cash, Wilbur J. *The Mind of the South*. New York: Vintage Books, 1991.

Cavell, Stanley. *The Senses of Walden*. New York: Viking Press, 1972.

Chadwick-Joshua, Jocelyn. *The Jim Dilemma*. Jackson, MS: The University Press of Mississippi, 1998.

Chapman, Richard M. "Mixing New and Old Wine in Minnesota: Spirituality, Ecumenism, and Religious Traditions in Ferment." *Daedulus* 129, no. 3, summer 2000.

Charters, Samuel. *The Country Blues*. New York: Da Capo Press, 1975.

————. *The Poetry of the Blues*. New York: Avon Books, 1963.

Childs, Marquis. *Mighty Mississippi: Biography of a River*. Ticknor & Fields, New Haven and New York, 1982.

Chilton, John. *Let the Good Times Roll: The Story of Louis Jordan & His Music*. Ann Arbor: University of Michigan Press, 1994.

————. *Sidney Bechet: The Wizard of Jazz*. New York: Da Capo Press, 1996.

Christensen, Laird, and Hal Crimmel, editors, *Teaching About Place*. Reno: University of Nevada Press, 2008.

Christgau, Robert. "Up from Darien," *Village Voice*, 1998. (Multibook Review of Charles Keil)

Clemens, Samuel. *The Autobiography of Mark Twain*. New York: Harper Perennial, 1990.

Cluster, Dick, editor. *They Should Have Served That Cup of Coffee*. Boston: South End Press, 1979.

Cobb, James C. *The Most Southern Place on Earth: The Mississippi Delta and the Roots of Regional Identity*. New York/Oxford: Oxford University Press, 1992.

Cohen, Scott. *Yakety Yak*. New York: Simon & Schuster, 1994.

Cohn, Lawrence, editor. *Nothing But the Blues: The Music and the Musicians*. New York: Abbeville Press, 1993.

Cole, Bill. *John Coltrane*. New York: Da Capo Press, 1993.

————. *Miles Davis: the early years*. New York: Da Capo Press, 1994.

Condon, Eddie. *We Called It Music*. New York: Da Capo Press, 1992.

Considine, Shaun. "The Hit We Almost Missed." Op-Ed Section, *New York Times*, December 3, 2004.

Cott, Jonathan. *Wandering Ghost: The Odyssey of Lafcadio Hearn*. New York: Alfred A. Knopf, 1991.

Cray, Ed. *Ramblin' Man: The Life and Times of Woody Guthrie*. New York: W.W. Norton & Co., 2004.

Crosby, David, and David Bender. *Stand and Be Counted*. San Francisco: HarperSan Francisco, 2000.

Curtis, Susan. *Dancing to a Black Man's Tune: A Life of Scott Joplin*. Columbia, MO: University of Missouri Press, 1994.

Davis, Clive, with James Willwerth. *Clive: Inside the Record Business*. New York: Ballantine Books, 1974.

Davis, David Brion. *Inhuman Bondage: The Rise and Fall of Slavery in the New World*. New York: Oxford University Press, 2006.

Daniels, Douglas Henry. *Lester Leaps In*. Boston: Beacon Press, 2002.

Davis, Francis. *The History of the Blues*. New York: Hyperion, 1995.

————. *Outcats*. New York: Oxford University Press, 1990. ("O")

Davis, Miles, with Quincy Troupe. *Miles*. New York: Simon and Schuster, 1989. ("MD")

Delong, Thomas. *Pops: Paul Whiteman, King of Jazz*. Piscataway, NJ: New Century Publishers, 1983.

Dempsey, Terrell. *Searching for Jim: Slavery in Sam Clemens's World*. Columbia, MO.: University of Missouri Press, 2003

DeVeaux, Scott. *The Birth of Bebop: A Social and Musical History*. Berkeley: University of California Press, 1997.

de Lerma, Dominique-Rene., ed. *Black Music in Our Culture*. Kent, Ohio: Kent State University Press, 1970.

de Wilde, Laurent. *Monk*. New York: Marlowe & Co., 1996.

Dickinson, Emily. *The Selected Poems of Emily Dickinson*. New York: The Modern Library, 2000.

Dickstein, Morris. *Gates of Eden: American Culture in the Sixties*. New York: Basic Books, 1977.

Dixon, Willie, with Don Snowden. *I Am The Blues*. New York: Da Capo Press, 1989.

Dougherty, Steve. "Highway 61, Visited." *New York Times* (online), September 11, 2005.

Driggs, Frank, and Harris Lewine. *Black Beauty, White Heat*. New York: Da Capo Press, 1995.

Du Bois, W. E. B. *The Souls of Black Folk*. New York: Fawcett Publications, 1961.

Dunaway, David King. *How Can I Keep from Singing: Pete Seeger*. New York: McGraw-Hill Book Company, 1981.

Dunlap, ? "Title Unknown," unpublished manuscript.

Dylan, Bob. *Another Side of Bob Dylan*, Columbia Records recording, 1964.

——. *Blonde on Blonde*, Columbia Records recording, 1966.

——. *Bob Dylan*, Columbia Records recording, 1962.

——. *Bringing It All Back Home*, Columbia Records recording, 1965.

——. *Chronicles, Volume One*. New York: Simon and Schuster, 2004.

——. *The Freewheelin' Bob Dylan*, Columbia Records recording, 1963.

——. *Highway 61 Revisited*, Columbia Records recording, 1965.

——. Liner Notes to *Peter Paul and Mary, In the Wind; Joan Baez In Concert, Part 2*.

——. *The Times They Are A-Changin'*, Columbia Records recording, 1964.

Dylan, Bob, interview by Nora Ephron and Susan Edmisten, 1965, http://www.interferenza.com/bcs/interw/65-aug.htm.

Dylan, Bob, interview by Nat Hentoff. "The Playboy Interview," *Playboy*, February 1966.

Dylan, Bob, interview by Ron Rosenbaum. "Interview," *Playboy*, February 1978, http://www.interferenza.com/bcs/interw/play78.htm.

Dylan, Bob, with Jonathan Cott. "Bob Dylan: The Rolling Stone Interview," *Rolling Stone*, November 16, 1978.

Dylan, Bob, with Kurt Loder. "Bob Dylan: The Rolling Stone Interview," *Rolling Stone*, June 21, 1984.

Dylan, Bob, with Scott Cohen, "Not Like a *Rolling Stone* Interview," *Spin*, December 1985.

Early, Gerald. *The Culture of Bruising*. Hopewell, NJ: The Ecco Press, 1994

Edwards, David Honeyboy. *The World Don't Owe Me Nothing*. Chicago: Chicago Review Press, 1997.

Eisenberg, Evan. *The Recording Angel: Explorations in Phonography*. New York: McGraw-Hill Book Company, 1987.

Elie, Louis Eric. "Rebuild a Second Line," *DownBeat*, September 2006.

Eliot, T. S. *Collected Poems 1909–1962*. New York: Harcourt Brace Jovanovich, 1963.

Ellington, Edward Kennedy "Duke." *Music Is My Mistress*. New York: Da Capo Paperback, 1973.

Ellison, Ralph. *The Collected Essays of Ralph Ellison*. New York: Random House Digital, 2003. (specifically including "Change the Joke and Slip the Yoke.")

Engel, Dave. *Just Like Bob Zimmerman's Blues: Dylan in Minnesota*. Mesabi, Rudolph, WS.: River City Memoirs, 1997.

Evans, David. *Big Road Blues*. New York: Da Capo Press, 1982.

Faulkner, William. *Absalom, Absalom!* New York: Vintage Books, 1985.

——. *Light in August*. New York: Vintage Books, 1985.

——. *The Sound and the Fury*. New York: Vintage Books, 1946.

Ferber, Dan. "Duck Soup." *Audubon Magazine*, "America's River" special issue, May-June 2006.

Ferris, William. *Blues from the Delta*. New York: Da Capo Press, 1984.

Fields, Rick. *How the Swans Came to the Lake: A Narrative History of Buddhism in America*. Boston: Shambhala, 1986.

Filene, Benjamin. *Romancing the Folk: Public Memory & American Roots Music*. Chapel Hill: University of North Carolina Press, 2000.

Fishkin, Shelley Fisher, ed. *A Historical Guide to Mark Twain*. New York: Oxford University Press, 2002.

———. "In Praise of 'Spike Lee's Huckleberry Finn' by Ralph Wiley," http://faculty.citadel.edu/leonard/od99wiley.htm.

———. *Lighting Out for the Territory: Reflections on Mark Twain and American Culture*. New York: Oxford University Press, 1997.

———. *Was Huck Black?* New York: Oxford University Press, 1993.

Fitzhugh, Bill. *Highway 61 Resurfaced*. New York: William Morrow, 2005.

Floyd, Samuel A. Jr. *The Power of Black Music: Interpreting Its History from Africa to the United States*. New York: Oxford University Press, 1995.

Foster, George "Pops," as told to Tom Stoddard. *The Autobiography of Pops Foster: New Orleans Jazzman*. San Francisco: Backbeat Books, 2005.

Friedman, B. H. *Energy Made Visible*. New York: McGraw-Hill Book Co., 1972.

Friedwald, Will. *Stardust Melodies*. New York: Pantheon Books, 2002.

Gabbard, Krin, ed. *Jazz among the Discourses*. Durham, NC: Duke University Press, 1995.

Gates, David. "Dylan Revisited," *Newsweek*, October 6, 1997.

Gendron, Bernard. "'Moldy Figs' and Modernists: Jazz at War (1942–1946)," in *Jazz among the Discourses*, ed. Krin Gabbard. Durham, 31–56. NC: Duke University Press, 1995.

Genovese, Eugene D. *Roll, Jordan, Roll: The World the Slaves Made*. New York: Vintage Books, 1976.

Giddins, Gary. *Riding On a Blue Note: Jazz and American Pop*. New York: Da Capo Press, 2000.

———. *Satchmo*. New York: A Dolphin Book/Doubleday, 1988.

———. *Visions of Jazz: The First Century*. New York: Oxford University Press, 1998.

Gill, Andy. *Don't Think Twice, It's All Right*. New York: Thunder's Mouth Press, 1998.

Gillespie, Dizzy, with Al Fraser. *To Be or Not to Bop*. Minneapolis: University of Minnesota Press, 2009.

Gitler, Ira. *Swing to Bop*. New York: Oxford University Press, 1985.

Gleason, Ralph J. *Celebrating the Duke*. New York: Delta, 1976.

Gordon, Robert. *Can't Be Satisfied*. Boston: Little, Brown & Co., 2002.

Graubard, Stephen R., ed. *Minnesota: Real & Imagined*. Minneapolis: Minnesota Historical Society Press, 2000. (including "A View from the Countryside," by Joseph A. and Anthony Amato)

Greenfield, Bob. *The Last Sultan: The Life and Times of Ahmet Ertegun*. New York: Simon & Schuster, 2011.

Grimes, Anne. *Stories from the Anne Grimes Collection of American Folk Music*. Athens, Ohio: Ohio University Press, 2010.

Guralnick, Peter. *Lost Highways*. New York: Random House, 1982.

———. *Searching for Robert Johnson*. New York: Dutton, 1989.

Gushee, Lawrence. *Pioneers of Jazz: The Story of the Creole Band*. New York: Oxford University Press, 2005.

Guthrie, Woody. *Bound for Glory*. New York: New American Library, 1970.

Haas, Joseph. "Bob Dylan Talking," *Chicago Daily News*, November 27, 1965.

Habegger, Alfred. *My Wars Are Laid Away in Books: The Life of Emily Dickinson*. New York: The Modern Library, 2001.

Hadley, Frank John. "Four Wise Men," *DownBeat*, February 2001.

Hadlock, Richard. *Jazz Masters of the 20s*. New York: Da Capo Paperback, 1988.

Hajdu, David. *Positively 4th Street*. New York: Farrar, Straus and Giroux, 2001.

Halberstam, David. *The Children*. New York: Random House, 1998.

Hamilton, Marybeth. *In Search of the Blues*. New York: Basic Books, 2008.

Hammond, John, with Irving Townsend. *John Hammond on Record: An Autobiography*. New York: Penguin Books, 1977.

Handy, W. C. *Father of the Blues*. New York: Da Capo Press, 1991.

Harding, Walter, ed. *Thoreau as Seen by His Contemporaries*. New York: Dover Publications, 1960.

Harrison, Daphne Duval. *Black Pearls: Blues Queens of the 1920s*. New Brunswick, NJ: Rutgers University Press, 1993.

Harvey, Todd. *The Formative Dylan: Transmission and Stylistic Influences, 1961–1963*. Lanham, MD, and London: The Scarecrow Press Inc., 2001.

Hasted, Nick. "To Kingdom Come," *Uncut*, April 2005.

Hedges, Inez. *Framing Faust: Twentieth Century Cultural Struggles.* Carbondale, IL: Southern Illinois University Press, 2005.

Heine, Steven. *Bargainin' for Salvation: Bob Dylan, a Zen Master?* New York: Continuum International Publishing Group., 2009.

Helm, Levon, with Stephen Davis. *This Wheel's on Fire.* New York: W. Morrow, 1993.

Hemphill, Paul. *Lovesick Blues.* New York: Viking, 2005.

Henley, Don, and Dave Marsh, eds. *Heaven Is under Our Feet: A Book for Walden Woods.* New York: Berkley Books, 1991.

Hentoff, Nat. "The Crackin', Shakin', Breakin' Sounds." *The New Yorker*, October 24, 1964.

———. *Listen to the Stories.* New York: HarperCollins, 1995.

Heylin, Clinton. *Bob Dylan: Behind the Shades Revisted.* New York: William Morrow, 2001.

Hilburn, Robert. "Rock's enigmatic poet opens a long-private door," *Los Angeles Times*, April 4, 2004. (CalendarLive.com, http://www.calendarlive.com/music/pop/cl-ca-dylan04apr04,0,3583678.story)

Hicks, John, ed. *Thoreau in Our Season.* Amherst: University of Massachusetts Press, 1962.

Hodeir, Andre. *Jazz: its evolution and essence.* New York: Grove Press, 1956.

Holiday, Billie, with William Dufty. *Lady Sings the Blues.* New York: Penguin Books, 1984.

Holmes, John Clellon. *Nothing More to Declare.* New York: Dutton, 1967.

Huang, Yunte. *Charlie Chan.* New York: W.W. Norton & Co., 2010

Hyde, Lewis, ed. *The Essays of Henry D. Thoreau.* New York: North Point Press, 2002

———. *The Gift: Imagination and the Erotic Life of Property.* New York: Vintage Books, 1979.

Isacoff, Stuart. *Temperament.* New York: Alfred A. Knopf, 2001.

Jones, LeRoi. *Black Music.* New York: William Morrow and Company, Inc., 1968.

———. *Blues People.* New York: William Morrow and Company, 1963.

Joyner, Charles W. *Folk Song in South Carolina.* (Tricentennial Booklet Number 9). Columbia, South Carolina: University of South Carolina Press, 1971.

Kahn, Ashley. *A Love Supreme.* New York: Viking, 2002.

Kaplan, Justin. *Mr. Clemens and Mark Twain.* New York: Simon and Schuster, 1970.

Kaplan, Paul. "Contraband Guides: Twain and His Contemporaries on the Black Presence in Venice." *Massachusetts Review*, spring/summer 2003, 182.

Kastin, David. *Nica's Dream: The Life and Legend of the Jazz Baroness.* New York: W.W. Norton & Company, 2011.

Keil, Charles. *Urban Blues.* Chicago: University of Chicago Press, 1966.

Kellner, Charles. *Carl Van Vechten and the Irreverent Decades.* Norman, OK: University of Oklahoma Press, 1968.

Kemp, Mark. *Dixie Lullaby.* New York: Free Press, 2004.

Kenney, William Howland. *Jazz on the River.* Chicago: University of Chicago Press, 2005.

Kerouac, Jack. *On the Road.* New York: Viking Press, 1957.

———. *Visions of Cody,* New York: McGraw-Hill Book Company, 1972.

Kipen, David. "Twain's most chilling time was a fall in San Francisco," *San Francisco Chronicle*, February 3, 2004, D-1.

Kirkeby, Ed. *Ain't Misbehavin'.* New York: Da Capo Press, 1966.

Kmen, Henry A. *Music in New Orleans: The formative Years 1791–1841.* Baton Rouge: Louisiana State University Press, 1966.

Kunian, David. "African, Second Line and Swing With Some R&B Funk," *DownBeat*, September 2006.

Lamont, Peter. *The Rise of the Indian Rope Trick.* Boston: Little, Brown & Co., 2004.

Lass, William. *Minnesota.* New York: W.W. Norton & Co., 1998.

Lebeaux, Richard. *Young Man Thoreau.* Amherst: University of Massachusetts Press, 1977.

Lemann, Nicholas. *The Promised Land.* New York: Vintage Books/Random House, Inc. 1992.

———. *Redemption: The Last Battle of the Civil War.* New York: Farrar, Straus and Giroux, 2006.

Leonard, James S., Thomas A. Tenney, and Thadious M. Davis, eds. *Satire or Evasion?: Black Perspectives on Huckleberry Finn.* Durham and London: Duke University Press, 1992.

Leonard, Neil. *Jazz: Myth and Religion.* New York: Oxford University Press, 1987.

———. *Jazz and the White Americans.* Chicago: University of Chicago Press, 1962 ("Leonard 2")

Levine, Lawrence. *Black Culture and Black Consciousness.* New York: Oxford University Press, 1977.

Levy, Paul. "The Land and the Blood," *Minneapolis Star Tribune*, May 14, 1989.

Lewis, John, with Michael D'Orso. *Walking with the Wind*. New York: Harcourt Brace & Co., 1998.

Lewis, Tom. *Divided Highways*. New York: Penguin Books, 1997.

Lockwood, C. C. *Around the Bend*. Baton Rouge: Louisiana State University Press, 1998.

Lomax, Alan. *The Land Where the Blues Began*. New York: Pantheon Books, 1993.

———. *Mister Jelly Roll*. New York: Pantheon Books, 1993.

Lopes, Paul. *The Rise of a Jazz Art World*. Cambridge and New York: Cambridge University Press, 2002.

Lott, Eric. *Love and Theft: Blackface Minstrelsy and the American Working Class*. New York: Oxford University Press, 1993.

Loving, Jerome. *Walt Whitman: The Song of Myself*. Berkeley: University of California Press, 1999.

Mann, Charles C. *1491: New Revelations of the Americas Before Columbus*. New York: Alfred M. Knopf, 2005.

Marable, Manning. *Race, Reform, and Rebellion: The Second Reconstruction and Beyond in Black America, 1945–2006*. Jackson: University Press of Mississippi, 2007.

Marcus, Greil. *Bob Dylan: Writings 1968–2010*. New York: Public Affairs, 2010.

———. *Like A Rolling Stone: Bob Dylan at the Crossroads*. New York: Public Affairs, 2005.

———. *Mystery Train*. New York: Penguin Books Ltd., 1975.

Marqusee, Mike. *Chimes of Freedom*. New York: New Press, 2003.

———. *Redemption Song: Muhammad Ali and the Spirit of the Sixties*. London: Verso, 1999.

Marquis, Donald M. *In Search of Buddy Bolden: First Man of Jazz*. Baton Rouge: Louisiana State University Press, 2005.

Marx, Leo. *The Machine in the Garden*. New York: Oxford University Press, 1964.

———. *The Pilot and The Passenger: Essays on Literature, Technology, and Culture in the United States*. New York: Oxford University Press, 1988.

Matthiessen, F. O. *American Renaissance: Art and Expression in the Age of Emerson and Whitman*. New York: Oxford University Press, 1941.

McFarland, Gerald W. *Inside Greenwich Village: A New York City Neighborhood, 1898–1918*. Amherst: University of Massachusetts Press, 2001.

McGregor, Craig, ed. *Bob Dylan: A Retrospective*. New York: William Morrow & Company Inc., 1972.

McKeen, William. *Highway 61*. New York: W.W. Norton & Co., 2003.

McLean, Duncan. *Lone Star Swing: On the Trail of Bob Wills and his Texas Playboys*. New York: W.W. Norton & Company, 1998.

McNally, Dennis. *Desolate Angel: Jack Kerouac, the Beat Generation, and America*. New York: Random House, 1979.

McPhee, John. *The Control of Nature*. Thorndike, Maine: G.K. Hall & Co., 1999.

Mezzrow, Milton "Mezz" and Bernard Wolfe. *Really the Blues*. New York: Citadel Press, 1990.

Mingus, Charles. *Beneath the Underdog*. New York: Penguin Books, 1980.

Murray, Charles Shaar. "Highway 61 Resurrected," *The Guardian* (UK), September 28, 2001.

Nickels, Cameron. "Mark Twain and Minstrelsy," paper presented at Elmira, NY, 2009.

Oakley, Giles. *The Devil's Music: A History of the Blues*. New York: Da Capo Press, 1997.

Oates, Stephen B. *William Faulkner: The Man and the Artist*. New York: Harper & Row, Publishers, 1987.

http://oldweirdamerica.wordpress.com/

Oelschlaeger, Max. *The Idea of Wilderness: From Prehistory to the Age of Ecology*. New Haven: Yale University Press, 1991.

Olivier, Rick, and Ben Sandmel. *Zydeco!* Jackson: University Press of Mississippi, 1999.

O'Meally, Robert G., ed. *The Jazz Cadence of American Culture*. New York: Columbia University Press, 1998.

O'Neal, Jim, and Amy Van Singel. *The Voice of the Blues: Classic Interviews from Living Blues Magazine*. New York: Routledge, 2002.

Palmer, Robert. *Deep Blues*. New York: Penguin Books, 1982.

Parry, Albert. *Garrets and Pretenders*. New York: Dover Publications Inc., 1960.

Pearson, Barry Lee, and Bill McCulloch. *Robert Johnson: Lost and Found*. Urbana: University of Illinois Press, 2003.

Pegg, Bruce. *Brown Eyed Handsome Man: The Life and Hard Times of Chuck Berry*. New York: Routledge, 2002.

Peretti, Burton W. *The Creation of Jazz: Music, Race, and Culture in Urban America*. Urbana: University of Illinois Press, 1994.

Perry, Mark. *Grant and Twain*. New York: Random House, 2004.

Petrulionis, Sandra Harbert. *To Set This World Right: The Antislavery Movement in Thoreau's Concord*. Ithaca: Cornell University Press, 2006.

Phillips, Caryl. *Dancing in the Dark*. New York: Alfred M. Knopf, 2005. (novel on Bert Williams – did not finish)

Porterfield, Nolan. *Jimmie Rodgers: The Life and Times of America's Blue Yodeler*. Urbana: University of Illinois Press, 1979.

Powers, Ron. *Mark Twain: A Life*. New York: Free Press, 2005.

Prial, Dunston. *The Producer: John Hammond and the Soul of American Music*. New York: Farrar, Straus & Giroux, 2006.

Pyne, Stephen. *How The Canyon Became Grand*. New York: The Penguin Group, 1998.

Rabham, Jonathan. *Old Glory: An American Voyage*. New York: Simon and Schuster, 1981.

Ramsey, Frederic, Jr. *Been Here and Gone*. Athens, Georgia: University of Georgia Press, 2000.

Ramsey, Frederic, Jr., and Charles Edward Smith. *Jazzmen*. New York: Harcourt, Brace, 1939.

Reich, Howard. "The Rise of Jazz Piano," *DownBeat*, July 1999, 60.

Reich, Howard, and William Gaines. *Jelly's Blues*. New York: Da Capo Press, 2003.

Richardson, Peter. *A Bomb in Every Issue: How the Short, Unruly Life of Ramparts Magazine Changed America*. New York: The New Press, 2009.

Richardson, Robert D. Jr. *Henry Thoreau: A Life of the Mind*. Berkeley: University of California Press, 1986.

Ricks, Christopher. *Dylan's Visions of Sin*. New York: Harper Collins Publishers, 2003.

Riley, Tim. *Hard Rain: A Dylan Commentary*. New York: Alfred M. Knopf, 1992.

Robertson-Lorant, Laurie. *Melville: A Biography*. Amherst: University of Massachusetts Press, 1996.

Robinson, Forrest G. *In Bad Faith: The Dynamics of Deception in Mark Twain's America*. Cambridge: Harvard University Press, 1986.

Rosenberg, Neil V., ed. *Transforming Tradition: Folk Music Revivals Examined*. Urbana and Chicago: University of Illinois Press, 1993.

Rossman, Michael. *The Wedding Within the War*. Garden City, NY: Doubleday, 1971.

Rotolo, Suze. *A Freewheelin Time: A Memoir of Greenwich Village in the Sixties*. New York: Broadway Books, 2008.

Sales, Grover. *Jazz: America's Classical Music*. New York: Da Capo Press, 1992.

Salter, Cathy Riggs. "Lewis and Clark's Lost Missouri," *National Geographic*, April 2002.

Santelli, Robert. *The Bob Dylan Scrapbook, 1956–1966*. New York: Simon and Schuster, 2005.

Santoro, Gene. *Highway 61 Revisited*. New York: Oxford University Press, 2004.

Sattelmeyer, Robert. *Thoreau's Reading: A Study in Intellectual History with Bibliographical Catalogue*. Princeton: Princeton University Press, 1988.

Scaduto, Anthony. *Bob Dylan*. New York: New American Library, 1979.

von Schmidt, Eric, and Jim Rooney. *Baby, Let Me Follow You Down: The Illustrated Story of the Cambridge Folk Years*. Garden City, NY: Anchor Books, 1979.

Schroeder, Patricia. *Robert Johnson, Mythmaking, and Contemporary American Culture* Champaign, IL: University of Illinois Press, 2005.

Scorsese, Martin, director. *No Direction Home: Bob Dylan*. (Film) 2005.

Segrest, James, and Mark Hoffman. *Moanin' at Midnight: The Life and Times of Howlin' Wolf*. New York: Pantheon Books, 2004.

Shapiro, Nat, and Nat Hentoff. *Hear Me Talkin' to Ya: The Story of Jazz as Told by the Men Who Made It*. New York: Dover Publications, Inc., 1955.

Shaw, Arnold. *Honkers and Shouters: The Golden Years of Rhythm and Blues*. New York: Macmillan, 1978.

Sheed, Wilfrid. *The House That George Built*. New York: Random House: 2008.

Shelton, Robert. *No Direction Home: The Life and Music of Bob Dylan*. New York: Da Capo Press, 1997 (Wm. Morrow 1986).

Shortridge, James R. *The Middle West: Its Meaning in American Culture*. Lawrence: University Press of Kansas, 1989.

Shi, David. *The Simple Life: Plain Living and High Thinking in American Culture*. New York: Oxford University Press, 1985.

Sidran, Ben. *Black Talk*. New York: Da Capo Press, 1981.

Siegel, Jules. "Well, What Have We Here?" *Saturday Evening Post*, July 30, 1966.

Sisario, Ben. "Revisionists Sing New Blues History," *New York Times*, February 28, 2004.

Smith, Willie "the Lion," with George Hoefer. *Music On My Mind*. Garden City: Double & Co., 1964.

Snyder, Gary. *Back on the Fire: Essays*. Berkeley: Counterpoint, 2007.

Sounes, Howard. *Down the Highway: The Life of Bob Dylan*. New York: Grove Press, 2001.

Spoto, Donald. *The Kindness of Strangers: The Life of Tennessee Williams*. New York: Da Capo Press, 1997.

Stearns, Marshall W. *The Story of Jazz*. Oxford: Oxford University Press, 1956.

Stewart-Baxter, Derrick. *Ma Rainey and the Classic Blues Singers*. New York: Stein and Day, 1970.

Stoddard, Tom. *Jazz on the Barbary Coast*. Berkeley: Heyday Books, 1998.

Sublette, Ned. *The World That Made New Orleans: From Spanish Silver to Congo Square*. Chicago: Lawrence Hill Books, 2009.

Sudhalter, Richard M. *Lost Chords: White Musicians and Their Contribution to Jazz, 1915–1945*. New York: Oxford University Press, 1999.

Sudhalter, Richard M., and Philip R. Evans. *Bix: Man & Legend*. New York: Schirmer Books, 1974.

Sutter, Barton. *Cold Comfort: Life at the Top of the Map*. Minneapolis: University of Minnesota Press, 1998.

Swank, Bill. "Did Neologic Baseball Pitcher Invent 'Jazz'? *DownBeat*, August 2007.

Swenson, John. *Bill Haley, The Daddy of Rock and Roll*. New York: Stein and Day, 1983.

Szwed, John. *So What: The Life of Miles Davis*. New York: Simon and Schuster, 2002.

Tauber, Alfred I. *Thoreau and the Moral Agency of Knowing*. Berkeley: University of California Press, 2001.

Taylor, Bob Pepperman. *America's Bachelor Uncle: Thoreau and the American Polity*. Lawrence, Kansas: University Press of Kansas, 1996.

Teachout, Terry. *Pops: A Life of Louis Armstrong*. Boston: Houghton Mifflin Harcourt, 2009.

Thomas, J. C. *Chasin' the Trane: The Music and Mystique of John Coltrane*. New York: Da Capo Press, n.d.

Thompson, Toby. *Positively Main Street: An Unorthodox View of Bob Dylan*. New York: Coward-McCann Inc., 1971.

Thoreau, Henry David. *The Maine Woods*. New York: Quality Paperback Book Club, 1997. ("TMW")

———. *A Week on the Concord and Merrimack Rivers*. Orleans, Massachusetts: Parnassus Imprints Inc., 1987. ("C&M")

———. *Walden*. New York: Airmont Publishing Co., 1965

Thorn, John. *Baseball in the Garden of Eden: The Secret History of the Early Game*. New York: Simon & Schuster, 2011.

Toll, Robert C. *Blacking Up: The Minstrel Show in Nineteenth-Century America*. New York: Oxford University Press, 1974.

Tonkinson, Carole, ed. *Big Sky Mind: Buddhism and the Beat Generation*. New York: A Tricycle Book/ Riverhead Books, 1995.

Tosches, Nick. *Unsung Heroes of Rock 'n' Roll*. New York: Charles Scribner's Sons, 1984.

Townsend, Charles R. *San Antonio Rose: The Life and Music of Bob Wills*. Urbana and Chicago: University of Illinois Press, 1976.

Townsend, Henry, with Bill Greensmith. *A Blues Life*. Urbana and Chicago: University of Illinois Press, 1999.

Turner, Frederick. *Spirit of Place*. Washington, D.C.: Island Press, 1989.

Turner, Richard Brent. *Jazz Religion, the Second Line, and Black New Orleans*. Bloomington: University of Indiana Press, 2009.

Twain, Mark. *Life on the Mississippi*. New York: Harper & Row, 1965.

———. *Tom Sawyer* and *Huckleberry Finn*. New York: Platt & Munk, 1960.

Uzzel, Robert L. *Blind Lemon Jefferson: His Life, His Death, and His Legacy*. Austin: Eakin Press, 2002.

Van Ronk, Dave, with Elijah Wald. *The Mayor of Macdougal Street*. New York: Da Capo Press, 2005.

Veith, Gene Edward, and Thomas L. Wilmeth. *Honky-Tonk Gospel*. Grand Rapids, MI: Baker Books, 2001.

Ventura, Michael. "Hear That Long Snake Moan," *Whole Earth Review*, Spring 1987. (from *Shadow Dancing*, Tarcher, 1985).

Versluis, Arthur. *American Transcendentalism and Asian Religions*. New York: Oxford University Press, 1993.

Wald, Elijah. *Escaping the Delta*. New York: Amistad/Harper Collins, 2004.

———. *How the Beatles Destroyed Rock 'n'Roll: An Alternative History of American Popular Music*. New York: Oxford University Press, 2009.

———. *Josh White: Society Blues*. Amherst, MA: University of Massachusetts Press, 2000.

Waldo, Terry. *This Is Ragtime*. New York: Da Capo Press, 1991.

Walton, Anthony. *Mississippi*. New York: Vintage Departures, 1996.

Ward, Andrew. *Dark Midnight When I Rise: The Story of the Fisk Jubilee Singers*. New York: Farrar, Straus and Giroux, 2000.

Ward, Martha. *Voodoo Queen: The Spirited Lives of Marie Laveau*. Jackson: University of Mississippi Press, 2004.

Wardlow, Gayle Dean. *Chasin' That Devil Music: Searching for the Blues*. San Francisco: Backbeat Books, 1998.

Waterman, Dick. *Between Midnight and Day: The Last Unpublished Blues Archive*. New York: Thunder's Mouth Press, 2003.

Watts, Alan. *In My Own Way: An Autobiography*. New York: Vintage Press, 1973.

Weingroff, Richard. "From Names to Numbers: The Origins of the U.S. Numbered Highway System," http://www.fhwa.dot.gov/infrastructure/numbers.cfm.

———. "U.S. Route 61: A Highway History," October 1987. Privately shared.

White, Charles. *The Life and Times of Little Richard*. New York: Harmony Books, 1984.

Widen, Larry. *Tombstone Blues*. Milwaukee: Apple Core Publishing, 2005.

Wilentz, Sean. *Bob Dylan in America*. New York: Doubleday, 2010.

Wilentz, Sean, and Greil Marcus. *The Rose and the Briar: Death, Love and Liberty in the American Ballad*. New York: W.W. Norton & Co., 2005.

Wilkinson, Alec. *The Protest Singer: An Intimate Portrait of Pete Seeger*. New York: Alfred A. Knopf, 2009.

Williams, Paul. *Performing Artist: The Music of Bob Dylan*. vol. 1. Novato, CA: Underwood-Miller, 1990.

Williams, Tennessee. *Cat on a Hot Tin Roof*. New York: Signet Books, 1985.

Williamson, Joel. *William Faulkner and Southern History*. New York: Oxford University Press, 1993.

Williamson, Nigel. "Rock of Ages," *Uncut*, June 2005, 40–44.

Wilson, Elizabeth. *Bohemians: The Glamorous Outcasts*. New Brunswick, NJ: Rutgers University Press, 2000.

Wolfe, Charles & Kip Lornell. *The Life and Legend of Leadbelly*. New York: HarperPerennial, 1992.

Wondrich, David. *Stomp and Swerve: American Music Gets Hot 1843–1924*. Chicago: A Cappella Books, 2003.

Wood, David F. *An Observant Eye: The Thoreau Collection at the Concord Museum*. Concord, MA: The Concord Museum, 2006.

Wood, Gordon S. *The Americanization of Benjamin Franklin*. New York: Penguiin Books, 2004. ("GW")

Woodward, C. Vann. *The Burden of Southern History*, 3rd ed. Baton Rouge: Louisiana State University Press, 1993.

———. *The Strange Career of Jim Crow*, 3rd ed. New York: Oxford University Press, 1974.

Wyatt-Brown, Bertram. *Southern Honor: Ethics and Behavior in the Old South*. New York: Oxford University Press, 1982.

Zane, J. Peder. *Remarkable Reads*. New York: W.W. Norton & Company, 2004.

Zuckerman, Matthew. "If There's an Original Thought Out There, I Could Use It Right Now: The Folk Roots of Bob Dylan," http://expectingrain.com/dok/div/influences.html.

Permissions

Acknowledgments

SPECIAL THANKS GO to all the kind people who aided me. Joel Selvin shared his remarkable library. The San Francisco Public Library is a wonderful place—all blessings to it and its staff. Holly Hancock helped me get started with some professional legwork. She's one of the reasons why I love librarians.

Starting in the north, Paul Levy of the *Minneapolis Star-Tribune* introduced me to the great north woods. Captain Steven Pal, Mississippi River man (and my thanks to Dennis Alpert and Mark Duncan for connecting me to him), gave me a taste of life on a Mississippi barge.

In St. Louis, Madeleine Dames gave me the kindest hospitality, and Harper Barnes made available his research on the tragic events of East St. Louis in 1917.

In Clarksdale, Patty Johnson (once part of *Living Blues*) and Shelley Ritter of the Blues Museum were good company as well as sources of information. Southern hospitality is still real: Dick and Cinda Waterman in Oxford are lovely people—and also supremely forthcoming with information. In New Orleans, Ben Sandmel was especially kind and extremely knowledgeable, and Don Marquis answered some important questions.

Stephen LaVere kindly read my manuscript and caught my mistakes—great thanks for that.

In Concord, Jeff Cramer of the Walden Institute and Michael Frederick of the Thoreau Society were most helpful. In Elmira, Barbara Snedecor of the Mark Twain Center was incredibly gracious and encouraging.

My correspondence with Shelley Fisher Fishkin and Sandra Harbert Petrulionis was profoundly informative—I thank them for their time and courtesy. Tom Lewis connected me with the inestimable Richard Weingroff (Information Liaison, Highway Administration), who did his job superbly.

My dear friends Sofi Milani; Phil, Arden, Sam, and Max Coturri; Jeff Briss and Dorothy Fullerton; and Tom and Maggie Pinatelli kept promising they'd read the book some day. Israel Moyston told me I should include him—and he was right.

On the journeys, Lou Tambakos was part of the first, and Susana Millman the second. Thanks, as they say, for the ride.

Jeff Rosen at Special Rider Music was kind and a joy to work with—heartfelt thanks. I've been extraordinarily lucky to have the best agent imaginable in Sarah Lazin, and a truly superb editor in Charlie Winton. His reading of the manuscript aided it immeasurably. What a pleasure a really good editor is!

And thanks for family: my wife, partner, and photographic eye Susana Millman, my daughter and son-in-law Season and Jono Korchin, and my lovely grandsons Julian and Elias Korchin. May they grow up in an America that honors and reflects this tradition.

SAN FRANCISCO, 2014

Index

Printed in the United States
by Baker & Taylor Publisher Services